absence of clutter

absence of clutter minimal writing as art and literature

Paul Stephens

The MIT Press
Cambridge, Massachusetts
London, England

© 2020 Massachusetts Institute of Technology

All rights reserved. No part of this book may be reproduced in any form by any electronic or mechanical means (including photocopying, recording, or information storage and retrieval) without permission in writing from the publisher.

This book was set in Helvetica Neue Pro byThe MIT Press. Printed and bound in the United States of America.

Library of Congress Cataloging-in-Publication Data
Names: Stephens, Paul, author.
Title: Absence of clutter : minimal writing as art and literature / Paul Stephens.
Description: Cambridge, Massachusetts : The MIT Press, 2020. | Includes bibliographical references and index.
Identifiers: LCCN 2019032457 | ISBN 9780262043670 (hardcover)
Subjects: LCSH: Visual literature--History and criticism. | Minimalism (Literature) | Art and literature.
Classification: LCC PN56.V54 .S74 2020 | DDC 709.04/058--dc23
LC record available at https://lccn.loc.gov/2019032457

10 9 8 7 6 5 4 3 2 1

Contents

Introduction: The Aesthetics of Information Scarcity 1
1 Varieties of the Minimal 17
2 Close Viewing / Distant Reading / Readography 47
3 `absence of clutter` 57
4 The Indexical Present 69
5 "A Radium of the Word": From Imagism to Concretism 77
6 The One-Word Poem 93
7 The Transreal 111
8 "Really 'Reading In'": Robert Grenier's *Sentences* 127
9 To Icon or Not to Icon 149
10 "TOREVERSETHEREVERSE": Molecular Conceptualism 185
11 Minimal Maximalism 203
 Coda: @no_ideas_but_in_??? 217

Acknowledgments 223
Appendix: A Selected Bibliography of Oneworders 225
(Categorized by Primary Word)
Notes 237
Index 275

Introduction The Aesthetics of Information Scarcity

The idea for this book came to me as I was driving to teach a class at a maximum-security prison. The class was called Twentieth-Century American Literature and the Visual Arts, and I had assigned Vito Acconci and Bernadette Mayer's journal of conceptual art and writing *0 To 9* (copies of which had been generously donated by the publisher of its reissue, Ugly Duckling). Teaching visual art in a maximum-security prison has its complications: no electronic devices are permitted, and there is no internet access. No images of nudity are allowed, which makes it difficult to assign most art history textbooks. Several weeks earlier, my copy of *Art Since 1900*, the standard textbook in the field, had been confiscated by prison officials after a guard flipping through the pages caught sight of Lynda Benglis's well-known 1974 *Artforum* advertisement (a controversial self-portrait of the artist wearing only a strap-on dildo and sunglasses). Given my inability to show images in class, as the semester progressed I turned increasingly to teaching visual literature and text art. I had for some time been a fan of the minimal poems of Aram Saroyan, and I was curious how my students would respond to his poems in *0 To 9*.

For me, part of the appeal of studying minimal writing is that it is the antithesis of the kind of work I wrote about in my book, *The Poetics of Information Overload: From Gertrude Stein to Conceptual Writing*. There I was interested in sprawling maximal works like Stein's 925-page *The Making of Americans*. I made the case that such "unreadable" or repetitive works responded to the information abundance of modern societies. Perhaps counterintuitively, the rise of minimalism in the 1960s can also be understood in relation to new developments in media. Many minimal works may have been austere in form or spare in content, but they were often gigantic in scale, and fantastically complex in their implications. Whereas many 1960s pop artists and New York School poets gleefully included the detritus of consumer society in their work, minimal and conceptual artists stripped language down to its most basic components, the word and the letter. As Robert Smithson wrote (in another text I assigned that semester, "The Spiral Jetty"), "size determines an object, but scale determines art."[1] Minimal writing depends on the scale of the page (or other medium) to convey meaning. Minimal poems can be richly associative, and the absence of context can allow readers and viewers to imagine their own context. As Craig Dworkin has pointed out, minimal poems can lead to maximum exophora—or associatively, to "really 'reading in,'" in Robert Grenier's words.[2]

Minimal poems are limit cases not just for written expression, but also for aural and visual expression. Can there be a one-word poem in isolation? And if so, how is it seen, heard, or remembered? All literary works and all artworks are mediated when they are published, displayed, or disseminated; minimal writing foregrounds those processes in fascinating ways. Minimal poems have appeared not only in books and online, but also in, on, and as paintings, photographs, posters, films, billboards, cards, buttons, matchbooks, license plates, tote bags, graffiti, sidewalks, walls, t-shirts, neon signs, tattoos, and bookmarks. David Antin's *Sky Poems* required a fleet of five skywriting airplanes, and Ian Hamilton Finlay's garden of poems, Little Sparta, was the culmination of his life's work.[3] Christian Bök has encoded poems into DNA, and Jen Bervin has "fabricated a silk film with the poem written in nanoscale in a six-character chain that corresponds to the DNA and the silkworm's filament drawing method."[4] Bök's and Bervin's projects reimagine not only how meaning is conveyed, but also how the entirety of the genetic code writes who we are as individuals and as a species.

"Less is more" is the most pervasive cliché of minimalism.[5] It served as the motto of Ludwig Mies van der Rohe, and variants can be found in many 1950s and 60s discussions of minimal painting, sculpture, and architecture.[6] "Less is a bore," Robert Venturi countered in 1966, offering a postmodern riposte to Mies's modernist optimism.[7] Contained within the "less is more" cliché is one of the main themes of minimalism, namely the dialectical opposition of minimal form and content with the maximalism of modern media and everyday life. The oft-quoted opening to John Ashbery's 1970 "The New Spirit" puts the paradox in seemingly plain terms:

> I thought that if I could put it all down, that would be one way. And next the thought came to me that to leave all out would be another, and truer, way.
>
> clean-washed sea
>
> The flowers were.
>
> These are examples of leaving out. But, forget as we will, something soon comes to stand in their place.[8]

Generally speaking, Ashbery, like Venturi, opted for a maximal style in which he "put it all down." The non sequiturs and laconic floating words of his 1962 collection *The Tennis Court Oath* largely evolved into the long, meandering verse lines of the later work. And yet much is left out of Ashbery's later work as well. It is often unclear who is speaking to whom, even if the later poems are generally syntactically correct, and do not leave readers hanging on mystifyingly partial sentences such as "The flowers were." As Ashbery observes, our minds restlessly attempt to create meaning by association— "something soon comes to stand in" for what gets left out.

Minimal writing offers an implicit challenge to traditional genre boundaries between visual poetry and text art, verse and prose—as well as to conventional expectations for the specificity of media formats. In the nineteen-tens, futurism, synthetic cubism, and Dada all sought to make language integral to pictorial representation (or nonrepresentation). Could even the titles of readymade sculptures be considered minimal poems? Perhaps the question is a tendentious one, and not much is at stake other than whether to assign these traditions to art historians or literary historians. On the other hand, as Liz Kotz writes in *Words to Be Looked At*, Marcel Duchamp's readymades allowed "artists to address a vast field of 'language in general' that potentially takes in words wherever they are found—brand names, advertising slogans, office records, grocery lists, banal conversations, telegrams, assembled documents, and instructions for making a work."[9] The most famous of all readymades, Duchamp's 1917 *Fountain*, could well be described as an early multimedia experiment. Not simply a sculpture, *Fountain* was an elaborate P.R. stunt. No original of the sculpture exists. *Fountain* was first "exhibited" in the pages of *The Blind Man* as a photograph by Alfred Stieglitz. According to "The Case of Richard Mutt," written by Duchamp's close friend Beatrice Wood, the urinal's "useful significance disappeared under the new title and point of view [which] created a new thought for that object."[10] One might go so far as to suggest that the work's title made it not only an art object, but also a literary text. Duchamp himself noted of his titles: "There is a tension set up between my titles and the pictures. The titles are not the pictures nor vice versa, but they work on each other. The titles add a new dimension, they are like new or added colors, or better yet, they may be compared to varnish through which the picture may be seen and amplified."[11] In terms of both the effort to make the artwork and to assign the all-important title, *Fountain* could hardly be more laconic. And yet its influence could hardly be greater.[12]

In 1913, Duchamp posed the question: "Can one make works which are not works of 'art'?"[13] One might also ask: "Can one write works which are not works of 'literature'?" If the most basic, unadorned, and unmodified manufactured items could be made into art, why couldn't the most basic, unadorned, and unmodified elements of language be made into literature? "Literature" as a terminological category raises the specter of elitism for many contemporary readers, but Duchamp saw his own work as deeply literary, and viewed literature as a means by which to challenge the naive retinalism of the nineteenth century: "I was interested in ideas—not merely in visual products.... And my painting was, of course, at once regarded as 'intellectual,' 'literary' painting."[14] While Duchamp tends to put the word "literature" in scare quotes, he also consistently describes himself in literary terms, as for instance when he writes: "Dada was an extreme protest against the physical side of painting. It was a metaphysical attitude. It was intimately and consciously involved with 'literature.'"[15] Duchamp's visual productions are inextricable from his textual productions—many of which were inherently minimal and fragmentary and classified by him as "texticles." His early readymades

INTRODUCTION 3

predate minimalism as a movement, but Duchamp's description of his process has much in common with how subsequent minimalists described their work, as when he claims: "Reduce, reduce, reduce was my thought—but at the same time my aim was turning inward, rather than toward externals. And later, following this view, I came to feel an artist might use anything—a dot, a line, the most conventional or unconventional symbol—to say what he wanted to say."[16] Similarly, Mallarmé would claim: "My work has been created by elimination."[17] Across the visual and written arts, reduction, redaction, and erasure have remained significant practices.[18]

Duchamp did more than simply challenge genre boundaries between sculpture and manufactured objects or between painting and poetry; his larger challenge was to the very terminological categories of art and literature. What is literariness? Is there a length requirement for a work of literature? How much concision can literature take? Can an emoji or icon convey literary meaning?[19] Is literature inherently durational? Gotthold Lessing maintained that poetry is extended in time, while painting is extended in space. Lessing's dichotomy was meant to apply to epic poetry and to classical painting and sculpture, and perhaps offers little guidance to the contemporary critic.[20] Nonetheless, we associate different temporal experiences to reading literary works as opposed to viewing artworks. What if, as is the case with Saroyan below, the artwork is simply a single word—comprehensible in a glance, and yet suggestive of larger cultural associations? As Robert Grenier once asked in conversation, "Is it a long poem if you look at it long enough?" Minimal poems, particularly when they are valued as art objects, offer iterative reading experiences on multiple levels, from the fleeting to the ponderous. Duchamp's notion of the "infrathin" or *inframince* is particularly germane to the study of textual minimalism. Although Duchamp insisted that the infrathin "escapes precise definition," in the most basic terms it could be described as the most minimal difference between two differing states "and not a precise laboratory measure."[21] The infrathin, importantly, is both temporal and spatial. Marjorie Perloff describes the implications of this for post-1960s poetics: "In aesthetic terms, the 'interval between two names' which is the *infrathin* spells the refusal of metaphor—the figure of similarity, of analogy, of likeness—in favor of the radical *difference* at the core of the most interesting art works and poetries since the 1960s. For no sooner is a link between two items (e.g., table/tables) made, than it is negated by a shift in focus or context."[22] It is just such infrathin shifts in focus or context that minimal writing often makes possible—as Saroyan's limit-case minimal poems demonstrate especially well.

As background to my class on *0 To 9*, I had assigned Saroyan's poetics statement from Mary Ellen Solt's 1968 *Concrete Poetry: A World View*:

> I began as a "regular" poet, imitating effects I liked in Creeley, Ashbery, everybody. Then one night by accident I typed eyeye. I didn't know what it was. Someone else saw it and said—yes! That was about two years ago. For a year after that I did plenty of visual poems. But differently than the concrete poets....

> As McLuhan says, you can't make the new medium do the old job. The information in a new poem can't be the same as the information in an old poem. In a visual poem an "imitation" of the shape of an object outside the poem, let's say like the horizon of Holland (to use Finlay), well that's the same type of describing, really, as an old linear poem does. In a good visual poem there are no horizons, fields, kisses, hugs, sentiments etc. but those implicitly inside the *shape* of the word constellation, which never never never should refer outside—to anything outside it. After all they've been doing shaped poems for centuries. That's entirely old—ruinously old.[23]

Saroyan's rhetoric here is paradoxical in the extreme. A new poem cannot contain the same information as an old poem, and yet the poem seemingly should not describe anything outside itself. Like television, the one-word poem circumvents the reading process, according to Saroyan.

> What interests me now is that new poetry isn't going to be poetry for reading. It's going to be for looking at, that is if it's poetry to be printed and not taped. I mean book, print culture, is finished. Words disappeared in sentences, meanings, information, in the process that is reading (a boring, very boring moving of the eyes) that is the same in a poem by Edgar Guest as it is in a poem by Creeley—and, yes The Media Is The Message, and reading is nothing as a medium at all, it's finished if literature is an art form because the process of moving the eyes is antique, has nothing to do with what eyes are doing now—like in painting, really since impressionism, the eyes haven't been directed. And I mean, still, there's no such thing as looking at writing—looking at words on a page—you have to start at the beginning and READ! That has absolutely nothing to do with words, and they (these) are the message. No information in them but themselves.
> I mean for real! No more reading! If you have to read, resolve any structure of language into a meaning, well that's just it—it resolves! The words disappear into a meaning. What are words?[24]

Saroyan's manifesto-like statement echoes the historical avant-garde of the nineteen-tens and twenties, and in particular futurist claims to have superseded the reading and writing processes by technological means. As Saroyan writes elsewhere, "It was the nervous system itself that was my primary subject matter at this stage of my writing."[25] Or in even starker terms: "I was a typewriter."[26] By fusing with the machine, Saroyan is able to achieve a radical depersonalization and a remarkable condensation that (purportedly) transcends meaning. The effect is not unlike the giddy poetics statement of a young Velimir Khlebnikov in 1919: "Is a poem not a flight from the I? A poem is related to flight—in the shortest time possible its language must cover the greatest distance in images and thoughts!"[27] Against the widely held presupposition that poetry is a contemplative, nostalgic genre, Saroyan and Khlebnikov invoke the insatiable acceleration of modern life.

In response to Saroyan's statement, Solt suggests what is at stake when she asks: "If the next step beyond William Carlos Williams is prose or nonlinear form, what is the next step beyond Saroyan? Out of words? Back to more words? Where? There can be no doubt that [Saroyan's poem] 'eatc.' says it. The question is, could it be said

with less? More could be said with less: 'eatc.'"[28] Solt's response both invokes and subverts the "more is less and less is more" cliché. Saroyan differentiates himself from the other concrete poets in her anthology by rejecting calligraphic or shape poems, and he attributes his first minimal poem to a felicitous typo. He misrepresents concrete poetry to some extent (more on this below) as simply calligramatic. He also invokes Eugen Gomringer's notion of the word constellation, but only to object to it. The one-word poem, for Saroyan, responds to changing media, whereas he sees the shape poem as a static tradition. Saroyan declares that there is no informational content whatsoever to his poems, and he ends by posing a central question of modernism: "What are words?" Modernism's "revolution of the word" variously explored the nature of the individual word by splitting up words, creating portmanteaus and neologisms, as well as, in the case of Stein especially, by using serial repetition. A rose might not have any other name than a rose. How minimal can the minimal poem get? If minimal poems truly foreclose all possibility of meaning and the sequentiality of syntax, are they a kind of anti-poetry aimed only at teasing readers? The poem that Solt quotes—"eatc."—could be both the noun (and conjunction) *et cetera*, as well as a homophone of the verb "eats." Like Saroyan's most famous poem, "lighght," this poem adds a conventionally unpronounceable element to the source word. The abbreviation of *et cetera* is an ideal example of compression. "Etc." is theoretically infinite in its inclusion of unspecified other things, and yet its three letters can also be utterly vacuous. According to Ian Hamilton Finlay, "The artist has this disadvantage: he has no equivalent of the word 'etc.'"[29] Finlay seems to be suggesting that for an artist to use the "etc." is to undermine the mimetic nature of art—as if to say "yadda yadda" or "blah blah"—or, in other words, "I could go on, but I won't" is a sort of representational cop-out.

As a rejoinder to Saroyan's claim to have created instant poems that circumvent the reading process, consider Bernar Venet's "Instant Poem," which reads in its entirety [including ellipses] "... in a necessarily transitory conceptual state."[30] The single line of the poem is aligned with its title (set in a different font) at the very top of the page without a line break. Here the transitory conceptual state counteracts any sense of instantaneousness. Without a process of perception, there can be no recognition of the poem-as-poem. Minimal poems such as "eatc." or "Instant Poem" are limit cases not only for literature and literary theory, but also for mediation and visual perception. They can seem beguilingly simple and inviting on the surface, but their publication and remediation histories can be remarkably complex. My aim with this book is to introduce minimal texts not only to literary scholars and poets, but also to historians of art, graphic design, and media. I hope, finally, that this book's interdisciplinary approach will make minimal writing—which has too often been overlooked by literary scholars and art museums—more visible both from up close and from a distance, in order to help reflect on how we read, see, and pay attention in a time of rapidly shifting reading and writing practices.

Post-1960s visual art is strongly characterized by the "linguistic" turn, and artists such as Lawrence Weiner, Carl Andre, Dan Graham, Joseph Kosuth, Barbara Kruger, Lucy Lippard, and Jenny Holzer built lucrative and highly visible careers from text-based art. I hope to demonstrate that minimal poets working during this same era produced work of equal complexity and power—and to show how minimal writing has enjoyed a recent resurgence among writers working with computer code, as well as among those working with emergent publication platforms.

The opening of a "vast field of language" to the visual arts in the 1960s had a profound historical impact; pop art, conceptualism, and minimalism are all strongly characterized by their use of textual material.[31] There was considerable cross pollination between the visual arts and avant-garde literature in the 1960s, but often what designated an artwork as such was its value in the art market. By contrast, literary works (other than commercial fiction and nonfiction) tended to be noncommercial. Marcel Broodthaers, who began his career as a poet and later became a leading conceptual artist, expressed his "doubt ... that it is possible to give a serious definition of Art, unless we examine the question in terms of a constant, I mean the transformation of art into merchandise."[32] Despite (or perhaps due to) his own commercial success, Broodthaers saw art and literature as distinct fields, and mused, "Art and literature ... which of the moon's faces is hidden?"[33] Perhaps no figure was more responsible for the commercial success of conceptual art than Seth Siegelaub, who was able to offer for sale works that were typically not created by the hand of the artist, and that would have been nearly impossible to monetize a few years earlier. "We fought very seriously against the confusion with poetry,"[34] Siegelaub recalled of himself and his roster of conceptual artists (some of whom, like Lawrence Weiner, worked exclusively with text or with concepts, i.e., "The piece need not be built").[35] "Because," Siegelaub continued, "it wasn't about poetry. It was about physical objects in the world."[36] Siegelaub's segregation of art and poetry helped make it possible to sell unique (or limited edition) works of text art that often contained no imagery whatsoever. This separation of conceptual art and the poetic may have in turn contributed to the marginalization of visual poetry as an art form in the wake of the 1960s. As Saroyan remarked to me in an email: "The difference between Bob [Grenier] and me and Laurence Weiner is that he came in through the Art Door and we entered through the Writing Door."[37] One aim of this book is to attempt to reconsider largely noncommercial works of visual literature alongside better-known commercial works of visual art.

"Minimalism" has multiple senses as a word, and has spawned multiple movements, some of which are explored and disambiguated in the first chapter, "Varieties of the Minimal," which gives an account of minimal writing based on the unit of composition in relation to various media formats, and draws on examples from Ed Ruscha, Ulises Carrión, Hollis Frampton, Alison Knowles, and Martine Syms.

The second chapter, "Close Viewing / Distant Reading / Readography," presents a media-theoretical framework for interpreting minimal writing as both literature and visual art, and uses for a case study a Jen Bervin quiltwork adaptation of an Emily Dickinson fragment.

The third chapter explores the sociocultural implications of minimalism. "`absence of clutter`," from which the book derives its title, is the complete text of a poem by Robert Grenier, as well as a phrase used by Steve Jobs to describe his design aesthetic. Guides for minimal living, such as those by the bestselling author Marie Kondo, have proliferated in recent years. Some have found the ethos of minimal living a powerful response to capitalist overconsumption; others have suggested that the minimal living craze is elitist and simply another symptom of capitalist overconsumption.

"The Indexical Present," the fourth chapter, offers an account of minimal works by artists such as Adrian Piper, Glenn Ligon, Jenny Holzer, and Barbara Kruger in which the referent (such as "I," "you," "this") is dependent on the context.

The fifth chapter, "'A Radium of the Word': From Imagism to Concretism," explores the modernist roots of minimalism. It takes its title from Mina Loy's poem "Gertrude Stein," in which Loy credits Stein with having been able to "extract / the radium of the word" from "the tonnage / of consciousness." I locate the origins of minimal writing in multiple sources: Mallarmé's late work, Stein's early cubist-inspired writing, Ezra Pound and H.D.'s imagism, and Marcel Duchamp's readymades. I draw a distinction between these modernist works and other traditions of lyric compression, such as the haiku, the fragment, the epitaph, and the maxim, and I suggest that minimal writers were responding to new developments in advertising and the visual arts, as well as to new technologies such as the telephone and television, and, more recently, to formats such as text messaging, Twitter, and Instagram.

Chapters 1 through 5 of this book establish a theoretical framework for reading and viewing minimal writing. Chapters 6 through 11 offer close media-historical readings, beginning with Aram Saroyan, whose one-word poems move beyond the concrete poetry of the 1950s and early 60s by experimenting with the most minimal units of language, and placing words (or parts of words) in stark relief. Saroyan's poems are influenced by, and emerge largely in tandem with, pop art, minimal art, and conceptual art.

Norman Pritchard, whose work I take up in chapter 7, was arguably the most formally innovative visual poet in New York City in the late 1960s and early 70s—yet nonetheless vanished from the literary scene after publishing two exceptional books. His work has enjoyed a recent revival, but as yet there is no full-length scholarly article on his work. A founding member of the Umbra group, Pritchard occupies a unique position within postwar African American literature.

Robert Grenier's 1978 *Sentences* is often taken to be the inaugural work of the Language writing movement, but it also exhibits features of minimalism (a label Grenier disavows) and conceptualism. Chapter 8 offers the most complete media-archival history to date of Grenier's poem (or poems), and is based on extensive research

undertaken with Grenier's papers at Stanford. The *Sentences* project, I argue, can be read as a series of interactive experiments in how poetry is mediated and experienced.

Chapter 9 discusses the art of Natalie Czech, whose *Poems by Repetition* series has adapted poems by Stein, Saroyan, Grenier, and others. Czech's work is based on elaborate background research, as well as a uniquely involved practice of reworking physical sources, such as album covers and advertisements. Her work pays homage to the minimal poems of the 1960s and 70s at the same time that it reveals how text and image relate in a society dominated by mass culture and onscreen textuality. Her most recent project, *To Icon*, explores various computer icons—creating works of text art from the ubiquitous visible language of digital devices.

Chapter 10, "'TOREVERSETHENEVERSE': Molecular Poetics," attempts to reverse-engineer recent work by Jen Bervin, Craig Dworkin, and Christian Bök—each of whom draws from molecular biology in order to create (or convey) their writing. Bervin's *Silk Poems*, Dworkin's *Fact*, and Bök's *Xenotext* all explore aspects of the nanosublime in their ambitious attempts to fuse form and content.

I conclude with a chapter on the print-on-demand books of Holly Melgard, the code poetry of Nick Montfort, and the Twitter-based work of Allison Parrish. I suggest that these three writers employ minimal means to maximal ends. Montfort's "ASCII Hegemony," for instance, employs a single line of computer code to produce a twelve-page poem (in its print version), which in its electronic version could theoretically go on infinitely (or until the host computer crashes). Melgard's *The Making of the Americans* eliminates every repeated word from Stein's *Making of Americans*, resulting in a text with roughly 1 percent of the original word count. Parrish's @everyword bot, by contrast, tweeted every word of the English language one word at a time over a seven-year span, offering at once a stark antithesis and a fitting tribute to the one-word minimalism with which the book begins.

"Media" is a notoriously slippery term, which I understand broadly in the context of this book to refer to the modes and technologies—the multiplicity of mediums—that convey and constitute literature and visual art.[38] The body too is a medium—for the voice (in spoken poetry) or for the gesture (in performance art).[39] Lyric poetry is particularly interesting from a media-theoretical perspective, because it can seem like the most unmediated and transhistorical genre.[40] Upon closer inspection, however, lyric poetry is no more or less mediated than any other literary genre. The public poetry reading, for instance, is a comparatively recent historical development, dating for the most part to the 1950s.[41] Readings are usually from printed texts, and are often recorded. Visual art may not typically have an aural dimension, but the same cannot always be said of visual poetry. Intermedia experimentation has been a defining characteristic of postwar visual art and literature.[42] By reimagining scale and emphasizing the smallest units of meaning, minimal writing offers a rich range of examples of experimentation with words and images in many contexts and across many platforms.

I should note at the outset that this book primarily offers an account of *visual-textual* minimalism, and does not presume to offer a comprehensive theory of minimalism across the arts. Due largely to the limits of my own expertise, this study primarily focuses on North American writers and artists: a more global collection of minimal writing could also be assembled.[43]

. . .

To be honest (or "tbh" in textspeak), teaching the starkly informatic black-and-white *0 To 9* in prison did not go as well as I had hoped. Prison is an information- and image-poor environment. Typewriter art has enjoyed a recent resurgence among those who never had to struggle with typewriters, but many prisoners still regularly use typewriters because they lack access to computers. (Nearly all of the 2.3 million prisoners in the U.S. are denied internet access, which the United Nations has declared a universal human right.)[44] After classes on abstract expressionism and pop art, the conceptual/typewriter aesthetic of *0 To 9* seemed austere, and to require too much work for not enough visual reward. Without much context, *0 To 9* seemed more like a D.I.Y. inside joke than the most significant mimeograph journal produced in New York in the late 60s. If you spend much time at the Museum of Modern Art or at DIA Beacon (not far from where I was teaching), you will be exceptionally familiar with the pantheon of artists included in *0 To 9*: Robert Smithson, Sol LeWitt, Dan Graham, Lawrence Weiner, Adrian Piper, et al. But the collected *0 To 9* can be a mystifying tome without that background. My aim in the class was to explore parallel developments in art and literature. Earlier in the semester we had read the issue of the journal *The Blind Man* in which Duchamp's *Fountain* first appeared, as well as *Fire!!*, the extraordinary Harlem Renaissance journal which printed poetry and fiction, as well as visual art by Aaron Douglas. My students had a strong preparation in modern art, but they were still caught somewhat off guard by the typographic restraint of *0 To 9*.

One virtue of minimal poems is that they can be easy to remember and reproduce on the spot. On the day I taught *0 To 9* I brought with me an "eyeye" Aram Saroyan tote bag made by the publisher Primary Information. The students immediately noted that the poem was a palindrome, and that the poem was a homophone for "I, I" as well as "aye-aye." They also pointed out that the poem was effectively stereoscopic or binocular: we look at the poem with two eyes, and the poem looks back at us as with two eyes. I asked the students if they could think of any possible translations of the poem. A Spanish-speaking student offered "ojojo" as a possible translation, and we noted that, like the original, "ojojo" was a palindrome of five letters total, but composed of only two letters.[45] We tried French next: "oeiloeil" didn't work as well; nor did "yeuxyeux."

Another poem we discussed was Saroyan's *m* with an extra hump (or an extra shoulder, in more precise typographic terms) (figure 0.1). Written in the summer of 1965, the strange new letterform was created with an X-ACTO knife at a print shop where Saroyan worked.[46] The poem was subsequently dubbed the world's shortest by the *Guinness Book of World Records*. One might approach this poem/letterform simply as a visual pun and not as a word—it contains no vowels, nor does it seem to refer to anything or anyone in particular. But one can also approach the poem as suggesting either "mm" or "I'm" or possibly even "mn." The shape of the letterform—with its bold rectangular feet and head serif—has to be a direct reference to the M&M logo. First produced by the Mars Corporation in 1941, the iconic candy was named for Forrest E. Mars Sr., the founder of the Newark company, and Bruce Murrie, son of Hershey Chocolate's president William F. R. Murrie.[47] The candy's slogan, well known to generations of children, was the alliterative "melts in your mouth, not in your hand."

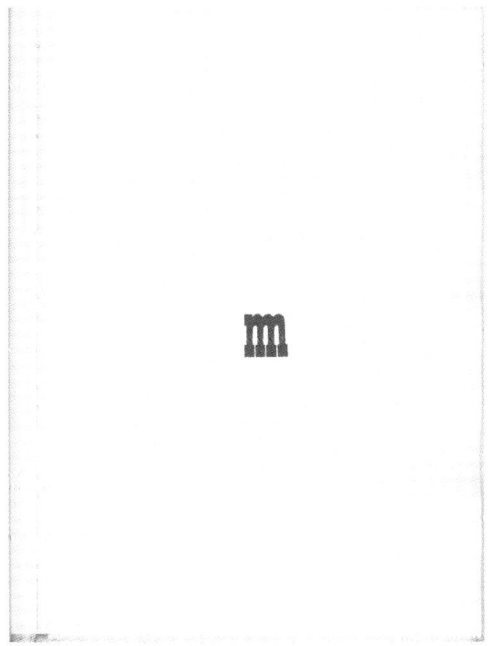

0.1
Aram Saroyan, *Aram Saroyan*, 1968.

The poem could also allude to the exclamation "mm," for which the *OED* offers these primary definitions: "1. Used to express contentment or pleasure; 1.1 Used to express agreement or approval; and 2. Used to express uncertainty or reflection." Perhaps it is the last of these meanings that the poem enacts, but it is difficult to say. The poem could also refer to the contraction for "millimeter." Or it might suggest a unit of length even shorter or longer than a millimeter. The poem thus pairs a minimum level of denotative content with a maximal range of allusive reference. Given that there is no letter-form or word that corresponds to the three-humped *m*, it might easily also suggest "nm," the state abbreviation for New Mexico or, in recent years, the textspeak shorthand for "never mind." Under the *OED* entry for "mm" or "m'm," James Joyce's *Ulysses* is even listed as an example:

A sleepy soft grunt answered:
—Mn.[48]

This is the first word that Molly Bloom speaks in *Ulysses*, and it is immediately taken by Leopold Bloom as a "no" in response to his question: "You don't want anything for breakfast." This "mn" can't help but prefigure, or negatively echo, the book's famous last word, Molly's "yes."[49]

A poem such as this creates meaning out of the most molecular components of language. We might in fact speculate that the poem remains "mum" about its denotative meaning, if it has one. Minimal poems can be contemplative, annoying, gimmicky, and revelatory. They can be superficial and profound, hermetic and allusive, comical and indignant, politically indifferent or didactically political. They are built of the particulate matter of language and the fundamental elements of symbolic representation. They pose an extreme challenge to scholars. In the absence of syntax, narrative, and often context, minimal poems thwart most strategies of reading and textual analysis. Minimal poems can be read closely; they can also be read distantly.

Not long after I taught my class on Saroyan and *0 To 9*, I was invited to give a talk at the SUNY Buffalo Poetics Program. I decided to take advantage of Buffalo's rich collection of small press and visual poetry by employing an unusual "distant reading" research constraint: I would attempt to find as many one-word poems as I could during several days at the library, and then present my findings. I found several hundred one-word poems mostly in English from about thirty countries, and I began to assemble a bibliography. While I was visiting Buffalo, Steve McCaffery, an adept practitioner of the form, introduced me to the term "oneworder"—a term I appreciated because it encompassed work from both literary and visual arts traditions. The constraint of the single word was admittedly an arbitrary one: it included works from multiple literary and artistic movements, but could the title of a painting or sculpture count? Or a corporate logo? Many of these one-word poems and artworks are visually appealing

in their own right, and some (though not all, to be sure) offer ample opportunity for literary critique. Whether or not something counts as a one-word poem is ultimately less interesting to me than attempting to apply strategies of literary and art historical interpretation to works that, for the most part, would not have been considered art or literature until comparatively recently.

Part of the provocation of the term "minimal writing" is to trouble genre distinctions between poetry, visual poetry, text art, and visual art. By definition, most minimal poems are not verse—that is, they do not contain regular line breaks and are not composed in metrical units. Thinking specifically of futurism and Dada (and the historical avant-garde more generally), Roman Jakobson writes that "The borderline dividing what is a work of poetry from what is not is less stable than the frontiers of the Chinese empire's territories. Novalis and Mallarmé regarded the alphabet as the greatest work of poetry. Russian poets have admired the poetic qualities of a wine list (Vjazemskij), an inventory of the tsar's clothes (Gogol), a timetable (Pasternak), and even a laundry bill (Krucenyx)."[50] Modernist experimentation in poetry was closely tied to experimentation in the visual arts, music, dance, and theater. Mainstream lyric poetry in the Anglo-American tradition, by contrast, has typically not been so closely tied to avant-garde practices across the arts. In contrast to visual literature, lyric poetry and realist fiction tend to ignore completely the visual significance of letters and words on the page. One-word poems and artworks were more or less inconceivable or nonexistent before the twentieth century. My selection of the constraint of the one-word poem was admittedly something of an arbitrary one, but it allowed me to study minimal poems in the aggregate as literary and visual works at the same time that I attempted to read closely works that seemed to me to have particular significance.

As an extreme example of the remediation of minimal art or found poetry, consider the art collective General Idea's *Imagevirus*, whose textual content is simply the word "AIDS," modeled on Robert Indiana's iconic 1965 *LOVE*. Art historians have little difficulty considering *Imagevirus* a work of art, but could it be considered a literary work? The art critic Gregg Bordowitz has devoted an entire book to the four letters of *Imagevirus* (as he has to Glenn Ligon's similarly minimal *Untitled (I Am a Man)*, discussed below) in which he details among the work's many facets its strong connection to the work of William S. Burroughs. Bordowitz offers this eloquent overview.

> What General Idea truly did with AIDS was to take hold of its form as a word-image and subject the acronym itself to the most powerful microscopic scrutiny possible in the field of art. They did this by inhabiting so many different formats with *Imagevirus*—not only by painting, sculpture, installation, wallpaper, etc., but also art discourse. General Idea took the abbreviated name of a virus often invoked alongside moral invectives against people with AIDS—homosexuals, drug users, poor people, people of color, the most vulnerable and stigmatized in society—and rendered it amoral. They went Kabbalistic on the word, cracked it open to reveal the limitless significance of the thing. They opened the word to both revelation and revolution.[51]

Imagevirus raises fascinating questions about textual representation, as well as about how words and memes circulate in contemporary contexts. The list of formats and venues *Imagevirus* has inhabited is staggering. The original 1965 Robert Indiana Christmas card image (it was later realized as prints, paintings, sculptures, banners, rings, tapestries, and stamps) from which *Imagevirus* derives remains significant, but *Imagevirus*'s proliferation could only have been effective within a specifically tragic historical context. As Bordowitz puts it, "Did love lead to AIDS? Of course not."[52] Perhaps *Imagevirus* cannot be claimed as a literary work; nonetheless, it reveals how minimal works can powerfully test the limits of what is conventionally considered art or literature.

Minimal poetry of the kind discussed in this book is largely noncommercial, and most creative writing programs have shown little interest in this work, as it (presumably) does not offer the kind of craft and depth required of academic poetry. But perhaps minimal writing has more to say about mass culture and more to say to a mass audience. Although contemporary poetry is difficult for many readers to access and identify with, in theory it should be the most inexpensive genre to produce and circulate. The Situationists suggested that "poetry is the anti-matter of consumer society,"[53] and Karl Holmqvist describes poetry as "a form of invisible visual art, or as a form of Everyman's visual art."[54] Audre Lorde points eloquently to the political potential of poetry's inherent economy, but she also points to the continuing elitism of how poetry and visual art are created and consumed:

> Of all the art forms, poetry is the most economical. It is the one which is the most secret, which requires the least physical labor, the least material, and the one which can be done between shifts, in the hospital pantry, on the subway, and on scraps of surplus paper. Over the last few years, writing a novel on tight finances, I came to appreciate the enormous differences in the material demands between poetry and prose. As we reclaim our literature, poetry has been the major voice of poor, working class, and Colored women. A room of one's own may be a necessity for writing prose, but so are reams of paper, a typewriter, and plenty of time. The actual requirements to produce the visual arts also help determine, along class lines, whose art is whose.[55]

Minimal poetry would seem to push poetry's inherent economy of means to its furthest extreme. In his poster-essay "Some Poetry Intermedia" (1976), Dick Higgins writes that "Literature is a poor man's art, since not only is there no money in working so directly with ideas, but even a poor man can afford to do it."[56] Higgins saw intermedia experimentation as a means to counteract the blandness of genre purity. For him, Duchamp's readymades were a crucial touchstone: "Part of the reason that Duchamp's objects are fascinating while Picasso's voice is fading is Duchamp's pieces are truly between media, between sculpture and something else, while Picasso is readily classifiable as a painted ornament."[57] In the digital era, intermedia approaches have proliferated. Recent work by African American artists and writers has been particularly

characterized by intermedia experimentation. One of the most influential recent books of U.S. experimental poetry, Claudia Rankine's *Citizen* (2014), deploys photographs and artworks that are recognizably minimal (by artists such as Glenn Ligon and David Hammons). Cameron Rowland's work is both visual and textual and draws directly on the readymade tradition to point to the material history of slavery and its aftermath.[58] As with Duchamp, Rowland's titles, such as *Insurance* (2015), are all-important. The sublime understatement of his work demonstrates that an economy of means can result in a plenitude of reference.

Part of the appeal of minimal writing may be that its restrictions on content and mediation appeal to readers who are inundated with audiovisual content. Prisoners, by contrast, have a media diet that is severely restricted. I routinely hear friends and relatives complain about too much screen time. At the end of a long day of working on a computer, a vinyl record comes as a welcome reprieve, even if the same content might be more easily available online. I use the term "adverse convergence" informally to refer to the paradox of why more efficient multimedia technologies don't always lead to more copacetic practices of producing and consuming "content." The media theorist Henry Jenkins defines "convergence" as "the flow of content across multiple media platforms, the cooperation between multiple media industries, and the migratory behavior of media audiences who will go almost anywhere in search of the kinds of entertainment experiences they want."[59] Convergence offered the hopeful possibility that as our devices were increasingly able to create, host, and replay all manner of audiovisual content, then *Gesamtkunstwerks* of multimedia art and literature should have been soon to emerge. Maybe those works have emerged, and our media habits have yet to catch up. But perhaps delimiting and constraining the abundant textuality and imagery now streaming 24/7 was another approach, which revealed not only how old media operated, but also how more is not always more in the world of new media.[60]

There is no inherent harm in too much poetry being published, but the sheer calculus of how much poetry is being produced compared to how much is being read—much less read critically or historically—is mind-boggling.[61] On more than a few occasions, I've spoken to well-regarded writers who were surprised that a scholar of contemporary literature might have read only a few of their books. But how could it be otherwise? In my experience, it takes many years to explore fully the oeuvre of a writer. After years of studying the New York poetry scene up close, it seemed to me that many poets either reveled in what I call graphoria or suffered from graphomania. Both of these terms are highly unscientific, and bear strong value judgments about the worth of a writer's work. "Graphoria" suggests a kind of joy that can derive from writing prolifically, and conveys favorable connotations; whereas "graphomania" suggests compulsion and neurosis, and implies a surplus or logorrhea of publication. I see no real case against graphoria as a phenomenon, but I do wonder if the volume of poetry being published makes it difficult for nonpoets to identify with poetry. Many of the sprawling, unreadable works

that I discussed in my first book were designed to frustrate and exhaust readers—and they succeeded in being TMI (too much information) for many of the nonspecialists who read my book, and reported to me that they loved the introduction, but couldn't relate to the poetry I discussed in the main chapters. Minimal poems, by contrast, are, at least on the surface, remarkably demotic—or, in other words, they can appear to be all *surface* and no content. Many minimal poems do indeed short-circuit a reading *process* (more on this in chapter 6, "The One-Word Poem"). But many minimal poems only work as poems or artworks because they draw on associations from mass culture—or they draw on the historical associations that words and images accrue. According to Maurice Merleau-Ponty, "True philosophy consists in relearning to look at the world."[62] Substituting two words (or five letters) in that formulation, I propose that "True philology consists in relearning to look at the word." While that statement risks sounding grandiose, it does give a sense of the close attention to the materiality of language that should remain a central ongoing concern of literary historiography.

tl;dr: who has time for long poems, anyway?[63]

1

Varieties of the Minimal

It does not need that a poem should be long. Every word was once a poem.
Ralph Waldo Emerson, "The Poet"

I hold that a long poem does not exist. I maintain that the phrase,
"a long poem," is simply a flat contradiction in terms.
Edgar Allan Poe, "The Poetic Principle"

This book employs the terms "minimal poetry" and "minimal writing" interchangeably as loose rubrics to encompass text art or poetry that is generally shorter than a single sentence—or that serially repeats or links fragments of language that are shorter than a sentence.[1] Minimal poems, this book suggests, should be read both as literary works and as works of visual art. Further, they should be read and viewed historically as media-specific artifacts. Correspondingly, works of visual art that incorporate text can be read in much the same way as poems. Minimal writing is so often concerned with the conditions of its own presentation that I sometimes think of it as perceptual writing or perceptual poetry (in contradistinction to conceptual writing or conceptual poetry). As Ulises Carrión writes in his manifesto, "The New Art of Making Books," "The old art takes no heed of reading. The new art creates specific reading conditions."[2] Minimal writing is coeval with, though not simply the result of, the extraordinary technological changes that have altered reading practices and visual perception over the past century. Many of those technologies—telegraph, telephone, television, personal computing, handheld computing—required compression or encoding in order to function.[3] Character limits are not new. The front-page newspaper headline emerged in the late nineteenth century, and was followed by an explosion of urban signage and advertising in the early twentieth century. Slogans, logos, icons, and acronyms became omnipresent, and these condensed forms of communication signify on both semantic and visual levels. A potential consumer might see a Coca-Cola logo anywhere in the world, and artists and writers like Andy Warhol, Décio Pignatari, and Mirella Bentivoglio could reimagine the brand's iconicity for their own purposes. Pop art drew

upon the international language of corporate branding, and protest art too repurposed that branding. The signage of protest art, in particular, could be described as "the epitome of concise communication."[4] In the early decades of the twenty-first century, new forms of minimal writing, such as text messaging and microblogging, have significantly altered how we communicate and consume information. Our devices may be able to handle unlimited streaming information, but our perceiving minds are more receptive to text in smaller doses.[5]

A common thread among minimal writers is their experimentation with the unit of composition: the word, the letter, the grapheme, and even the pixel.[6] These writers also experiment with various units of transmission (or framing): the page, the screen, or other means of display.[7] Minimal writers break language down into its most basic components, which often turn out to be less simple than they seem. Minimalist experimentation, as we have seen with Saroyan's four-shouldered *m*, reimagined the scale of expression and envisioned that a poem could be as short as a single letter.[8] Some minimal poems—for example, pages from Mallarmé's *Le Livre*, Norman Pritchard's "transreal" poems, or Hannah Weiner's *Code Poems*—contain no letters. At the limit extreme, asemic writing such as the work of Mirtha Dermisache can lack even the smallest units of conventional textual meaning. And there are also artworks, such as Anni Albers's 1961 *Haiku*, which are titled as poems (or based on poems), but contain no letters or words. By experimenting with the smallest elements of meaning, minimalist writers mimicked and explored some of the fundamental scientific and technological discoveries of modernity: particle physics, cell biology, and genetic encoding—or even technological miniaturization in a broad sense.[9] High modernist writers and filmmakers were obsessed with mechanomorphic depictions of humans as they became ever more machine-like. Postwar writers increasingly become interested in what might loosely be described as *infomorphic* depictions of bits and pieces of language (the term "bit," for the most basic unit of information in computing, was coined by Claude Shannon in 1948). Miniaturization and acceleration have been defining characteristics of the information society, and the rise of minimal writing can be loosely linked to those transformations in how language is transmitted and processed.[10]

If one were to draw a Venn diagram of minimal writing and related movements, there would be considerable overlap between minimalism, conceptualism, pop art, and concrete poetry.[11] For the most part, the minimal writing discussed in this book postdates the formative years of concrete poetry, which run from roughly 1955 to 1968, but differentiating between concrete and minimal poetry can often be difficult. According to Mary Ellen Solt, "there is a fundamental requirement which the various kinds of concrete poetry meet: concentration on the physical material from which the poem or text is made.... The essential is *reduced language*."[12] The term "minimal writing" is inexact, but so too are other competing genre designations such as text art, visual poetry, concrete poetry, expanded poetry, typewriter art, intermedia art, language art,

etc.[13] In her entry on "minimalism" for the *Princeton Encyclopedia of Poetry and Poetics*, Marjorie Perloff usefully defines the term as "the principle of intentional reduction, whether formal or semantic, with respect to the size, scale, or range of a given poetic composition. The term may refer to poems that are very short and condensed, to poems that use short lines or abbreviated stanzas, or to poems that use a severely restricted vocabulary."[14]

Like minimal art and writing, concrete poetry (discussed in greater detail in chapter 5) suffered from charges that it was too easy to produce and too easy to consume. Cia Rinne wittily parodies this sense of minimal writing's transparent immediacy (figure 1.1).[15] Deploying a monospaced typewriter aesthetic, Rinne offers an appropriately minimal before and after scenario for the entire movement. Rinne's witty poem aside, the minimalist movement is now over half a century old. Claims that concrete and minimal poetry are overly simplistic do not fully appreciate the aims of the writers and artists who produced this work, nor do such claims take into account the impressive global scope of minimal textual practices. Jamie Hilder writes astutely of concrete poetry: "Perhaps it is not the poem that needs reading, but the act of reading itself. What do we expect from ink on pages? What do our habits of looking prevent us from seeing, and what do they allow?"[16] By placing text under a figurative microscope, concrete poetry explores fundamental conditions for communication in a society dominated by mass media. Such writing often refuses linguistic mastery, and explores the linguistic and visual implications of incomplete statements or dysfluent syntax.[17] As Hilder writes, "Could 'the incompetence of the reader' be 'a poetic strategy'? Incompetence here should not here be considered a pejorative, in the same way that illiteracy would…, but as a necessary condition in an expanding, poly-linguistic global environment."[18] When we travel to a locale where we are unfamiliar with the language, or when we fleetingly glimpse an advertisement, we are placed in the position not of illiteracy but of partial competence. We are continually filtering the language we see, and assessing it for its relevance and reliability. Concrete and minimal poetry could be said to mimic how we receive language in bits and pieces in a hypermediated society. In the inaugural essay that coined the term "minimal art," Richard Wollheim speculated that the "principle reason for resisting the claims of Minimal Art is that its objects fail to evince what we have over the centuries come to regard as an essential ingredient in art: work, or manifest effort."[19] Wollheim was describing the phenomenon that was later dubbed "deskilling," wherein little or no craft or skill was required to produce an artwork.[20] Whereas many 1960s minimal artists, whose work is now canonical, have largely overcome the notion that economy of means or simplicity of form equates to simplicity of thought, minimal poetry may still suffer from the notion that is too easy or too arbitrary. A fuller account of the media employed by minimal writers reveals that in fact much effort and skill did go into these works.

```
here it comes:

MINIMALISM

there it went.
```

1.1
Cia Rinne, *Minimalism*, carbon ribbon on paper,
40.6 x 29.7 cm (2009).

The emergence of minimal writing has to do not only with developments in media, but also with discoveries in theoretical physics and microbiology. Daniel Albright has proposed the term "poememe" to describe how "the methods of physicists' elementary particles helped to inspire poets to search for the elementary particles of which poems were constructed."[21] According to Albright, inspired by the insights of relativity and quantum mechanics,

> the more narrowly the Modernists tried to isolate the poememe the more elusive it became. Therefore, as the particle model of analyzing the behavior of poems developed itself, a contrary model developed side by side: the wave model. If a poem is made, not of little bits of poem-stuff arranged by the poet, but out of beams, or radiowaves, or X-rays, it will behave quite differently, and that difference will entail new—sometimes disturbing—relations between the poet and the audience.[22]

Thinking primarily of W. B. Yeats, Ezra Pound, and T. S. Eliot, Albright is not wrong in insisting that these poets were troubled by a materialist account of atomic physics.[23] But Albright seems to share certain Romantic assumptions about poetry as an unmediated genre that differ from how the postwar minimalists under discussion here understood their work. Albright asserts that the poememe can take the form of pure thought in the mind of the poet or listener/reader: "The poememe is not necessarily an element that exists only on a typed page or in speech—a lexeme or a phoneme: it may subsist before the poet verbalizes it, and it may remain in the reader's mind after the poem's exact wording has been forgotten."[24] This seems applicable to how poetry is imagined and remembered in bits and pieces, but implies an idealist sense of the poem as an organic whole. Albright continues:

> I doubt that there are valid quanta of poetry. A poem is not a bundle of discrete inspirational units, but an inflection of language, exploring intensifications of semantic figures by means of counterpoint with patterns of acoustical figures. Therefore the search for irreducible poetical minima of poetry—whether particles or waves—is bound to lead to exasperation.[25]

Note here the vocabulary of the "inspirational units" and "intensifications"—combined with an expectation that poets will write in a form equivalent to counterpoint in music. If indeed these are preconditions of poetry (or of a poem as a unit), then Albright is correct that the "quanta" of poetry in and of themselves are bound to disappoint. Minimal poets and text artists, however, did not necessarily share this sense of exasperation. A poem did not have to be defined by verse lineation or stanza regularity any more than a painting had to offer a three-dimensional picture plane within a rectangular frame. The artist Kay Rosen, who works extensively with minimal units of text, offers an excellent defense of her own minimal practices. Rosen quotes Virginia Woolf as a devil's advocate to her own practice. According to Woolf, "[Words do not] like being lifted out on the point of a pen and examined separately. They hang together, in sentences, in paragraphs, sometimes for whole pages at a time."[26] By contrast to Woolf, Rosen argues of her own work:

> As true as this might be for writers who compose large passages of text, it is completely untrue for me, whose practice does just that—extracts single words and examines them alone or in small groups, as objects, architecture, or sculptures. Instead of being shaped by surrounding paragraphs and pages of words, my texts are shaped by visual clues associated with art, grammar, and typography; and by the words' own internal structural components: letters.[27]

Rosen's case here can be extended more broadly to encompass the practices of text artists and visual poets. Traditional markers of literary competence—syntactical structure, narrative continuity, realistic description—do not necessarily apply to works of minimal writing.

The postwar impulse to minimize and reduce led writers and artists to venture beyond the page, as well as to experiment with the space of the page, particularly as shaped by the typewriter grid. Larry Eigner's 1974 poem-essay "Be minimal then ..." offers this credo:

> Minimizing (not stringent, actually, less condensation than aversion to tongue-twisters, etc., leavetaking of the ponderous, in fact the ideal of Work in areas of abundance, let alone overabundance, no quixotic hang-up on aristocratic heroisms, facilitates thinking, integration, the assessment of things). Coming to weights, and feeling them. Thus expansions come of themselves too—the easy, amid so much hardship and complication, massive nowadays.[28]

By way of a condensed poetic prose, Eigner offers a defense of a plain style. His title comes from Hart Crane's *The Bridge*—a long poem whose rhetorical register of exotic vocabulary and exclamation points could hardly be more different from Eigner's sparse, colloquial, unpunctuated poetry. Crane in fact wrote "Be minimum, then ..."—but Eigner remembered it as "Be minimal then ..."—an interesting slippage Eigner chose to retain. Taken from "The Tunnel" section of *The Bridge*, the phrase describes the claustrophobic feeling of descending into a subway crowd: "Be minimum, then, to swim the hiving swarms."[29] Eigner transforms the quotation to refer to poetic form, as well as to personal space. The poem-essay begins:

> personal
> favorite what
> exchange
> the 19th century
>
> echo
> parts as
> all one's property or
> another's
>
> botanical conquest[30]

Already the poem has broken almost every rule of traditional verse—having no punctuation, irregular line lengths and breaks, and no identifiable narrator. It is difficult to imagine a nineteenth-century poem beginning with the single word "personal"—presumably modifying "favorite." Unornamented and seemingly without a specific setting, the poem seems to be a negative "echo" of the "19th century" it evokes. The poem rejects heroism and conquest, and instead offers a humble *ars poetica*:

> I pick
> some song
> people to
> do with
> come by
> settle[31]

Depending on how one might punctuate these lines, they could form a complete sentence, albeit one with odd syntax. The final "settle" locates the poem within a domestic space among friends, as opposed to "heroically" pursuing the "discovery" and "conquest" of the poem's first half. To be minimal, then, is to be minimal in multiple senses: through a rejection of "aristocratic heroisms," through a sparse deployment of words on the page, as well as through a direct communication of the poem to an intimate audience. In its elaborate use of the page, the poem also becomes a visual work.

The term "minimalism" is more often applied to the visual arts and to music than it is to poetry or literature. The aim of this book is not to claim minimalism as a cohesive literary movement, but rather to explore minimal tendencies and patterns, primarily in post-1960s art and writing.[32] Minimalism has larger sociocultural implications (explored in chapter 3), and was a central tendency in twentieth-century architecture and design. There are also more specialized senses of "minimalism" in fields (or subfields) such as minimal linguistics or minimal computing. The lines between genres and subgenres are often blurry, and I hope readers will find this book to be an invitation to further reading, and not to offer a definitive or restrictive canon of minimal writing. While minimalism may have its origins in the historical avant-garde of the nineteen tens, it coalesced as a set of tendencies in the mid-1960s. According to Marc Botha, minimalism is "best grasped as an *existential modality*: a way of existing in the world. What connects different types of minimalism—aesthetic, linguistic, legal, computational, or lifestyle—is that their existence is entangled with and comported towards *minimum*. Minimum finds two principle expressions: the infinitesimal, or the *least possible*; and the parsimonious, or the *least necessary*."[33] As James Meyer argues, minimalism is "best understood not as a coherent movement but as a practical field."[34] Accordingly, this book offers a selection of representative artists and authors, and of necessity overlooks many other figures that otherwise might merit inclusion. Part of the reason that this book makes the case for an expansive, nonexclusive understanding of minimalism

is because many so-called minimalists have objected to the category. Sol LeWitt's ambivalence is indicative:

> Recently there has been much written about minimal art, but I have not discovered anyone who admits to doing this kind of thing. There are other art forms called primary structures, reductive, rejective, cool, and mini-art. No artist I know will own up to any of those either. Therefore I conclude that it is part of a secret language that art critics use when communicating with each other through the medium of art magazines.[35]

LeWitt is being somewhat tongue-in-cheek here, but his skepticism does point to the slipperiness of a term applied to artists and writers whose work emerged from many contexts and not necessarily as a unified movement. It is in the interest of a critic like me to refer to movements and genre categories in order to reveal historical patterns—but the category of "minimalism" should be understood here more as a placeholder than as a brand that an artist should aspire to conform to or reject. For some writers and artists, minimalism was a phase, for others a lifelong commitment.

A good place to get a sense for the multiple media formats of the minimal movement is *Aspen*'s "Minimalism" issue 5+6, published in 1967. The journal-in-a-box was edited by Brian O'Doherty, who commissioned Barthes's "Death of the Author" essay for the issue, which also contained three LP records, a super-8 film, musical scores, booklets, and even a cardboard sculpture. The issue featured the first installment of Dan Graham's "Schema," which varied based on its publication venue ("Schema" is discussed in chapter 10). As Gwen Allen writes of the issue,

> In its metamorphosis from a flat, two-dimensional object into an unbound three-dimensional experience, *Aspen* in some sense paralleled the minimalist shift from an illusionistic pictorial realm to a physical or spatial reality, expressed by Judd's assertion that "three dimensions are real space." And like Judd's specific objects, which he asserted were "neither painting nor sculpture," *Aspen* 5+6 threw into question its own category or medium, insisting on its hybrid status with its multimedia components ("objects in between categories" was one of the themes listed on its table of contents).[36]

Minimal writers did not necessarily always have recourse to three-dimensional media, but they did experiment extensively with scale, space, and serial repetition. A good example of a serial work (one that is usually categorized as a work of concrete poetry but could also be placed under the rubric of minimalism) is Emmett Williams's book *sweethearts* (1967), which merely offers variations on the letters that form the word "sweethearts" for 138 pages. Billed as an "erotic poem cycle," *sweethearts* does in fact contain subnarratives, and is intended to achieve "a primitive cinema effect" when "flipping the pages fast enough."[37] Indeed, in the elegant recent web version of the poem designed by Mindy Seu, the work becomes even more cinematic, especially if one moves the cursor quickly along the top of the page (figure 1.2).[38] Although Williams is in effect only drawing on seven available letters in a fixed order, he is still able to sustain a minimal narrative through varying the reappearance of the letters.

A logical endpoint of minimalist reductionism would be silence, as Susan Sontag observes in *Aspen*'s minimalism issue. Her "Aesthetics of Silence" reviews the extreme gestures of renunciation of works by Samuel Beckett and John Cage, and suggests that more recent minimalist works offer a response:

> Aesthetic programs for a radical reduction of means and effects in art—including the ultimate demand, for the renunciation of art itself—can't be taken at face value, undialectically. These are neither consistent policies for artists nor merely hostile gestures aimed at audiences. Silence and allied ideas (like emptiness, reduction, the "zero degree") are boundary notions with a complex set of uses; leading terms of a particular spiritual and cultural rhetoric.[39]

Sontag raises important interrelated issues here. Silence, as Cage maintained, cannot be uncritically opposed to music or to noise. The isolation of a word or a sound in itself has no effect without context.[40] The minimal work might either particularize or elaborate its materials, whether they be linguistic or visual or both. If the silent work attempted to accost the listener with its absolute lack of content, the minimal work might refocus the attention of the listener, while retaining the confrontational aesthetics of the avant-garde. An even more radical gesture might be that of conceptual artist Lee Lozano, whose *Dropout Piece* chronicles her gradual rejection of the commercial art scene altogether.[41]

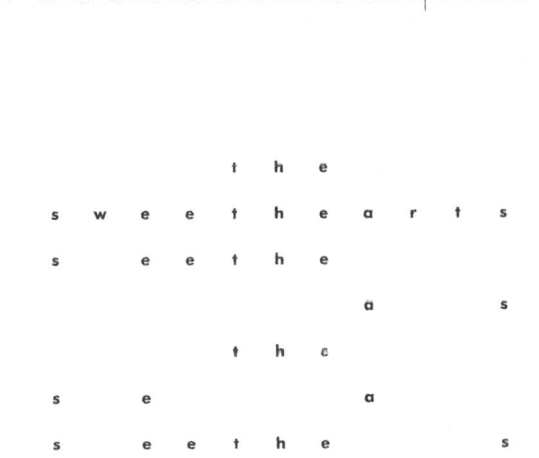

1.2

Emmett Williams, *sweethearts* [digital version (2014)].

VARIETIES OF THE MINIMAL

One main topic of contention regarding minimal art in the 1960s was the degree to which it was performative or exhibited "theatricality" (in Michael Fried's somewhat confusing terms, "theater" should be distinguished from "theatricality").[42] In "The Death of the Author," perhaps the most influential literary essay of the period, Barthes offered a structuralist account that applied J. L. Austin's notion of the performative utterance:

> the modern writer (scriptor) is born simultaneously with his text; he is in no way supplied with a being which precedes or transcends his writing, he is in no way the subject of which his book is the predicate; there is no other time than that of the utterance, and every text is eternally written here and now. This is because (or: it follows that) to write can no longer designate an operation of recording, of observing, of representing, of "painting" (as the Classic writers put it), but rather what the linguisticians, following the vocabulary of the Oxford school, call a performative, a rare verbal form (exclusively given to the first person and to the present), in which utterance has no other content than the act by which it is uttered.[43]

Though many, perhaps most notably Michel Foucault, took issue with Barthes's essay, it was richly suggestive for how the figure of the author had been placed in question at least since the late writing of Mallarmé. Although Barthes is circumspect about the role technology had played in this transformation of authorship and his polemic can be difficult to parse, he forcefully claims that a desacralized form of textuality had supplanted the prevailing view that a literary work could be understood as the product of the intentions of a singular author.

Minimal and conceptual art and writing from the 1960s is often self-reflexive in the extreme, and in many cases reflects upon the conditions of its publication or display. Consider, for instance, Ed Ruscha's 1969 gunpowder-on-paper print *Poetry* (figure 1.3).[44] Ruscha's oeuvre is replete with literary quotations, and although he is generally considered a pop artist, works like *Royal Road Test* are typically classified as conceptual. So could *Poetry* be considered a poem? In a way, the question reveals the limits of assigning genre categorizations in a period like the late 60s when artists and writers explored all manner of media and materials. One could answer the question from a contextual standpoint, and note that *Poetry* was not only a painting, it also appeared on the cover of the fourth issue of the Larry Fagin–edited *Adventures in Poetry*. The faux-Asian lettering of the text could allude to Ezra Pound's idealization of the Chinese character.[45] Perhaps the lettering also alludes to gunpowder's Chinese origins. The use of gunpowder rather than ink suggests an explosiveness that would be at odds with the presumed refinement of poetic language, as calling something "poetic" remains a term of general praise. A subsequent Ruscha gunpowder print from 1971, *Pure Poetry* (figure 1.4), points to this sense of poetry as elevated language, and alludes to the French symbolist doctrine championed by Baudelaire and others.[46] And yet a print featuring only the words "Pure Poetry" can't help but place in question whatever it is we mean by a purity of poetic language. The swirling letterforms of *Pure Poetry* seem

to disavow a purity of language that could be disentangled from its visual appearance. Whereas *Poetry* conforms to the vertical layout of a piece of 8.5" × 11" typing paper, *Pure Poetry* is laid out horizontally, as if to evoke the widescreen cinema of the 1950s and 60s. *Poetry* and *Pure Poetry* would be very different works if they were simply typed and centered on a page, as Saroyan's minimal poems are. Here Robert Smithson is useful in elaborating a loose contrast between the visual austerity of minimalism as opposed to the visual extravagance of pop art when he notes that "The scale of a letter in a word changes one's visual meaning of a word. Language thus becomes monumental because of the mutations of advertising. A word outside of the mind is a set of 'dead letters.'"[47] In Ruscha's terms, scale is equivalent to temperature: "Words have temperature to me. When they reach a certain point and become hot words, then they appeal to me. 'Synthetic' is a very hot word. Sometimes I have a dream that if a word gets too hot and too appealing, it will boil apart, and I won't be able to read or think of it. Usually I catch them before they get too hot."[48] Conventionally, varying the size of letterforms is anathema to poetry and prose, but in Ruscha's art, as in advertising, the scale of words becomes a tool of intensification. Rendered in gunpowder, the letters are combustible to the point of explosiveness. *Pure Poetry* conveys a multimediatic joke which alludes to Clement Greenberg's argument that medium purity was inherent to modernism's project of self-criticism. In response to the appearance of "art for art's sake" and "pure poetry" in the late nineteenth century, Greenberg writes, the avant-garde felt that "subject matter or content becomes something to be avoided like the plague."[49] For Greenberg, "Pure poetry strives for infinite suggestion, pure plastic art for the minimum."[50] What then does Ruscha's *Pure Poetry* strive for? Its three-dimensionality alludes to plastic art; its letterforms are not particularly pure in their legibility; its use of gunpowder and pastel hardly suggests "pure painting." *Pure Poetry* could thus be understood as a succinct, witty refutation of Greenbergian formalism.

Many 1960s and 70s minimal and conceptual text-based works aspire to a haecceity of language, in which the text describes some aspect of its own action or presentation (as I discuss below in greater detail in chapter 4, "The Indexical Present"). Lawrence Weiner's 1970 wall-based text "AN ACCUMULATION OF INFORMATION TAKEN FROM THERE TO HERE," for instance, is a left-to-right literalization of a communication that ironically communicates nothing other than its own presence. The album design for the 1968 LP by The Beatles, *The Beatles* (almost universally referred to as "The White Album"), offers another example. Designed by the pop and conceptual artist Richard Hamilton, *The Beatles* features only the band's name in embossed lettering, together with each album's serial number. The cover is not quite devoid of content, but it could hardly be more minimal—or more unlike the garish cover of *Sergeant Pepper's Lonely Hearts Club Band* which preceded it the year before.

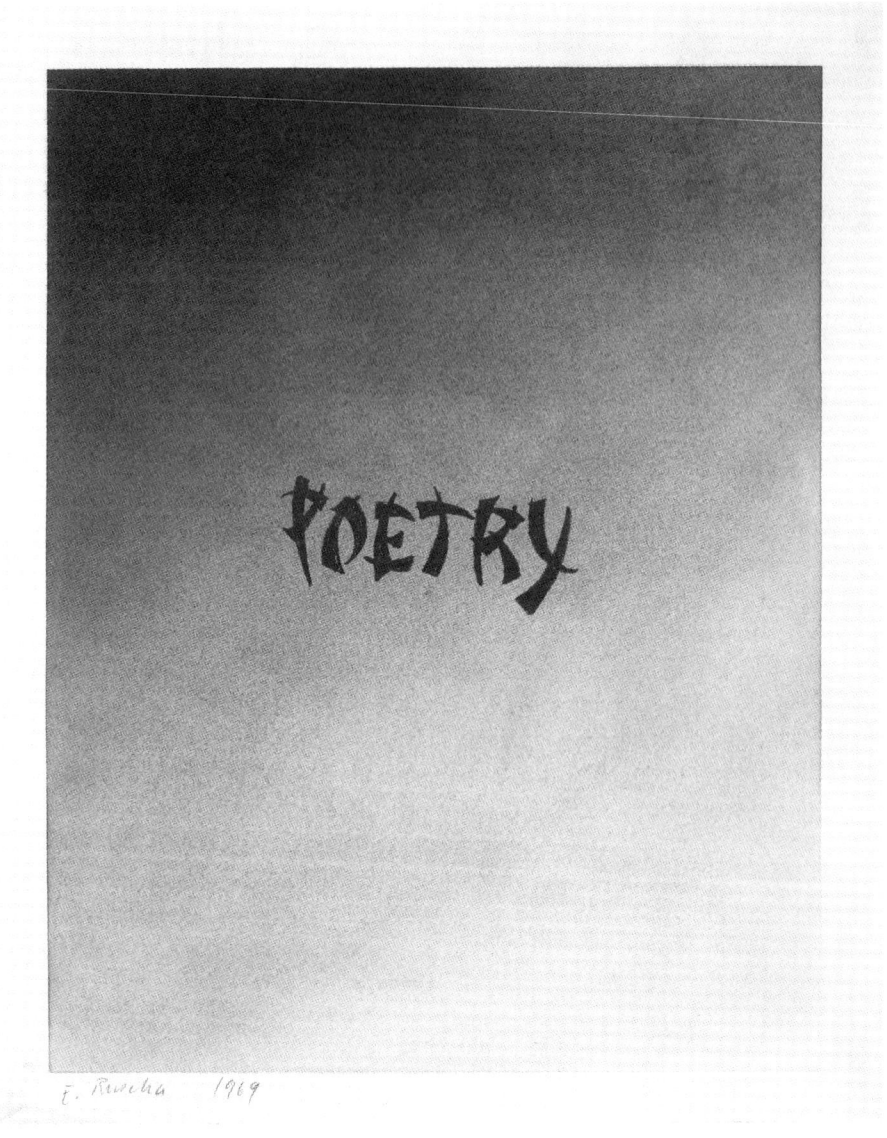

1.3
Ed Ruscha, *Poetry*. Gunpowder on paper,
12.75" × 10.5", 1969. © Ed Ruscha.
Courtesy Gagosian.

1.4

Ed Ruscha, *Pure Poetry*. Gunpowder
and pastel on paper, 11.5" × 29", 1971.
© Ed Ruscha. Courtesy Gagosian.

1.5

Glenn Ligon, *Warm Broad Glow*. Neon and paint, 36" × 192", 2005. Photographer credit: Rick Gardner. © Glenn Ligon; courtesy of the artist and Regen Projects, Los Angeles.

The stark literalness of minimal text works can nonetheless be richly allusive, as in Glenn Ligon's *Warm Broad Glow* (figure 1.5), which quotes directly from the opening of Gertrude Stein's "Melanctha":

> Rose Johnson was a real black negress but she had been brought up quite like their own child by white folks.
> Rose laughed when she was happy but she had not the wide, abandoned laughter that makes the warm broad glow of negro sunshine. Rose was never joyous with the earthborn, boundless joy of negroes. Hers was just ordinary, any sort of woman laughter.[51]

With the front side of the neon tubes painted black, *Warm Broad Glow* casts yellow light back at the museum wall. Even if the viewer doesn't know the specific source text, the obsolete word "negro" conjures its own difficult history. As Scott Rothkopf writes of the work:

> Ligon's sign upends the figure of speech it seems to instantiate. The broad glow of negro sunshine is not the minstrel's white smile set off from the sooty skin but an opaque blackness set off from its impossibly bright shadow. The work inverts the relationship between light and dark one expects from a lighted sign against a recessive ground; it casts a pall over Stein's nagging phrase, but there remains, as well, a paradoxically effulgent and hopeful penumbra.[52]

As basic as the work's conception may be, it is difficult to imagine a more dialectical usage of two seemingly oxymoronic terms. Stein's racialized language is both foregrounded and rejected. In a disturbingly witty takedown of Stein in another context, Ligon parodies her damningly: "a nigger is a nigger is a nigger."[53] Rose Johnson does not after all possess the "warm broad glow," as she has been raised by "white folks"—nonetheless, she is described as a "real black negress," with reference solely to her skin color. Another Ligon neon sculpture/installation, *I Sell the Shadow to Sustain the Substance*, ingeniously adapts the words of Sojourner Truth to play similarly on notions of light/dark, black/white, authentic/inauthentic. The sentence can also be understood as a recursive expression of a commercial artist's need to sell their work. A subsequent Ligon neon, *Untitled (I live on my shadow)* (2009), revives this motif. Key to Ligon's work is versioning. *Warm Broad Glow*, it should be noted, exists in two other significantly different neon versions, *Warm Broad Glow (dark)* (2007), and *Warm Broad Glow II* (2011). There are also over a hundred iterations of *Study for Negro Sunshine* (in uppercase black and white stenciled letters) that postdate the original *Warm Broad Glow*, and share little in common visually with the neon versions.

Stein quotations have provided a number of artists with source material for minimal works. In addition to Ligon's *Warm Broad Glow*, notable works in this vein include Joseph Kosuth's *Five Words in Green Neon* (1965), Emmett Williams's *13 Variations on 6 Words of Gertrude Stein* (1965), Eve Fowler's Stein posters, and Erica Baum's *Line Line Green Red* (2018) (figure 1.6). Included in an exhibition titled "A Long Dress," after the section from Stein's *Tender Buttons*, *Line Line Green Red* is a deceptively

simple oneworder. As Rachel Churner notes, the photograph's title likely derives from "A Box," in the "Objects" section of *Tender Buttons*: "It is so rudimentary to be analyzed and see a fine substance strangely, it is so earnest to have a green point to red but to point again."[54] The green line in the photograph does point to the red line—but perhaps the composition is not so rudimentary. Taken from Baum's *Patterns* series, derived from sewing templates, *Line Line Green Red* is richly textured, and calls to mind Mondrian in its square composition subdivided by rectangles. Removed from its utilitarian origins, the repeated "line" is the literal material of poetry, and plays an indexical trick similar to Saroyan's journal *Lines* or Carrión's *Looking for Poetry*, which is composed entirely of visual and textual analogues to lines.

Minimal writing and appropriation writing often, though not always, overlap. As Ulises Carrión writes in "The New Art of Making Books," "A writer of the new art writes very little or does not write at all."[55] Carrión's *looking for poetry / tras la poesía* exemplifies some of the difficulties in classifying and interpreting minimal writing (figure 1.7). Mónica de la Torre writes that Carrión was "perhaps Mexico's most important conceptual artist. Although he eventually became involved in mail, video, and performance art—in addition to making books and running the bookshop and exhibition space for artists' books and multiples Other Books and So in Amsterdam—his early body of work was situated precisely at the intersection of conceptual art and poetry."[56] Working in these overlapping modes, Carrión explored fundamental conditions for textual and visual expression, and his work is often playful as it reflects back on its media. *looking for poetry / tras la poesía* is not so much a poem as it is a literal search for how to represent the lineation of verse spatially and semantically. Published by the Beau Geste Press, the book advertises itself on its title page as published in "England—Latin America," as if to parody Carrión's multinational identity, but on its colophon page reveals itself with extreme precision to have been printed in Cullompton, Devon, in Winter 1973. *looking for poetry / tras la poesía* attempts to do what its title suggests, and its page layout approximates the sparse content of its text (figures 1.7 and 1.8). Each page features eight purple lines under a single word in English with its Spanish equivalent. For the most part, these words are synonyms or metonyms for the lines on the page, and the first pages read: "lines / líneas" … "threads / hilos" … "wires / alambres" … "strings / cuerdas." The metonymic literalization of word and image in *looking for poetry / tras la poesía* is characteristic of minimal writing, as line-words come to substitute for the lines of the page.

Visual poetry and text art have often been likened either to musical scores or to music itself, as when Carrión writes that "space is the music of unsung poetry."[57] For Carrión, who was devoted to experimenting with the form of the codex, "Printed words are imprisoned in the matter of the book."[58] "The New Art of Making Books" placed in question the book as a container for ideas, in part by recognizing the accelerating pace of modern life and its textual forms: "In the new art, the reading rhythm changes,

1.6
Erica Baum, *Line Line Green Red*.
Archival pigment print, 16" × 16.61", 2018.
Courtesy of Erica Baum and Bureau.

1.7
Title page, Ulises Carrión, *looking for poetry / tras la poesía*, 1973.

looking for poetry
tras la poesía

ulises carrión

Beau Geste Press
England - Latin America

1.8
Ulises Carrión, *looking for poetry / tras la poesía*, 1973.

lines
líneas

quickens, speeds up." Another of Carrión's book experiments, *Tell me what sort of wall paper your room has and i'll tell you who you are* (1973), is printed entirely on repurposed wallpaper.

Works of serial minimalism such as Williams's *sweethearts* borrow analogies from cinema; filmmakers and computer programmers also experimented with serialized text fragments.[59] Structural films of the 1960s and 70s such as Paul Sharits's *Word Movie*, Lis Rhodes's *Light Reading*, Michael Snow's *So Is This*, and Mike Dunford's *Tautology* typically feature minimal units of language—often using only a single word or phrase per shot.[60] Among the most ambitious and complex filmic works that could be placed under the banner of serial minimalism is Hollis Frampton's 1970 *Zorns Lemma* (figure 1.9), described by Kenneth Goldsmith as "the best poetry film ever made."[61] Although typically categorized as a work of structuralist film, *Zorns Lemma* could also be classified as serial found poetry. The film's forty-five-minute main section is composed of 2,700 single words found within the urban environs of Manhattan, mainly from street signs or commercial advertising. Each word/frame is a one-second unit, organized alphabetically. The title, borrowed from set theory, had been suggested to Frampton by Carl Andre, who also worked extensively with linguistic seriality in his 1960s poetry.[62] The effect of this rapid-fire circulation of images is dizzying and sublime—making us aware that in any urban environment we are continually confronted with the language of branding and of basic communication. *Zorns Lemma* might also point to the long history of silent narrative film, in which film intertitles had to be minimal in order to achieve their purpose.

Early computer poetry also often took the form of minimal units of language that could be reconfigured or shuffled to create surprising semantic and visual effects. Alison Knowles's *The House of Dust* (1967), for instance, was realized as a computer program, as a book, and as two site-specific installations. Each quatrain of the work lists four qualities that could pertain to a house; those qualities are then randomly assigned by a Fortran program, and then realized as a computer printout. A typical stanza looked like this:

A HOUSE OF DISCARDED CLOTHING
 UNDER WATER
 LIGHTED BY CANDLES
 INHABITED BY PEOPLE FROM ALL WALKS OF LIFE[63]

In every stanza, the active verb is "inhabited." Although predictable in the syntax of its verbal output, *The House of Dust* was also a physical structure, an installation that was realized both in Chelsea in New York City and at Cal Arts. *The House of Dust* was cutting-edge not only in its placement of language in physical architectural space, but also in its use of the computer. By comparison with another site-specific language-based work, Allan Kaprow's 1961 *Words*, which took a more graffiti-like approach to

1.9
Screenshot from Hollis Frampton, dir., *Zorns Lemma*, 1970.

VARIETIES OF THE MINIMAL

its display of text, the constrained approach of *The House of Dust* is decidedly minimal and informatic. Kaprow described *Words* as "involved with the city atmosphere of billboards, newspapers, scrawled pavements and alley walls, in the drone of a lecture, whispered secrets, pitchmen in Times Square, fun-parlors, bits of stores in conversations overheard at the Automat."[64] Likewise, Knowles's traveling exhibition *The Big Book* (1966–) was, compared to *The House of Dust*, maximal in its deployment of language within the space of a gallery.[65] *The House of Dust* is an inward-looking work, an imagined home, rather than a cornucopia of text. Code poetry, as I discuss in chapter 6, may offer the ultimate in serial minimalism. Electronic texts also draw additional attention to their own mediation, even if they purport to take on dematerialized forms. As N. Katherine Hayles writes,

> the physical form of the literary artifact always affects what the words (and other semiotic components) mean. Literary works that strengthen, foreground, and thematize the connections between themselves as material artifacts and the imaginative realm of verbal/semiotic signifiers they instantiate open a window on the larger connections that unite literature as a verbal art to its material forms.[66]

Martine Syms, *Twoness*, 2013. Illustration for the lecture "Black Vernacular: Reading New Media" at SXSW Interactive 2013. Courtesy the artist

1.10
Martine Syms, *Twoness*, 2013.
Courtesy of the artist.

The physical form of the literary artifact does not determine exclusively its content or its significance, but to the extent that it does, literary historians and media theorists have an important role to play in recording and theorizing those effects.

Audre Lorde's eloquent defense of poetry's economy of means (quoted in the introduction) might be updated for the digital era to reflect that poets and artists have had enormous resources available to them since "the laptop revolution," and yet those technologies have not always lent themselves straightforwardly to breakthroughs in text-image art. Consider Martine Syms's *Twoness* (figure 1.10). Syms is a visual artist who describes herself as "a web designer, mostly," but also as a "conceptual entrepreneur."[67] *Twoness* is a work of visual art, but it could also be described as a minimal poem. Its visual presentation suggests far more than its seven letters might suggest if stripped of all formatting and context (if this were possible). In her "Mundane Afrofuturist Manifesto," Syms parodies those who would make "obvious, heavy-handed allusions to double-consciousness," and yet later in the same manifesto she writes that "Our [African American] 'twoness' is inherently contemporary, even futuristic. [W. E. B] Du Bois asks how it feels to be a problem. Ol' Dirty Bastard says 'If I got a problem, a problem's got a problem 'til it's gone.'"[68] Seen from one perspective, Syms's *Twoness* could be obvious and heavy-handed. But when considered in a fuller media context, the image is richly suggestive. The word is split in two halves by the simplest visual means, a black and white inversion on the page. The whiteness of the page might suggest Zora Neale Hurston's statement, "I feel most colored when I am thrown against a sharp white background"—a sentence given new life by Glenn Ligon's painting (also in black and white) of the same name.[69] Much in the same way that a Kara Walker painting uses the white space of the museum wall, *Twoness* creates a silhouette out of the space of the page (or screen). It suggests a doubled interplay not only between black and white, but also between artist and viewer, as well as perhaps between the artist and the medium (or institution) that conveys the text.

"What does it mean for a black woman to make minimal, masculine net.art?" Syms asks in her essay "Black Vernacular: Reading New Media."[70] Like contemporary net.art (an umbrella term for internet art made since the 1990s), 1960s minimalism was largely associated with works by white men. In partial answer to the question posed above, Syms writes: "I am interested in the tension between conventional, segregated channels of distribution and black imagination. I believe that amphiboly—in the form of code-switching, the practice of alternating between dialect and 'standard' English—drives black thought."[71] Conceptualism and minimalism have been construed by some to be exclusively white channels—inasmuch as this is the case, it is incumbent upon artists and critics to desegregate these channels.[72] The charge that minimalism and conceptualism are inherently identity-denying is complicated by the minimal practices of visual artists such as Jo Baer, Rosemarie Castoro, Hanne Darboven, David Hammons, Christine Kozlov, Agnes Martin, Adrian Piper, Anne Truitt, Carmen Herrera,

1.11
Martine Syms, *GIRRRL* ... Installation view, Museum of Modern Art, 2017. Courtesy of the artist.

Jenny Holzer, and Lee Lozano, as well as by the minimal practices of musicians such as Julius Eastman or Pauline Oliveros, or more recently by the minimal tendencies of African American visual artists such as Adam Pendleton, Steffani Jemison, and Martine Syms.[73] One might also note that in many minimal poems by white men, the subject position is hardly exotic or heroic, but rather domestic and self-deprecatory.[74]

Syms's recent Museum of Modern Art installation, *Incense Sweaters & Ice*, is emblematic of the many visual modes and technologies available to artists working with text. Laid out against a long wall and dominating the field of view is a text painting that can loosely be construed as a one-word poem: "GIRRRL GIRLLL GIIIRL GIRRRL" (figure 1.11). Playing on different African American intonations of the word "girl," the wall of text engages the amphiboly that Syms articulates as a central goal of her work. On the right-hand side of the wall is a poster for the 1974 film *Together Brothers*. The centerpiece of the show is Syms's film *Incense Sweaters & Ice*, which plays on three screens successively in the center of the gallery. The film has three characters, Girl (a stand-in for Syms herself), White Boy (Girl's boyfriend), and Queen Esther (described as a "preacher, self-help guru, and talent coach"). Syms draws upon many platforms to construct her multimedia collages.[75] Her sources include television, Youtube, GIFs, Vines, police-cam recordings, and surveillance footage, and the installation incorporates a smartphone app specifically made for the show. When one holds the app up to a photograph or other object in the show, new texts and images appear (figure 1.12). When the phone is directed toward the *Together Brothers* poster toward the right of *GIRRRL ...* , for instance, an iMessage conversation between Girl and White Boy appears. The story is augmented in some sense—but at the same time, traditional boundaries between filmic and other media are dissolved in a palimpsest of text and device. The text of *GIRRRL ...* in this context operates along the lines of a built-in billboard for *Incense Sweaters & Ice*. As the curator Jocelyn Miller writes of the text, "The undoing and redoing of the word [girl] points to the violence of appropriation but also represents the way it sounds when carrying different meanings. It might refer to Riot Grrrl, or even No Doubt's 1990 single 'Just a Girl,' sung in the film."[76] The multiple spellings of "GIRRRL" can also allude to the hashtag #grrrrrl (and variants) and to the informality of meme culture, with the enormous lettering summoning the emphatic language of black Twitter. The self-reflexive nature of Syms's generic "Girl" persona places Syms at the center of multiple overlapping social networks that are variously mediated, and as Miller suggests, the violence of appropriation is undone by repetition and by the word's multiple connotations. The SMS bubble captions are themselves powerful indexes of minimal communication: supposedly casual and spontaneous, such messages may be more revealing than more formal, considered communications are.

It may be something of a stretch to place a work such as Syms's *GIRRRL ...* under the banner of minimalism, given that the work exists within a larger installation that

1.12
Martine Syms, iPhone screenshot from mobile app for *Incense Sweaters & Ice*, 2017. Courtesy of the artist.

deploys text so extensively and is characterized by many overlapping media formats. My aim in doing so is not to claim another adherent to minimalism as a movement, but to explore how minimal texts operate within larger media environments. Looking back to *Aspen*'s "Minimalism" issue, we can see that minimalist works have often depended on a hypermediated backdrop. Vito Acconci voices the concerns of many detractors of minimalism when he observes: "The flaw in minimalism, as I saw it, was that it could have come from anywhere, it was there as if from all time, it was like the black monolith in *2001*."[77] That sense of ahistorical formalism may be at the heart of minimalism's appeal—especially if the austerity of mid-60s minimal sculpture continues to characterize the movement the most for general observers. And yet minimalism also created new possibilities even for its detractors, and the now half-century-old movement has generated many counterresponses. Acconci said minimalism "forced [me] to recognize an entire space, and the people in it.... Until minimalism, I had been taught, or I taught myself, to look only within a frame; with minimalism the frame broke, or at least stretched."[78] Consider how difficult it is to apply Acconci's metaphor of looking outside the frame to a work as multifaceted as Syms's installation: some elements of Syms's installation are minimal in their textuality, but those elements find their significance only in concert within a larger framework. Minimalism, once again, is not simply about diminution and restraint, but about engagement with scale across multiple overlapping contexts and media as they develop over time.

2

Close Viewing / Distant Reading / Readography

"All art aspires to the condition of music," Walter Pater wrote well more than a century ago. If art (meaning literature as well as visual art) aspires to any universal condition today, textuality may be that condition.
Raphael Rubinstein[1]

Joseph Kosuth's series of photographs subtitled *Art as Idea as Idea* merely presented enlarged dictionary definitions of words such as "definition," "meaning," and notably, in this context, "less." Kosuth's definitions were arguably the most austere formulation of conceptual art—reducing art to the ideational content of language. "Being an artist now," Kosuth maintained in 1969, "means to question the nature of art. If one is questioning the nature of painting, one cannot be questioning the nature of art.... That's because the word 'art' is general and the word 'painting' is specific. Painting is a *kind* of art. If you make paintings you are already accepting (not questioning) the nature of art."[2] Kosuth's definitions provided an uncompromising version of the "dematerialized" art object, but they were of course sold in material forms. A more literal subtitle for the series might be *Art as Idea as Photograph* or *Art as Text as Photograph*. Although Kosuth deterministically maintains that a painter will by virtue of painting accept the nature of art, his overarching use of text allows him to equate language with thought, and in so doing to demediate his work.[3]

To employ a physical media cliché, much ink has been spilled concerning conceptual art's "dematerialization." Skirting this debate somewhat, I propose that we consider minimal writing as mediated text—that is to say, as both ideational and material, as both art and literature. Nick Thurston has recently proposed the term "readograph(em)ic art" in response to the question: "Is it possible to practice an art of reading in a sense that is adequate to the complicated ideas of both 'art' at stake in our ideas about contemporary art and 'reading' at stake in our ideas of apprehension, attention, comprehension and imagination?"[4] Thurston argues that both creators and critics should be more attuned to the interplay of the semantic and visual aspects of text art, and he suggests that "Readograph(em)ic art, done by readographers as acts

of readography, gives us the full complex of form, actor and action in a way that can be both logical and fraught—practicable and contestable, and so changeable in a way that gives us a shared horizon rather than a definitional cage."[5] Likewise, this book aims to introduce readers (or readographers) to a shared exploration of minimal writing, rather than to cement a canon of minimal writing.

"Distant reading" as a method was proposed by Franco Moretti, who aspired to find genre patterns by studying and comparing large numbers of literary texts. Moretti was sometimes caricatured as a canon-destroying opponent of traditional close reading, but despite his sometimes hyperbolic provocations, he did not mean to abandon close reading altogether; rather, he hoped to supplement traditional literary interpretation by broadening the scope of inquiry. Distant reading, for Moretti, was all about scale:

> where distance, let me repeat it, *is a condition of knowledge*: it allows you to focus on units that are much smaller or much larger than the text: devices, themes, tropes—or genres and systems. And if, between the very small and the very large, the text itself disappears, well, it is one of those cases when one can justifiably say, Less is more. If we want to understand the system in its entirety, we must accept losing something. We always pay a price for theoretical knowledge: reality is infinitely rich; concepts are abstract, are poor. But it's precisely this "poverty" that makes it possible to handle them, and therefore to know. This is why less is actually more.[6]

Here again Mies's cliché surfaces as a credo. Without using the term explicitly, Moretti defends the notion of scientific reductionism, which the Nobel Prize–winning neuropsychiatrist Eric Kandel explains in clearer terms than I can:

> Reductionism, taken from the Latin word *reducere*, "to lead back," does not necessarily imply analysis on a more limited scale. Scientific reductionism often seeks to explain a complex phenomenon by examining one of its components on a more elementary, mechanistic level. Understanding discrete levels of meaning then paves the way for exploration of broader questions—how these levels are organized and integrated to orchestrate a higher function. Thus scientific reductionism can be applied to the perception of a single line, a complex scene, or a work of art that evokes powerful feelings. It might be able to explain how a few expert brushstrokes can create a portrait of an individual that is far more compelling than a person in the flesh, or why a particular combination of colors can evoke a sense of serenity, anxiety, or exaltation.[7]

Minimal poems may be radically reductive of language and of literary experience, but they are not necessarily simplistic, nor are they ever completely void of context or content. Distant reading, it should be underscored, makes it possible "to focus on units that are much smaller or much larger than the text," and as such should not be uncritically opposed to close reading. Minimal poems, this book suggests, are richly experimental in their reduction of literary and visual expression to their most basic components—which upon closer (or more distant) inspection, often turn out to be less "basic" than we might have assumed. As Karl Kraus says, "The more closely you look at a word, the more distantly it looks back."[8] Or as Robert Smithson would have it, "Look

at any *word* long enough and you will see it open into a series of faults, into a terrain of particles each containing its own void."[9] Or as Christopher Wool puts it in a painting (in all-caps with no spaces): "THEHARDERYOULOOKTHEHARDERYOULOOK."[10]

Although this book is influenced by practices of distant reading, my methodology more often takes the form of close reading from a mediacentric, or perhaps more accurately, media philological perspective. Media archaeology and media ecology are thriving fields of which I would understand media philology to be a subset that is more specifically concerned with language and textuality. Philology, despite the important recent work of scholars such as Jerome McGann and Susan Howe, remains something of an unfashionable term in North American departments of literature and language.[11] And yet it might be the best available umbrella term to describe the systematic study of texts and textuality, or what McGann calls "the inorganic organization of memory."[12] Susan Howe's recent *Spontaneous Particulars: The Telepathy of Archives* makes an implicit case for close textual examination of works that may have been overlooked because of their size or assumed insignificance:

> In research libraries and collections, we may capture the portrait of history in so-called insignificant visual and verbal textualities and textiles. In material details. In twill fabrics, bead-work pieces, pricked patterns, four-ringed knots, tiny spangles, sharp-toothed stencil wheels; in quotations, thought-fragments, rhymes, syllables, anagrams, graphemes, endangered phonemes, in soils and cross-outs.[13]

Howe offers an excellent rationale for why microscopic details matter; readers will forgive me, I hope, if some of my readings dwell on what might at first appear to be minutiae. According to McGann, "To the philologian, all possible meanings are a function of their historical emergence as material artifacts."[14] Referring to himself, Nietzsche defined a philologist as "a teacher of slow reading."[15] Minimal poems can be "read" quickly, but they can also be reread slowly, and they are best approached from a variety of perspectives. Stephen Best and Sharon Marcus have proposed "surface reading" as a hybridized practice that would move beyond the symptomatic reading strategies of ideology critique (or the "hermeneutics of suspicion") that characterized literary theory in the 1980s and 90s. Best and Marcus understand "surface" not simply as superficial—rather, they advocate reading strategies that give serious consideration to "surface as materiality" as well as to "surface as the elaborate verbal structure of literary language."[16] Minimal writing is well suited to microscopically close reading, but to be fully understood historically, it is also important to consider these works in the aggregate, and to explore their history in relation to visual culture and new media more generally.[17]

Close reading off the page may have been the dominant mode of Anglo-American literary criticism since the 1930s, but as visual poetry, text art, electronic literature, and sound poetry all demonstrate, it is also vitally important to undertake close *viewing* as well as "close listening." For Charles Bernstein, the appearance and performance of a

poem can be as important as the "original" printed text: "Focusing attention on a poem's content or form typically involves putting the audiotext as well as the typography—the sound and look of the poem—into the disattend track" (the "disattend track" is Erving Goffman's term for phenomena which are excluded from the primary frame through which a phenomena or work is perceived).[18] Printed texts, as Bernstein notes, still retain their primacy for literary critics—but this primacy is very much at odds with the many venues and contexts for contemporary poetry and text art, and leads literary critics to overlook the many formats and platforms in the era of "expanded publication" since the 1960s. As Fred Moten asks, "What are the internal relations within that experience between the intellection of the poem's meaning and the sensing of its visuality and/or aurality? What are the relations between versions of or variations on the poem, manifestations of the eye and ear that raise the too deep question of the ontological status of the poem itself?"[19] Minimal writing in particular, this book argues, poses significant theoretical questions related to versioning (or "variantology"), and these questions, as Moten rightly observes, are not superficial or arcane: in fact, they are fundamental to how we interpret and conceptualize contemporary poetry and text-based visual art.

Minimal writing should be of particular interest to historians of literary experimentalism, as it continually tests the limits of literary form. Through its self-reflexivity regarding the material components of expression, minimal writing demonstrates well Warren Motte's observation that "literature is certainly literal in nature—that is, it is constructed (in its written form, at least) out of letters … [but] that is something we mostly forget, preferring to think that literature is a matter of words, of ideas, of themes, of styles, and so forth."[20] Christian Bök offers an even more uncompromising account of literature's basis in the particulate matter of language: "All 'concepts' for poetry may, in fact, depend upon a premise about the minimal element of composition for a text—its unit, or its 'atom,' from which a poem might build a poetics through recombinant permutation."[21] Others, such as Isidore Isou and the Lettrists and Georges Perec and the Oulipo, have shared Bök's insistence on the letter as the smallest component of meaning-making.[22]

To stretch the historical sense of the term "minimal writing" for the sake of discussion, Emily Dickinson could be the greatest minimal writer the U.S. has produced. Dickinson too was concerned with atomism and the smallest components of meaning. Dickinson had no need, or desire, to publish her work in print form, and she produced and preserved her poems by means of simple household materials. As Jen Bervin and Marta Werner's edition of Dickinson's "envelope poems," *Gorgeous Nothings*, compellingly demonstrates, even the most fragmentary of her writings can be appreciated as poems. Like Dickinson's manuscript poems, postwar minimal writing undermines the notion that the book, the print periodical, or the public reading are the only outlets for poetry. Dickinson's poems, and the problems of publication they present, are a

good point of reference, even if Dickinson falls outside the period under consideration in this book. As Susan Howe puts it with fitting succinctness: "These manuscripts should be studied as visual productions."[23] That too can be claimed of the minimal writing under discussion here. That nearly all of Dickinson's writing was in manuscript and was intended for intimate contexts made it difficult, if not impossible, for readers to appreciate her poems as visual artifacts until comparatively recently. Bervin explains, "Dickinson's writing materials might best be described as epistolary. Everything she wrote—poems, letters, and drafts, in fascicles, on folios, individual sheets, envelopes, and fragments—was predominantly composed on plain, machine-made stationery."[24] As Bervin writes of the poems collected in *The Gorgeous Nothings*,

> These manuscripts are sometimes still referred to as "scraps" within Dickinson scholarship. Rather, one might think of them as the sort of "small fabric" Dickinson writes of in one corner of the large envelope interior, A 636 / 636a: "Excuse | Emily and | her Atoms | The North | Star is | of small | fabric but it | implies | much | presides | yet." The writing in this poem is small in relation to compositional space, floating in its firmament. This poem exemplifies Dickinson's relationship to scale so perfectly. When we say *small*, we often mean less. When Dickinson says *small*, she means fabric, Atoms, the North Star.[25]

Coming from a poet-artist who herself works with textiles as a medium for her work, Bervin's astute analysis should remind us not to take for granted the primacy of print publication and the codex book. That Dickinson handwrote her poems and hand-sewed her fascicles made them unavailable in their original form for nearly a century. Bervin's account of the background to Dickinson's "small fabric" poems is highly pertinent to this study:

> The concept of the "atom" emerges in ancient Greek philosophy as the idea of the smallest hypothetical body. At the outset of the nineteenth century, modern atomic theory recasts the atom in chemical terms. In 1830 Emily Dickinson is born in Amherst, Massachusetts. She is thirty-five years old when the Civil War ends, and Johann Josef Loschmidt first measures the size of a molecule of air. In the range of philosophic, scientific, and popular definitions for atom in the *OED*, we also find a dust mote, the smallest medieval measure of time, "the twinkling of an eye," in this apt, obsolete meaning too: "At home."[26]

Applying these older definitions of the "atom," one might well describe minimal poetry as atomically concerned with the fragmentary, the everyday, and the domestic. As such, the most minimal of poems, like Dickinson's "scraps," have tended to be overlooked by conventional poetry audiences.

Bervin's *Dickinson Composites*, a series of large-scale quilts, ingeniously reclaim what editors have typically considered the minutiae of Dickinson's writing, and could be described as un-erasure poems. A variant (signified in Dickinson's fascicles by a + sign) cannot be read simultaneously with that which it replaces. Sharon Cameron's *Choosing Not Choosing* articulates the issue well: "Variants indicate both the desire

for limit and the difficulty in enforcing it. The difficulty in enforcing a limit to the poems turns into a kind of limitlessness, for, as I shall demonstrate in numerous instances, it is impossible to say where the text ends because the variants extend the text's identity in ways that make it seem potentially limitless."[27] The first of six large (6" × 8") quilts (figure 2.1) that Bervin sewed for the *Dickinson Composites* can be read as a minimal poem in its own right. It reads (in Bervin's transcription):

And could I further
"No"?

Surrounding this line (or arguably two lines) are a composite palimpsest of Dickinson's manuscript punctuation, including variant + marks, from the entirety of Fascicle 16, which ends with this emphatic question. Until Ralph Franklin's reading edition appeared in 1998, most readers would have encountered an edited version of this line, which when first published in 1914 read:

And could she, further, "No?"[28]

And which, in the widely used Thomas Johnson edition of 1955, read:

And *could* she, further, "No"?[29]

Dickinson did in fact write two versions of the poem, one written from a first-person "I" to a male addressee; the other written from a third-person "she" to a female addressee, and sent to her sister Susan. An editor using only one version must choose one, and editors until Franklin typically chose the latter version. There are other anomalies in the editing as well: there are no commas in the original, and Johnson adds an italicized "could," for which there is no indication within the fascicle version. Cristanne Miller, correctly in my view, does not italicize "could" in her recent edition.[30] In the context of the full poem (in the male addressee version), the concluding "'No'?"—with its quotation marks and final question mark—gives the poem a climactic moment of irresolution. The line echoes "I could not find my 'Yes'" in the previous stanza. Either the speaker could be saying no, she will not continue climbing with the addressee; or she could be suggesting that she could not refuse him. "No" may mean either "yes" or "no" in a context when it is phrased as a question, and Dickinson ingeniously plays upon this ambiguity. Bervin's version adds an extra remove. Could Dickinson go further? Could Bervin go further? Can we as readers further *know*? Perhaps the variants and punctuation marks that surround this enigmatic line evoke a constellation of nonsemantic meaning—pointing to an indecision and repetition that lead us back to Dickinson's process, and overwriting the erasure of Dickinson's mixed (and ultimately unknowable) intentions.

Much to the eventual advantage of Dickinson's reputation, the canon of American nineteenth-century poetry was rewritten in the twentieth century with modernist tastes in mind. The formal verse of The Fireside Poets gave way to the maximal lines of Whitman's free verse and the minimal lines of Dickinson's ballad stanzas. If one cursorily flips through, say, the John Hollander–edited anthology *American Poetry: The Nineteenth Century* (1993), one will find few poems shorter than a sonnet. Whitman and Dickinson are highly anomalous among their contemporaries. Assessing Dickinson's use of various media—the page, the fascicle, the letter, and the envelope—is particularly difficult given that she did not intend to publish her writing. We are still, in a sense, unlearning the normalization of Dickinson that her editors undertook to make her verse palatable to early twentieth-century audiences, and Bervin and Werner's reclaiming of Dickinson's fragmentariness could be said to continue to reveal and reverse that process of standardization.

2.1 (following pages)
Jen Bervin, *The Composite Marks of Fascicle 16*.
Cotton and silk thread on cotton batting,
6' × 8', 2004–2008.

"And cared I so the no"?

CLOSE VIEWING / DISTANT READING / READOGRAPHY 55

3

absence of clutter

Nature is not cluttered ...
Henry David Thoreau, "Autumnal Tints"

Why do we assume that simple is good? Because with physical products, we have to feel we can dominate them. As you bring order to complexity, you find a way to make the product defer to you. Simplicity isn't just a visual style. It's not just minimalism or the absence of clutter. It involves digging through the depth of the complexity. To be truly simple, you have to go really deep.
Steve Jobs (interviewed by Walter Isaacson)

The blog *Absence of Clutter*—hosted at www.absenceofclutter.com—shares its title and its URL with a poem from Robert Grenier's *Sentences* (see chapter 8). The blog is well written and has high production values, but it has not been updated for several years. Its creator, a fifth-grade teacher from Florida, seemingly gave up on the site after a four-month burst of enthusiasm. Designed for the overworked professional, the blog, according to its subtitle, was intended to help "Organize your life to improve your home, body and mind." Perhaps this instance of what Michel Foucault would call "self-writing" did expand its author's ability to improve her home, body, and mind. Or perhaps the blog was abandoned because paradoxically it took more time than it saved, or cost more money than it earned.

The spare aesthetic of *Sentences* is well characterized by "**absence of clutter**"—just three words centered on the page without a verb or a specific utterer (figure 3.1). The 500 index cards contained in the *Sentences* box (figures 8.1 and 8.2) mimic standardized bureaucracy in their unclutteredness, and in this instance the monospaced type makes the two seven-letter nouns symmetrical on either side of the "of." I've read this poem as a slogan for how to organize my desktop, although there is no internal evidence that suggests this reading. One might also read the poem simply as a matter-of-fact description of a space (presumably a domestic space). "Clutter" is not a mellifluous word; its ragged consonants suggest a kind of disorder. In any case, the poem marks the absence rather than the presence of clutter. Another card from *Sentences* could offer a rejoinder:

3.1

Robert Grenier, **"absence of clutter,"** from *Sentences*, 1978.

```
I guess
the house is a mess
```

As vague as this rhyming monosyllabic poem may be, it could have a communicative function in a household, although that function seems to be making an excuse, rather than resolving to do anything about the messy situation. The rather pat rhyming of "guess" and "mess" might also suggest that there is some reason behind the clutter—that some meaning might be extracted from the mess.

The word "clutter" is almost never used in a favorable sense, and Americans seem to be experiencing an epidemic of clutter. Here is a partial list of recent book titles that contain either the word "clutter" or "declutter" (feel free to skim!):

Detox Your Desk: Declutter Your Life and Mind; *Minimalism: Declutter and Discover*; *The More of Less: Finding the Life You Want under Everything You Own*; *Clutterfree with Kids: Change your thinking. Discover new habits. Free your home*; *Clutter Free: Quick and Easy Steps to Simplifying Your Space*; *Living with Less: An Unexpected Key to Happiness*; *The Joy of Less: A Minimalist Guide to Declutter, Organize, and Simplify*; *Living with Less: Discover the Joy of Less and Simplify Your Life*; *Declutter Your Mind: How to Stop Worrying, Relieve Anxiety and Eliminate Negative Thinking*; *Declutter: How to Organize Your Life, Maximize Your Productivity, and Enjoy a Clutter-Free Life*; *Declutter Your Home Effectively: House Cleaning Hacks to a Clutter-Free Life*; *Lose the Clutter: Lose the Weight: The Six-Week Total-Life Slim Down*; *Never Too Busy to Cure Clutter: Simplify Your Life One Minute at a Time*; *Clutter Busting: Letting Go of What's Holding You Back*; *Control Your Clutter!: You Don't Have to Get Rid of EVERYTHING! Even Hoarders Will Succeed with This Method!*; *Clutter Free: 10 Simple Ways You Can Turn Chaos into Clarity*; *Getting Rid of It: The Step-by-Step Guide for Eliminating the Clutter in Your Life*; *Clutter Busting Your Life: Clearing Physical and Emotional Clutter to Reconnect to Yourself and Others*; *Clutter's Last Stand: It's Time to De-Junk Your Life!*; *Clutter to Calm: The De-Cluttering Journey*; *Easy Minimalist Living: 30 Days to Declutter, Simplify and Organize Your Home without Driving Everyone Crazy*; *Breaking Up with Your Stuff: Emotional Homework to End Your Toxic Relationship with the Clutter Culture*; *Clutter Rehab: 101 Tips and Tricks to Become an Organization Junkie and Love It!*; *Careful Where You Set This Down: Companion Workbook Guide to Take You From Clutter to Clarity*; *Less Is Best: Declutter, Organize, and Simplify to Reach Minimalism: Get More Time, Money, and Energy*; *Clear the Clutter, Find Happiness: One-Minute Tips for Decluttering and Refreshing Your Home and Your Life*; *Organized Simplicity: The Clutter-Free Approach to Intentional Living*; *Tidying Up: Changing Your Life with the Mind-Blowing Experience of Decluttering*; *The Truth about Clutter: Why Am I Holding On to This?*; *Clutter Coach Success Secrets: Strategies, Inspiration, and Motivation to Create a Clutter-Free Life*; *Your Spacious Self: Clear the Clutter and Discover Who You Are*; Clearing Emotional Clutter: Mindfulness Practices for Letting Go of What's Blocking Your Fulfillment and Transformation; The Gentle Art of Swedish Death Cleaning: How to Free Yourself and Your Family from a Lifetime of Clutter.

One immediate takeaway from these titles is that they are surprisingly long and redundant. In "Style, Inc.: Reflections on 7000 Titles," Franco Moretti studied a database of British novel titles from 1740 to 1850, and confirmed what many scholars would have suspected: novel titles grew considerably shorter during the period, likely due to demands of the marketplace as well as considerations of recordkeeping and bibliography.[1] From the above list, it seems to be a requirement that the titles of decluttering self-help books contain a colon, as well as, in most instances, a second-person appeal within the subtitle. Almost every conceivable genre of self-help is connected to ridding oneself of clutter: finding happiness, eliminating stress, losing weight, being a better parent, overcoming addiction, managing one's time more effectively, etc. Personal minimalism here becomes a panacea for every life challenge.

By way of comparison to "`absence of clutter`," Bernar Venet's poem "As Regards Plain" simply offers a list of synonyms, beginning with the word "uncluttered" (figure 3.3).[2] Known best for his work as a minimalist sculptor, Venet writes poems that are typically devoid of metaphor or syntax. The titles of his two collections of poems—*Apoétiques* and *Poetic? Poétique?*—aptly describe his work, much of which would be unrecognizable as poetry to conventional audiences. In this particular list, the slippage among synonyms reveals the impossibility of exact homology. To be "ordinary" is not necessarily to be "brief." To be "balanced" is not necessarily to be "minimal." Plainness is acculturated and is more difficult to describe precisely than it might seem. Published in a facing-page translation, the French title "À propos de sobre" implies a sense of sobriety or abstemiousness, as well as of plainness. Nowhere in the English text do we get this same sense of sobriety—the closest terms might be "austere" or "balanced." In effect, Venet has written a thesaurus poem that brings us no closer to a precise definition of "plainness." Maybe the most poetic aspect of the poem is that it ends on the term "measured," possibly alluding to traditional poetic measure. The associative nature of the poem offers a dry commentary on linguistic imprecision; at the same time, perhaps, the poem reveals a sort of linguistic clutter. We have both too many and too few words to represent things accurately as they are.

The impulse to limit one's possessions and material needs might seem uncontroversial, but some have suggested that the contemporary obsession with minimal living is more a reflection of contemporary capitalism than it is a meaningful response to it. In a *New York Times* article "The Oppressive Gospel of Minimalism," Kyle Chayka writes:

> Despite its connotations of absence, "minimalism" has been popping up everywhere lately, like a bright algae bloom in the murk of postrecession America.... It's easy to feel overwhelmed by the minimalism glut, as the word can be applied to just about anything.... Part pop philosophy and part aesthetic, minimalism presents a cure-all for a certain sense of capitalist overindulgence.... [A]s an outgrowth of a peculiarly American (that is to say, paradoxical and self-defeating) brand of Puritanical asceticism, this new minimalist lifestyle always seems to end in enabling new modes of consumption, a veritable excess of less. It's not really minimal at all.[3]

American Puritanical restraint, as Chayka notes, has always been oddly paired with the wealth and excess of the country as a whole. Nicholas Berggruen, "the homeless billionaire" and "the richest minimalist on the planet," provides a good example of the hypocrisies of minimalism among the super-rich:

> Twelve years ago, Nicolas Berggruen sold his apartment, which was filled with French antiques, on the 31st floor of the Pierre Hotel in Manhattan. He said he no longer wanted to be weighed down by physical possessions. He did the same with his Art Deco house on a private island near Miami. From that point on he would be homeless. Now he keeps what little he owns in storage and travels light, carrying just his iPhone, a few pairs of jeans, a fancy suit or two, and some white monogrammed shirts he wears until they are threadbare. At 61, the diminutive Berggruen is weathered, but still youthful, with unkempt brown hair and stubble. There's something else he hung on to: his Gulfstream IV. It takes him to cities where he stays in five-star hotels.[4]

This passage seems appropriate to a time of widening inequality, in which according to one recent report, eight billionaires are as rich as the poorest half of the world's population.[5] The homeless billionaire is homeless by choice, and seems unencumbered by connection to any city or nation state.[6] His minimalist flair gives him a kind of cachet; he is free to be where he pleases, and to associate with whomever he wishes. His minimalism might say more about the freedom of capital to circulate around the globe than it does about his personality or ethics.

In a scathing review of Marie Kondo's bestselling *The Life-Changing Magic of Tidying Up: The Japanese Art of Decluttering and Organizing*, Arielle Bernstein claims similarly that the minimalism movement's recent resurgence is tied to growing inequality. Decluttering, for Bernstein, is as much a sign of privilege as it is a sign of restraint:

> There's an arrogance to today's minimalism that presumes it provides an answer rather than, as originally intended, a question: What other perspectives are possible when you look at the world in a different way? The fetishized austerity and performative asceticism of minimalism is a kind of ongoing cultural sickness. We misinterpret material renunciation, austere aesthetics and blank, emptied spaces as symbols of capitalist absolution, when these trends really just provide us with further ways to serve our impulse to consume more, not less.[7]

3.2 (following pages)
Bernar Venet, "As Regards Plain" / "À propos de sobre."

As Regards Plain

Uncluttered
Ordinary
Austere
Elementary
Simple
Balanced
Brief
Minimal
Measured

98

À propos de sobre

Dépouillé
Ordinaire
Austère
Élémentaire
Simple
Pondéré
Sommaire
Minimal
Mesuré

In another indignant review of Kondo's *Life-Changing Magic of Tidying Up*, Rob Horning writes that the book could be read as "a parable or fantasy about a digitally driven post-possession lifestyle."[8] Like the homeless billionaire's lifestyle, Kondo's minimalism is predicated on the power of digital tools. While minimalist lifestyle practices may seem far afield from minimal writing, they do point to larger issues surrounding the history of minimalism in the arts and in the broader culture.[9] The rise of minimalism in the 1960s is roughly coterminous with the rise of the environmental movement, for one thing. But again contradictions emerge: since the 1950s the average American house has more than doubled in size.[10] Americans may have wanted to consume less as environmental awareness grew, but their behaviors demonstrated the opposite. The muscle car emerged in the mid-1960s boom, and the SUV became ubiquitous in the 1990s boom. Both categories of vehicle can hardly be reconciled with minimalist restraint.

The legacy of minimalism in architecture is so pervasive that it can be difficult to discuss impartially. For some, minimalism is an oppressive capitulation to the global dominance of the corporation and of corporate aesthetics. For others, minimalism was an unavoidable consequence of modernism's rejection of ornament and excess. Contradictions can be found in both positions. Writing of the gaudy minimalism of Trump Tower, Liam Gillick argues that

> Minimalism is not a continuation of utopian modernism, it is a critique of utopian modernism on the basis of material facts and by way of a self-conscious play of real illusion against fake illusion. Minimalism is a development beyond modernist visions of totalizing utopia, one that breaks both from the everyday and from an illusionistic representation by attempting to include the human within a set of material encounters devoid of pretentions to completeness or truth of whatever kind.[11]

Gillick has here, in a sense, offered a postmodern defense of modernist minimalism. Less still seems to be more for Gillick, but he also complicates minimalism's relation to corporate or monumental architecture. The oxymoronic quality of his language—"real illusion" and "fake illusion"—suggests a Baudrillardian embrace of the simulacral, and yet Gillick also seems to suggest that minimalism can offer individuals perspective on the material conditions of the built environments they inhabit.

"Thoreau, the First Declutterer," the title of an optimistic recent *New York Times* article, is mostly self-explanatory. Describing Thoreau as the "nation's original domestic minimalist," Danny Heitman positions him as a depoliticized champion of rugged individualism. Like Kondo, Heitman's Thoreau would easily find himself at home with information technology's potential to reduce our dependence on physical media:

> In a journal entry, he wondered how grand it would be to have a library's bounty out in the woods, hungering for the age of easily accessible reading we now have with the Internet. If Thoreau moved to Walden today, it's possible—if not likely—that he would bring a laptop with him. His struggles to square civilization with serenity are still very much our own.

> Thoreau sought a decluttered life because he thought it would lead to a decluttered mind. The abiding lesson of *Walden* is that only in occasionally standing offstage from our daily routines can we grasp what is really important to ourselves, our family, our country.[12]

This techno-boosterist Thoreau seems to have little in common with the author of "Civil Disobedience," but is instead fashioned as a self-improvement guru. Steve Jobs, perhaps the greatest techno-boosterist of our era, had one overriding concern, according to his biographer: "His main demand was 'Simplify!'"[13] Jobs advocated endlessly for minimalist design, and his mantra is not far off from Thoreau's famous slogan, "Simplicity, simplicity, simplicity!" The full quotation from *Walden*, however, reveals differences between Thoreau and Jobs: "Our life is frittered away by detail. An honest man has hardly need to count more than his ten fingers, or in extreme cases he may add his ten toes, and lump the rest. Simplicity, simplicity, simplicity! I say, let your affairs be as two or three, and not a hundred or a thousand; instead of a million count half a dozen, and keep your accounts on your thumb-nail."[14] For Jobs, no detail was too small, but those details should be invisible to the computer user. The very first advertisement for Apple Computer, published in 1977, offers what might be loosely considered a variation on the "less is more" cliché (figure 3.3). The paradox is, again, the minimal-maximal one: to be simple is to be aware of scale and of limitation, and not to traffic in ornament.

Jobs's commitment to minimalism was spectacularly influential, to say the least. The two largest corporations in the world by market capitalization (as of my writing this book), Apple and Alphabet, are strongly tied to minimalist aesthetics. Their very names speak to the fundamental nature of knowledge. The most visited web page in the world, google.com, could hardly be more minimal. But here, in decimal notation, is a "googol," from which Google takes its name: 10,000. The name of the company is meant to invoke the infinity of knowledge, and the interface is designed to provide a nondescript universal portal. The keyword search bar in itself is minimal—asking of users only that they type a few words in any language. At first glance, Google's home page might lead one to believe that the company is a noncommercial entity, and yet its interface has generated immense wealth (if not yet a googol of dollars), most of which has remained in private hands. Under the banner of platitudes like "Think Different" and "Don't Be Evil," American global info-capitalism has arguably never been stronger, or more committed to a universalist minimalism that has made a select few extraordinarily wealthy.

The minimalist impulse to renounce material possessions, as we have seen, is a fraught one, even if reducing one's overall level of consumption (assuming basic needs are met) seems to be an unequivocal good.[15] In his *Statements*, Lawrence Weiner writes that "Being an artist means doing a minimum of harm to other human beings."[16]

ABSENCE OF CLUTTER

3.3
Apple Computer brochure, 1977.

It is hard to disagree with the Hippocratic sentiment behind this statement, although perhaps one could invert it to claim that the role of the artist is to be of maximum benefit to others. Still, Weiner's proscriptive statement might be paradigmatic of a certain minimal-conceptual aesthetic that privileges ideas over material objects. For Michel Foucault, asceticism was a practice of the self that could allow the individual greater autonomy; and many, if not most, ancient religions counsel some form of asceticism or renunciation. One possible response to these injunctions to practice personal renunciation is Georges Bataille's notion of the accursed share, in which excess and nonutilitarian consumption play a central role in the development of culture. As William Blake famously wrote, "the road of excess," not of restraint, "leads to the palace of wisdom." Another counterargument against restraint might be inherent within Keynesian economics. Underconsumption leads to underproduction: modern liberal economies require massive stimulus programs in order to emerge from depressed conditions. Austerity may worsen, rather than improve, the economic conditions of advanced countries; thus, minimizing one's own consumption habits could be bad for the overall unemployment rate. Moreover, without regulation or oversight, voluntarily minimizing one's personal consumption could, at least in theory, make goods and services cheaper for those who have no compunction about their overconsumption, and thus lead those who disproportionately consume resources to consume even more.

Minimal artworks have intervened topically in debates about consumption. Barbara Kruger's *I shop therefore I am*, which was realized both as a serigraph print (1983) and a shopping bag (1990), offers a famous instance. Ironically, Kruger's iconography was adopted by the Supreme clothing brand, and in response Kruger mounted an installation, *Untitled (The Drop)* (2017), at the Performa 17 biennial. The artist Brian Singer (also known as Someguy) has produced similar slogan-based work that intervenes in the paradoxes of consumption. His *Economy* paintings (which are also realized as stickers and placards) feature sentences such as "greed is good for the economy" and "carpooling is bad for the economy." One work, *Guns Are Good* (2018), is composed from gunpowder, and offers a sans-serif diptych that reads on one side: "guns are good for the economy," and on the other, "guns are bad for the economy." Both statements place in question our notions of collective utility and responsibility within a capitalist economy.

The postmillennial American drive to minimize and declutter generally presumes that overconsumption is a primary threat to one's productivity and even mental health. But there are many who do not have the luxury of overconsumption, and the twenty-first century remains troubled by forced migrations. The minimalism of Theodor Adorno's *Minima Moralia* was the product of exile, and of a profound terror of the unbridled forces of capitalism. Written between 1944 and 1947, *Minima Moralia* is described by Adorno as a kind of "ascesis," requiring "the renunciation of explicit theoretical cohesion."[17] There could be no pretension to a grand, overarching ethics (or a *Magna*

Moralia) in the wake of the Holocaust. American industrial power had defeated Nazi Germany, but the reprieve from fascism might only be temporary. For Adorno, resistance to the power of "absolute production" offered the only hope: "Only by virtue of opposition to production, as something still not totally encompassed by the social order, could human beings introduce a more humane one. If the appearance [*Schein*] of life were ever wholly abrogated, which the consumption-sphere itself defends with such bad reasons, then the overgrowth of absolute production will triumph."[18] Over seventy years later, it looks no less likely that "absolute production will triumph" and irreversibly imperil the planet. Voluntary minimalism will not be sufficient to save us. Whether our disastrous dependence on fossil fuels can be counteracted by a global minimalism that promotes greater equality and sustainability is a topic for another book.

4

The Indexical Present

Adrian Piper offers this remarkable assessment of her body of work: "the indexical present has provided the major strategy of my work, which is direct, immediate, and confrontational. Racism is not an abstract, distanced issue out there that only affects those unfortunate other people. Racism begins with you and me, here and now, and consists in our tendency to try to eradicate each other's singularity through stereotyped conceptualization."[1] In direct contrast to the normative white masculinity with which conceptualism and minimalism have often been associated, Piper's work draws on indexical constructions in order to focus attention on questions of race and gender.[2] Works like her *Catalysis* series (1972–1973) or her calling cards or her *Cornered* (1988) confront viewers by emphasizing in-person linguistic exchanges. To highlight just how striking Piper's self-assessment of her use of the indexical present is, consider a parodic counterexample, a short text written by Mónica de la Torre:

> Traditionally, the locus of enunciation should not matter. Any statement about the avant-garde and its relationship to identity politics would aspire to be valid regardless of when, where, or by whom it was formulated. Convention has dictated that it is best to avoid bringing in contextual information about the position from which one speaks. Such information highlights contingencies instead of the general point one is trying to make, is therefore petty and in bad taste.[3]

In the text that follows this paragraph, de la Torre removes all personal pronouns and references to herself, so that it becomes difficult to know who is talking about whom. The first sentence begins: "_____ began writing this piece in Marfa, Texas, where _____ had an odd exchange with an Anglo woman worth recalling." Without a specific subject, we can only assume that de la Torre is either the first- or third-person subject of the text (although the grammar of this first sentence could also allow for a second-person construction). The redaction of proper names and/or personal pronouns strikingly disproves the universalist claims of the introductory text. In indexical constructions, according to David Kaplan, the leading philosopher of language on the topic, "the referent is dependent on the context of use and ... the meaning of the word provides a rule which determines the referent in terms of certain aspects of the context."[4]

By removing crucial aspects of context, Piper and de la Torre reveal patterns of what Piper refers to as "stereotyped conceptualization."

In Benjamin Buchloh's influential terms, conceptual art developed away from the model of the analytic proposition ("linguistic definition alone") and toward "the critique of institutions."[5] More recently, Nizan Shaked has written, "If Conceptual Art was art about art, then synthetic conceptualism became art about political art (not simply art about politics). Isolating agency from subjectivity, these artists examined the subject's relation to the identity-based collective and society as a whole."[6] As Shaked notes, conceptual art became more politicized toward the end of the 1960s and the beginning of the 1970s, as well as characterized by a more diverse roster of artists (by comparison especially to the almost exclusively white male group of artists represented by Seth Siegelaub). Although minimal and conceptual art often seemed to eliminate the first-person specificity of the artist's perspective, for Piper such tactics could also reveal the social construction of viewership:

> One of the major drives in minimal art is the idea of repudiating abstract aesthetic theory and focusing attention on the individual, specific, unique object, reducing the object to a set of properties that reveal it simply as what it is: as an object in space and time, and not something that is full of external associations, suppositions, and preconceptions. If you think that xenophobia can be overcome by focusing on the specific, unique, concrete qualities of individuals, then it would make sense to think of minimal art decision-making as a kind of aesthetic strategy for drawing attention to the concrete, specific, unique qualities of individuals, and that is what my work does.[7]

Indeed, the indexical present, and an offshoot that I call the counterfactual indexical, may be one of the central modes of conceptual art, as well as of minimal writing. By "counterfactual indexical," I mean to describe works such as Yoko Ono's *This Is Not Here* (1971) or Magritte's *La Trahison des images* [Ceci n'est pas une pipe] (1929) or Christine Kozlov's *THIS IS NOT ART* (1969). Such works typically offer a proposition that can be taken as true or untrue depending on context. Robert Morris's *Document (Statement of Esthetic Withdrawal)* (1963) highlighted the paradoxical situation of an artist attempting to deny an object the status of being an art object. After Duchamp's introduction of the readymade, such a refusal of aesthetic value could only be ironic.

Glenn Ligon's *Untitled (I Am a Man)* (1988) (figure 4.1) is a good example of an analytic proposition located in the indexical present.[8] Although it is a handmade painting (and so not technically speaking a readymade), *Untitled (I Am a Man)* could be said to have no "original" content. The painting merely borrows the iconic text and design of signs worn during the 1968 Memphis Sanitation Workers' Strike (during which Martin Luther King Jr. was assassinated). It does, however, remediate the sign and abandons its original red lettering. The painting is, in effect, a quotation of a quotation, which may derive from another quotation, the first sentence of Ralph Ellison's *Invisible Man* ("I am an invisible man").[9] According to the National Gallery of Art website: "This

painting is Ligon's most important and iconic work"—something of an extraordinary claim to bestow upon a work that is seemingly only a reproduction of a preexisting iconic image.[10] The work derives its power, in large part, from its indexical context. For a queer black man to make this most tautological of all statements in 1988, at the height of the AIDS crisis, took on a new valence. In Shaked's terms, a work such as this is "political not only because of its subject matter, but also because it performed self-analysis of its own means of reference, reflecting upon the implications of visual and physical manifestations of meaning."[11] Here is another example of a tautological political statement: at a queer-friendly bar in New York City, the words "A bathroom is a bathroom" are painted on the bathroom doors. The reference to gender-neutral bathrooms is implicit, but likely would not have made sense before the introduction of North Carolina's "bathroom bill" of 2016.[12] On the other hand, truisms can obfuscate, as was the case when Donald Trump tweeted "A WALL is a WALL!"[13] Coming in the midst of a bitter debate about immigration and the U.S.–Mexican border whose terms kept shifting, this statement was misleading and simplistic in the extreme.

Truisms and paradoxes are common within conceptual and minimal writing, not only because they exist in the indexical present, but because they show the limits of our access to the indexical present. Jenny Holzer's "IT'S JUST AN ACCIDENT THAT YOUR PARENTS ARE YOUR PARENTS," for instance, like Ligon's *Untitled (I Am a Man)*, derives its power from cultural assumptions that indicate the opposite of the purportedly truistic claim. Michael Harvey's *White Papers*, a 1971 collection of seventy-one index cards, contains two identical cards that both simply read "unique." Which of the cards is truly unique? Another card reads "Words, words, words"—quoting Hamlet, and offering a true, if absurdly generic, account of what is being read. An astonishing number of 1960s and 70s art and text works have similarly generic titles: Vito Acconci's "Text," Robert Creeley's *Words* and *Pieces*, Dan Graham's "Schema," Robert Grenier's *Sentences*, Harvey's *White Papers*, Holzer's *Truisms*, Joseph Kosuth's *Titled (Art as Idea as Idea)*, Sol LeWitt's "Sentences on Conceptual Art," Adrian Piper's *Here and Now*, Aram Saroyan's *Pages* and *Aram Saroyan*, Lawrence Weiner's *Statements*, and so on . . .

Perhaps due to their seeming simplicity, indexical constructions have received less attention from literary historians than from art historians. Another good example of a visual-literary text that recursively points to the conditions of its presentation is Robert Grenier's "`staring at the at`" from the poster-poem *CAMBRIDGE M'ASS*. Printed in a monospaced font, the first "at" is exactly in the center of the line (there are eight letter-spaces to the left and eight letter-spaces to the right of the first "at"). To read this poem is to contemplate what the "at" is. Does the second "at" refer to the first "at"? Looking at a constellation of roughly 250 short poems on the poster, a viewer might read (or stare) at the poster-poem for hours without "staring at the at." Like a koan, this poem might be utterly profound or utterly vacuous—depending,

4.1

Glenn Ligon, *Untitled (I Am a Man)*. Oil and enamel on canvas, 40" × 25", 1988. Collection of National Gallery of Art, Washington, DC. Photographer credit: Ronal Amstutz. © Glenn Ligon; courtesy of the artist and Regen Projects, Los Angeles.

I AM
A
MAN

4.2

Barbara Kruger, *Untitled (Your gaze hits the side of my face)*. Photograph and type on paperboard, 18⅞" × 15⅜" × 1¾", 1981. © Barbara Kruger; courtesy Mary Boone Gallery, New York.

THE INDEXICAL PRESENT

in large part, on how an observer engages with the text. Such a text is radically perspectival, and does not specify a speaker or a reader (although they can be inferred). By comparison, a work such as Barbara Kruger's 1981 *Untitled (Your gaze hits the side of my face)* (figure 4.2), the text of which is written next to a profile view of the face of a female statue, specifies a first- and second-person relationship.[14] And yet the work still evokes the indexical present, since the viewer is in fact gazing upon the face of the unspecified woman. To stare is different than to gaze, and although Kruger does not specify a male viewer, one can be assumed, in part, through the allusion to Laura Mulvey's 1975 "Visual Pleasure and Narrative Cinema," in which Mulvey coined the term "male gaze." There is a seeming contradiction too in the gaze *hitting* the side of the face. The work would lose much of its power if, for instance, it read: *Patriarchal scopophilia is a violent activity in which you are currently engaged.* The contrast of the seemingly impassive, statuesque profile of the unnamed woman with the italic Futura font, which suggests the iconography of advertising, offers another layer of complexity. Although the text works of Kruger and Holzer may seem direct or didactic (and perhaps that is the point), these works can also be surprisingly subtle, and richly suggestive in their revelation of how words and images circulate within an increasingly crowded infosphere.

5

"A Radium of the Word" From Imagism to Concretism

On or about December 1912—to adapt Virginia Woolf's famously ambiguous claim about December 1910 and human nature—poetry changed. In May 1912, F. T. Marinetti had published his "Technical Manifesto of Futurist Literature," which called for "the destruction of syntax" in order to "fuse the object directly with the image it evokes, providing a glimpse of the image by means of a single, essential word."[1] Also that spring or early summer, Ezra Pound, H.D., and Richard Aldington agreed on the central tenets of what was to become imagism. And that summer Gertrude Stein began *Tender Buttons*. In her poem "Gertrude Stein" (1924), Mina Loy was to credit her with having been able to "extract / the radium of the word" from "the tonnage / of consciousness."[2]

If 1912 saw the beginnings of what was to become a new minimalist aesthetic in poetry, 1913 was the *annus mirabilis* of the modernist impulse toward a new unadorned style. In January 1913, poems by "H.D. Imagiste" appeared in *Poetry*. In February, the Armory show opened in New York, introducing American audiences to cubism and futurism. In March, *Poetry* published a short essay by F. S. Flint on "Imagisme" followed immediately by Pound's famous "A Few Don'ts." Flint wrote that the "imagistes ... were contemporaries of the Post Impressionists and Futurists; but they had nothing in common with these schools"—overstating the case somewhat.[3] Both Pound and Marinetti railed against adjectives and abstractions, and both aspired to overthrow reigning poetic orthodoxies. Marinetti's program was more radical, but both poets shared an interest in science and in microscopic attention to individual words. Marinetti aspired "to introduce the infinite life of molecules into poetry."[4] In the nineteenth century, Edward Lear and Lewis Carroll had experimented with nonsense verse and with the portmanteau. Marinetti called for both splitting and fusing words: "Our lyric intensity must be free to dismantle and remake words, cutting them in half, extending and reinforcing their centers or their extremities, increasing or reducing the number of their vowels and consonants. In this way, we shall have the *new orthography* that I call *freely expressive*. This instinctive transformation of words is in keeping with our natural tendency toward onomatopoeia."[5]

For Marinetti, a reconfigured, technologized language could bring poets closer to a more accurate representation of nature and reality. Pound downplayed Marinetti's influence, and would not go so far as "to eradicate the 'I'" in literature. Nor would Pound have sympathized with Marinetti's assault on the attempt of writers like Flaubert to find *le mot juste*, or as Marinetti put it with reference to another French writer: "I am at war with the precious, ornamental aesthetics of Mallarmé and his quest for the rare word."[6] The "rare word," or perhaps the name-in-itself, was also under assault in the writing of Gertrude Stein, who in 1913 first wrote the line "Rose is a rose is a rose is a rose"—which was to become a mantra for herself and others.[7] Whereas Stein resisted the authority of the proper name by means of repetition, Pound by late 1913 had received Ernest Fenollosa's papers from his widow, and began to place his trust in the exactitude of the Chinese character and its potential for "correct denomination of names." Also in 1913, Russian futurists Aleksei Kruchenykh and Velimir Khlebnikov wrote their manifestoes "The Letter as Such" and "The Declaration of the Word as Such," the latter illustrated by Kazimir Malevich.[8] That same year, the Ukrainian-Russian futurist Vasilisk Gnedov published his short sequence *Death to Art*—fifteen short poems that become successively shorter until the sequence culminates in a blank page.[9] Preceding the blank page are two untitled oneworders. *Death to Art* performs its title as an entropic withering away of representation—ending with blankness, not unlike the more famous Malevich *Black Square* painting, first displayed in 1915.

The canon of modernist American poetry more or less (forgive the phrasing) begins with the injunction not only to "MAKE IT NEW," but also to make it economical. The initial imagist program, as outlined by Flint, consisted of three principles:

1. Direct treatment of the "thing" whether subjective or objective.
2. To use absolutely no word that does not contribute to the presentation.
3. As regarding rhythm: to compose in the sequence of the musical phrase, not in sequence of a metronome.[10]

If the first two principles are recognizably modern, the third is perhaps less so. While the imagist poem might be as concise as two lines, it is still recognizably a lyric poem meant to be mellifluous. For Pound, "Dichten=condensare" (poetry is the most concentrated form of verbal expression) is a central tenet of his poetics.[11] The (supposedly) ideogrammic nature of the Chinese character may have seemed the ultimate synthesis of signifier and signified to Pound, but he likely would have balked at the idea of a one-word poem in an alphabetic language. Neither would a one-word poem have the potential for musicality, nor would it have any inherent visual interest. The contemporaneous readymades of Duchamp may have pointed in a new direction, but Duchamp was a comparatively obscure figure in the United States until the 1960s, and it is difficult to assess his direct influence on American modernist poetry (aside from his significant personal relationships with writers such as Mina Loy and members of the Arensberg circle).

Mallarmé, Apollinaire, Marinetti, and others experimented with the spatialization and sizing of words in their poetry, but generally speaking their work also was not recognizably minimal in the postwar sense.[12] It is important to emphasize that postwar minimalism is not simply equivalent to concision; minimal poetry, like minimal music, often features serial repetition. *The Princeton Encyclopedia of Poetry and Poetics* offers this definition of "concision":

> Concision has been described as "native to the lyric," but poetic media influence its exercise. The terseness of epitaph is in part conditioned by the need to carve it in stone. Brief forms are suited to the spatial constraints of a print culture in which poems must fit in magazines, on subway walls, and in the pages of anthologies. (They are also suited, some would say, to the pedagogical requirements of academic settings.) Some 21st c. poetry exhibits the compactness of contemporary, character-restricted communications (e.g. text messaging, microblogging).[13]

Crucial here is the emphasis on poetic media. Modern urban landscapes offered one site for experimentation with poetic language; modern media formats offered another. Perhaps it is true that brief forms are suited to academic settings, but they also frustrate conventional forms of interpretation. Pound's classroom standby "In a Station of the Metro" may be the exception that proves the rule.

In its initial incarnation in the April 1913 issue of *Poetry*, "In a Station of the Metro" (figure 5.1) was printed with conspicuous spaces that suggest a slow or contemplative pacing, and the colon at the end of the first line as well as the period at the end of the poem were also allotted extra space. Like many minimal poems, the poem was redacted from a longer original. Pound had not yet discovered the intensity of the ideogram, but he had discovered "the one-image poem," which he described (somewhat confusingly) as a form of

> super-position, that is to say, it is one idea set on top of another. I found it useful in getting out of the impasse in which I had been left by my metro emotion. I wrote a thirty-line poem, and destroyed it because it was what we call work "of second intensity." Six months later I made a poem half that length; a year later I made the following *hokku*-like sentence:

"The apparition of these faces in the crowd:
 Petals, on a wet, black bough."[14]

Already by 1916, Pound had revised the spatialization of the poem without adding or removing a word—arguably further condensing the poem. For Pound, the poem has not just one idea but two, and the poem fuses those two ideas into a single image. Note too that though Pound claims the poem is a single sentence, it famously does not contain an active verb.

POETRY: *A Magazine of Verse*

I come to you as a grown child
Who has had a pig-headed father;
I am old enough now to make friends.
It was you that broke the new wood,
Now is a time for carving.
We have one sap and one root—
Let there be commerce between us.

IN A STATION OF THE METRO

The apparition of these faces in the crowd :
Petals on a wet, black bough .

Ezra Pound

[12]

5.1
Ezra Pound, "In a Station of the Metro,"
Poetry Magazine (April 1913).

Another of American modernism's most famous poems, Marianne Moore's "Poetry," has a redaction history comparable to, though far more complex than, that of "In a Station of the Metro." The first published version, which appeared in 1919 in the final issue of *Others* (edited by none other than William Carlos Williams), was thirty lines long; the final version, a mere four lines long, was published according to Moore's instructions in her 1967 *Collected Poems*. Ben Lerner, in his recent *Hatred of Poetry*, which takes its title from her poem, relates that he learned of the poem from his ninth-grade English teacher, who recommended it as the shortest poem she knew.[15] Lerner notes in passing that the poem has more than one version, but he only cites the shorter version. The last line of the 1925 thirteen-line version—not included in either the 1919 version or the 1967 version—might be particularly pertinent to Lerner's argument:

> It may be said of all of us
> That we do not admire what we cannot understand;
> enigmas are not poetry.[16]

Much of Lerner's case for why people hate poetry is based on the notion that it is too difficult for the average reader in Topeka, and Moore may agree.

Some early commentators on the 1967 version of the poem took it to be a clever joke, especially given that a thirty-two-line version appeared in the notes. Most anthologies continue to include one, but not both, of these versions.[17] Of the poem's multiple versions, Hugh Kenner wrote: "is it a text or a process … ? Has a text ever before become a footnote to an excerpt from itself?"[18] Anthony Hecht noted that Moore's "most widely anthologized poem … has been studied and taught to death, and the present [1967] version may be her wry comment on this."[19] As with other cases of literary redaction, the text that is erased continues to comment on the text that remains. "Poetry" operates almost like a puzzle in set theory: its multiple versions suggest that poetry is composed and recomposed of ever-shifting fragments of language. There are poems within poems, and enigmas within enigmas—although for many the poem has been fully reduced to the meme of its first line.

Imagism had already exhausted itself by the time of the initial publication of Moore's "Poetry," and the -isms that followed imagism—vorticism, Dadaism, surrealism—were considerably more radical in their juxtaposition of text and image (or text-as-image). Writers like e. e. cummings were able to divide the word up into letters and fragments; meanwhile, Abraham Lincoln Gillespie, Eugene Jolas, and James Joyce attempted to create supranational languages by way of the portmanteau. The most ambitious such attempt, Joyce's *Finnegans Wake*, is composed of words derived from as many as sixty to seventy languages. The ten one-hundred-letter thunder words of *Finnegans Wake*, in particular, may have been a high water mark for the fusion of the word.[20] Though its composition overlapped with the first generation of objectivist writing, the expansive, dreamy poetics of *Finnegans Wake* were very much the antithesis of the sparse,

sober writing of Louis Zukofsky, George Oppen, and Lorine Niedecker. These writers were also inspired by the example of William Carlos Williams, whose poetry "out of the mouths of Polish mothers" offered an American plain style in response to the elevated expatriatism of Pound and Eliot.[21]

Williams's "Red Wheelbarrow," "This Is Just to Say," and "The Locust Tree in Flower" convincingly demonstrate the power of short domestic lyrics to enter the literary canon. Even if these poems are not minimal in the postwar sense, they deploy a new sense of the line, which could now be as short as a single word. "The Red Wheelbarrow" is eight lines: four three-word lines and four one-word lines, which alternate. The second version of the "Locust Tree in Flower" consists of thirteen one-word lines—drastically reduced from the twenty-four lines of the original version, which was published in the same volume, *An Early Martyr*. Curiously, the shorter second version was published immediately preceding the longer first version—presenting the reader with the redacted version first (which includes only words derived from the original version).[22]

Williams's short poems have had remarkable afterlives as memes, and even as bots, that testify powerfully to the importance of remediation in the transmission of minimal poetic texts. In the predigital era, Charles Demuth and Robert Indiana recognized that Williams's short poems could be adapted into visual works. In the internet era, countless variations have been generated. A recent *New York Magazine* think piece is revealingly titled, "This Is Just to Say I Have Written a Blog Post Explaining the Icebox-Plum Meme."[23] This rendering of the poem is indicative:

This Is Just to Say
I have written
this story
on the internet
about a poetry meme

and here
you were probably
planning
to make this joke yourself at some point

Forgive me
it is delicious
so sweet
and so dumb[24]

The new media scholar Mark Sample has even created Twitter bots to automatically generate versions of "The Red Wheelbarrow," "This Is Just to Say," and "In a Station of the Metro." As of my writing this sentence, the "This Is Just to Say" bot has generated 30,000 versions of the poem, and 1,600 followers receive a new version of the poem

every two hours. Most of these versions are grammatically correct, but more or less nonsensical in some fashion. The page's pinned tweet reflects this sense of linguistic chaos:

> I have eaten
> the horrors
> that were in
> the toilet
>
> Forgive me
> They were postmodern
> so ornamented
> and so unwavering[25]

Many of the bot-generated versions feature exotic vocabulary, in stark contrast to Williams's characteristic use of plain speech. The bots do, however, by default respect Williams's unconventional enjambment, upon which "so much depends." Hugh Kenner, in his discussion of "The Red Wheelbarrow," writes out the poem as a single line of prose in order to reveal the strangeness of Williams's syntax—as well as to demonstrate how much Williams's use of the visual space of the page contributes to the power of his shortest poems.

Deeply influenced by Pound and Williams, Louis Zukofsky's initial program for objectivism updated and revised imagism for a second generation of modernist poets, and specifically invoked a microscopic attention to detail: "*An Objective: (Optics)—The lens bringing the rays from an object to a focus. That which is aimed at.*"[26] For Zukofsky, this minute attention to observed phenomena reveals "historic and contemporary particulars."[27] The single word in isolation takes on new power in objectivism as an antidote to sentimental verbiage:

> The disadvantage of a strained metaphor is not that it is necessarily sentimental (the sentimental may at times have its positive personal qualities) but that it carries the mind to a diffuse everywhere and leaves it nowhere. One is brought back to the entirety of the single word which is in itself a relation, an implied metaphor, an arrangement, a harmony or a dissonance.
>
> The economy of presentation in writing is a reassertion of faith that the combined letters—the words—are absolute symbols for objects, states, acts, interrelations, thoughts about them. If not, why use words—new or old?[28]

Zukofsky placed an extraordinary confidence in the power of the word, and although he seems not to have fully shared Fenollosa's and Pound's confidence in the power of the Chinese character, he did believe that the shape of words and letters could relate to their meaning: "Most western poets of consequence seem constantly to communicate the letters of their alphabets as graphic representations of thought—no doubt the thought of the word influences the letters but the letters are there and seem to exude

thought."[29] Zukofsky was insistent, moreover, that the best objectivist writing would be done by "poets who see with their ears, hear with their eyes, move with their noses and speak and breathe with their feet."[30] The first part of this sentence prefigures a similar synesthetic inversion to be found in Gertrude Stein's 1946 interview with Robert Haas: "a writer should write with his eyes, and a painter paint with his ears."[31] Stein's frame of reference was more cubism than imagism—nonetheless she too saw close visual and aural observation as key to her poetics. Though Zukofsky aimed to focus attention upon the single word as much as possible, he was not averse to repetition, advising his readers: "Emphasize detail 130 times over—or there will be no poetic object."[32]

Expanding on his published definition of objectivism, Zukofsky wrote to Lorine Niedecker that

> Obj. [objectivists] go beyond the Imag. [imagists] both by their choice of subjects & by the implications which are allowed to appear from the image, the Obj. suggest the direction of the streams of objects, facts, situations, incidents, the tendency in things which we call history. And by the sequences & juxtaposition of images in their poems & by the cadences of their phrases, they suggest often their own judgment on history.[33]

Imagism, for Zukofsky, lacked in historical power because it lacked serious subject matter as well as specific particulars. The politics of 1931 were far different from those of 1913, and rather than the perspectival abstraction of cubism, Zukofsky sought a documentary poetics that would combine the power of socialist realism with the technical precision of traditional poetic and musical craftsmanship. Among the objectivists, Niedecker was perhaps the most attuned to radical compression in her poems. Her "Poet's Work" is an *ars poetica* and among her best-known poems:

> Grandfather
> advised me:
> Learn a trade
>
> I learned
> to sit at a desk
> and condense
>
> No layoff
> from this
> condensery[34]

The "condensery" refers to the milk production facilities of Niedecker's native Wisconsin, but it also describes her poetic practice. There can be no layoffs from the work of "Dichten=condensare"—just as there is no end to labor in general. Despite her tireless efforts, Niedecker, like Zukofsky, saw little remuneration for her work. Or as Niedecker put it, referring to her family and community: "What would they say if they knew / I sit

for two months on six lines / of poetry."[35] Niedecker's poem, like Gustave Flaubert's *le mot juste*, is a reminder that fewer words can often require more work to write, and that the modern author may in some cases be as much a redactor as a creator.

Charles Olson's influential 1950 essay "Projective Verse" would prove lastingly influential for visual poets in particular, and can be read as a midcentury bridge between the poetics of objectivism and those of the New American Poets. Olson's larger-than-life Maximus persona is seemingly antithetical to the aims and traits of minimalism—but Olson, in both "Projective Verse" and the later *Maximus Poems* especially, was deeply interested in some of the same considerations of scale as later minimalists. "Projective Verse" attempts nothing less than a reconsideration of the poetic line—measured not according to the metrical foot, but instead by the syllable and the unit of the breath: "Let's start from the smallest particle of all, the syllable. It is the king and pin of versification, what rules and holds together the lines, the larger forms, of a poem."[36] There is a mediatic dimension to Olson's claim as well: "What we have suffered from, is manuscript, press, the removal of verse from its producer and reproducer, the voice."[37] Paradoxically, the antidote is the typewriter, which "due to its rigidity and its space precisions ... can, for a poet, indicate exactly the breath, the pauses, the suspensions even of syllables, the juxtapositions even of parts of phrases."[38] Often when poets speak of "voice," they are referring to a particular sense of selfhood, but Olson emphasizes that speech and hearing are physical phenomena. Elsewhere he writes:

> Flow ... is not continuous "length," it is leaped atomism—quanta, jumping, like nerves in fatigue—which is rightly sought & used as a habit because it has a survival value: it is a physical memory. And physical memory & causation spring from the same root: they are both physical perceptions. A poem must do equal justice to atomism, to continuity, to causation, to memory, to perception, to quantitative as well as qualitative forms, and to extension (measurable existence in field).[39]

Olson understands poetry, and communications more generally, to be embodied phenomena. As such, he also sees them as irreducible below the unit of vitality, the breath of the individual.

A late *Maximus* poem gives a good sense for how Olson experimented with the unit of the page as well as the unit of the line (figure 5.2). The poem/page is simply one off-kilter line—"the unit the smallest there is" a line whose angle is echoed by the tilt of the poet's name. Between the line and the name is the date: July 16, 1969 (although in the parentheses the date has shifted from Wednesday to Thursday). It was a significant day: Apollo 11 had launched for the moon. The "unit"—whether it be the breath, the poet himself, the town of Gloucester (subject of his epic poem), or the planet itself—is tiny in comparison with the metaphorical space of the page as it stands in for outer space. The poem/page may also be in dialogue with Robert Creeley's *Pieces*, published in the spring of 1969 and the most minimal of Creeley's books to date. That summer Creeley was living near Gloucester in Annisquam, Massachusetts,

where, according to Robert Grenier, Creeley read the entirety of *Pieces* out loud to Olson. A piece, we might recall, is by definition a part of something else. Olson and Creeley were both experimenting with the particulate matter of language, and attempting to find a new sense of "measure" based in scientific and philosophical analogues. To do so, they explored alternatives to the traditional units of metrical verse: the foot, the line, and the stanza.

Imagism, objectivism, and projective verse did not envision that the word itself (or its component letters) could be intrinsically interesting as visual art, but concretism did. For the most part, imagism and objectivism retained traditional verse formatting on the page, whereas concretism was premised on rejecting conventional lineation. For Eugen Gomringer, "Of all poetic structures based on the word, the constellation is the simplest. It disposes its groups of words as if they were clusters of stars."[40] This notion of the poetic constellation came in response to the rise of advertising and changing patterns of global communication:

> Our languages today are in a process of formal simplification. A reduced number of minimal forms are developing. The content of a sentence is often carried by a single word, while longer statements may be broken down into groups and letters. Instead of many languages we are learning to work with a handful that are more or less universal. Does this reduction & simplification of language & writing signal the end of poetry? Reduction in the best sense—as simplicity & compression—has always been a force in poetry. It follows from this that language & poetry today have enough in common to begin to feed each other both in form & substance. Some such relationship (still largely unrecognized) is apparent all around us. Headlines, advertisements & other groupings of sounds & letters that could serve as patterns for a new poetry, are only waiting to be discovered & meaningfully applied.[41]

Recent criticism by Jamie Hilder, Marjorie Perloff, and Marvin and Ruth Sackner has done much to rescue concrete poetry from detractors' claims that it is simplistic or universalist in its embrace of reduced language.[42] As early as 1960, Haroldo de Campos defended concrete poetry against such charges, and drew upon Benoit Mandelbrot's theory (by way of Max Bense) of an informational temperature for any given text. Mandelbrot used the example of the language of children to stand for a low information temperature, and the example of James Joyce for a high information temperature. Mandelbrot limited himself to semantic or factual information, and to the question of whether words were "well employed" or "badly employed." This formulation, according to de Campos, is inadequate for concrete poetry, which "responds to a notion of literature not as *craftsmanship* but, so to speak, as *industrial* process. Its product is a prototype, not the typical handiwork of individual artistry. It tends toward a minimal, simplified language, increasingly objectified and, for that reason, easily and quickly communicated."[43] This should not lead us to the conclusion, however, that concrete poetry is simplistic. For de Campos,

> The relative intensity or weakness of temperature, separate from any aprioristic norm of merit or demerit, can be correctly approached only when it is considered as a function of the specific creative process to which it contributes. Therefore, it will be factors of an aesthetic order, and not necessarily those of an exclusively linguistic-statistical order, which will involve the need for a higher or lower proportion, a maximum and minimum, in the informational temperature of a given artistic text.[44]

Two significant points can be made here: first, concretism adopts the production methods and media formats of its epoch; and second, de Campos's invocation of "a specific creative process" can be broadly construed as suggesting that in order to appreciate and understand concrete poetry, we should do so with its specific context in mind. As Jamie Hilder writes, "The concrete poets emerged out of and in response to these shifts that allowed for greater connectivity across a reformatted globe, but that also prompted philosophical questions about how information is processed and received."[45] Gomringer himself specifically notes the influence of the telephone and the long-distance call when he speaks of "a transformation in the spirit of the times, namely the emergence of brevity: the brevity of time, the brevity of the message, the desire to become informed about a matter more quickly.... Brief poetry was to an extent conscious communication theory in order to give poetry its organic function in society."[46]

One of the earliest and most famous of concrete poems, Gomringer's "silencio" (1953), demonstrates well the difficulties of differentiating between concretism and minimalism (figure 5.3).[47] It also demonstrates the global reach that works that deploy reduced language can have. Born in Bolivia, but resident in Switzerland when the poem was written, Gomringer tapped the postwar zeitgeist perfectly with the poem, which has been compared to works that deploy or foreground silence by figures such as Paul Celan, Maurice Blanchot, and John Cage. Merely the word "silencio" spatialized and repeated a sonnet-like fourteen times, the poem has been taken as a political statement by many, particularly in its later German "schweigen" version.[48] Willard Bohn offers this perceptive reading:

> The problem with Gomringer's poem, one comes to realize, is that silence is defined as both absence and presence. In retrospect, the two semiotic systems, visual and verbal, can be seen to contradict each other. Like a drawing by Martin Escher, the work embodies two mutually incompatible perspectives. The composition appears to depict a silent center surrounded by a wall of noise.[49]

The poem's paradoxical present absence of language can be observed in other minimal poems such as "`absence of clutter`." In German in particular, the poem's one word, "schweigen," can be taken as both a noun and an imperative verb. Poet and reader could be said to be tied up in a loop of self-canceling meaning.

5.2
From Charles Olson, *The Maximus Poems*.

the unit the smallest there is

 Wed night (after 2 AM Thursday
 July 16th –
 'LXIX

 Charles Olson

"A RADIUM OF THE WORD"

silencio silencio silencio
silencio silencio silencio
silencio silencio
silencio silencio silencio
silencio silencio silencio

5.3
Eugen Gomringer, "silencio" (1953).

Like de Campos, Gomringer was adept at promoting and defending concrete poetry as an appropriate formal response to postwar mass culture. Gomringer invokes poetry's perennial interest in compression and concision, and at the same time suggests that mass culture has brought with it new contexts and conditions for poetry. Although "silencio" shuts out the noise of mass culture, many concrete poems were deeply engaged with global advertising and with the spread of linguistic and graphic standardization. Décio Pignatari's "beba coca cola" (1957), one of the most widely anthologized of all concrete poems, illustrates this well. With increasing urbanization and globalization, American brands and logos became omnipresent in the twentieth century. The commercialization of both language and public space was widely reflected across the arts, according to architectural historian Malcolm McCullough:

> Vision famously fragmented in the twentieth century, from cubist painting at its start to clickable windows by its end, yet it mostly kept its frame. Indeed, you could identify that century as the one where people sat down passively in front of framed, flickering screens. Now, as display technology diversifies in size, role, and use, visual culture is accelerating and transforming once again. The more that images diversify, proliferate, and compete, the less any one of them may succeed at capturing your attention.... Not all displays describe someplace else; sensing, networking, and embedded computing increase the capacity for displayed images to be about current conditions in their immediate surroundings.[50]

We tend to conceive of literature as inhabiting books (or more recently screens), but in the twentieth century nearly every public space became a platform for textuality—even if the vast bulk of that text would not ordinarily be construed as literary. Minimal writing offered novel ways of reframing and interpreting the logorrhea of mass culture, and one way in which it did so was to draw attention to surroundings. Signage tells us where to go, what to do and what to buy. Signage is presentist and performative, and we generally can't turn it off or exclude it from our field of vision. After he had "published" his *Sky Poems*, David Antin was asked by a TV reporter: "What's a poem?" Antin wittily replied, "A poem's a commercial that isn't selling anything."[51] In an era dominated by the imagery and textuality of mass culture, that definition seems as good as any.

6

The One-Word Poem

A really perfect poem has an infinitely small vocabulary.
Jack Spicer, "Second Letter to Federico García Lorca"

Writing in 1961, at the founding of the Oulipo (*Ouvroir de littérature potentielle*) movement, Raymond Queneau and François Le Lionnais, two of France's most significant postwar literary experimentalists, wondered to one another "how few words can make a poem?"[1] According to Le Lionnais, this question would preoccupy the two until Queneau's death fifteen years later. Even in 1976, they doubted that a poem could be constructed from fewer than several words. Perhaps because their backgrounds were not primarily in experimental poetry or postwar art (Le Lionnais was a mathematician and Queneau primarily an editor and novelist), the two oddly overlooked concrete poetry. The two also seemed unaware of the work of Aram Saroyan, whose mid-1960s poems explored and broke the limits proposed by Queneau and Le Lionnais. Though the Oulipo's founders may have been underinformed about concrete poetry (which did not have as strong a presence in France as in Latin America, German-speaking countries, or North America), their skepticism is telling: setting aside concrete poetry in the 1950s, it was not until the 1960s with the contemporaneous emergence of pop art, minimalism, and conceptual art that a single word or letter could be recognized as a poem.

The one-word poem may in fact have rapidly reached the height of its popularity in late 1967 with the final issue of Ian Hamilton Finlay's journal *Poor. Old. Tired. Horse*. In July of that year, Finlay wrote to Saroyan—then only twenty-four, but a leading practitioner of the form—that he intended to put together an entire issue of *P.O.T.H.* devoted to one-word poems:

> the idea being that the poem consists of one word and a title. These are to be thought of as 2 straight lines, which make a corner (the poems will have form); while the paradox of these corners is, that they are open in all directions. This is because we can't have whole-world poems (we haven't got one), but at the same time we should not despair of something with corners, such as making them, and opening them up.[2]

As can immediately be discerned from Finlay's letter, the rubric "one-word poem" is slightly misleading. All of the poems included in the issue featured a title, and most of the titles were longer than a single word. Following Finlay's lead, I too consider as one-word poems not merely a single word in isolation on the page, but a single word repeated per poem, as in the column version of "crickets" discussed below, or per page (or other unit of publication) that is repeated (in whole or in part) as a series. This expansive definition would include many notable concrete poems—for instance, Eugen Gomringer's "silencio" or Finlay's "ajar" or Mary Ellen Solt's "Zinnia"—and my own rough estimate is that perhaps as many as 10 percent of concrete poems are primarily constructed of a single word. Saroyan, however, understood himself to be writing not as a concrete poet, but as a minimal poet.

Perhaps the greatest influence on Saroyan's minimal poems was Louis Zukofsky, to whom Saroyan had been introduced by another strong influence, Robert Creeley, in 1964. Creeley's poems also became more minimal in the late 1960s, but never so minimal as a single word or a single word repeated. Zukofsky provided the epigraph for Saroyan's journal *Lines*, and he may have partially inspired Saroyan's "lighght," as well as his "crickets / crickets / crickets …" Saroyan wrote three distinctly different cricket poems, two of which were recorded for LP.[3] The column version of "crickets" would go on to become a signature poem of Saroyan's, as evidenced by a 1968 *Paris Review* advertisement that found Saroyan at the peak of his fame (figure 6.1). The column of "crickets" (like "not a cricket," below) should be listened to in order to be appreciated fully. In the 1967 recording, the one word is repeated by Saroyan for eighty seconds, and it evokes that of which it speaks by onomatopoeia. According to the author, the poem "was written in the spring of 1965 in an apartment building on East 45th in New York City, proving that crickets are powerful creatures, capable of penetrating New York City itself."[4] Interestingly, Saroyan repeats the word "crickets" about thirty-three times per minute—not far off from the thirty chirps per minute produced by the North American field cricket, as suggested by one website.[5] (The speed at which a cricket chirps is determined by species and temperature—it is even possible, following Dolbear's Law, to determine the temperature outdoors by counting the frequency of cricket chirps.) The poem may well have been influenced by a poem from Zukofsky's *All*, first published in 1965. Zukofsky's poem—a mere nineteen words in sixteen lines—begins with "Crickets' / thickets" and ends with "are crickets' / air" (figure 6.2).[6] Saroyan in fact recalls visiting Zukofsky with Clark Coolidge in New York City not long after the column of crickets had been published in *Lines* 6 in November 1966: "Louis mentioned the poem right away, saying something like 'Alright, but what about' and here he switched into mellifluous recitation—'crickets' / thickets // light, delight….' He didn't go on long but it was clear I had gone too far for his tastes."[7]

6.1

Advertisement for *Aram Saroyan*,
in *Paris Review* (Spring 1968).

16

Crickets'
thickets

light,
delight:

6.2
Louis Zukofsky, from "29 Songs," in
All: The Collected Short Poems (1965).

Saroyan's other two contemporaneous cricket poems play on the sonic and visual properties of the word in other ways. Also a single column, "crickets / crickess / cricksss …" removes one letter from the word for eight lines and then re-adds a letter for each line. The word "cricket" disappears and reappears visually among the additional s's. Saroyan's "not a cricket," by contrast, plays with a sonic and semantic paralipsis:

not a
cricket

ticks a
clock[8]

Although it was not written specifically for *The Dial-a-Poem Poets*, that recording is crucial to understanding the poem. Saroyan reads the poem slowly as if it were a radio or telephone announcement of the time, and "ticks a / clock" sounds very much like "six o'clock" (perhaps in reference to the iconic chimes of Big Ben that have been broadcast worldwide daily by the BBC at six o'clock since 1924). Although "ticks a" half-rhymes with "cricket," it is not the same word, as in the other "crickets" poems. Moreover, the poem plays a trick similar to Magritte's *Ceci n'est pas une pipe* or George Lakoff's *Don't Think of an Elephant*—it negatively conjures something, as if to suggest a cricket doesn't make a sound like a clock. Or perhaps there is a silence so deep that only a clock can be heard. As the first poem in a short pastoral sequence, *Sled Hill Voices*, the poem also alludes to an inside-outside scenario.[9] Most likely the poet at his typewriter is hearing sounds from inside and outside the house, and absentmindedly attempting to differentiate these sounds. The last poem in the sequence—"the noises of the garden among the noises of the room"—presents a similar perceptual scenario.

"crickets" and "not a cricket" can be usefully compared to another contemporaneous poem by Saroyan: simply the word "tick" centered on two facing pages. Like the crickets poems, it is onomatopoeic, and in fact may sound more like a clock than the conventional English "tick-tock" or the French "tic-tac" (the Italian candy, introduced in 1969, is said to have taken its name from the sound of the candies rattling in their container).[10] A clock does not have two sounds that alternate every other second; it has one. "Tick" in this context will bring a clock to mind for most readers, but here again the lack of context could be suggestive. Tick as a noun might suggest two insects. Or it might suggest another meaning of "tick" as a verb, such as to tick something off a list. Saroyan's use of the facing pages is ingenious, however, and indicates the tick as a unit of time, although the poem (as Saroyan suggested was his intent with the minimal poems) may not involve any durational reading process, as one might see both ticks stereoscopically at once. The poem originally appeared in *0 To 9* and would not have been possible to include in Saroyan's three main books of minimal poetry,

as these all had poems printed on the right-hand pages only. Saroyan's isolation of the single word had powerful effects: it denarrativized and decontextualized language, and it placed the word, typically a noun, in stark relief. In a letter which accompanied the poem, Saroyan wrote to Vito Acconci in September 1967 that

> I've discovered that the best work I can do now is to collect single words that happen to strike me and to type each one out in the center of a page. The one word isn't "mine" but the one word in the center of the page is. Electric poems I call them (in case anyone starts throwing Concrete at me)—meaning that isolated of the reading process—or that process rendered by the isolation instant—each single word is structure as "instant, simultaneous, and multiple" as electricity and/or the Present. In effect the single word is a new reading process; like electricity—instant and continuous.[11]

Multiple overlapping claims about media are embedded in this McLuhanesque reading of his own work. As Saroyan wrote elsewhere, the poems were analogous to his generation's experience of television. The one-word poem could be compared to a freeze frame—except, I might interject, that such poems typically offer an opportunity for reflection or contemplation. "tick … tick" is also an echo poem, and there is a temporality (however brief) between any two sounds that echo. According to Frank Kermode's influential *Sense of an Ending* (coincidentally also published in 1967), "*tick* is our word for a physical beginning, *tock* our word for an end. We say they differ. What enables them to be different is a special kind of middle."[12] The middle, in this case, would be the gutter of the book and the blank space of the facing pages. "The clock's *tick-tock*," for Kermode, is "a model of what we call a plot, an organization that humanizes time by giving it form; and the interval between *tock* and *tick* represents purely successive, disorganized time of the sort that we need to humanize."[13] That there is no "tock" might also suggest, in Kermode's terms, that the poem undertakes an infinite loop, and short-circuits any sense of successive time.

A useful comparison to "tick … tick" is "oxygen … oxygen," written in 1967, but not published until 1971, by which point Saroyan had given up on the format of right-hand page only. As Saroyan recalls, "It was about a year after both books [*Aram Saroyan* and *Pages*] had been published that it dawned on me with chilling clarity that the right-hand-page-only decision had the opposite of the intended effect: that instead it tended to prompt the reader to turn the page, indeed, created a new kind of narrative momentum."[14] When I first encountered this observation, I was somewhat surprised, as I had read most of Saroyan's poems for the first time in the facing-page *Complete Minimal Poems*. When I became more interested in his work, I acquired the right-hand-page versions, and I had the opposite reaction from the one Saroyan describes. The single word in the blank space of two 8.5" × 11" pages invited me to contemplate the poems as art, and I sensed that I moved more slowly from one poem to the next. Reading speed is difficult to measure, and Saroyan's view was likely influenced by how people read the poems in bookstores (rather than buying the book) or by Edwin Newman's 1968 reading of the entirety of *Aram Saroyan* on the *NBC Evening News*.

Complicating matters, Saroyan has an earlier "oxygen" poem in *coffee coffee* that is centered on a right-hand page only, and another "oxygen" poem on a verso page that faces the word "gum" on the recto page.[15] The two facing-page oxygen poems I (semiseriously) refer to as "dioxide"—but one might also note that oxygen is diatomic, and what we conventionally call oxygen is in fact the homonuclear molecule O_2. Oxygen is the most plentiful element on earth, and yet we cannot see, touch, or feel it. Centered in the middle of the page, the single word "oxygen" is almost like a blank page in its invocation of a ubiquitous unseeable substance. Like "tick ... tick," the facing-page "oxygen" poems frustrate any conventional sequentiality. Writing to Saroyan in 1967 in response to the poem, his close friend Clark Coolidge was skeptical that "oxygen ... oxygen" in fact lived up to Saroyan's claims that it thwarted the reading process entirely: "'oxygen/oxygen is a split-second continuously.' sounds to me like you're trying to stop or suspend time here on page (?) That one page with repeated same-word = time being 'all there' or a solid unchanging substance? I don't think so ..."[16] Coolidge may be right that the poem does not entirely "stop or suspend time," but he seemingly overlooks the paradoxical "split-second continuously" formulation, which suggests an interval, however brief. Coolidge experimented extensively with minimal writing in the mid-1960s, but moved definitively toward a maximal style by the early 70s. As he was to remark in his 1977 talk "Arrangement": "when I was living in Cambridge in the same house with Aram Saroyan, and he was writing these one-word poems, dividing everything down to the smallest possible thing, as I was talking about, and I immediately wanted to put them together. I couldn't stand the idea of one word. I don't think there *is* one word."[17]

Saroyan's version of minimal writing energized not only Coolidge but also Vito Acconci to turn in the opposite direction, toward a maximal style that likewise can present extreme difficulties of interpretation. Acconci's late-60s writing included in *0 To 9* especially emphasizes the contrasting styles. "tick ... tick" is in fact embedded within a long and elaborate Acconci poem called "ON" that took up much of issue 3 of *0 To 9*.[18] Acconci describes his all-or-nothing reaction to Saroyan's poems:

> In the late Sixties, when I called myself a poet, Aram was the poet I envied. Because you couldn't be sure if he was fooling or if he had really gotten to all there is to get. Because while the rest of us tried to be verbs, like everybody told us to do, he had the nerve to stop at nouns. Because he took a deep breath and willed himself into the self-confidence of naming. Because it wasn't "nouns," it was "noun," only one noun, because he boiled it all down to one. Because then he let himself go, he let himself stutter, he let the one go and let the one double and go out of focus: while the rest of us ran for our lives all over the place and over the page, his noun shimmered and breathed and trembled and moved—shh! softly, softly—from within.[19]

6.3
Aram Saroyan, *lighght*. Silkscreen poster printed by Brice Marden, 29" × 26", 1966.

As Acconci well knew, many of the one-word poems were the result of felicitous typos or language appropriated from the ambient surroundings; and in fact, in many cases Saroyan's method of appropriating text and sound was similar to Acconci's, although Saroyan worked in smaller units. But Acconci also ascribed to Saroyan's writing a powerful interiority because he attempted to avoid such interiority in his own dense, informatic writing of the late 1960s and early 70s.

Many of Saroyan's poems have a more interesting media history than is generally recognized. Saroyan's most famous one-word poem, "lighght," for instance, became famous (or infamous) several years after it was in written in the fall of 1965, and was first published as a 24" × 36" poster by Brice Marden in early 1966. As part of a set of five Electric Poems posters, *lighght* (the title is italicized when it is considered as an artwork) was printed in yellow, as if to suggest sunlight (figure 6.3). Around the same time, it was printed in red in Saroyan's self-published *Works*, which contained twenty-four minimal poems. It was not until 1970 that the poem was to gain widespread notoriety, when Congressman William Scherle decried the poem on the floor of Congress, noting that the National Endowment for the Arts had spent $107 per letter on the poem. In retrospect, the controversy over "lighght" was an opening salvo in the battle over NEA funding that continues to this day.[20] As in the reaction to so many works of avant-garde and minimal art, the resistance to this work lay in the supposed lack of skill or effort to create it. Although he had not yet read Marshall McLuhan when he wrote the poem, Saroyan drew on McLuhan in offering a reading of the poem:

> Why only a single word—and a misspelled word at that? Let me stick with McLuhan, who wrote that the electric-television era of communication has three fundamental characteristics: (1) It is instant. 2) It is simultaneous. 3) It is multiple.
>
> A one-word poem is, in its own way, a structure that embodies all of McLuhan's essential characteristics and hence reflects the unique reality of the time during which it was made.[21]

This mediacentric autocritique shares much in common with Saroyan's statement (quoted in my introduction) for the Solt anthology.[22] Saroyan seems to allude to the opening pages of *Understanding Media* in which McLuhan claims, "The electric light is pure information," and that "the 'message' of any medium or technology is the change of scale or pace or pattern that it introduces in human affairs."[23] McLuhan's media-deterministic account of television and global telecommunication is in many respects a good fit for a defense of minimalism, particularly given that McLuhan emphasizes scale and speed as important components of communication and expression.

But "lighght" may not be as void of content as it first appears. The poem may look like a felicitous typo (like "eyeye"), but the poem was not the result of an accident.[24] One possible inspiration for the poem might even have been Zukofsky's "crickets' / thickets // light / delight" (figure 6.2). In the version of that poem published in 1965, the words "light" and "delight" align vertically so that if one were to delete the "deli," the

6.4
"Lucy. Lucy." from Aram Saroyan, *Words & Photographs*, 1970.

result could be "lighght." Saroyan himself has suggested some possible implications of his poem, claiming, for instance, that the effect of the poem is "to render light itself more palpable, as if the word holds the phenomenon."[25] A number of commentators have noted that the poem evokes vibrating light waves. "Light" can be a noun, verb, or adjective in English. The extra "gh" is unpronounceable and intangible. Or perhaps one might elongate the word and stretch out the *i* sound. In practice, I've generally heard the poem read aloud as a list of letters, L-I-G-H-G-H-T, rather than as a single syllable—thus turning the poem into seven syllables.

Saroyan conceived his one-word poems as being fundamentally photographic, as his 1970 *Words & Photographs* made more clear than the earlier minimal books.[26] Having worked as photographer Richard Avedon's assistant as a high school student, Saroyan in this book juxtaposed verso poems with recto photographs.[27] Like much of Saroyan's later work, *Words & Photographs* is largely autobiographical and begins with photographs of his family. The first image/poem in the book is of his sister (figure 6.4), whose name, Lucy, is cognate with "light." The back-cover text seemingly alludes to this when it claims: "The combination of photo and poem is at times haunting and cryptic, at times witty, and always lucid." Unlike his more austere earlier one-word poems, the poems in *Words & Photographs* are each punctuated with periods, as if to create a one-to-one mimetic correspondence of word and image. In common with many one-word poems, the text is effectively metonymic—metaphor and narrative are precluded. The centered text on the left page symmetrically mirrors the image on the right, and the repetition gives the sense of an infinite echo.

Not all of Saroyan's minimal poems were so austerely black and white as they are in his early books or in *Complete Minimal Poems*. Produced in the summer of 1965, *TOP* (spoiler alert) consists of the title and a single word that can be difficult to distinguish at first (and thus *TOP* seems to qualify as a one-word poem, according to Finlay's definition) (figure 6.5). The one word, which never appears all at once on any single panel, is simply "GOING." *TOP* is almost a work of op art in its deployment of the diamond shape of a spinning top. Its use of the stencil form gives the panels an almost militaristic sensibility, and a number of the panels contain only *O*'s and *I*'s, which in the stencil format can easily be seen as zeros and ones, suggesting binary code. *TOP*'s spatial deployment of letters and colors is ingenious: the center panel of the front (or top) side consists only of red O's (or zeros), as if to suggest that the top has reached maximum speed and has become blurred in our vision. I included a spoiler alert above because I think *TOP* should be read with fresh eyes in order to be appreciated, as there is generally a delay between a reader's apprehension of the letterforms on the page and recognition of the specific word. The poem can't help but invoke the cliché of "going, going, gone," and even if it only takes thirty seconds to cognize "going," that delay will almost surely be a component of a reading process that all too soon will be gone.

It is difficult to gauge the immediate impact of Saroyan's one-word poems, but one comical parody or offshoot was the Dave Morice/Joyce Holland–edited journal *Matchbook: Magazine of 1-Word Poetry* (figure 6.6), to which Saroyan was a contributor.[28] Made out of found matchbooks and one-inch-square pieces of paper inserted in place of matches, each installment included nine poems. According to Richard Kostelanetz, Morice created the persona of Joyce Holland, "whose specialty was minimal poems," as a parody of Morice's own "garrulous predisposition."[29] The pseudonym seems to have been largely transparent to those in the Iowa Writers' Workshop community, and both names could sometimes be found in the same publication.[30] The poems in *Matchbook* were occasional in every sense, and even Saroyan's own contribution—"puppy?" (figure 6.7)—seemed to play on the cuteness of the undertaking.[31] Allen Ginsberg contributed the word "apocatastasis" (which for some reason was not included in his *Collected Poems*). Other contributions were bawdy or even homoerotic, as in the case of Kenward Elmslie's "one word trilogy," which took up three pages: "shy // boy // sex."[32] The poems in *Matchbook* were unapologetically opuscular, and presumably not meant to be taken too seriously. *Matchbook*'s 1972–1973 run may, however, have indicated a high-water mark for first-generation minimal poetry. Many of *Matchbook*'s contributors (Barrett Watten, Bob Perelman, Barbara Baracks, Ron Silliman, Bruce Andrews) would go on to be associated with Language writing, and the constraint of the single word was difficult to harness to the growing politicization of the writing scene in the later 1970s.[33] It could also be the case that the matchbook as a publication platform lent itself to the trivial and comical, whereas Saroyan's minimal poems were more varied in their content and in their use of media.

By the time Morice was publishing *Matchbook*, Saroyan had largely moved on from the one-word poem. Toward the end of Saroyan's minimal phase, in late 1967 and early 1968, his writing became sparser and more conceptual. The transition is apparent in *0 To 9* issue 3, discussed above, which was published in February 1968. But it is even more apparent in ©*1968*—or *Ream*—conceived in late 1967 and realized in early 1968. Merely a blank 500-page ream of paper, ©*1968* might also be read as a one-word poem whose one word is implied but never directly stated. As a farewell to minimal poetry, the gesture could hardly be more perfect. ©*1968*, about which Craig Dworkin writes extensively in *No Medium*, adopts the standard medium of the typewriter, while seemingly rejecting content altogether.[34] The scale of the ream is infinitely out of proportion to its contents—and yet ©*1968* can be understood as a sculptural object as well as a work of conceptual literature. The title makes the object Saroyan's intellectual property, and yet there is nothing to protect. The author's assertion of rights mocks an entire system of authorship at the same time that it reinscribes it by including only the author's name and copyright. The blank pages could be the potential work of everyone and no one—except for the simple assertion of Saroyan's role.

Saroyan's minimal poems offer a loving parody of both fame and the graphomania that often accompanies literary fame. At the same time that Saroyan was assembling his three main collections of minimal poems, a remarkable cultural development was taking place:

> while you can't tell exactly when graffiti started, we're able to put a fairly accurate date on when it changed in a way that would transform city life, public transit, public art, and ultimately visual art the world over. In Philadelphia and New York City, roughly contemporaneous with the 1967 Summer of Love, was when graffiti began to change: The idea became to write your name or moniker all over the city, in a stylish way, again and again and again, with a goal of street fame and self-expression. That same basic idea basically defines modern graffiti.[35]

There is no direct relation between Saroyan's practices and those of graffiti writers, nor is there any indication that Saroyan was aware of graffiti at the time. But a loose comparison can be suggestive: both Saroyan and the graffiti writers were engaged in more or less noncommercial art practices. The book *Aram Saroyan*, not unlike a graffiti tag, established his name within a subculture—in part by refusing The Great American Novel type of book that might be expected of the son of a famous writer whose fame had faded, but whose life remained defined by an extreme dedication to his writing.[36] The younger Saroyan had seen up close the effects of fame all his life, and in the spring of 1967, the interview of Jack Kerouac that he conducted, with Ted Berrigan and Duncan McNaughton, offered a particularly strong cautionary tale.[37] Not long after, Saroyan auditioned for the lead role in Mike Nichols's *The Graduate*, but walked away in order to pursue his writing. The minimal poems were, in their way, the ultimate renunciation of the role of author as oracle and performer. For Dworkin, Saroyan's early books can be read "as scenes in a sorry family drama," and yet "each of these early books asserts Aram Saroyan's own right to be identified with the typewriter, however long the shadow cast by his celebrity father's own identification with the machine."[38] "[F]or all their whimsical irony," Dworkin concludes, "the critiques [these books] wager are bought at the cost of insisting on literary value, not negating it."[39]

A little known 1971 poem (not collected in *The Complete Minimal Poems*) gives a good sense for how the one-word poem can be both banal and profound (figure 6.8).[40] The poem is simply the eight letters of the word "activity" repeated eight times (possibly vaguely evoking the Beatles' song "Eight Days a Week").[41] Like the obsessive repetitive emptiness of Vito Acconci's "Read This Word" or Hanne Darboven's "Words," the poem goes nowhere and everywhere. Life itself can be described as an activity—or it could be described as the sum of our activities. "Activity" is a measure of vitality, but "activities" in the plural can suggest a routinization or lack of differentiation, as in a sentence like "I can hardly keep up with all of my child's activities." The repeated "activity" invites metonymic substitution: the poem could be rewritten as "writing / sleeping / smoking / seeing," etc.—although for me the poem would seem to ask to be read

6.5

Aram Saroyan, *TOP*, accordion book, 8.5" x 11", 1965.

6.6

Matchbook: magazine of 1-word poetry,
No. A (1972).

6.7
Aram Saroyan, "puppy?,"
Matchbook: magazine of 1-word poetry,
Nos. E/H [double issue] (1973?).

```
activity
activity
activity
activity
activity
activity
activity
activity

            —aram
              saroyan
```

6.8
Aram Saroyan, "activity," 1971.

self-reflexively as a commentary on the activity of writing. As someone who writes and who studies writers, I often wonder why writers write so much. In many cases, the activity itself must give satisfaction, since conventional utilitarian considerations cannot possibly pertain. In other cases, the activity must seem like an onerous burden. The one-word poem inverts the graphomanic impulse—but it also plunges us into an abyss of linguistic vagueness, jolting us from a passivity in which we suppress the mysteriousness of language: where letters disappear into words and words disappear into sentences and sentences disappear into books and books consume their authors. Here, for the active reader, that process might be reversible.

7

The Transreal

Norman Pritchard may have been the most formally innovative visual poet in New York City in the late 1960s and early 70s, and yet he largely vanished from the literary scene after publishing two exceptional books, and did not publish at all for the last two decades of his life. His work has enjoyed a recent revival, but much remains unknown about Pritchard, and what follows here is only an introductory account of his late "transreal" writing, which is uniquely extreme in its ambitious attempt to transcend standard syntax, spelling, and discursive meaning.

Pritchard's work, especially his later transreal work, defies categorization. He is sometimes described as a concrete poet, but he could also be described as a sound poet, and he presented his poetry in conjunction with his photography and even his own paintings. A member of the Umbra group, he went on after the group's dissolution to become closely involved in the New York intermedia art, music, and film scenes in the late 1960s.[1] Pritchard did not, so far as I am aware, describe himself as a minimalist, and yet he traveled in the same circles. He collaborated with the minimalist composer James Tenney around the same time that Tenney worked with Alison Knowles to realize *The House of Dust*. It is intriguing to note that he was almost an exact contemporary of the black minimalist composer Julius Eastman, who similarly abandoned the downtown New York scene to die in obscurity at a comparatively young age—only to have his work celebrated posthumously.

Pritchard's work became increasingly minimal until the point at which he stopped publishing. But he seems to have been less interested in the industrial or technological aspects of minimalist seriality than he was in spiritualism and theosophy, and he could somewhat reductively be described as a nature poet, as many of his poems have bucolic settings. Yet his work resists many of the associations we commonly have with nature poetry: the work is minimalist in its aesthetic on the page, and it is incantatory when read aloud. It is to be hoped that more recordings of Pritchard will surface or be made available to the public—in the meantime, readers new to Pritchard would be well advised to listen to his extraordinary rendition of "Gyre's Galax" from the 1967 LP *New Jazz Poets*. As Lillian-Yvonne Bertram writes perceptively,

7.1
From Norman Pritchard, *EECCHHOOEESS* [Daniela Gioseffi copy, Poets House Library], 1971.

no attempt to "read" Pritchard's texts can be fully satisfactory or representative without experiencing its sounds. While Pritchard does not write in what would have then been considered the African-American dialect or Black English that, at the height of the Black Arts Movement and Black Power, would have been in heavy circulation by a good number of African-American writers, there is a case to be made for Pritchard (like [Charles W.] Chesnutt) graphically representing the words as they sound, as in his use of "thru," "ajourn," and "accuring."

My own experience of reading the text was agonizingly slow, a process of reading and sounding out that emphasized the differences between what you see and what you hear, and how you hear what you see. It is also a process that involves the reader in speaking into existence the very elements that are at play—the earth, or an ear, for example.[2]

Bertram's description of the sonic and visual complexity of Pritchard's work suggests, in part, why his work has proven so resistant to criticism. Pritchard was fascinated by the "very elements" of perception and representation, and to an uninitiated reader his poetry can seem at one extreme radically simplistic and, at the other, radically hermetic.

Pritchard, who studied art history at NYU and Columbia, was keenly aware of the visual aspects of his work. His books must have been exceptionally challenging to design and publish in the predigital era, and Pritchard himself routinely hand-colored copies of the books to give to friends and colleagues. One of the most unique visual characteristics of Pritchard's books is their use of the entire space of the page, without any margins, often making the ink of the poems visible on the page edges. Many of Pritchard's letterforms were hand drawn, and he often squeezed text even into the gutters of his books. In Pritchard's second book, *EECCHHOOEESS*, nearly every aspect of the book is doubled or mirrored—from the letters in the title to the full pages of zeros and ones interspersed throughout. The book opens with the poem "FR / OG" (as its title is listed in the table of contents). For ten pages, "FR / OG" features a vertical column on each page, which consists of either "as" or "as a" and then intersperses other words to the right of each column (figure 7.1). In its seriality, the poem is onomatopoeic when read aloud, and recalls both the print version and the recording of Aram Saroyan's single-column "crickets," a poem it would have been nearly impossible for Pritchard not to have seen or heard. Frogs eat crickets, we might recall, even though Pritchard does not ever directly mention Saroyan.

Pritchard's "Hoom, a short story" is a good place to begin to get a sense of the visual complexity of his work. The title page (figure 7.2) might at first appear to read "WHOO" or by an optical illusion even to be "WHOOM."[3] One might "translate" or "recompress" the text of the right-hand page as:

> what claim of will did defend its perch with eyes and skies to footer gain searching through the plains of mist remaining quiet lyre regaining might thee be if wat was said should spread of light if lifting grim to heights of bright brou brou brou brou brou brou brou brou brou brou brou brought back again the dirth of shall shall we come kind pilgrim put upon by some odd star and farther then strove oft to sing the quest of light the truth to bring

THE TRANSREAL

7.2
Norman Pritchard, "Hoom, a short story," 1970.

Any such transcription of Pritchard's poem oversimplifies the original, and it could be argued that such a transcription is an entirely different poem. The exercise might help, however, to reveal the patterns of repetition and seriality that underlie much of his work. Many of Pritchard's poems exist in two published versions—one conventionally spaced and another with elongated spacing.[4] The irregular spacing of words and the splitting and fusing of words are common to Pritchard's mature practice. In the case of the page just quoted, Pritchard published an alternate version in *The Matrix* titled "The Harkening." Although the two versions are similar semantically, the spacing is very different, with words split in varying places. Based on Pritchard's own dating, "The Harkening" (figure 7.3) should be the earlier text (it is included in the 1965–1967 section of *The Matrix*).[5] Some features such as capitalization, the use of numerals, and the variation of words—for instance, "da" in "The Harkening" in place of "the" in "Hoom"—also suggest a nonstandard speaker of English.

In the aggregate, Pritchard's letter spacing is sublimely complex—and often mysterious. He even republished one poem, "Agon," upside down.[6] In "Hoom," some of the letters are redacted and some letters run into the gutter or margin, so it is almost impossible to know (unless more audio or video recordings surface) how this poem would have sounded when read aloud. The poem, in effect, stutters its way through a dozen iterations of "brou" before it comes to "brought." The elevated diction becomes more apparent when the elongated spacing is removed, but the poem still seems to lack a narrative structure that would qualify it as the "short story" promised by its subtitle. In reworking the text, Pritchard changed little about the ostensible "content," but he framed the two versions differently, and added the "brou brou brou" stuttering effect, almost as if to indicate he was having difficulty updating and editing his own work.

Above the text of "Hoom" on the right is Pritchard's signature motif: the circle or sphere (see figure 7.2). In the earliest critical account of his work, Kevin Young observes that "throughout the text of *The Matrix*, the O's have it. The zero-like and anti- and ante-mimetic 'Wreath' also doubles as the typographical representation of nothing (zerO) and the primal poetic mOan ("oh")."[7] The first poem in *The Matrix* is, as Young notes, merely a circle with the title "Wreath." The circle was the sign of the "transreal" for Pritchard, as he notes in a 1969 letter to Ishmael Reed: "Transreal is a word which visited me in the fall of 1967 while making initial probes into a book which I call Origins: A Contribution to the Monophysiticy of Form. My 'definition' is: Transrealism = O."[8] Given that Pritchard's transreal is without singular definition, the critic's role may merely be to note some of the possible implications of the circle motif as it relates to the transreal. The circle is transcendental, as in Empedocles' "God is a circle whose circumference is everywhere but whose center is nowhere." The circle is also the emptiness of the void. It is the zero and the letter O, and possibly by extension the chemical symbol for oxygen.[9] The "transreal" also seemed to signify radical collaboration for Pritchard, who throughout the early 1970s led a series of "transreal workshops," as well as hosting

"transreal awakenings." In March 1972, for instance, an event called "The End of Intelligent Writing: A Transreal Awakening" was held in New York City featuring local luminaries such as Vito Acconci, W. Bliem Kern, Richard Kostelanetz, and even the satirist P. J. O'Rourke.[10]

The title "Hoom" could refer to an archaic spelling of "home," as in Chaucer's General Prologue to *The Canterbury Tales*. Possibly the title could also refer to the two places Pritchard seemed to consider home—Martha's Vineyard and New York City—which are listed as the places of composition at the end of "Hoom." The word "hoom" is also likely a sort of neologism suggesting a lost language or a language that can only be partially understood through fragments of undifferentiated words. It might also allude to hoodoo and to hoodoo man, or could possibly suggest a contraction of hoodooism (Ishmael Reed mentions his term "neo-hoodooism" in the introduction to *19 Necromancers from Now*). As his friend and fellow Umbra member Lorenzo Thomas wrote of his work, Pritchard "investigated the underpinnings of 'Black English' before most of us even understood the significance of the term. Pritchard's early experiments, which were to lead to a 'transrealism' that resembles concrete poetry, resulted in poems written in tampered English in which the combination of sounds approximated vocal styles and tones of African languages."[11] Note here the syncretism of standard English, Black English, and African languages, as well as how Pritchard uses both visual and sonic means to conjure ancestral and futuristic fragments of language.

The word "hoom" also appears once in the poem "PASSAGE" from *The Matrix* (figure 7.4). The most striking aspect of "PASSAGE" is its use of the book's gutter to allude to the Middle Passage. The poem can't help but be read in juxtaposition with the poem on the facing page, "Silhouette." The two poems are densely laden with half-rhymes ("condemns" / "amend" // "shame" / "disdain") and internal rhymes ("ravaged" / "scavaged"), and their emotional register is violent in the extreme. The unnamed collective protagonists of the poems are "held fast to each shore." As "PASSAGE" progresses, they seem to become resigned to the "shame" and "rage" that they feel toward those who "taunted them with treacherous eyes." The poem ends ambiguously with the line "though bowed them they to hoom passed," and it is difficult again to know specifically what "hoom" refers to in this context. The bowing would seem to indicate supplication and resignation, but the "though" would seem to suggest a contrast. One way to read the poem might be to think of it in terms of a master-slave dialectic. The Middle Passage altered the worlds of both those who were enslaved and those who enslaved. The passage, once being made, is impossible to reverse—the ambiguous pronouns of the poems suggest that all parties are debased, even if all are not complicit.

The title page of "Hoom, a short story" is immediately followed by a complete page consisting only of the letters *s* and *h* (figure 7.5). One way to read the page is as a continuation from the first page: "WHOO … sh …" Another possibility is to take the entire pages of *s-h*'s to signify a silencing that nonetheless remains vaguely audible.

THE HARKENING

```
W  hA  t  c  la  im  o  fw  i  ll
d  id  d  efe  nd  i  ts  pe  rch
sear  chin  g  th  rough  d  plai  ns  of  m  ist
rem  ain  ing  q  uie  tl  y
r  eg  a  in  in  g
m  ig  h  t
t  hee
be
if  wha  t  wa  s  sai  d  shoul  d
spr  ead  o  f  l  i  g  h  t
lif  ting  g  rim  2  h  eig  hts  of  b  right
b  r  ought  b  ack  a  g  ain
da

Or it would be possible to read the page as a sound poem. How might Pritchard have read a line of forty *h*'s in a row? Unless a recording of Pritchard reading the poem miraculously appears, we may never know. It may be that this page is impossible to read aloud; it might also be the case that the page is simply an onomatopoeic representation of the sound of the ocean. Jack Kerouac's *Big Sur* attempts similarly to employ "sh" sounds in order to approximate the sound of the ocean:

... The sea is We—
   Parle, parle, boom the
   earth—Arree—Shaw,
   Sho, Shoosh, flut
   ravad, tapavada pow,
   coof, loof, roof,—
      No,no,no,no,no,no,no—
      Oh ya, ya, ya, yo, yair—
   Shhh—[12]

Like Kerouac's, Pritchard's beachside sojourn seems to have been a fraught one. The long poem "N OCTUR N" also features coastal settings, and Anthony Reed plausibly suggests that the poem "evokes both alcoholism and the Middle Passage."[13] The summer of 1969, we might recall, was an eventful one, particularly on Martha's Vineyard, where Pritchard was composing "Hoom." On July 18, Senator Ted Kennedy drove off the bridge connecting Edgartown (where Pritchard was living) to the town of Chappaquiddick, killing his companion, Mary Jo Kopechne. Kennedy was silent about the accident for ten hours. Two days later, on July 20, Apollo 11 landed on the moon.

   It is difficult to say to what extent "Hoom" is a short story or in what sense it was intended to be narrative fiction. Letters to Ishmael Reed during this period reveal that Pritchard was under the impression that the collection *19 Necromancers from Now* would contain only fiction, and Pritchard seems to have largely put "Hoom" together by rewriting previously published material. Ultimately, the genre distinction probably meant little to Pritchard, since for him the "transreal" seems to have transcended genre. Compiling materials for a transreal anthology that was never realized, Pritchard wrote to Reed in 1970: "The forms of the contributions include poetry, prose poetry, prose, plays, dances and transrealist texts, which are usually rendered in the form of an oracular diagram."[14] Pritchard was unable to find a publisher for his novel *Mundus* (likely completed in 1967), and he grew increasingly frustrated with editors and readers who were unsympathetic to his work.[15] In 1968, Pritchard wrote to Reed: "Oddly seem to be getting away from a literary outlook on life seem to be tending more toward a type of theosophical inquiry which of course began to manifest itself in Mundus but now appears to be pervading my being. Literature in and of itself doesn't seem to have a broad enough scope for me any more, can't take criticism very seriously for I feel it

to be a sort of bastardized philosophy written for the most part by people who would have better invested their time in advertising or street cleaning or some such activity of the shoulders."[16] Elsewhere in the letter he wrote: "I seem to be becoming even more of a hermit."[17] Pritchard's growing distance from the literary scene apparently compounded his difficulties in finding an audience, but he seems to have been ambivalent about fame and recognition all along. As Reed was to write in his biography for *19 Necromancers from Now*: "When asked his own definition of poetry, N. H. Pritchard uttered guttural, bestial primitive grunts and groans. Through his intuitive, visionary work, N. H. Pritchard attempts to put together fragments of a lost primordial poetry."[18]

Pritchard's deep spiritualism, about which much remains unknown, has proven particularly difficult for readers and critics to access. Lorenzo Thomas, Anthony Reed, Aldon Nielsen, and Lillian-Yvonne Bertram are entirely correct to suggest that Pritchard's poetics have much to do with a black poetics of "broken witness," but critics have had little to say about Pritchard's theosophical and philosophical inquiries. Anthony Reed's analysis is indicative of this difficulty: "If Pritchard's work does uncover and deploy African retentions, it does so without a key, making his obscure signifying practice essentially self-canceling. That sense of unsolvable enigma and antitranscendence is central to Pritchard's poetics of unsaying, through which he refigures the possibilities of poetry as an expressive act."[19] Pritchard would, I think, be sympathetic to Reed's account, except perhaps for the notion that his work is antitranscendent. In a rare unpublished video from 1981, Pritchard states forcefully: "I feel that there's only one reality, and that reality is God. Everything else is actual—or what I call 'transreal.' In other words, everything is transreal except God. 'Trans' meaning through, across, within, into within—transreality I can also say another definition is an equation."[20] Reed undertakes, with justification, to describe Pritchard's poetics in terms of "ironic materiality," and notes, "At the limit, Pritchard's self-undermining poems ask us whether poetry needs words at all."[21] Pritchard seems to have been profoundly and earnestly committed to a poetics of revelation as much as he was to a nonreferential self-canceling poetics—and perhaps those two versions of nonsignification are not at odds with one another.

**7.5 (following pages)**
From Norman Pritchard, "Hoom, a short story," 1970.

THE TRANSREAL

Pritchard's use of the codex as a platform for experimenting with the transcendental is particularly evident in his longer poem sequences, such as "VIA" (figure 7.6), the concluding section of *EECCHHOOEESS*. By eliminating every repeated word, the twenty-nine pages of "VIA" could be transcribed (or decompressed) as:

> Glistening blinks the dusk descending forums of ruined will echoing lits arkening the hush of ancient hill spilling crowds loudly acclaiming the wane like some strorm without name listlessly diminished by a sea proclaiming that empty B

Such a transcription mangles the poem, and it would be pointless to attempt to "correct" the spelling of words like "arkening" or "strorm," which are likely fragmentary by design. "VIA" echoes itself visually and sonically, as can be seen in the hand-drawn mirrored *V* and *A* of its title, which are divided by a horizontal capital *I* that at first looks more like a minus sign. To be reductive in the extreme, "VIA" is a sunset poem. But it is also much more, thanks to Pritchard's remarkable use of the page and the codex as a unit. An entire page filled simply with the word "crowds" is indicative of his ingenuity: as both noun and verb, "crowds" enacts the very crowding of which it speaks (figure 7.7).

Two more examples of Pritchard's "transreal" poems reveal the trajectory of his practice as he gradually left behind semantic representation. The poem titled only "@" (in the book's table of contents) can be read as "atom" or "@Om," as in the sacred sound and spiritual icon of the Hindu religion (figure 7.8). In a 1971 letter to Ishmael Reed, Pritchard mentions that he is working on a third book, titled *Spheres*, which would have been a fitting tribute to his fascination with the cosmological significance of the circle. In this context, his use of the @ sign was prophetic.[22] The @ sign had originally stood for "at a rate of" for commercial transactions, but in 1971 Ray Tomlinson was to introduce the @ sign as a universal locator for all email addresses. In a manner of speaking, all humans are @ Earth, and all matter is composed of atoms. The small *m* in "@"—which is slightly below the center of the circle—seems to suggest this microcosm/macrocosm interplay, and would also seem to mirror the small *a* at the center of the @ sign. The poem could also render the very structure of a hydrogen atom, with the *m* as a single proton and the @ being the one valence electron that has been excited beyond the shell.

Other late "transreal" poems are even more enigmatic. It is difficult to say if there is any title other than ":" for the transreal poem by Pritchard in Figure 7.9.[23] We could call the poem "colon" if we were to give it a semantic title. The centering of the title colon would seem to indicate an equivalence of left and right. But a colon also suggests that some sort of explanation or enumeration will follow. Rectangular in shape, the body of the poem is composed of small dots. These dots might be periods, but their wide spacing would seem to indicate that they are not colons. The dots, when looked at closely, are revealed to be hand-drawn. The body of the poem might resemble a stylized dot-matrix letter *O*, or it could resemble a zero. The poem is eighteen lines

**7.6**
Norman Pritchard, "VIA," from
*EECCHHOOEESS*, 1971.

**7.7**
Norman Pritchard, "VIA," from
*EECCHI IOOEESS*, 1971.

THE TRANSREAL

**7.8**

Norman Pritchard, "@," from *The Matrix*, 1970.

**7.9**

Norman Pritchard, ":" from *Dices or Black Bones: Black Voices of the Seventies*, 1970.

*N. H. Prichard* / **67**

long and thirty dots wide with twelve dots missing in the center—for a total of 528 dots (or 530, including the two dots of the title). The poem doesn't just "square the circle"; it is a square made of circles, at the center of which is a void. This symmetrical square of dots at first may resemble a sonnet-like poem, but it seems to be absolutely nonlinguistic—a message aimed at the beyond, perhaps. The point of all these points of ink might not be for the reader to make sense of this poem, but to leave sense behind, and to follow the poet into an infinite ellipsis of meaning that leads nowhere and everywhere.

In conclusion, transreal = O

# 8

## "Really 'Reading In'" Robert Grenier's *Sentences*

I certainly don't think of myself as a Minimalist Poet, whatever that means. I'd just like the things to stand on their own, without assumption of necessary content, or even of one person's voice or authority/authoring.... I'd really like the reader to really participate in the work, such that both make an experience. Not many poems admit of really 'reading in,' really finding something which is both there, in the words, & given to the words by the state of mind & feelings, the intelligence of the reader ...
**Robert Grenier, letter to Burroughs Mitchell, October 19, 1976**[1]

So wrote Robert Grenier to a publisher as he was nearing the completion of his 1978 *Sentences*. A work with a uniquely complex composition and publication history, *Sentences* poses a number of methodological challenges for the literary historian. Although usually categorized as an inaugural work of the Language writing movement, *Sentences* also exhibits features of minimalism and conceptualism (although Grenier, as quoted above, typically eschews such labels). *Sentences* marks a distinctive turn toward Gertrude Stein within postwar U.S. poetry, and like Stein's writing, *Sentences* foregrounds processes of perception and cognition, and tests the limits of referential ambiguity. Abandoning the codex format, the uniquely ambitious poem-in-a-box was structured to be read in any order. Following standard practice, I refer to *Sentences* in the singular, but as Bob Perelman notes, "its title is problematic—is it a singular or plural noun?"[2] In its fullest form, *Sentences* was published in an edition of 200 as a box of 500 5" x 8" index cards produced on an IBM Selectric typewriter (figures 8.1 and 8.2). *Sentences* is composed of discrete lyric poems, but it is also a work of visual art that explores fundamental phenomena of how we read, recognize, and remember poetry, whether aloud, in the mind, or on the page or screen. *Sentences*, in other words, can be read as a complex set of interactive experiments in how poetry is mediated and experienced.[3]

To an unusual degree, *Sentences* requires active participation from readers, not only to arrange its contents (sequentially or spatially), but also to provide background for poems that often have little, if any, context or explicit connection to other poems.

In Roland Barthes's terms, *Sentences* is radically "writerly"; its goal is to make the "reader no longer a consumer, but a producer of a text."[4] As Grenier continues in the same letter, "I'd like the context brought to a poem by a reader, just as particular words somehow passing through my mind at times seem significant to me. I write [poems] down, to look at them anew. The 'good' ones [are] like friends you keep coming back to, that corny."[5] The poet imagines himself here as reader to the extent that his own poems surprise him when they reappear. Moreover, the poems form a kind of community, and the poet is not ashamed if the poems, like friends, are sometimes "corny." The poems of *Sentences* are indeed often humorous in their fragmentariness. As one card that characterizes my experience of reading *Sentences* puts it, **"I've been reading to this & laughing."** If this poem worked as (presumably) intended—that is, if you got the joke—it would be what J. L. Austin terms a "performative utterance" or "performative sentence."[6] The "**reading to this**" construction is key here, and the poem would be very different if a proper name were specified (for example, "I've been reading Gertrude Stein & laughing"). The indexical "this" in the sentence could refer to anything that it is possible to read (or possibly to read along to), but in the context of the *Sentences* box, the "this" can't help but refer self-reflexively either to the card or to the box as a whole. Many readers of postmodern poetry have assumed that it is impossible to read poems such as this one closely or historically, and Barthes went so far as to wonder if "There may be nothing to say about writerly texts."[7]

**8.1 and 8.2**
Robert Grenier, *Sentences* (1978).

Both Craig Dworkin and Stephanie Burt have recently written of the phenomenon of "reading in"—or of exophora or *eisegesis* ("reading one's own ideas into a text")[8]— that can characterize the attempt to ascribe meaning to Grenier's poems. As Burt writes about a poem from Grenier's *A Day at the Beach*, "Minimalists make art in units so small, and with so few clearly separable features, that they require us to examine ourselves and to fall back on our own experience rather than looking only 'within' one work. Very short or apparently featureless works cast our attention back on the empty air, the 'negative space' on the page."[9] Similarly, Dworkin observes: "Neither merely simple descriptions of Grenier's own quotidian experience nor abstractions of sheer linguistic play, these poems advance their documentary snapshots in tandem with their material surface. Exophora in Grenier's writing emerges not in place of, but *by way* of a concurrent self-reflexive formalism."[10] This "self-reflexive formalism," I am proposing, takes place on the level of mediation as well as on the levels of syntax and content.

*Sentences* has an exceptionally well-preserved archival history, as well as an intriguing afterlife as a work that was difficult to access until a digital edition was produced in 2003. Physical copies of the box are now valuable and rare, but the original edition was priced at only $10 (about $37, adjusted for inflation).[11] Although the elegant cloth box seemed to many readers an integral feature of the project, it was something of a last-minute addition, made possible by a grant to the publisher from the National Endowment for the Arts. Early notebook drafts reveal that Grenier originally planned to sell copies for $5 in the same boxes that Oxford index cards were sold in. According to Grenier, he was "giving back to the Oxford Index Card Company the 500 cards that one bought, except w/poems on them."[12] Many Language writers, such as Lyn Hejinian and Bruce Andrews (following in the tradition of the cut-ups of Dada, John Cage, William Burroughs, and others), used collage or pastiche techniques to assemble disparate fragments into larger poems.[13] Whereas their efforts generally resulted in dense prose poetry, or verse written in long lines, Grenier's fragments are held apart by the space of the index card. In all its versions (other than the early *Sentences toward Birds* and various serial publications), *Sentences* is set in a monospaced Courier font and centered on the page (or screen).[14] As Ron Silliman noted in his 1985 *The New Sentence*—a book that positions Bay Area Language writing directly in relation to *Sentences*—"Grenier's obsessive formal concern is with balance."[15]

The format of *Sentences* offers a challenge both to the unit of the book and to the speech-based poetics of Charles Olson and the New American Poets.[16] Grenier writes in the guide to his papers at Stanford that *Sentences* is "an attempt to 'stop Time' / 'destroy the Book' in reaction to method (apparently achieved / 'over with') of Robert Creeley's beloved *Pieces*."[17] Grenier's claim that the index card format can "stop Time" may well be hyperbolic in the extreme, but as media historian Markus Krajewski writes similarly (although in more subdued terms): "Index cards owe their potential for surprise

to the reading effect. If the accumulated notes remind users of what they were thinking, and if the texts also exhibit associations and connections to the complex rest of the content, then the notes serve not only as a memory aid, but also as a comparative horizon, shifted by time."[18] Unlike pages in codex books, index cards can be reorganized and cross-referenced, and so played a central role in the storage and transmission of information from the Enlightenment to the computer era. But without an organizing schema, "In isolation, every index card is in peril of becoming a data corpse; to live it must enter into relations with the remaining content."[19] Without ordering, the index cards of *Sentences* effectively lose the informatic power of the cross-reference (and of sequential narrative). Thus, Zuzana Husárová and Nick Montfort place *Sentences* in the category of "shuffle literature," and compare *Sentences* to other combinatorial works such as Marc Saporta's 1962 *Composition No. 1* and John Cage's 1959 *Indeterminacy*. For Husárová and Montfort, works of shuffle literature, such as *Sentences*, serve "to rearrange the discourse and model processes of memory, random association, and cognition." They note further that similar unbound works can result in billions of possible arrangements or permutations.[20] Index cards also provided the basis for a number of influential conceptual artworks, such as Robert Morris's *Card File* (1962), Lucy Lippard's index card exhibition catalogs (1969–1974), Michael Harvey's *White Papers* (1971), and the Art & Language group's *Index 01* (1972) (which filled an entire room with file cabinets of index cards).[21] Such works are characteristic of what scholars such as Eve Meltzer have termed the "aesthetic of information" or the "systems aesthetic" of the 1960s and 70s.[22]

Although the well-designed 2003 web edition of *Sentences* has done much to make the poem available to a larger audience, *Sentences* is a very different work when removed from the physicality of the box and the index cards.[23] It is a more paratactic work when the box and cards are physically on a surface in front of a reader/viewer. The roughly 3,300 words of *Sentences* can be clicked through quickly, and unless one opens multiple web browsers, only one card can be viewed at a time. Though the typewriter font is approximated, much of the sense of Grenier's writing materials is lost, as is the physical heft of the six-pound box. As Grenier noted in a 1982 discussion of poems from *Sentences*, "you start writing in relation to ... writing materials."[24] With the typewritten index cards in particular, one gets a sense of Marshall McLuhan's 1964 claim (inspired by Charles Olson's "Projective Verse") that "At the typewriter, the poet commands the resources of the printing press."[25] Even though *Sentences* was offset-printed on large sheets of paper, the index cards look as if they could have come straight from the typewriter. The *Sentences* box, in other words, looks like a handmade work of conceptual art; it invites reverence and immersion on the part of the reader.

Although its component cards have no fixed order, whenever *Sentences* was read aloud, projected as slides, or selected from for journals, anthologies, or translations,

kept on going to the corner store

**8.3**
Robert Grenier, *Sentences* (1978).

certain poem-cards were given greater emphasis. In a 1981 reading with Hejinian at The Poetry Project in New York, for instance, the first poem Grenier read aloud—and subsequently read again three more times during the reading—was (figure 8.3):

`kept on going to the corner store`

Grenier's repeating the poem later in the reading helps to emphasize that the poem operates like an infinite loop. The unnamed subject or actor in the sentence is perpetually "going to the corner store," an utterly routine activity. Going to the "corner store" is typically a matter of convenience; one would generally go to the corner store to acquire a few stray items, but to a supermarket to obtain one's groceries. (In New York City, one might say: "kept on going to the bodega.") Given that this poem is not directly connected to any other poem in the sequence, how can we ascribe any greater meaning to it than any other poem? Is it rather a nonpoem, perhaps suggesting a compulsive or pointlessly single-minded behavior? In a 2006 discussion of the poem with Charles Bernstein, Grenier offers some background: "This was me when I was a kid; I liked to get popsicles, and you had to walk about two blocks to this store, and you would have this purpose in mind, and you were darned well going to get to the corner store to get that popsicle."[26] Perhaps this tidbit of information adds little to a potential reading of the poem; nonetheless, it reveals that autobiographical narratives can dwell within even the most minimal poems. Grenier continues in the same interview: "It's a complete commonplace, but if you look at it, it didn't need to happen. There was no necessity for any of it, for being alive … but you're still in that kind of amazed state which I search for. The main thing to do in my experience is to recognize that you are alive in the eyeblink in which you exist. There are these times in which you realize you exist and it's a miracle."[27]

This sense of the poem as a vitalist engagement with the present moment—of being "alive in the eyeblink"—runs through *Sentences*, and through Grenier's later color drawing poems as well.[28] Like many of the poems in *Sentences*, "`kept on going to the corner store`" constructs its own temporality—presenting an *epoché* in which background context is withheld and conventional communication is interrupted.

Patterns do emerge among the poems as they are repeated or ordered spatially, and the poet also sometimes imaginatively pairs poems within the sequence.[29] As Bernstein tells us in this same interview, the preceding poem is unofficially paired with "`walking down Washington Avenue`" (figure 8.4). Here, for the sake of demonstrating the differences between editions, I have chosen a screenshot from the web version, which presents the cards randomly in a different order each time a reader visits the site:

Here the sense is of a generic street that could be found in any American city.[30] Once again the poem has no identifiable subject, unless we assume that the poet himself is the one walking down the street. Like most of the poems in *Sentences*, it is not in fact a "complete" sentence. The collection might more accurately be called

**8.4**
Robert Grenier, *Sentences*
[web version].

*Sentence Fragments* or *Phrases* or *Parts of Sentences*. But this could also depend on how one defines a sentence.[31]

In the conventional definition, a complete sentence contains a subject and a predicate. But in a broader linguistic definition, a sentence can be merely one or more words that are grammatically linked. As they have no named subjects, "`kept on going to the corner store`" and "`walking down Washington Avenue`" qualify as the latter but not as the former. As is the case with nearly all of the poems in *Sentences*, there is no punctuation to guide our grammatical parsing.

Stein, in the "Sentences" section of *How to Write*, poses the question "What is a sentence" repeatedly, and offers multiple answers and nonanswers. "What is a sentence. A sentence is a part of speech." Or so she writes early in the book, but then seemingly contradicts herself by declaring that a sentence is made of multiple parts of speech: "A sentence is made of an article a noun a verb."[32] Elsewhere, she asks: "The great question is can you think a sentence. What is a sentence. He thought a sentence."[33] This last sentence—"He thought a sentence"—suggests that a sentence is a unit of thinking, a formulation particularly resonant in the context of *Sentences*: a notebook draft of a title page for the sequence from 1972 is even titled "SENTENCES or COMPLETE THOUGHTS."[34] A "complete thought" is one definition for a sentence, but this might depend on how one defines a "complete thought."

One of the ways in which Stein attempted to create a "continuous present" was through the use of ungrammatical constructions. As Astrid Lorange notes of this middle period of Stein's writing:

> Following *Tender Buttons*, Stein's preoccupations shifted from objects and object relations to grammar and grammatical construction. She began a thorough investigation into the functions of sentences and paragraphs, and she appraised language units according to their capacity to be interesting—a category she judged according to the potential for ambiguity. She directly associated interestingness with the likelihood of being mistaken: language is interesting if it is likely to be misrecognized, read as error, or read in error; inversely, language is uninteresting when it attempts the direct transmission of unambiguous fact.[35]

*Sentences* too is replete with ambiguity as well as with ungrammatical constructions that contain errors or unconventional locutions that invite a reader to puzzle over syntax as well as context. "Oh yes, the sentence," Grenier's close friend Creeley once told the critic Burton Hatlen, "that's what we call it when we put someone in jail."[36] The witticism implies that for Creeley the restrictions of conventional grammar were inherently confining. If so, then Grenier was something of an escape artist from the prison house of syntax. A good example of a deceptively simple ungrammatical construction from *Sentences* is:

```
nobody to talk to anything about
```

Reading quickly, I mistook this sentence for "Nobody to talk with about anything." This in itself would be an odd construction, but the syntax of the actual poem is much stranger. How does one "talk to anything"? Furthermore, the poem once again does not contain an active verb, but rather an infinitive, "to talk." "Nobody" is a negatively ambiguous construction, whereas "anything" is unrestricted in its reference. The poem seems to suggest a double absence: "[there is] nobody to talk to [and there isn't] anything [to talk] about." One might even perceive a caesura after "talk to"—perhaps suggesting that there is no one or no thing physically "about" at present.

Like Grenier's later color drawing poems, many of the poems in *Sentences* are concerned with language acquisition and with stages of cognitive development in which syntax and grammar are more fluid than for adults. An important source for *Sentences* was Grenier's daughter Amy, who was learning to talk and write during the poem's composition, which roughly spanned the years 1971 to 1978. Grenier has estimated that as many as one-sixth of the poems in *Sentences* are verbatim quotations from her.[37] By incorporating what we might call "creative syntax" in the poems, Grenier introduces phenomena of misrecognition that, in Stein's terms, create "interesting" language, and which also slow the process of reading. In both Stein and Grenier, representing objects and their formal properties through language can result in a sense of sheer joy for both writer and reader. Another ambiguous poem from *Sentences*—"I love the shapes of things"—recalls a sentence from *How to Write*: "Successions of words are so agreeable."[38] One notebook page from 1974 reads in its entirety (figure 8.5):

THE CONTINUOUS PRESENT
you have the
memory
of a flea

---

let's
make pleasure
the basis
of language

The ideal critical term for this, to quote Grenier himself, might again be "corny." Stein, of course, believed that memory was an obstacle to achieving the "continuous present," and her poetics are grounded in the pleasure of language. Absence of "definitive" or "final" meaning in Grenier and Stein is cause not for alarm, but for celebration at the ambiguities of lived experience.[39]

The draft materials in Grenier's archive reveal that his composition and selection process was considered and meticulous, and that he discarded far more poems than he included. There are a total of 905 "reject" cards; there are also roughly 35 holographic

**8.5**
Spring 1974 notebook, box 1,
Robert Grenier Papers.

notebooks preserved from the period of the composition of *Sentences*.[40] And there are dozens of poems that were published in periodicals under the rubric of *Sentences* that were not included in the final 500-card version, as well as poems that were shown as slides but never printed. It would be instructive to compile a full census of the poems intended for *Sentences*, as well as to track the revision process—but such a variorum edition of *Sentences* would be a considerable undertaking for a textual scholar.[41] Even in the absence of such exhaustive textual scholarship, however, it is possible to glean a good deal of background information about *Sentences*. The notebook draft of the following poem, for instance—

```
FORM

cherished objects dearly from a room
```

—shows that there was a subsequent version of the poem, in which "form" was substituted for "from," and that the poet reverted to the earlier version. "Form," like "rain" and "snows" and many of the other monosyllabic words of *Sentences*, can be both noun and verb. The substitution of "form" for "from" shifts the syntax of the poem considerably. The poem almost certainly alludes to Stein: both to the tripartite "Objects"/"Food"/"Rooms" structure of *Tender Buttons* and to this sentence from *The Autobiography of Alice B. Toklas*: "Gertrude Stein is awfully patient over the breaking of even her most cherished objects, it is I, I am sorry to say who usually break them."[42] By titling the poem "`FORM`," Grenier suggests a one-to-one correspondence between the "cherished objects" and the care—the "dearly" and the "cherished"—that gives a significance to the objects that does not necessarily inhere in them as objects qua objects.

Another draft, originally titled "NH," offers further insight into how Grenier drafted and then revised the poems (figure 8.6). This poem eventually was published as

```
s o m e o l d g u y s w i t h s c y t h e s
```

and with the original title (or titles) dropped. The poem, in either its one-line or three-line version, is a tongue twister, with four sibilants in five syllables. By removing the line breaks and adding a space between each letter of the poem, Grenier plays with the unit of the individual word, revealing strange patterns of spoken language—"swith" and "scythes" would seem to echo one another, for instance. And who are these old guys with scythes? Is this simply a sound poem? Or is the poet literally describing "old guys" using obsolete tools? Could these "old guys" be multiple Fathers Time? "Father Time" is a term that is not normally pluralized. "Scythes" takes the plural form awkwardly as well: the final *s* does not result in an extra syllable; it merely adds another sibilant. The poem might also be gently self-mocking if read as "so me old guy ..."

**8.6**
Notebook, box 2, Robert Grenier Papers.

**8.7**
Franconia College *Sentences* installation, 1972.
Box 20, Robert Grenier Papers.

**8.8**
Robert Grenier, *CAMBRIDGE M'ASS* (1979).

Much can be read into the ambiguous spaces of the poem, and it would look very different in a proportional font, where each letter would not occupy precisely the same space.

From early on in the *Sentences* project, Grenier paid close attention to the visual properties of the poems, and experimented with arranging them visually. In Spring 1972 he displayed a selection of the poems in the art gallery at Franconia College. Photographs reveal that Grenier affixed at least 300 of the poem-cards to the gallery wall in carefully ordered rows (figure 8.7).[43] A comparison with Grenier's 1979 poster-poem *CAMBRIDGE M'ASS* (figure 8.8) helps us to understand the development of how the poet envisioned the space of the page, as well as the space of the room.[44] *CAMBRIDGE M'ASS* features approximately 255 poems, many borrowed from *Sentences*.[45] Whereas the *Sentences* card poems are isolated in the vast white space of the index cards, the poems of *CAMBRIDGE M'ASS* are squeezed into much smaller spaces surrounded by black. The dense, rectilinear organization of *CAMBRIDGE M'ASS* suggests the congestion of blocks of urban space, whereas the horizontal spareness of the empty white spaces of the *Sentences* cards calls to mind the snowy and silent landscapes of northern New Hampshire, where Grenier was living.[46] The card titled "`SNOW`," for instance, merely repeats the line "`snow covers the slopes covers the slopes`" four times, thus evoking the layering effects of multiple snowfalls.

The horizontal page layout of the *Sentences* cards allowed Grenier not only to suggest "`what a weird deserted place New Hampshire is`," but also to frame the poetic line of each poem across the page. This helped him to innovate on the models of the minimal poems of Louis Zukofsky, Creeley, and especially Aram Saroyan. Grenier had known Saroyan since at least 1964, but had taken little interest in his minimal poems until he began his own sequence (written from October 1969 to January 1971 but never published) called *A Day at the Beach* (now known as Ur-*A Day at the Beach*, since Grenier recycled the title for an entirely different 1985 book).[47] Writing to Grenier in the summer of 1972, Saroyan's close friend Clark Coolidge asked Grenier about Saroyan's influence on the poems in *Sentences*. Grenier replied: "I think my work most distinct from Aram's in this: that his shows what's out there ('Lucy') intensely photographed/registered (lighght) whereas I'm preoccupied with interior significance ('meaning') of events also seen. I want to know what's going on, while being in it."[48] This last sentence is paradigmatic of Grenier's poetics; much like being "alive in the eyeblink," Grenier's aspiration is to explore the processes of perception and cognition that make poetry possible. Grenier alludes to two poems by Saroyan, one simply "Lucy. Lucy."—which is on a facing page with a photograph of Saroyan's sister, Lucy. The other is Saroyan's "lighght"—perhaps the most famous of all one-word poems. Grenier considers both of these poems photographic, whereas the poems in *Sentences* are not intended to register the photographic instant, but rather to prolong and complicate the momentary isolation of the image or experience.

"I want to know what's going on, while being in it" entails a necessary engagement with processes of perception and mediation, and in particular with the typewriter. As he puts it in the guide to his papers, these "different stories/thousands of them happen necessarily & continuingly/ continuously (potentially) or 'happen at once.' The form of *Sentences* has a lot to do w/ the IBM Selectric Typewriter, which was the 'Office Machine' of the early 1970's."[49] The multiple temporalities preserved in this passage—"continuingly/ continuously (potentially) or 'happen at once'"—give a sense of Grenier's attempt to engage his readers not merely by capturing an instant of time, but by capturing the duration of the writing process. Punctuation (other than quotation marks and apostrophes) is rare in Grenier's mature poetry; his critical prose, by contrast, is characteristically overpunctuated, as if to resist the determinacy of conventional syntax and the temporal fixity of verb tenses. A card such as "`restless moving to the right`" attempts to enact that of which it speaks, the saccades of the reading process. The poem also reenacts the typing process.

Larry Eigner was a key influence on the genesis and typographic execution of the *Sentences* project. Eigner, who was born with cerebral palsy, could only type with his index finger and thumb, and Grenier retyped Eigner's poems for publication in the fall of 1970 and winter of 1971. According to Grenier, for both Eigner and himself, "The typewriter, as a 'machine', made all possible—with the agency of the manual typewriter, one could range round (in the typewriter page—*if* one could type) with 'perfect freedom' (inside its grid—which could come to be a 'whole world') and capacity to *precisely* indicate exactly where each letter 'goes.'"[50] According to Michael Davidson, "Eigner's is decisively a poetry of the page, a field of intense activity," and much the same could be said of *Sentences*, although Grenier tended to place far fewer words on each page.[51] Eigner could not use an electric typewriter such as the Selectric, without which the elaborate and precise spacing of *Sentences* would have been difficult, if not impossible, to achieve.

*Sentences* also has a significant aural dimension that can be heard in recordings from the period. A number of the poems in *Sentences toward Birds* (the earliest non-periodical publication derived from *Sentences*, which consists of forty 3" × 5" cards collected in an envelope) attempt to render bird song into poetry (figure 8.9). With four anapestic lines, the poem "A Bird" channels a bird call, and invites a reader to hear the bird's song onomatopoeically. Characteristic of Grenier here is the attempt to create a correspondence between sound and the space of the page. Note the extra space between each line, and how the poem is centered (but left-justified). The audio recording of "A Bird" during the 1981 St. Mark's Poetry Project reading offers more background.[52] After reading the poem once, Grenier interjects self-deprecatingly: "well, that's dopey, a lot of these are really uh, like …" Without finishing his sentence, he reads the poem a second time, and then offers a possible microreading: "that's actually a transcription of a, of a, bird sound, but it comes out like it was this sort of

A BIRD

who would call

not for me

but for you

in the day

**8.9**
Robert Grenier, *Sentences toward Birds* (1974).

minor melodrama, so what can you do? But you could just read it as ..." At this point, he reads the poem a final time and moves on to the next poem. Whether or not the poem is "dopey" (or corny), it is highly formalized in its approximation of birdsong. Moreover, Grenier has *read into* his own poem a narrative, a "minor melodrama," and then in another self-deprecatory move, seemingly rejected his own need to give a narrative to the poem. In a final self-deprecatory gesture, he attempts to reduce the poem to its sheer sonic qualities. By this point, multiple remediations have taken place: the sounds of nature have been transcribed to the card and then turned to speech. Note too that it is the reader, the "you" of the poem, who is called by the bird. The poem operates by a paralipsis (or displacement), along the lines of: *Let me tell you what you heard that I didn't hear. It might have meant this, but you might not think so.*

Rather than offer an argument or linear narrative, perhaps *Sentences* is coming from a place of deep skepticism about how we construct meaning from our immediate sense perceptions. A deeply Steinian card that Grenier has repeatedly emphasized, and that he projected as a slide in a 1982 discussion attended by many leading Bay Area Language writers, demonstrates again how ambiguity of syntax and reference can lead to a multiplicity of possible interpretations:

```
if rain it's raining
```

Here we would seem to begin with a conditional "if" construction, but once again the poem shifts to an ungrammatical, but not nonsensical, construction.[53] Grenier does not use commas in *Sentences*, but if he did, we might expect a comma after "rain." The apparently conditional construction could also be pleonastic; an approximation could be "if it rains, it rains." Unlike the cliché "when it rains, it pours," there is no difference in magnitude between "rain" and "raining." Both can be taken as referring to rain occurring in the present.

This four-word poem may seem like a self-contained koanic brain-teaser, but it can also be richly allusive: "`if rain it's raining`" could allude to Samuel Beckett's *Molloy*, which concludes: "Then I went back into the house and wrote, It is midnight. The rain is beating on the windows. It was not midnight. It was not raining."[54] Here, as in the Grenier poem, the transition from raining to not raining creates a mental loop in the mind of the reader. The strength of the phrase "the rain is beating" makes it seem unlikely that the rain could stop so quickly, and yet perhaps it is possible in literal terms that the rain has stopped in the moment that midnight passes. Although we are dealing with an unreliable narrator in *Molloy*, the overarching problem here might be: How can one accurately describe conditions in the present moment when it is always slipping into the past?[55]

Repetition in *Sentences*, like repetition in Stein, often results in strange effects. More accurately, Stein described her own use of iterated language as "insistence"

rather than "repetition." For her, "no matter how often you tell the same story if there is anything alive in the telling the emphasis is different."[56] If there is "anything alive" in "`if rain it's raining`," perhaps it is the poem's ability to inhabit multiple temporalities. It suggests both that it might rain and that it is currently raining. The poem is paired (in the 2006 Bernstein interview and in the 1982 talk) with another poem that similarly explores indeterminacy of temporal reference: "`rain drops the first of many`." Once again, the syntax is ambiguous: the splitting of "rain" and "drops" into two separate words could suggest that "rain" is the subject and "drops" is an active verb. Heard aloud, it is difficult to distinguish "rain drops" from "raindrops." A "raindrop" allows for the particularization of a single drop of rain; even so, like a proverbial snowflake, raindrops must come in infinite shapes and sizes. "Rain" might even be dropping something else other than itself; figuratively, rain might be dropping cats and dogs. During a 1982 discussion in which poems from *Sentences* were projected as slides, Hejinian observed: "You can also read it that the rain is dropping the first of many ... something-or-others ... the rain is dropping the first of many 'leaves.'"[57] There is a sense of expectation in "the first of many"—that a deluge is about to occur—but indeed there is little precision to the statement. In that same discussion, Perelman proposed that the poem could be read as "almost like a ... miniature *Finnegans Wake* or something ... no, seriously, it goes around in a circle ... 'rain drops the first of many raindrops.'"[58] Although the "recirculation" may not be as "commodious" as that of *Finnegans Wake*, it seems accurate to describe the poem as circular. Like so many of the poems in *Sentences*, "`rain drops the first of many`" takes place in the present tense, but it also alludes to another time in the near future: the imminent arrival of more raindrops.

As with other poems from *Sentences*, "`rain drops the first of many`" can work mnemonically—that is, if you're familiar with the poem, it can come to mind when it starts to rain, especially if you're with someone else who is familiar with the poem. A fellow scholar and Grenier enthusiast once reported, for instance, that his ten-year-old without prompting recited this poem from *Sentences* when they were at the beach:

```
I'm Ronald McDonald
and it's a seaside town
```

Poems like this may provide very little situational context to a reader, but their associative range of potential reference can extend much further. Is this poem baby talk? Is McDonald's, like a trip to the beach, a "treat" for a child? Or perhaps Ronald McDonald's message of corporate optimism is out of place in the (implicitly small) seaside town? Or is there no connection at all between the first-person address of Ronald McDonald and the location of the seaside town? Perhaps there is a sonic parallelism of the two lines? Both lines are six syllables in length, with (depending on how you scan them) unstressed syllables near the middle. "Ronald" of course rhymes with

"McDonald," but the two lines of the poem do not end-rhyme. The poem isn't particularly mnemonic formally, but somehow it can act as a meme if two or more people are familiar with the poem. A similar phenomenon occurred recently when I was cooking an elaborate meal and realized several times that I had forgotten key ingredients. Each time I headed out the door, I would say to my partner: "**kept on going to the corner store**."

By withholding context and lacking what we would conventionally describe as a narrative, *Sentences* mimics the experience of having only partial information about one's immediate circumstances or even about one's own life history. An adult can only incompletely remember or relive their experiences of childhood. For a small child, a trip to the corner store might seem to be as consequential as, say, the death of a pet or a relative. All our lives we might say we have the experience of being "alive in the eyeblink." This is a very Emersonian notion, and one critic, Alan Golding, has even referred to Grenier as "Emerson as postmodern materialist."[59] It would be difficult, however, for a poet of Emerson's time to recognize that a poem as unadorned as "**kept on going to the corner store**" could be considered a poem.[60]

The eyeblink, or *Augenblick*, is a key term for Heidegger that denotes a decisive or visionary moment.[61] The eyeblinks of *Sentences* are just as often indecisive and seemingly not out of the ordinary. There are visionary moments too, however, as in a poem as direct as—"**beautiful tomatoes this morning of mornings**"—which in the plainest language uses the simplest of reiterations, "morning of mornings," to suggest an epiphany of recognition on a unique morning. We can infer some context (the time of day and the time of year) from the poem, but not much else. The language is, if anything, folksy, and the sentiment Romantic—very unlike the urbane, difficult, opaque poetry that readers typically associate with the Language writing movement. *Sentences* may be mostly made up of fragments of the everyday American speech championed by Stein and William Carlos Williams, but *Sentences* is strikingly unlike any modernist precedent. Instead, Grenier's poem exemplifies his lifelong attempt to render visible the ambient language of everyday life. In theory, it would be possible to create an extensive set of annotations to *Sentences*, yet *Sentences* is not abstruse. A conceptually rich work that can expand our notions of the forms poetry can take, it can be enjoyed by children as well as adults.

Not long before the *Sentences* box was published, Grenier offered a remarkable appraisal of the project in a 1977 letter to his close friend Robert Creeley:

> If I've done anything these 6 years in the woods (I haven't been practical! I didn't fublish [sic]!), it's been to see stuff in Dickinson, in Stein, Zuk., P., WCW, yrself, Eigner & refine & develop a method of paying attention & graphing experience in the '"weights & measures"' of spaces & letters. Finished, I can't stand it, either, but not because it's not polished prose.[62]

It was a difficult time for Grenier. He had left Franconia College, and was struggling to make ends meet in Cambridge, Massachusetts. He had not published a book since 1967, although he had produced a number of lengthy typescripts. Much to his, and Creeley's, consternation, he did not receive proper credit from Scribner's for his role as editor of Creeley's 1976 *Selected Poems*. Nonetheless, Grenier was proud of his accomplishment in writing *Sentences*, though not optimistic about what it might do for his career prospects:

> I like some assumptions in the work: that the whole is there in every part; that rhythm occurs inevitably in the motion from one to two, e.g. in the flow of letters through a word; that scale (long poem/short poem; epic/lyric) is the "almost mechanical" result of perspective & distance from the eye and/or light source (e.g., in these slides, simply how far the screen is from the projector); that the "I" is there in every word equally or not at all, so in the work (Zuk's "Nouns: acts as much as verbs'). & all that, which can be "discussed"; they can see it, right? I want my "reward"—e.g. to stay alive in the terms I'm working in.[63]

The letter describes a slide show of the poems that Grenier had hosted for friends the night before. The poet was again theorizing how the presentation of the poems would affect their reception. His eloquent summation of *Sentences* pays attention to every element of the project—from letters to words to lines to cards (or slides) to the box in its entirety. *Sentences* is built of juxtaposed contradictions: it is both epic and lyric; it can be read in an hour, but it can also be reread and re-viewed and recalled in countless combinations. The idea that "the whole is there in every part" allows *Sentences* to be personal at the same time that it is an "'almost mechanical' result" of processes of perception and representation. At the end of the paragraph, he wonders whether "they" (presumably prospective audiences) will be able to "see" *Sentences* for what it is. The only "reward" he asks for his six years of labor is "to stay alive in the terms I'm working in." The asked-for reward is an unfortunate commentary on the precarity of poetry as a livelihood, but it is also a succinct defense of a uniquely ambitious, vital project. Whether or not readers can appreciate the work on its own terms may be, to quote a characteristically enigmatic card, a "`question of recognition phenomena`[.]"

# 9

## To Icon or Not to Icon

### 1. "Later / the atelier / ate her": Poems by Repetition

Natalie Czech's *Poem by Repetition by Aram Saroyan #3* (figure 9.1), like much of her work, is more than simply a remediation of, or a tribute to, a source poem.[1] Czech describes her work as a form of "writing with photography," but neither of these terms fully encompasses the complexity of her process. K. Silem Mohammad has suggested the term "sought poems" for works that differ either from "found poems" or from the "passive" appropriation methods common to "pure" conceptualism:

> Whereas the idea behind found poems is that they're just something you stumble upon and say hey, that's poetry, I'm thinking of a process of aggressively *looking* for something, with the intent of *enlisting* it in some capacity. Sought poems come about as the result of invasive surgeries performed on already-mangled bodies. The poet knows those happy—or unhappy, as the case may be—accidents of language are out there, but it may take repeated sallies into the underbrush before they are flushed out. The sought poem is not passively awaited, but teased, prodded, hectored into existence. The poet thus assumes a level of involvement that in many ways is very old-school: She once again puts her manipulative ego into full gear, and becomes responsible for aggressively intentional structures.[2]

Czech's *Poem by Repetition by Aram Saroyan #3* takes its semantic text directly from Saroyan's 1965 poem:

> POEM
> Later
> the atelier
> ate her[3]

But Czech's is a very different work, and arguably says more about her work and her process than about Saroyan's original poem. Like many of Czech's works, it is difficult to reproduce online or in book format. When viewing it closely in a gallery setting, one can see more easily that *A Poem by Repetition by Aram Saroyan #3* is in fact three separate framed photographs—with each photograph containing a single line of the poem derived from three separate source images taken from identical brochures.

These photographs have not simply been Photoshopped; rather, Czech has used a black marker to physically write over the language of the original brochure, and, for the final line, "ate her," has made an incision into the brochure in order to "reveal" Saroyan's poem. She has also left the ghostly traces of the text of the original advertisement.

*A Poem by Repetition by Aram Saroyan #3* might at first seem rudimentary in its execution, but it is the result of an exhaustive process of acquiring physical media and remediating those artifacts into digital media and back again to physical media. Czech had to locate at least three separate physical brochures in order to make the work, and yet online I could find only one image of the Braun television being advertised, and no images of the 1987 brochure, the text of which reads: "DIE FERNBEDIENBARE ATELIER ANLAGE 87/88" (the remote-controlled Atelier unit 87/88). The image is odd for a television advertisement: shown on the TV screen are three deck chairs and an ambiguously cloudy sky, with blue the dominant color. Perhaps the advertisement gestures toward the impossibility of advertising the picture quality of a television by means of print. The ad also seems to suggest that the TV viewer might be better off outside, not watching TV. Perhaps this obscured view might suggest that the artist too is confined within the atelier—both within the restricted vista of the television and within the literal studio in which the artwork was produced. Jens Asthoff describes the piece in *Artforum* as "a laconic, metaphorically complex play on advanced media consumption and the atelier as a classic site of art production."[4]

Czech's *Poem by Repetition by Aram Saroyan #1* (figure 9.2), now in the permanent collection of the Museum of Modern Art, similarly fuses minimal poetry with the imagery of advertising, although in this case the source is far more iconic (or at least seemingly so).[5] The source image is derived from Pink Floyd's *Dark Side of the Moon*, one of the most recognizable and bestselling LPs of all time. But the cover is in fact the French edition of the group's 1973 seven-inch 45-rpm single of "Money." The American, British, German, and Mexican versions of the single either had no cover and only a sleeve (common for single releases) or featured an entirely different image. Such distinctions may seem negligible to a noncollector, but they point again to the lengths to which Czech goes to select and assemble her physical materials. As with *Poem by Repetition by Aram Saroyan #3*, the work is divided into three parts made from three separate covers, which are each modified by means of a marker. The ring marks from the records and the tears in the originals are preserved in Czech's version, and the original lettering that does not correspond to the Saroyan poem remains visible beneath her pen marks.

The original Saroyan poem is made no less enigmatic by Czech's repurposing. Are Pink Floyd and their design company, Hipgnosis, simply out to make the "money" of the title? But what does this have to do with Saroyan's original (figure 9.3)? How might one say this poem aloud? Should the pronunciation be *"nee / mo / money"*—which might suggest *"need / more / money"* and might also problematically suggest an

appropriation of "street language"? In a way, the poem stutters—the syllables of the poem's only complete word are reversed in the first two lines, and the word becomes recognizable only in its last iteration. Writing of the literary and poetic implications of stuttering, Craig Dworkin notes: "Stuttering … is less a condition that does or does not exist than a rate at which one aspect of the normal mechanism of speech can no longer be ignored or overlooked."[6] Like many of Saroyan's poems that feature serial repetition of words or of parts of words, the poem is arguably dysfluent; readers must construct their own meaning (and sounds) from the repeated letters on the page. For Dworkin, the fragmented repetition of stuttering suggests that "All language is referential, but it need not refer to concepts; when language instead refers back to the material circumstances of its own production, we can hear the murmur of its materials."[7] Saroyan's "ney / mo / money" may even have a parent text, his poem "Gradually Money" (published in 1966, but likely written in 1965) (figure 9.4).[8] The text of that poem contains only the words "gradually money" repeated four times with varying capitalizing and lineation. The poem ends simply with the line "money," as if the final lowercase "money" had finally been earned.

In Saroyan's original "ney / mo / money" (which in book form preserves the typeface of his typewriter), the poem's centering on the page points to the precision of the typewriter grid, and perhaps even to the repetitive but irregular sound of typing on a typewriter. Czech's version, which ignores the original lowercase lettering and spacing of Saroyan's, draws attention to altogether different materials and processes. Whereas Saroyan's version is utterly removed from commercial advertising iconography, Czech's version is immersed in it. The mediated materials that Czech chooses as sources can be hauntingly familiar or utterly obscure. Her work archives the iconography of advertising and album art at the same that it distorts and repurposes it. She also sometimes draws on multiple media formats to rework the same poem; in the case of *Poem by Repetition by Aram Saroyan #3*, there is another version (figure 9.5) derived from a 2003 European promotional CD of the same single.[9] The six-color rainbow prism is preserved in the CD version, but otherwise the designs of the record and the CD share little in common. Czech has in effect "poured" the same "content" into similar containers. Effectively, an album is an audiovisual commercial artifact, whereas in the era of digital music, we increasingly listen to music without seeing its original "packaging." Records and CDs also, in a manner of speaking, stutter or skip when they are worn. Digital music, by contrast, is "streamed," and the "murmur of its materials" is minimized, if not eliminated.

**9.1 (following pages)**
Natalie Czech, *A Poem by Repetition by Aram Saroyan #3*. Three prints, 112.2 × 62.5 cm (total), 2015. All works by Natalie Czech courtesy Capitain Petzel, Berlin / Kadel Willborn, Düsseldorf. Photos © VG Bild-Kunst Bonn.

**9.2 (following pages)**
Natalie Czech, *A Poem by Repetition by Aram Saroyan #1*. Three prints, 65 × 65 cm, 65 × 15.7 cm, 65 × 18.5 cm, 2013.

NEY

MO

MONEY

```
 ney
 mo
 money
```

**9.3**

Aram Saroyan, *Pages*, 1969.

**9.4**

Aram Saroyan, *Works: 24 Poems*, 1966.

**GRADUALLY
MONEY**

Gradually
Money

**gradually
money**

**gradually** money

money

**9.5**
Natalie Czech, *A Poem by Repetition by Aram Saroyan #3 (CD)*. Three archival pigment prints, 101 x 65 cm (total), 2016.

The eclectic visual sources that Czech draws upon can be richly suggestive to a writer or viewer. The song "Money" will have different associations for different listeners. The song remains iconic on classic rock radio, and it featured prominently in the 1982 film *The Wall*. For the generation that grew up in the 1980s, the song would have been closely associated with the scene in which it is introduced. Pink, the young protagonist, is confronted by his stern teacher, who picks up Pink's notebook and begins to read:

**Teacher:** What have we here, laddie? Mysterious scribblings? A secret code? No! Poems, no less! Poems, everybody!

[Classmates laugh]

**Teacher:** The laddie reckons himself a poet!

[Reads poem from Pink's little black book]

**Teacher:** "Money, get back / I'm all right, Jack / Keep your hands off my stack / New car / Caviar / Four-star daydream / Think I'll buy me a football team."

[Slams the book onto Pink's desk]

**Teacher:** Absolute rubbish, laddie.

[Whacks him with a ruler, growls at Pink]

**Teacher:** Get on with your work.[10]

None of this is directly referred to in Czech's *Poem by Repetition by Aram Saroyan #3*—but the work, like other minimal poems discussed in this book, can't help but radiate allusiveness, particularly when the source material is of a metapoetic nature. Pink is in need of money to escape his circumstances; poetry is his impractical imaginative means of escape. Some Pink Floyd fans have taken "Money" to be a satirical condemnation of wealth; others have taken it to be a cynical commentary on the band's financial success. The allusiveness of any literary text will always be proportional to how well a reader knows the material being alluded to, but here I would suggest that the longer one spends with an allusive work, the more one may be tempted to explore the allusions. Were one to put *Poem by Repetition by Aram Saroyan #3* on their wall, for instance, one would be repeatedly exposed to the work; one might be asked questions about the work by others, and so on. This effect would also likely vary depending on how much one identified with the source material.

Perhaps the most labor-intensive of Czech's "sought poems" is *Poem by Repetition by Aram Saroyan #2* (figure 9.6).[11] The multicolored ukuleles evoke a childlike cuteness—as they were no doubt designed to do by their German manufacturer, Baton Rouge guitars. Divided into four frames, the work contains either seven or eight ukuleles.

**9.6**
Natalie Czech, *A Poem by Repetition by Aram Saroyan #2*. Four prints, 136 x 81.4 cm (total), 2014.

More precisely, there are seven colors of ukulele, but one ukulele is divided between two frames. To stage this photograph, Czech would have had to obtain at least seven physical instruments. There is a rough symmetry to the arrangement of the ukuleles, but it is a deceptive symmetry: right and left are not split down the middle. The text of Saroyan's poem—

> o r
> o r

—is derived from the word "NOIR" (the make of these ukuleles), which appears in two instances on the headstock and in the soundhole. Czech could not have made the work with Photoshop, and the white background suggests an antiseptic orderliness—and yet again the language of the poem is revealed by creating an inverse palimpsest. In order to reveal the poem, Czech had to physically write over the manufactured text. NOIR would seem to be an ironic name for so colorful a line of products. But perhaps the piece also points to the indecision a child might feel when choosing a color. The construction "or or" does not make sense in conventional English, but the sense of "or … or" might well describe the seemingly infinite series of insignificant choices among manufactured objects. A rose ukulele in any other color might sound as sweet.

Czech's many decisions regarding source materials and remediation strategies might place her in the position of feeling perpetual indecision. Her knowledge of American poetry is exceptional, particularly for a nonnative speaker of English. The most minimal of minimal poems are often untranslatable, which paradoxically can make them available to a more global audience. Though her works are all in English, they do not passively partake of Global English; rather, they subtly intervene in the universalist aspirations of American advertising culture and its attendant media platforms. *A Poem by Repetition by Gertrude Stein*, for instance, was constructed from (or on) two iPads and two iPad minis—and one of each are upside down (figure 9.7).[12] Each of the two photos features two right hands (presumably the artist's) holding or touching an iPad. At the four corners of the work are low-resolution black-and-white images of Kant, Marx, Nietzsche, and Hegel. The highlighted text is from Stein's *Everybody's Autobiography*: "The minute you or anybody else knows what you are you are not it, you are what you or anybody else knows you are and as everything in living is made up of finding out what you are it is extraordinarily difficult really not to know what you are and yet to be that thing."[13] The rest of the text in *A Poem by Repetition by Gertrude Stein* is a pastiche taken from the "Music, Language and Literature" chapter of Andrew Bowie's *Aesthetics and Subjectivity: From Kant to Nietzsche*.[14] The text is a condensed cut-up version of the original, and is reformatted as a dialogue between "BG" and "ST," although there is no indication what these initials might stand for. The first half of the highlighted red "I am music, this is what music is." is taken from the

prologue to Monteverdi's *L'Orfeo*, which features Music as an allegorical character. It might also allude more generally to Stein's poem "The World is Round":

> I am Rose my eyes are blue
> I am Rose and who are you?
> I am Rose and when I sing
> I am Rose like anything.[15]

"I am music, this is what music is" creates a solipsistic circularity, not unlike Stein's "when I sing / I am Rose like anything." (The same poem was also adapted as a one-line-per-page book by none other than Aram Saroyan in 1971.)[16]

The text that is taken from Bowie's *Aesthetics and Subjectivity* mostly pertains to Hegel's account of the relation of music to truth and language. Some passages could again be read as describing the experience of a reader or viewer as she is looking at the work: "In attempting to grasp the meaning, he [the expert] is faced with puzzling tasks which quickly rush past, which are not always amenable to being deciphered and are capable of the most various interpretations."[17] This is in fact a quotation within a quotation, and the words are not Bowie's or BG's (to whom they are attributed), but are taken from Hegel's *Aesthetics*. This source history also presents an odd translational inversion: a German artist is quoting an English philosopher translating a German philosopher. The Hegel quotation presents a somewhat similar conundrum to the sentence from *Everybody's Autobiography*: How is aesthetic recognition possible given the constraints of individuated perception and taste? If "I am music, and this is what music is," then wouldn't we each, to use a cliché, march to our own drummer? The sentence from *Everybody's Autobiography* does not mention music, but perhaps there is a kind of visual musicality to the rhythmic patterning of Czech's quartet of iPads, which could be said to echo one another imperfectly. The orientation of the iPads would not be possible without the tilt/rotate function of the iPad, and the whole piece might be said to reflect on the comparatively new experience of reading on a tablet computer. The differing texts presented appear at first glance to be taken from a pdf or epub, but on closer examination they seem to be printed or photocopied on paper, and then either set on top of the screen or Photoshopped onto the screen. The texts look as if they were taken from a Wikipedia page rather than from an academic monograph, and footnotes and other formatting have been removed. The texts themselves speak of "the inadequacy of verbal language to certain fundamental aspects of our being"—which suggests a helpful way to view or read Czech's work, as it can't simply be reduced to the sequential, semantic text(s) of its source materials.[18]

*A Poem by Repetition by Bruce Andrews* (figure 9.8) gives a good sense of how Czech literalizes the processes of seeking and finding that she and her readers must engage in. The source poem is from Andrews's early minimal period, in which many of his poems were only a few words to a phrase long.[19] As I note in my book *The Poetics of*

*Information Overload*, Andrews has for much of his career composed his poems from slips of paper on which he compiles words and phrases.[20] From the late 1970s onward, these snippets of found language have largely been shaped into dense poems with long lines. In the early 70s, however, Andrews's writing more often took the form of this poem selected by Czech:

> find it
> never have
> have it[21]

This "finding" without "having" epitomizes the process of reading the triptych of clocks that Czech has used to "reveal" the poem, although in fact once again she has (partially) overwritten the original text by hand.[22] Like many of the poems selected by Czech, the original poem features internal repetition, and with the ordinarily nonsensical sequence of "have / have" would seem to pun on "have it" and "habit." The first clock offers the imperative "FIND IT"; the second, "never HAVE"; and the third, "HAVE IT." The clocks themselves present a uniquely odd rhetoric of superhero triumphalism aimed (presumably) at children. The poem in fact is found within a sentence written on each clock: "If we don't have it, a superhero doesn't need it." Each clock is set at 5:30, perhaps suggesting that being a superhero is an extracurricular activity, and that superheroes must lead dual lives. The visual repetition of the clocks implies successive days and the tedium of office work. Other aspects of the clocks' source text might also be suggestively connected to the poem, for instance: "Secret alliances will be forged" or "Underground lairs will be found." Again, the best way to interpret a poem/work like this might be to envision what associations the work could accrue over time, rather than to focus solely on the semantic meaning of the source text.

**9.7**
Natalie Czech, *A Poem by Repetition by Gertrude Stein*. Two prints, 101.8 x 49.1 cm (total), 2013.

**ST:** Music is a highly specific form of articulation. How would you compare Hegel's understanding of music to other German philosophers? And what is it that makes him think a deficit on the part of music itself?
**BG:** If you look at the late eighteenth- and nineteenth-century thinkers who give music a central role - such as the early Romantics, Schopenhauer and Nietzsche - Hegel regards in contrast to them music, like the rest of the arts, as a subordinate manifestation of truth. Although he evidently enjoyed music, he did not see it as particularly important. His remarks in the Aesthetics are in some respects most notable for how they epitomize a view of music which plays a role in much subsequent aesthetic theory, particularly in the Marxist tradition. For Hegel, purely "musical music" has to really free itself from the determinacy of the word. However, instrumental, wordless, music will not appeal to anybody

Manuel Kant

to the relationship between language music: a word *knows* the kind of that semantics tries to provide of truth conditions can play a role to a note in a piece of music. Music overcomes the lack of a philosophical object.
**ST:** Especially in the modern period, music takes on a vital role in relation to the emotions. It moves from being regarded in the first half of the eighteenth century as merely a manner of representing already familiar feelings, to being seen in the second half of that century and in much of the nineteenth century and since, as being able to give rise to and articulate new kinds of feelings.
**BG:** The openness of music to the new technologies made it clear that production and reception of music engage the understanding, Kant's faculty for rules. If you take it up to another level, music also engages the individual subject in ways which relate to the notion of 'feeling'. Feeling can never be represented as such, but is a motor for finding out the means of articulation which are not prey to the inadequacy of verbal lan-

### I am music, this is what music is.

else but to the expert, who will enjoy it because he can compare the music he hears with rules and laws he knows. There is, then, little sense here that music may in some circumstances be able to 'say' what you are unable to do with other means of articulation.
**ST:** You mean the expert will try to find more distinct ideas and a more familiar content in the music, and in this respect music becomes symbolic for him?
**BG:** Indeed. In attempting to grasp the meaning, he is faced with puzzling tasks which rush quickly past, which are not always amenable to being deciphered and are capable in fact of the most various interpretations. This being 'capable of the most various interpretations' is an extraordinarily apt description of significant literature in modernity - as Schleiermacher indicated, it is also a possibility for any kind of text. Given its interpretative history, it would be difficult to claim Hegel's own work would be very different, in this respect at least, from music. Part of what he means is, of course, simply based on the transience of the playing and hearing of music, as opposed, say, to the physical persistence of a text or a painting. However, pieces of music are actually idealisable in much the same way as texts are. I can keep the patterns of the movement of a symphony in mind, or if I have the right sort of training, of a piece of improvisation, in much the same way as I can that of a novel, and in listening to one or reading

Karl Marx

*ST:* Music is a highly specific form of articulation. How would you compare Hegel's understanding of music to other German philosophers? And what is it that makes him think a deficit on the part of music itself?
*BG:* If you look at the late eighteenth and nineteenth century, thinkers who give music a central role – such as the early Romantics, Schopenhauer and Nietzsche – Hegel regards in contrast to them music like the rest of the arts, as a substantiate manifestation of truth. Although he evidently enjoyed music, he did not see it as particularly important. His remarks in the Aesthetics are on some respects most notable for the way epitomise a view of music which plays a role in much subsequent aesthetic theory, particularly in the Marxist tradition. For Hegel, music "proper" in [...] really free itself from the determinacy of the word. However, instrumental, wordless, music will not appeal to anybody

**I am music, this is what music is.**

else but to the expert, who will enjoy it because he can compare the music he hears with rules and laws he knows. There is, then, little sense here that music may in some circumstances be able to "say" what you are unable to do with other means of articulation.
*ST:* You mean the expert will try to find more distinct ideas and a more familiar content in the music, and in this respect music becomes symbolic for him?
*BG:* Indeed. In attempting to grasp the meaning, he is faced with puzzling tasks which rush quickly past, which are not always amenable to being deciphered and are capable in fact of the most various interpretations. This being 'capable

Friedrich Nietzsche

the other in real time I am subject to temporality in much the same way. As such, it would seem that much of His [...] that music is not representational and referential in the manner of verbal language. Everything in Hegel's objection epitomises the way conceptions of language begin to diverge in the period he was living.
*ST:* The idea of Logos, language as the expression of human reason, whether in the form of a liturgical text or of the words of a song, is as yet basic to Hegel's conception. How would you describe his idea of the "musical note" and its being echoed in Mallarmé's idea of the word's "fragile vibration"?
*BG:* It is an expression which precisely by the fact that it is externally immediately makes itself disappear again. The body which vibrates to produce the note is negated in its static state, but returns to this state once the note has passed. The body persists where the note does not, although it is displaced when it vibrates - the body functions here rather like being in the Logik, which only becomes

---

really free itself from the determinacy of the word. However, instrumental, wordless, music will not appeal to anybody

**I am music, this is what music is.**

else but to the expert, who will enjoy it because he can compare the music he hears with rules and laws he knows. There is, then, little sense here that music may in some circumstances be able to "say" what you are unable to do with other means of articulation.
*ST:* You mean the expert will try to find more distinct ideas and a more familiar content in the music, and in this respect music becomes symbolic for him?
*BG:* Indeed. In attempting to grasp the meaning, he is faced with puzzling tasks which rush quickly past, which are not always amenable to being deciphered and are capable in fact of the most various interpretations. This being 'capable of the most various interpretations' is an extraordinarily apt description of significant literature in modernity as Schleiermacher indicated, it is also a possibility for any kind of text. Given its interpretative history, it would be difficult to claim Hegel's own work would be very different, in this respect at least, from music. Part of what he means is, of course, simply based on the transience of the playing and hearing of music, as opposed, say, to the physical persistence of a text or a painting. However, pieces of music are actually idealisable in much the same way as texts are. I can keep the patterns of the movement of a symphony in mind, or if I have the right sort of training, of a piece of improvisation, in much the same way as I can that of a novel, and in listening to one or reading

that music is not representational and referential in the manner of verbal language. Everything in Hegel's objection epitomises the way conceptions of language begin to diverge in the period he was living.
*ST:* The idea of Logos, language as the expression of human reason, whether in the form of a liturgical text or of the words of a song, is as yet basic to Hegel's conception. How would you describe his idea of the "musical note" and its being echoed in Mallarmé's idea of the word's "fragile vibration"?
*BG:* It is an expression which precisely by the fact that it is externally immediately makes itself disappear again. The body which vibrates to produce the note is negated in its static state, but returns to this state once the note has passed. The body persists where the note does not, although it is displaced when it vibrates - the body functions here rather like being in the Logik, which only becomes something when it is n [...] Consequently the body's truth in its inert facticity, but in the m[...]

Georg Wilhelm Friedrich Hegel

**9.8**

Natalie Czech, *A Poem by Repetition by Bruce Andrews*. Three prints, 58 x 68.1 cm (each), 2013.

One of the most recent works in the series—*Poem by Repetition by Robert Grenier #2* (figure 9.9)—also explores themes of consumer choice, as well as partial or obstructed visibility.[23] A diptych of two versions of the same ad, the work plays on a mental loop that is again not unlike a stuttering effect. On the left is the more recent ad for window shades, which has been updated to 107 colors from the original 86 colors. Fortunately, the indecisive consumer has the designer Geoffrey Beene to choose a color for them. Reflecting the energy crisis of the 1970s, the ad helpfully informs us that "the right choice of color can even cut down your air conditioning or heating load. (If there were a Riviera in every window, there might not be an energy crisis.)" The unadorned text of Grenier's poem provides an antithesis to the hyperbolic advertisement:

```
I CAN'T
I can't talk and
look out the window
and talk at
the same time
```
[24]

As with the juxtaposition of text and image in *Poem by Repetition by Aram Saroyan #3*, the Grenier text revels in a metaphor of frustrated perception or obstructed vision. The window of which the poem speaks is covered by Beene's miraculous blinds, which are themselves obstructed by a model wearing Beene's signature pink. We see only a sliver of blue sky, and further, the colors of the two ads differ slightly. One might even imagine the mute model with lips pursed, thinking to herself that she can't talk, much less look at the window behind her. As viewers, we too are drawn into a state of suspension as we puzzle out the interplay between the source advertisement and the text of the poem. To appreciate the work fully might be to enter a state of what (in the context of Emily Dickinson), Sharon Cameron refers to as "choosing not choosing."[25] We are not, after all, looking out a literal window, but we are looking through metaphorical windows—windows that when obstructed might also be mirrors.

**9.9 (following pages)**
Natalie Czech, *A Poem by Repetition by Robert Grenier #2*. Two prints, 28.4" × 21.7" × 1.6", 2017.

**Levolor Riviera blinds come in 107 extraordinary colors.
Geoffrey Beene liked one.**

**Levolor Riviera blinds come in 86 extraordinary colors. Geoffrey Beene liked one.**

TO ICON OR NOT TO ICON 167

## 2. "We Cannot Crave Whatever Is Ubiquitous"

Czech's more recent work has continued to explore the standardization of language and iconography in advertising and elsewhere. Her ongoing *To Icon* series draws upon the ubiquitous icons of personal and portable computing. The icons of personal computing attempt to overcome language barriers by substituting symbols for tasks or procedures, but often icons introduce new ambiguities and new overlaps among the things being symbolized. My subtitle—"we cannot crave whatever is ubiquitous"—is taken from Lori Emerson's *Reading Writing Interfaces*.[26] Icons are intended to facilitate ease of communication across languages, and as such, icons might be said to be universal symbols within ubiquitous communications systems. I take Emerson to be struggling with a pressing media theoretical problem: namely, how do we imagine ourselves in relation to tools and devices that have become so omnipresent as to become invisible? Traditional advertising was intended to make consumers desire that which they lacked; ubiquitous icons promise unlimited access to content and services. Czech's *To Icon* series could be said to explore the interplay between consumer items and the icons and devices that lead us to those items.[27]

In *Paperdraft* (figure 9.10), for instance, Czech compiles a list poem out of the various "meanings" of a piece of blank paper with a corner folded over—and then finds that rectangular shape (with a triangle cut out) in a starched tuxedo shirt.[28] How we (or potentially the wearer of the shirt) interpret the text might depend on the context in which the tuxedo is worn (by a person who attends formal galas, for instance, or perhaps by a waiter). The text itself is as void of localized meaning as could be:

> *A Draft*
> [Mail IOS 8.1.3 for iPhone]
> *A Blank Page*
> [Microsoft Word 14.0]
> *A Preview*
> [Epson Scan 3.9.2]
> *An Artboard*
> [Illustrator CS8]
> or just
> *New*
> [Windows XP]

The ornate cursive script, which could evoke an invitation or a menu, contrasts with the banality of the content, and points back to the elaborate composition of the photograph. The physical shirt and dress slacks were carefully laid out, and the blue outline of the icon is in fact a polymer that rises above the surface of the photo. The text too is not merely Photoshopped into the picture, but is printed on a physical tag laid on top of the clothes. The icon, moreover, is an excellent example of skeuomorphism (where software design mimics real-world examples, such as the trash can icon): the digital icon is premised on an analogy to paper documents.

Czech's formulation "to icon" suggests that icons are not merely things or nouns, but also actions or verbs. The artist is one who fashions icons, but icons are also part of the now universal experience of using computers to make art. Czech's art is fitted to the icons in question; the physical objects in the photograph are fitted to the icons as well. Although Czech's works are rarely composed in her own original words, they can be playfully self-referential. Another *To Icon* installment, *Nozzle Check*, derives from an Epson Inkjet printer error message, and plays on the artist's name. The first installment in the *To Icon* series, the avatar for one's avatar, offers another good example of the ironic layering and compiling effects that make Czech's work so powerful. In its full photographic form, *Motiv: Avatar / Me* (figure 9.11) is an elaborate set piece featuring folksy overalls in a red, white, and blue color scheme that can't help but evoke the American flag.[29] As with *Paperdraft*, *Avatar / Me* is carefully composed out of clothing, and a printed paper tag is affixed to the composition. The red suspender clip in the lower middle is again raised polymer applied to the surface of the photograph. Although the two uppercase letters of "ME" could hardly be simpler, the list of the avatar icon's possible meanings across platforms complicates matters considerably. The booklet (figure 9.12) that accompanied the exhibition of these photographs lists fifteen possible meanings of the avatar-for-avatar across fifteen different platforms.[30] Those meanings diverge wildly—from "About Me" to "Personal Info & Privacy" to "Celebrities"—revealing again that even the simplest icons cannot be uniformly standardized.

*Avatar / Me* is ingeniously accompanied by *Avatar / We* (figure 9.13).[31] Here too the possible readings of the icon diverge considerably—but both the "ME" and the "WE" of these compositions ultimately mirror one another, creating an echo effect. The juxtaposed "me" and "we" may allude to Muhammad Ali's spontaneous creation of a poem in front of an audience—either "Me! / We!" or "Me! / Whee!"—which George Plimpton considered the shortest poem in the language.[32] *Avatar / Me* and *Avatar / We* point to how technology and design imbricate every aspect of our lives. To produce Czech's final physical works required both the digital and the analog, the machine made and the handmade—temporarily freezing the ongoing flux of technological change and 24/7 online culture. As the title of Wendy Chun's recent book would have it, we are all continually *Updating to Remain the Same*.[33] Icons that we employ hundreds of

**9.10**
Natalie Czech, *Paperdraft*, from *To Icon*.
Print, 46.7" × 32.6" × 1.6", 2015.

**9.11**

Natalie Czech, *Avatar / Me*. Print, 34.3" × 50" × 1.6", 2016.

**9.12**

Natalie Czech, *One Can't Have It Both Ways and Both Ways Is the Only Way I Want It*, 2016.

**9.13 (following pages)**

Natalie Czech, *Avatar / Me* and *Avatar / We*, installation view, Capitain Petzel Gallery Berlin, 2016.

times on any given day may someday be unrecognizable to us or unreadable by the platforms that mediate how we present ourselves to others via profiles. Artists also create profiles or avatars of themselves. The special role of the text artist using found materials may be to make that which has become invisible to us through continual overexposure visible once again—by means of new forms and new juxtapositions of familiar objects and images that will in time no longer signify what they once did.

In contrast with the colorful *To Icon* photographs, the book *to icon: poems* (which is derived from the labels on the photographs and is not to be confused with Czech's more textually expansive book *One Can't Have It Both Ways and Both Ways Is the Only Way I Want It*) is austerely minimal and utterly without images. The language of the icons, when "translated" into simplified poems of one to two words per line, is reductive in the extreme. Whereas the *Poems by Repetition* "find" poetry in the ambient environment, the *to icon* poems "lose" the ambient *iconography* of their source materials and devolve into starkly empty texts. Compare, for instance, the image-texts for *Avatar / Me* and *Avatar / We* with the corresponding *to icon* poems:

> about me
> friends
> contacts
> people
> faces
>
> Me[34]

and

> about you
> friends
> hangout contacts
> celebrities
> users
>
> following
> You
> Me[35]

The poems have been arranged in such a way that they again echo one another, evoking the inviting first- and second-person user-friendliness of social media platforms that offer instantaneous global reciprocity of communication. But who is "following" whom, and in what sense? Upon closer inspection, the user-friendliness may mask a global echo chamber of participatory sousveillance and surveillance. Icons, in the European visual tradition at least, once primarily conveyed religious messages of faith and devotion; perhaps icons now convey implicit messages of faith and devotion in the products of computational capitalism.

The *To Icon* series also playfully explores fashion as a medium. *Speech Bubble / Richard Hell*, like the works just described, is more allusive than it might at first appear (figure 9.14).[36] The shirt in the picture is a recreation of the one found on the back cover of the 1977 album *Blank Generation* by Richard Hell and the Voidoids, although the posture of the wearer differs from the original wearer, drummer Marc Bell (who would later go on to become Marky Ramone of The Ramones) (figure 9.15). Nor is the posture of the wearer the same as Hell's on the back cover of the 1990 CD reissue of the album (figure 9.16). In effect, Czech has wittily revealed a chain of absences. The appropriately named Voidoids no longer existed by 1990; accordingly, Hell removed them from the album cover. Hell himself in some sense was soon displaced by the more famous Sex Pistols, whose manager Malcolm McLaren openly copied and exported Hell's style.[37] It is difficult to overstate Hell's influence on punk fashion, although one imagines that many self-styled punks over the decades have been unaware of his role. Lydia Lunch credits Hell "with originating the look that would become an enduring punk cliché," and being "the first rocker to spike his hair, rip his T-shirts, reattach them with safety pins, and scrawl across the front in magic marker—in 1974."[38] The idea that a rip or tear in a shirt could itself convey a message is a counterintuitive one, but enduringly influential. The triangle motif of the shirt itself ingeniously alludes to the title track of *Blank Generation*. Referring to his own misfortune at being born, Hell describes his image causing a mirror to shatter in the delivery room: "Triangles were fallin' at the window as the doctor cursed ..."[39]

Czech's version ingeniously replaces the circular tear in the shirt with a polymer adhesive in the shape of a speech bubble icon, and adds the following text in the lower right corner:

*Callout PicsArt for Windows 6.1*
*Compose Viber Windows 8*
*New Message Wick 2.1.0*
*Text Messages Blackberry 10.2*
*Free Text text+ Android 6.0.4*
*Chats WhatsApp iOS 2.12.1*

*Talk Yelp iOS 7.4.0*

Despite considerable variation across platforms, the speech bubble consistently suggests self-expression. Captions or speech bubbles go back at least to the Middle Ages as a way of indicating speech. Here the space is simply a transparent window onto the wearer's skin, and an empty speech bubble icon seems to only indicate potential speech. Here, the lyrics of "Blank Generation" are suggestive. The chorus alternates between "blank" being sung (or written) and "blank" being replaced with a short pause (or "\_\_\_\_") before "generation."[40] The song, in a manner of speaking, describes a

**9.14**
Natalie Czech, *Speech Bubble / Richard Hell*.
Print, 34.7" x 25" x 1.6", 2017.

**9.15**

Richard Hell and the Voidoids, *Blank Generation*,
LP back cover, 1977.

**9.16**

Richard Hell and the Voidoids, *Blank Generation*, CD reissue back cover, 1990.

situation of extreme decision stress: whether it is better to live or die, to care about the world or to withdraw into indifference and heroin addiction. "I can take it or leave it each time," repeats the self-proclaimed anti-spokesman for the blank generation. Hell himself was ambivalent about the song's meaning, and told Lester Bangs: "People misread what I meant by [the song] 'Blank Generation.' To me, 'blank' is a line where you can fill in anything. It's positive. It's the idea that you have the option of making yourself anything you want, filling in the blank."[41] Retrospectively assessing this reading in his autobiography, Hell wrote: "That's legitimate, but I was playing it up to head off Lester's making me out as all antilife. When people insist on narrowing down or overinterpreting what you're doing, the reflex is to point out other perspectives."[42] Hell's earlier reading is almost exactly in line with the sense of potentiality and promise offered up by the app developers Czech draws upon, and at odds with the nihilism of the actual song. Hell's later reading is perhaps more in line with how Czech's work offers layered ambiguities and interpretative impasses. The empty speech bubble is like Wallace Stevens's "nothing that is not there and the nothing that is." In some apps (such as iMessage), the speech bubble can signify that "someone else is typing" a message, giving the user a sense of expectation, or perhaps of dread.

Richard Hell and the Voidoids were founded in 1976, the same year as Apple Computer, the company that would not long afterward popularize the graphical-user interface (GUI) and with it the Windows, Icon, Mouse, Pointer (WIMP) model that would revolutionize how individual users interacted with computers. Such technological change is so ubiquitous that it has become almost banal to comment upon. Czech's interventions in the history of technology and design too may at first seem to elude commentary. And yet they reveal the extraordinary influence of media standardization in our lives. For nearly two generations, computer interfaces have aspired to be invisible to users. According to Lori Emerson, "the degree to which an interface becomes more invisible is the degree to which it is seen as more user-friendly (and so more human), but at the cost of less access to the underlying flow of information or simply to the workings of the machine/medium."[43] For Emerson, works of visual literature can help to explore and question the ideology of the user friendly.[44]

A recent book (with a mostly pessimistic view) is revealingly titled *The App Generation: How Today's Youth Navigate Identity, Intimacy and Imagination in a Digital World*. The "app generation" seems a far cry from the "blank generation"—or is it? "Blank Generation" directly parodies Rod McKuen and Bob McFadden's 1959 song "The Beat Generation," which offers a whimsical parody of an earlier, more innocent counterculture. The song also can't help but evoke The Who's anthemic 1965 "My Generation." Not long after "Blank Generation" had been written, Tom Wolfe popularized the term "Me Generation" with a cover story for *New York Magazine* in August 1976.[45] The cover featured several dozen Americans wearing yellow "ME" t-shirts, and all gesturing toward themselves. Like many cultural commentators before and after,

**9.17**
Richard Hell and the Voidoids, *Blank Generation*,
LP front cover, 1977.

Wolfe was trafficking in generation-baiting: countless examples could be cited, but a 2013 *Time* magazine cover story, "Millennials: The Me Me Me Generation," featuring a photo of a young woman posing for a selfie, offers a particularly apt example. Like many pundits then and now, Wolfe was particularly concerned that social and technological change would lead to narcissism and societal decay. He was also particularly fascinated by the metaphor of the blank space that one might fill in with a new identity—either through divorce (his primary example) or through adopting a new religion or lifestyle. According to Wolfe, if a single slogan could sum up the "Me Decade," it would be "'If I've only one life, let me live it as a _____!' (You have only to fill in the blank.)"[46] Wolfe's jeremiad was mostly aimed at white suburbanites, for whom Hell would have shared disdain. Punk had not yet registered for Wolfe, or within the larger American zeitgeist. Punk too was an identity, just as subject to co-optation as previous movements in style and music. If Wolfe's and Hell's understandings of 1970s youth culture differed, they could nonetheless find common ground in their belief in the radical malleability of social roles in the wake of the sixties. In Hell's description of the period, "The love-and-peace '60s had failed.... Everything was a lie or dead. In a way it was liberating. We had no attachments, nothing to lose. We could make ourselves up from scratch."[47] Having reinvented himself from scratch, Hell soon found himself imitated. Already by 1976, Hell recalls seeing "torn t-shirts, indirectly descended from the ones our band had originally flaunted, on mannequins in Macy's windows. It was gratifying in a way, but the point of those styles had been that they were created by those who wore them. The windows were a lesson that anything associated with a desired state gets appropriated by profiteers."[48] Nonetheless, Hell retains a sense of authenticity, which is grounded in the personality and performativity of the wearer: "clothes themselves, no matter how beautiful or interesting, are not great art; they remain decoration, unless they're actually worn, vivified into soul plumage, by an artiste of personal appearance."[49] That artiste was, of course, Hell come full circle, from the street to the Metropolitan Museum, only to disavow the value of his clothing as physical artwork. Czech's *Speech Bubble / Richard Hell*, by contrast, reveals little about the wearer other than the color of their skin. The supremely iconic original shirt, which seems only to exist in period photographs, takes on a new life. In transitioning from Richard Meyers to Richard Hell, the fill-in-the-blank individual might be the ultimate in personal creative destruction.

Christopher Wool was also directly inspired by the cover of *Blank Generation* (in this instance, the front cover, figure 9.17), and his *Untitled (You Make Me)* (1997) (figure 9.18) offers a useful comparison to *Speech Bubble / Richard Hell*. Wool's text works have sold for remarkable sums—perhaps because his texts engage viewers through provocation and humor. His *Untitled (Riot)* (1994) sold for nearly thirty million dollars—making it likely the most expensive oneworder in history.[50] His *Untitled (Fool)* (1990), another oneworder, recently sold for fourteen million dollars.[51] Wool describes *Untitled (Fool)* as "a linguistic self-portrait," but the viewer (or owner) of the work is also implicated.[52]

**9.18**
Christopher Wool, *Untitled (You Make Me)*.
Enamel on aluminum, 270 cm x 182 cm, 1997.
© Christopher Wool.

"You make me _____ " is an apt slogan for an artist whose work confronts viewers with such playful ambiguity. Wool requested Hell's permission to create *Untitled (You Make Me)*, and the two subsequently collaborated on an exhibition of minimal texts and an accompanying book entitled *Psychopts*.[53] *Untitled (You Make Me)* leaves out Hell's blank underline but retains empty space at the bottom of the painting. The "ME" can be seen to have been painted over a previous "ME" aligned with the same spacing as the one between "YOU" and "MAKE." The additional spacing between the second and third lines suggests a hesitation. The spacing below "ME," however, is too small to accommodate another word. The painting invites inversion, as if the artist is saying "I MAKE YOU." Wool's text paintings are austerely monochromatic and deploy stenciled letterforms that recall the text works of Jasper Johns and Lawrence Weiner. Glenn O'Brien remarks of Wool's word works, "It's sign painting with feedback."[54] Czech's work shares in common the feedback element, but the colorful and elaborate *To Icon* works could hardly be compared with sign painting or with the black-and-white typewriter aesthetic that characterized conceptual art and writing in the 1960s and 70s. *Speech Bubble / Richard Hell* could only have been made in the smartphone era. The multi-layered *To Icon* works are emblematic of a vastly reconfigured visual culture, and they speak powerfully to our hypermediated condition.

# 10

## "TOREVERSETHEREVERSE" Molecular Conceptualism

The title of this chapter is taken from a poem written from the perspective of a silkworm. Even more unlikely, the poem is designed to be encoded in a silk biosensor and placed under the skin of a human. In book form, these lines from Jen Bervin's *Silk Poems* look like this:

>   TOREVERSETHEREVERSE
>   BECOMESTHEWORK[1]

But they also look like the elaborate six-character-per-line helix strand of Figures 10.1 and 10.2. The lines (which quote poet and artist Cecilia Vicuña) offer a meta-reflection on the experience of the reader or critic: when I approach a work such as Bervin's, I try to reverse-engineer it in order to understand how it was created and how it might be interpreted.[2] The metaphor of reversal, in this instance, also alludes to the fourth-century Chinese poet Su Hui, who, as Bervin notes, "wrote a reversible poem in five colors of silk" that "had nearly eight thousand possible readings."[3] The line "TOREVERSE THEREVERSE" might also be heard homophonically as "To reverse their verse." In this case, we are reading a dramatic monologue meant to describe a species and its relevance to humans. The poet too is in some sense reverse-engineering how and why silkworms have evolved as they have.

Bear with me if this seems fanciful. Bervin's silk poems, like the works of Craig Dworkin and Christian Bök described below, could well be classified as a new kind of research conceptualism that draws extensively on scientific and bureaucratic data. Such works of research conceptualism, in my view, represent a significant move forward from the blanket appropriation methods of first-generation conceptual writing.[4] They place extreme demands on both their creators and their audience. These works may in part be 'pataphysical, but making that determination is often not easy, and these writers have gone to extraordinary lengths to realize these works, which are also often recursive: they record (and reverse) processes of bioinformatic composition. Far from rejecting "referentiality" or "expression" out of hand, these works suggest a complex and nuanced engagement with bioinformatics—from the microscopic code-script

**10.1**
Jen Bervin, *Silk Poem* strand, 2017.

**10.2**
Jen Bervin, *Silk Poem* strand [detail, "TOREVE / RSETHE / REVERS …" in upper left]

"TOREVERSETHEREVERSE"

of the individual chromosome to the mathematical sublimity of the human genome. We need not look far for evidence of the bioinformatic sublime writ very small and very large: All human cells (except mature red blood cells) contain a complete human genome. A complete human genome contains some three billion DNA base pairs. A typical human body consists of some 100 trillion cells.[5] "Bioinformatics" is defined by the *Oxford English Dictionary* as "the branch of science concerned with information and information flow in biological systems, esp. the use of computational methods in genetics and genomics." The National Science Foundation describes the field more narrowly as "the use of computing for the acquisition, analysis, and retrieval of biological data."[6] The emergence of bioinformatics as a field can plausibly be traced to Erwin Schrödinger's early 1940s claim that all genetic programming can be reduced to a code-script, but the word's earliest use is recorded as 1976.

*The Silk Poems* avoid (at least in theory) the anthropocentrism of conventional nature poetry in their assumption of a nonhuman narrator. The poems' deep interest in the biology and history of silk and silkworms cannot help but be addressed to a human perspective, but this interplay also suggests an ecocritical (and ecohistorical) perspective. The nanosublime is also acknowledged in the book's formatting—on each recto page, "a tiny version of the poem strand accrues progressively, apace with the reading."[7] According to Bervin, this miniature poem strand was inspired by Bob Brown's *Words*, in which "his poems disappear in plain sight, even when you're looking for them."[8]

The all-caps, no spaces formatting of the poems suggests genetic coding, reminding us that all biological reproduction requires writing, and that organisms other than humans may also be expressive of individual feelings or of the feelings of the species. The lack of spaces between words might also suggest the *scripta continua* tradition in Latin in which texts were generally read aloud.[9] The silkworm is both the agent and the medium of its own transformation:

SILK
LANGUAGE

MEDIUMS
INFINITELYLARGER

THAN
ANYINTENTION[10]

Bervin envisions not simply an imaginative communication between a silkworm narrator and a human, but also a biological exchange of information:

> HERE
> ISTHISTHING
>
> IMADEOFMYSELF
> WITHOTHERS
>
> ALIVE
> INYOU[11]

Getting under the skin here is imagined not as an annoyance, but as a bionic, curative supplement:

> CLOTHTISSUE
> BODYISSUE[12]

If we unpack this as "Here I is imagined as cloth tissue, body issue," we can begin to appreciate the recursive layers of medial complexity in *The Silk Poems*. If, as Rimbaud proposed, "je est une autre," who is the "autre" being invoked here? Not merely the silkworm, but also the species of the silkworm. Not merely the silk-cloth, but the bodily tissue (and the bioinformatic programming) that went into creating the cloth. Not merely the "I" of the author, but the "I" of the reader attempting to evaluate how well or badly the silkworm is being imaginatively ventriloquized.

*The Silk Poems*' formatting on the page and via poster and biosensor may make it difficult to recognize as lyric poetry. But one might also say that this is very much an expressive poetry for our time, which draws on the vast scientific knowledge of our era to supplement the traditional range of nature poetry. The script of the biological code is not static; it evolves at the same time that parts of its record are overwritten. To understand the metamorphoses inherent to life might help us better understand what is worth preserving. *The Silk Poems* reject any easy distinction between

> MEDIUMANDMATERIAL[13]

—as they reject any simple sense of the anthropocentric. Conceived on the nanoscale, these poems point us in another direction, toward the deep time of the interrelationships between humans and media of all varieties, both living and nonliving. *The Silk Poems* evoke both the longest of human cultural durations—the five thousand years of silk cultivation—as well as the short duration of the silkworm's thirty-day lifespan (with an additional twelve days if the silkworm is able to mate):

OUR
SHORT

PRODUCTIVE
LIVES[14]

Like Bök (whose work is discussed below), Bervin has written a love poem that draws not only on the most recent genetic research, but also on the *longue durée* or deep time of thousands of years of cultural history. At a launch event for *Silk Poems*, Bervin described the project as a "talisman of care."[15] Given liquefied silk's potential applications in health care, the poem might even help a human to (re-)imagine their own healing process. Unlike Bök's *Xenotext*, *The Silk Poems* are meant to dwell within an individual human, and thus are recursive within the life process. Poems such as these, which are embedded in human and nonhuman organisms, could not have been conceived before the discovery of DNA. More than ever we are aware, as Mary Ruefle observes of *The Silk Poems*, that "the unexpected wonder of pattern is everywhere, and that the smallest detail contains enough energy to spawn a universe."[16]

• • •

Thinking about thinking moves atoms …
Ronald Johnson[17]

Craig Dworkin's *Fact*, in its final incarnation as a poster, "records the relative molecular weights of the neurotransmitters activated when it is read"[18] (figure 10.3). Like Bervin's *Silk Poems* and Christian Bök's *Xenotext*, *Fact* employs bioinformatic data to fuse form and content—deploying the neurochemistry of perception in order to present a recursive reflection on the reading process. In effect, Dworkin attempts a new kind of site-specific poem that would take for its site the brain of the reader. *Fact* might at first seem to be a mechanistic exercise in uncreative writing—merely a mélange of scientific data that could be found online by a diligent researcher. If one attempts to reverse-engineer *Fact*, however, it soon becomes apparent that the text is far more than a procedural list of relative molecular weights.

10.3
Craig Dworkin, *Fact*. Poster, 24" × 36", 2016.

Craig Dworkin — FACT — 2016
The text below records the relative molecular weights of the neurotransmitters activated when it is read.

Voltage-gated axon scaffolds & cell-body synapses accommodating: glutamate [C$_5$H$_9$NO$_4$]: 47.75%; γ-aminobutyric acid [C$_4$H$_9$NO$_2$]: 28.85%; aspartate [C$_4$H$_7$NO$_4$]: 14.50%; sodium [Na]: 2.15%; calcium [Ca$_2$]: 1.65%; acetylcholine [C$_7$H$_{16}$NO+2]: 1.25%; nitric oxide [NO]: 1.20%; potassium [K]: 1.05%; neuropeptide Y [C$_{190}$H$_{287}$N$_{55}$O$_{57}$]: .90%; glycine [C$_2$H$_5$NO$_2$]: .65%; cholecystokinin [C$_{166}$H$_{261}$N$_{51}$O$_{52}$S$_4$]: .025%; noradrenaline [C$_8$H$_{11}$NO$_3$]: .0125%; somatostatin [C$_{76}$H$_{104}$N$_{18}$O$_{19}$S$_2$]: .0005%; alanine [C$_3$H$_7$NO$_2$], cystathionine [C$_7$H$_{14}$N$_2$O$_4$S], histamine [C$_5$H$_9$N$_3$], Substance P [C$_{63}$H$_{98}$N$_{18}$O$_{13}$S], and vasoactive intestinal peptide [C$_{147}$H$_{237}$N$_{43}$O$_{43}$S]: approx .0001%, respectively; suspicions of extracellular magnesium [Mg++]; neurotensin remnants [C$_{78}$H$_{121}$N$_{21}$O$_{20}$]; vestigial traces of oxytocin [C$_{43}$H$_{66}$N$_{12}$O$_{12}$S$_2$] & serotonin [C$_{10}$H$_{12}$N$_2$O]; indications of corticotropin-releasing factors [C$_{208}$H$_{344}$N$_{60}$O$_{63}$S$_2$]; relic enkephalins [C$_{28}$H$_{37}$N$_5$O$_7$]; fugitive endorphins [C$_{158}$H$_{251}$N$_{39}$O$_{46}$S]; vasopressin spoors [C$_{46}$H$_{65}$N$_{15}$O$_{12}$S$_2$]; the lees of secretin [C$_{130}$H$_{220}$N$_{44}$O$_{39}$], receding, washes of pre- and post-synaptic proteins; background films of adenosine monophosphate [C$_{10}$H$_{14}$N$_5$O$_7$P], adenosine triphosphate [C$_{10}$H$_{16}$N$_5$O$_{13}$P$_3$], and dipeptidyl aminopeptidase [C$_{19}$H$_{26}$N$_6$O$_3$·2HCl]; fumes, diffusive, of carbon monoxide [CO] and nitric acid [HNO$_3$]; proline [C$_5$H$_9$NO$_2$], taurine [C$_2$H$_7$NO$_3$S], & tyrosine [C$_9$H$_{11}$NO$_3$], ghosting; a residue of dopamine [C$_8$H$_{11}$NO$_2$], proleptic, depending.

Information as Material & Printed Matter, Inc. — Reading Matters — A distributed exhibition Oct. 28–Dec. 31, 2016

"TOREVERSETHEREVERSE"

The final version of *Fact* is the culmination of a project that began in 2000 and was completed in 2016 with the publication of the book *Twelve Erroneous Displacements and a Fact* together with the final *Fact* poster.[19] Each of the twelve "displacements" is a media- or site-specific work that attempts to describe the substrate of its materials.[20] Somewhat confusingly, many of the "displacements" were originally titled "Fact" individually, but were retroactively (or *ex post facto*) retitled with the publication of *Twelve Erroneous Displacements and a Fact*. Each displacement attempts to reveal the chemical composition of its constituent media in varying formats including photocopier, offset journal, billboard, smartphone touchscreen, compact disc, 16 mm film, digital video projector, and a wool rug. In so doing, the twelve displacements could be read as an elaborate homage to Dan Graham's "Poem-Schema," which was derived from a template that Graham would submit to editors of various publications, in effect creating a periodical-specific version each time it was published. Another inspiration for the *Fact* poems, though far simpler in execution and in its textual content, is Mel Ramsden's 1968 painting *100% Abstract*, which featured the text "TITANIUM CALCIUM 83% / SILICATES 17%." to refer back to the chemical components of its paint. "Poem-Schema," however, is much more complex in its implications (or displacements). As Dworkin himself writes of "Poem-Schema," it is "rigorously and recursively self-referential, the completed piece parses itself.... The result focuses attention on the most minute physical aspects of print."[21] Dworkin's displacements operate on an even more minute level, not merely describing the quantitative aspects of print publication (word count, line count, type size, etc.), but revealing the molecular composition of the physical, or even digital, artifact that conveys the specific instantiation of the text.

How factual are Dworkin's facts (or displacements)? *Twelve Erroneous Displacements and a Fact* features two seemingly irreconcilable quotes, one by Ludwig Wittgenstein at the beginning—"The world divides into facts"—and the other by Friedrich Nietzsche at its conclusion—"There are no facts, as such, only interpretations."[22] To rephrase my question with this latter quote in mind, to what extent should Dworkin's facts (or displacements) be considered interpretations? Graham claimed of "Poem-Schema" that "There is no author. There is no hierarchy of versions.... There is no composition. The contingent situation of publication determines the final form. There is no attempt to re-create or represent an authorial in-sight; there is no interior."[23] For Graham, "Poem-Schema" "defines itself in place only as information with simply the external support of the facts of its external appearance."[24] Graham seemed to foreclose the possibility that an editor's site-specific adaptations to "Poem-Schema" would rise to the level of interpretations; rather, he aimed for editors to mechanistically reconfigure "Poem-Schema" according to the preexisting protocols of a given publication. By the standards of "Poem-Schema," Dworkin's "facts" seem more like interpretations. But is it the author who is doing the interpreting/reading? Or is another reader implied? Are we (as readers) reading the poem? Or is the poem reading us?

One indication that Dworkin's multiple "Fact" poems are not completely accurate in their facticity is the manner in which he reprinted the first published "Fact," which appeared in *Chain* in 2005 and subsequently in *Poetry* in 2009 (figure 10.4). The two versions are nearly identical, with the exception of the page size specified. Had Dworkin conducted exactingly precise research on the chemical composition of the paper of each of these magazines, he almost certainly would have produced varying results—surely the ink and paper of the two publications could not have been identical. Obtaining the precise details of the chemical composition of manufactured products is difficult on multiple levels: such data is often considered proprietary by the manufacturer, and such data would also likely be difficult for a nonspecialist to interpret.

**10.4**

Craig Dworkin, "Fact," *Chain* 12 [first published installment], 2005.

Another indication that the "Fact" poems are not merely "the external support of the facts of [their] external appearance" is Dworkin's rechristening of them as "displacements." The *OED* offers two main definitions of "displacement": "The occupation by a submerged body or part of a body of a volume which would otherwise be occupied by a fluid" and "The action of moving something from its place or position." Rather than classify the "Fact" poems by way of elaborate claims to their site- or place-specificity, Dworkin has negatively reclassified the poems as incapable of approximating the physical data of their publication venues—not unlike Robert Smithson's notion of a "non-site," in which the artist attempts to recreate the site-specificity of an external landscape within the confines of a gallery or museum.

The "Fact" poems also have an audio dimension that is worth noting: when Dworkin reads the poems aloud, he tends to read them quickly, and not to say the full names of the chemical symbols.[25] This reading makes the texts seem more formulaic and procedural than they really are. The effect is a bit like reading the ingredients label on a processed food item: the further one goes down the list, the more exotic and bafflingly complex the ingredients become. What effects those ingredients might have on one's physiology is not easy for the average person to ascertain. One might also note redundancies in the text; the name of a compound may partially overlap with its abbreviation—for instance, in the final poster version of *Fact*: "suspicions of extracellular magnesium [Mg++]." This begs the question: Who is doing the suspecting here? According to Wikipedia, "Magnesium can affect muscle relaxation through direct action on cell membranes. $Mg^{2+}$ ions close certain types of calcium channels, which conduct a positively charged calcium ion into neurons. With an excess of magnesium, more channels will be blocked and nerve cells will have less activity." Are we to assume (or suspect), then, that *Fact* is causing our muscles to relax? But are there other countervailing neurotransmitters? The first half of the final version of *Fact*, it should be noted, specifies relative neurotransmitter weights by percentage, from greatest to least. The second half of the poem, by contrast, does not specify weights and so is no longer organized by quantity. Rather, the author seems to apply a nonhierarchical ordering to imagine in any order what compounds play a role in the reading process. The use of semicolons and periods to separate compounds plays a role in how each compound is described and differentiated. Dworkin also ascribes some limited significance to the compounds by means of qualifying adjectives or descriptors, for instance: "fugitive endorphins [C158H251N39O46S]." The preceding molecular formula, according to the National Institutes of Health, corresponds to human beta endorphin, "a 31-amino acid peptide that is the C-terminal fragment of BETA-LIPOTROPIN," which "acts on OPIOID RECEPTORS and is an analgesic."[26] Nowhere can I find the word "fugitive" connected to this endorphin other than in *Fact*—perhaps there is a micro-joke here in that the compound cannot presumably be measured or specifically located, but somehow its effects can be intuited or recalled. Is the poem acting on the opioid receptors

## PHARMACIE DU SOLEIL

calcium iron hydrogen sodium nickel
magnesium cobalt silicon aluminium
titanium chromium strontium manganese
vanadium barium carbon scandium yttrium
zirconium molybdenum lanthanum niobium
palladium neodymium copper zinc cadmium
cerium glucinum germanium rhodium silver
tin lead erbium potassium iridium
tantalum osmium thorium platinum tungsten
ruthenium uranium.

23

**10.5**
Harry Crosby, "Pharmacie du Soleil," 1931.

of the reader? If so, how is the poem eliminating pain? And given that there are some thirty-five different neurotransmitters listed in the poem, could that pain-relieving effect be canceled out by other neurotransmitters?

One possible inspiration for the "Fact" poems could be Harry Crosby's "Pharmacie du Soleil" (figure 10.5), which makes for an interesting comparison. Published in 1931, Crosby's poem is simply a list of forty-four elements. One might expect that these are elements that compose the sun, except that helium, the second most plentiful element in the sun, is notably absent. Perhaps "pharmacie" is meant to suggest that these are chemical components of drugs or alchemical compounds, but there is no indication what specific role, if any, each element plays. Nor does there seem to be any particular sequence to Crosby's elements. The "Fact" poems, by contrast, are far more precise, particularly where quantities are assigned to chemical compounds.

And what about the temporality of *Fact*? Are all of these neurotransmitters being released at once? Or does the poem follow an order not just of importance (or weight), but of sequence? Perhaps the poem's concluding two words—"proleptic, depending" (which are not assigned a molecular formula)—allude to this difficulty. From the perspective of the author, all readings of the work occur in the future. The present-tense participial construction of the poem from its first verb—"accommodating"—to its last verb—"depending"—suggests that the poem must act as a feedback loop in the mind of the reader, and yet the text is fixed, and cannot record the specific data of each readerly encounter. Mood could also play a role in each reading. If the reader is in a good mood, would there accordingly be a greater or lesser quantity of a given neurotransmitter? Or say the *Fact* poster is on the wall of a reader who sometimes ignores the text and sometimes becomes absorbed in it. Does it matter if the reader skims the text? Or what if the reader spends weeks reverse-engineering the text in order to find Dworkin's sources and their significance? Perhaps at that point, the reader will be exhausted or frustrated, and will have activated a different blend of neurotransmitters.

One way to read the "Fact" poems would be to take them as a parody of naïve materialism or of neuroscientific determinism—or what Carlo Umiltà and Paolo Legrenzi refer to as "neuromania." The historian of science Steven Shapin suggests what is at stake when he defines "neuromania" as

> the tendency to go beyond identifying the neural *bases* for beliefs and sensations to the claim that beliefs and sensations *really are* their neural bases. The first claim is unexceptionable: *of course*, sensations are the result of interactions between our neural structures and things in the world and elsewhere in our bodies. In this sense, neuroscience has begotten a set of *pleonasms*—using more words than necessary to convey a specific meaning—and these pleonasms have metastasized through contemporary culture. Insofar as our mental life is neurally based—and who now doubts that?—neuro-whatever might just be a potentially useful way of reminding us of this fact: "neuroaesthetics" *is* aesthetics; "neuroethics" *is* ethics; "neuromarketing" *is* marketing; "neuroeconomics" *is* economics—even if traditional practitioners of aesthetics,

ethics, and the like have not routinely had much to say about which areas of the brain "light up" when we see a beautiful painting, do a good deed, or buy a new car, and provided that we appreciate that what "goes on in the brain" includes what people know, remember, feel, and feel to be worth their attention.[27]

Even if we have precise data about the relative presence of neurotransmitters, we are still far from knowing how those neurotransmitters influence the creation and perception of aesthetic artifacts. *Fact* might be considered an example of "neuropoetics," except that all poetics could be considered "neuropoetics." Perhaps this renders the question of the factuality of *Fact* somewhat moot. Even if the information recorded were "accurate," how would a reader draw conclusions about their mental processes from that information?

Another way to read *Fact* (the fact-check method, perhaps) would be to exhaustively trace the effects of each of the neurotransmitters listed. What does it mean to poeticize such "raw data," as opposed to conveying it as matter-of-factly as possible? *Fact* invites, but also thwarts, specialized reading. To fully evaluate the poem, one might need to consult experts from the fields of neuroscience (or cognitive science), endocrinology, philosophy of mind, aesthetics, etc. It would be instructive to know how such experts might react to the work. Perhaps they would immediately recognize *Fact* as poetry; perhaps they might not recognize *Fact* as poetry or artistic writing at all. Or perhaps there might be a third way, and *Fact* might be read as what Christian Bök refers to as "surrational," as a 'pataphysical test of the limits of art and science. As Bök puts it in a nice chiasmus, "If poetry has failed to oppose science by being its antonymic extreme, then perhaps poetry can attempt to oppose science by being its hyperbolic extreme."[28]

Perhaps any attempt to philosophize how *Fact* does or does not pertain to "truth" or "factuality" may be fated to reproduce the circularity of the perceiver's relation to the text. What is the "truth" value of identifying and verifying the compounds that make consciousness possible? In the conclusion to the recent volume *Neuroscience and Philosophy: Brain, Mind, Language*, Daniel Robinson writes:

> The cosmos is ablaze with facts, the great plurality of them beyond our senses and even our ken. Out of that fierce and brilliant fire, we pull a few bits—the visible or nearly visible ones—and begin to weave a story. On rare occasions, the story is so systematic, so true to the bits at hand, that other stories flow from the first, and then others, and soon we are possessed of utterly prophetic powers as to which ones will come out next. It is the philosopher, however, who must put the brakes on the enthusiasms of the storytellers, for, left to their own devices, they might conjure a future that vindicates only our current confusions.[29]

Adapting Robinson's terms slightly, one might suggest that poets and storytellers can also offer us skeptical versions of our supposed mastery of the technical phenomena that underlie consciousness. And yet that skepticism, to be of interest, cannot simply reject scientific knowledge altogether.

The philosopher Michael Lynch has recently coined the term "neuromedia" to describe "a society where smartphones are miniaturized and hooked directly into a person's brain. With a single mental command, those who have access to this technology ... can access information on any subject."[30] Lynch cites Google cofounder and CEO Larry Page, who in 2004 predicted, "Eventually you'll have an implant, where if you think about a fact, it will just tell you the answer."[31] In a sense, Page's vision offers the ultimate in demediation—gone is a visual or aural interface, replaced by some form of direct-to-brain access to information. Implicit in Page's vision is an authoritative source of factual information. Google presumably would still play a role in verifying and delivering the facts.

What constitutes a fact in the era of "alternative facts" seems to be a question conveniently left out of the vision of neuromedia. As *Fact* demonstrates, knowledge is embodied and emotional, or as the title of Yvonne Rainer's autobiography would have it, "feelings are facts." Joshua Shannon has recently proposed the term "factualism" to refer to conceptual art's fascination with factual documentation in the 1960s. According to Shannon, conceptual artists, "whatever their rhetoric, hated facts as much as they loved them. They were certainly as interested in facts' emptiness as they were in their authority or power.... What matters to us in retrospect is that these artists were, in a rather complicated way, taken with facts, critically preoccupied with the apparently changing orientation of their society."[32] Shannon describes this factualism as resulting in a "weird stringent realism": "While in the broader culture facts generally served as evidence for rational, if not moral, conclusions, the facts that most interested these artists were insignificant, often absurdly so."[33] Shannon's account of "factualism" dovetails well with *Fact*'s exploration of a realism of (supposed) factual detail that verges on the absurd. For Shannon, "While we might say ... that [conceptual] art *resisted* the factual orientation of the culture at large, it would be more accurate to see it as an effort to strain that empiricism through art's traditional non-instrumentality."[34] Here again *Fact* comes full circle: it recursively places in doubt the nature of empirical knowledge by foregrounding the deep entanglements of processes of cognition, mediation, and perception.

• • •

Dissolve, thou too, too solid sense!
Melt into nonsense for a season,
Then in some nobler form condense.

—James Clerk Maxwell, "Molecular Evolution"[35]

poetry=living organism. metaphors=cellular unities of poetry. x=atomic elements of metaphors.

—Ulises Carrión, "Conjugations"[36]

The Xenotext project has now been underway for fifteen years, and may be the most laborious work of constrained writing since Georges Perec's *La Vie mode d'emploi*. The two central sonnets of *The Xenotext*, according to Bök, required four years to write, during which the author tested out some eight billion possible combination code scripts in order to create two mirrored sonnets that can be translated into the GCAT code of DNA. Each 14-line sonnet includes 40 words and 132 letters. The extraordinarily ambitious medial requirements of *The Xenotext* necessitate that its encoded text be minimal (although the project has spawned additional paratexts). If minimal poetry has often been derided for being too easy or deskilled, that charge cannot be made of *The Xenotext*. As Michael Leong writes in a perceptive article in *The American Scientist*:

> rather than being an example of deskilled poetry, *The Xenotext: Book 1* is hyperskilled: The complex structures that appear throughout the book, which include an extended anagram that is also a double acrostic, assure readers that high concepts and manual virtuosity can go hand in hand. Few poets have the technical excellence (or the patience) to pull off such feats, and in doing so Bök proves that he is as skilled at encoding extra layers of meaning into a poem as he is at encrypting poetry into DNA. Moreover, *The Xenotext: Book 1* is an example of what I would call *reskilled* poetry, one that insists that writers learn new capabilities to respond to the complexities of 21st-century life.[37]

Despite the extraordinary skill and effort put into *The Xenotext*, the project places human authorship in question on multiple levels. It is arguably a suprahumanist text, in the sense that it fulfills all of the humanist goals of creative expression: it is enduring, it is meaningful, and it is universal in its implications. But *The Xenotext* is also both posthumanist and postvital—it is self-reflexive to the extent that (when it is realized) it takes on an existence independent of digital and print media, and it imagines an alien or unknown reader. As Darren Wershler writes, "At the heart of the Xenotext Experiment is a set of basic problems about the nature of communication itself.... The idea of using bacteria to communicate with alien intelligences merely underlines problems that are always present in any communicative act: the risk of reaching out, and the real possibility of failure."[38] Indeed, *The Xenotext* has yet to succeed according to the terms set by its author, who offered this remarkable assessment of the project at MIT:

> I managed to get the project to work properly and definitively in a sample of E. coli. I did this several years ago in an effort to demonstrate proof of the concept so that I'd be able to then gain permission to work on the extremophile bacteria. I had to be able to demonstrate sufficient aptitude to engineer a well-understood organism. The extremophile is much more difficult to engineer, and there isn't as much expertise in the world that I can call upon to help me with it. Moreover, it's expensive to conduct any of these assays. It took me several years of work; I kept failing in E. coli, and I finally got it to work. I wish I had stopped there and said I'm the first poet in history ever to get a bacterium not only to store a poem but write one in response, because then I would get to be probably one of the most famous poets of my generation—and as it stands right now I'm maybe in the top five.[39]

Characteristically, Bök delivered this parting observation in a modest, deadpan tone, and his audience seemed not to react strongly to his claim that he might be the most famous poet of his generation had he only chosen to wrap up the experiment earlier. Among other angles that it can be approached from, *The Xenotext* might be described as a loving satire of literary immortality in a time of apocalyptic global warming and pandemic species extinction—or what Bök refers to as "the omnicide of the world."[40] Being a famous poet won't mean much if there are no humans left to read; one solution to this conundrum could be to write for nonhuman readers. Bök makes much of *The Xenotext*'s failure to replicate, but failure is endemic to love poetry. A queer (or, in Charles Bernstein's term, *'pataqueerical*) reading of the poem might place in question *The Xenotext*'s definition of success. As Jack Halberstam argues, "success in a heteronormative, capitalist society equates too easily to specific forms of reproductive maturity."[41]

For a futuristic text aimed at human and nonhuman readers alike, *The Xenotext* is surprisingly traditional in many of its aspects. *The Xenotext* sonnet proper (as opposed to the many paratexts generated by the project) employs no word longer than five letters, and yet much of its vocabulary is portentous. The opening couplet of "Orpheus" points to this seemingly antiquarian formalism:

> Any style of life
> is prim[42]

Prim, in the sense of being "stiffly formal," describes well the tone of the poem. And yet the poem reminds us that all of life is built out of ancient patterned structures. Life has a style, not only in how we choose to live it, but in how our bodies are written by and through underlying code-scripts. The poem continues with Orpheus invoking his fate as it is intertwined with the fate of species:

> o stay
> my lyre
>
> with wily ploys
> moan the riff
>
> the riff
> of any tune aloud
>
> moan now my fate
> In fate
> we rely
>
> my myth
> now is the word
>
> the word of life[43]

The "stay" of the first line might be taken both to summon the lyre to allow the beloved to "stay," and to suggest a "stay" of execution. In Nikki Stillman's reading of the poem, "The singer thus enjoins his lyre, a metonym for its counterpart technology, *D. radiodurans*, to impede ('stay') the flow of his song, ensuring its biological and aesthetic permanence through its submission to inherited, chemical rules."[44] The registers of this beguilingly simple poem are multiple: the musical mythography of Orpheus and Eurydice; the tragic romance of the doomed couple; the identification of the poet with the lyre that makes lyric poetry possible; the Christian sense of "the book of life" or the Gospel of John's "In the beginning was the word." *The Xenotext* in some sense is an archive not only for storing a poem, but for pointing to the fragmentary textual history of classical civilization.

The "xeno" in *Xenotext* can be read in several ways. Orpheus is literally a *xenos*, or foreigner, in the underworld. Like aliens in other contexts, he must follow the letter of the law or risk deportation. The *xenos*, in Bök's terms, "enters the underworld, testing its hospitality, expecting the Greek edict of *xenia* (of 'offerings') to be honoured."[45] The poem, in this sense, is the foreigner and the microbe is the host. Bök himself, like Dante's Virgil, takes on the role of *xenagogue*, the one who guides readers through this alien world. Note here that we have moved from the register of the lyric to the epic. It is difficult to know what future volumes of the *Xenotext* project will contain, but it is striking that the "Orpheus" and "Eurydice" sonnets, which are the raison d'être of the entire project, are omitted from *The Xenotext: Book 1*. One rationale for the omission could be that the poems' true medium is DNA. Another explanation would be that Bök is constructing an ongoing epic, with many of the features common to epic poetry. Book 1, for instance, begins with an invocation to "Wraith and Reader," and takes us back *ab origine mundi*, not merely to the Abrahamic creation story, but to the Big Bang. Contrary to the poet's evocative name, he is creating a secular scientific epic, which is still only *in medias res*. *The Xenotext* can also be read as an ecocritical epic. One-third of *The Xenotext: Book 1* is given over to a tour de force constrained translation of Book IV of *The Georgics* of Virgil entitled "Colony Collapse Disorder."

Like *The Silk Poems*, *The Xenotext* exhibits the close relation between the nanosublime and the cosmic sublime:

> ... such a poem might begin to demonstrate that, through the use of nanoscopic, biological emissaries, we might begin to transmit messages across stellar distances or even epochal intervals—so that, unlike any other cultural artifact so far produced (except perhaps for the Pioneer probes or the Voyager probes), such a poem, stored inside the genome of a bacterium, might conceivably outlast terrestrial civilization itself, persisting like a secret message in a bottle flung at random in a giant ocean.[46]

*The Xenotext* may stretch the loosened definition of a minimal poem offered in my introduction, but without spaces the entire poem would fit in a single 140-character tweet. We take messages to be discrete, intentionally directed communications, but

*The Xenotext* is aimed beyond us toward what we cannot comprehend. As language-using organisms, we tune out most of the biological processes that make communication and memory possible. Nathan Brown writes of the complex intertwining of existence and cognition:

> If the phenomenon of "life" seems self-evident, while its concept remains unthinkable, perhaps that is because life is an occlusion of the symmetrical relation between thinking and being, that which intervenes between existence and cognition. Writing is the record of that occlusion, by which it is both exposed and effaced. By way of a detour through "life," being writes itself as thought; thought writes itself as being. The medium of this detour, "life" is that occlusion which cannot think the very concept of its existence.[47]

Here again, thinking and writing are recursive processes that occur within embodied organisms. Humans are an exceptionally successful life form whose greatest threat is to themselves. *The Xenotext* makes our selves foreign to ourselves—and whether the project is of enduring significance may be "proleptic, depending" on the fate of the species.

Bervin, Dworkin, and Bök have written ambitious odes to the complexity of our developing scientific understanding. Bern Porter, trained as a physicist, referred to such works as "scipoe," and suggested that poetry might be as amenable to technoscience and futurology as works from the science fiction tradition.[48] At least until the Enlightenment, poets envisioned that scientific discovery could be comprehensively chronicled through verse epics such as Erasmus Darwin's *The Loves of the Plants* and Phineas Fletcher's *The Purple Island*. Under today's conditions of specialized scientific research, it would be difficult for any poet to create such an overarching scientific epic, and yet Bervin, Dworkin, and Bök have produced works of "scipoe" that would have been unthinkable thirty years ago. If these works are unusually difficult, that is in large part because they aspire to be state-of-the-art reflections on some of the most pressing scientific and ethical challenges of the twenty-first century.

# 11

## Minimal Maximalism

> NOW "there is no such thing as repetition" in *The Making of Americans*, because I deleted it. Herein, every word and punctuation mark is retained according to its first (and hence last) appearance in Gertrude Stein's 925-page edition of the book.
>
> —Holly Melgard, *The Making of the Americans*

Holly Melgard's *The Making of the Americans* reduces Gertrude Stein's epic to about 1 percent of its original length—beginning with 517,027 words and ending up with roughly 5,600 words. Whereas it took the wealthy and well-connected Stein fourteen years to find a publisher for her modernist masterpiece, Melgard's reduced version was self-published instantaneously on Lulu.com at no expense to the author. As Joey Yearous-Algozin, Melgard's coeditor (with Chris Sylvester) of the print-on-demand press Troll Thread, writes of POD publishing: "More than simply providing new channels through which to disseminate texts, this shift in platform has allowed for a simultaneous shift in scale.... [D]igital publishing allows for experiments in volume, with poets literally testing the physical limits of what we call the book."[1]

The rise of online publication has allowed experimental writers to publish countless texts that would not otherwise be publishable; it has also inspired writers to experiment with new forms of literary compression. Like many of the works described in this book, Melgard's *The Making of the Americans* adapts preexisting material in order to explore questions of scale, as well as of mediation. As Melgard's version proceeds, it becomes increasingly entropic, and loses its syntactical structure. Consider the famous sentences that begin the Martha Hersland section of *The Making of Americans*:

> I am writing for myself and strangers. This is the only way that I can do it. Everybody is a real one to me, everybody is like some one else too to me. No one of them that I know can want to know it and so I write for myself and strangers.
>
> Every one is always busy with it, no one of them ever want to know it that every one looks like some one else and they see it. Most every one dislikes to hear it.[2]

The corresponding passage in Melgard's version reads: "Dislikes readers comparing classifying descriptions reminds resembling commences ears sounding mixed-up."[3] These eleven words in fact take us through the next three pages of Stein's novel, and they could almost serve as an avant-garde *ars poetica*. Perhaps Melgard—as the name of her press implies—has in effect "trolled" her readers, as well as Stein's readers.[4] Rather than "a History of a Family's Progress," as Stein's subtitle promises, we are reading something more along the lines of a narrative of a family's dissolution. *The Making of Americans*, we might recall, was written before Stein's acrimonious split with her brother Leo, and although the Steins might have been made in America, they chose not to live there. Stein's pro-assimilationist, secular novel might after all have been more about Americans like herself than it was about all Americans. Melgard's version adds only one element (other than the epigraph) to her source text: the definite article "the" inserted into the title. This addition qualifies Stein's original title, and restricts the range of reference (paradoxically) from all Americans to some Americans. The effect of this "the" is somewhat analogous to Donald Trump's use of the phrase "the African Americans," which a linguist has remarked sounds racist because: "Neither candidate [Trump or Clinton] refers to the general American public as 'the Americans'—to do so would be deeply weird, since it would seem like they did not include themselves in the group."[5] Similarly, Melgard's insertion of "the" complicates Stein's narrative of assimilation.[6]

*The Making of the Americans* may seem simple to execute, and in the digital era perhaps it is, but it would have been a colossal undertaking to create a complete concordance of *The Making of Americans* without a computer; such a project might conceivably take years. If *The Making of the Americans* employs find-and-replace and POD to offer a reduced version of an epic tome, Melgard's *Black Friday* offers up instead an expansive tome that contains no words for 744 pages, the maximum number of pages allowable on Lulu, and is printed completely in black. Published on Friday, November 23, 2012, the book makes obvious reference to what is generally considered the busiest shopping day of the year in the United States—the day after Thanksgiving. Weighing almost four pounds, and almost certainly a money loser for Lulu at forty-two dollars (for the hardcover version), the book's order page features a single unsigned blurb: "HOW TO SHIT WHERE YOU EAT. HOW TO SHIT WHERE YOU EAT. HOW TO SHIT WHERE YOU EAT."[7]

Although the pages of *Black Friday* are intended to be black, the two copies I've seen have differed considerably in their coloration, and are far from a deep black. Rather, the pages appear in shades of grey, often with a white border, which varies in width. In some respects, *Black Friday* is like a low-budget inversion of Tauba Auerbach's 2011 three-volume *RGB Color Atlas* series, each codex book of which contains 3,632 pages designed to reproduce all of the colors of the RGB spectrum.[8] Auerbach's three artists' books are elaborately produced in limited numbers, each a perfect cube of

8" × 8" × 8", whereas *Black Friday* could be described as an assisted D.I.Y. project. Another comparable Lulu publication, Jean Keller's *Black Book*, contains the exact same number of pages in black, and was published in 2010. Keller's description of the project is revealing:

> Ink used for digital printing is one of the most precious substances in the world. A single gallon of ink costs over four thousand dollars and this is one reason why digitally printed books are so expensive. However, the price of a book is not calculated according to the amount of ink used in its production. For example, a Lulu book of blank pages costs an artist as much to produce as a book filled with text or large photographs. Furthermore, as the number of pages increases, the price of each page decreases. A book containing the maximum number of pages printed entirely in black ink therefore results in the lowest cost and maximum value for the artist. Combining these two features, buyers of *The Black Book* can do so [that is, buy the book] with the guarantee that they are getting the best possible value for their money.[9]

Though slightly smaller in size than *Black Friday*, *Black Book* poses some of the same questions with regard to the book as a utilitarian object. Keller offers a compelling case for the value inherent in his book, but it and *Black Friday* remain books that can be produced at any time—provided that the book does not violate Lulu's terms of service. As such, it seems that little to no value can accrue to the works as unique art objects. A "black book" is meant to contain names of those under suspicion, whereas a "little black book" is meant to contain contact information for potential romantic partners. Keller's *Black Book* is only 5.83" × 8.63", but it is almost as thick as it is wide.[10] Are works such as *Black Friday* and *Black Book* literary works? Or art objects? Or experiments in extreme media publication? Perhaps they are none or all of these. POD makes possible books that would not be economically feasible if they were offset printed. Such texts bypass traditional channels for poetry and art book publishing, and are generally given away for free as pdfs; typically, no profit accrues to the author when they are printed as physical books.

Like Melgard, Nick Montfort creates works that are both maximal and minimal in scale. His *Nanowatt* and *Megawatt*, for instance, draw upon Samuel Beckett's *Watt* in order to expand and contract the text of the novel. Montfort has also used the POD format to produce books that would otherwise be difficult to print offset. His *Autopia*, for instance, published by Troll Thread, is a 256-page book generated entirely from automobile names, which function as nouns and verbs, and are organized into complete sentences. The effect is a bit like a demolition derby of brand names, for example: "GRAND CHEROKEE RAMS DIPLOMATS."[11]

The title of Montfort's *#!* is shorter even than Louis Zukofsky's *"A"* (if one includes the quotation marks, as is customary). And even Andy Warhol's *A, A Novel* has a subtitle. Pronounced "shebang" (as opposed to "hashtag") the two characters "#!," characteristically for Montfort, expand into something larger than the sum of their parts. Four

of the poems in *#!* are thirty-two-character Perl programs drawing on alphabetical sequences (or abecedaria) that in turn point backward to a long tradition of procedural poems that draw on the complete alphabet (or an extended version of the alphabet). Here is the code for "Alphabet Expanding"—

{print$,=$"x($.+=.01),a..z;redo}

—which generates in print a text that (twelve pages in) looks like Figure 11.1, but which in its digital version can vary greatly depending on the computer one uses. In print, the poem, as it expands, can't help but recall Apollinaire's "Il Pleut." On a demonstration video that captures the poem running on a Windows computer, the poem resembles a blizzard of white letters on a black background. As the poem progresses, fewer and fewer letters appear, and strange looping effects can be observed.

Montfort makes media and platform specificity integral to his code works, and insists that in order for his work to be fully read, readers should familiarize themselves with his process and run his programs, which are available for free. Writing of another book of code poems, *2×6*, which plays on the binary language of gender in English (and five other languages), Montfort recommends that the poem "The Two" can be only partially appreciated in book form:

> However simple it is, "The Two" is for readers. Those who simply view the output, noting some of the words and phrases, looking at the window as if it were a screensaver and not bothering to truly read—those who don't attempt to figure out how to interpret the stanzories—walk or click away as empty as they arrived. And since translation is the ultimate reading, perhaps "The Two" finds its ultimate reader in a person who reads by translating the system to another language.[12]

I would supplement Montfort's last sentence slightly (and somewhat self-interestedly) to suggest that another kind of ultimate reader could be the critic or the media theorist. The type of reading Montfort is suggesting here is not merely close reading or textual analysis, but rather a larger and more encompassing attempt to come to terms with multiple (human) languages, as well as to understand the effects of machine languages and of the platforms that run those languages. And yet, as Montfort notes in an almost humanistic vein, code poems can also be "truly read" for enjoyment, as well as for the challenge of learning to create, execute, and reverse-engineer them. John Cayley has convincingly made this point both in his important essay "The Code Is Not the Text" and in his review of *#!*.[13]

Procedural poems that are constructed of the entire alphabet, or which sequentially repeat the letters of the alphabet, have a long history, likely originating with Louis Aragon's 1920 "Suicide."[14] That poem, like Montfort's "ASCII Hegemony," implies a determinism in which letters (and symbols) exert dominance over the semantic content that they are meant to convey. "ASCII Hegemony" merely repeats the entire ninety-five (printable) characters (including the space bar) of ASCII. In its print version, the poem

```
 y z a b c d e f g h i j k l
 m n o p q r s t u v w x y z
 a b c d e f g h i j k l m n
o p q r s t u v w x y z a b
 c d e f g h i j k l m
n o p q r s t u v w x y
z a b c d e f g h i j
k l m n o p q r s t u v
 w x y z a b c d e f g
 h i j k l m n o p q r s
 t u v w x y z a b c d
 e f g h i j k l m n o p
 q r s t u v w x y z a
 b c d e f g h i j k l
m n o p q r s t u v w x
y z a b c d e f g h i
j k l m n o p q r s t u
v w x y z a b c d e f
g h i j k l m n o p q r
s t u v w x y z a b c
d e f g h i j k l m n o
 p q r s t u v w x y z
 a b c d e f g h i j k
l m n o p q r s t u v w
x y z a b c d e f g h
i j k l m n o p q r s t
u v w x y z a b c d e
f g h i j k l m n o p q
r s t u v w x y z a b
c d e f g h i j k l m n
 o p q r s t u v w x y
z a b c d e f g h i j
k l m n o p q r s t u v
w x y z a b c d e f g
h i j k l m n o p q r s
t u v w x y z a b c d
e f g h i j k l m n o p
 q r s t u v w x y z . . .
```

**11.1**

Nick Montfort, "Alphabet Expanding," 2014.

MINIMAL MAXIMALISM

is set in sixteen-character lines, and each page is identical (except for the first and last pages). Like "Alphabet Expanding," the poem is limited to twelve pages in print, but is theoretically infinite in its digital form.

Using an alphabetical constraint, Montfort has also paid homage to Aram Saroyan's ©*1968*, or as it is more commonly known, "Ream" or "A Ream."[15] Like *Black Friday*, ©*1968* contains no text other than its title (although arguably it has no title, only a copyright notice). ©*1968* is merely an unopened 500-page ream of typing paper that was stamped with Saroyan's name, the copyright symbol and date, and the name of the publisher, Kulchur Press. Montfort's *Digital Ream*, written in HTML, offers 500 single words in sequence, each on a black background.[16] Initially composed in a single day on a ream of paper, Montfort's *Ream* and its later digital version may in fact be more similar structurally to Saroyan's *Cloth: An Electric Novel*, which also presents one word per page in a fixed sequence.[17] *Digital Ream* is designed to only move forward one click at a time, and thus to read the poem requires 500 clicks (unless one awkwardly enters URLs manually into the browser).

**11.2**
Screenshot from *Digital Ream*, 2006.

The best approach to *Digital Ream* might be to read it as a comedic work that parodies both its composition process and its own mediation. *The Digital Ream* "About" page tells us the following:

1. *Ream* is a 500-page poem.
2. The writing of *Ream* was entirely imagined and executed on one day: April 5, 2006.
3. On each page of *Ream* a single, one-syllable word appears, centered, in ordinary, 14-point type.
4. Page numbers do not appear on any of the pages and are unnecessary, since the words are in alphabetical order.
5. Pages 1–51 recapitulate Poe's "The Raven."
6. The sexy part starts shortly after page 230.
7. *Ream* can be read aloud in 12 minutes.[18]

Allow me to attempt to unpack and annotate this playful paratext. Ream seems not to be an algorithmically generated poem, but rather Montfort seems to have chosen the individual words in alphabetical order from a dictionary. Composing the poem in a day could parody the supposed realism of a work such as *Ulysses*, whose contents record a single day, although the novel required seven years to write. Ream is the antithesis: a kind of slacker-stoner stack of paper, and its web version the most basic of HTML file structures: one word per page (figure 11.2).

It is difficult to know precisely what Montfort means when he claims that the first fifty-one pages "recapitulate 'The Raven,'" since those pages do not seem to correspond in any specific way to the narrative of the poem. One might suggest, however, that Poe's essay "The Philosophy of Composition" recapitulates "The Raven," and that these fifty-one pages, or lines, could be a recapitulation of a recapitulation of how a constrained poem comes into being. "The Philosophy of Composition" undermines Romantic notions of poetic inspiration, instead suggesting a logical, procedural process that centers on the single word "nevermore"—a word that Poe indelibly stamped as his own. (Georges Perec also recapitulated a version of "The Raven" in his *La Disparition*—omitting the letter *c*.) Whether or not the account presented in "The Philosophy of Composition" records Poe's composition process accurately, it does reveal how a single word can take on exceptional mnemonic power. In *Digital Ream*, by contrast, it is difficult for individual words to stand out, particularly because so many of the words are common and are undifferentiated in their placement. Here are the fifty-one words/pages in *Ream* that (supposedly) correspond to "The Raven":

ache / adds / aim / airs / all / are / art / as / at / bars / base / bawls / beach / beams / bear / beats / bells / bend / bent / big / birds / blab / black / blank / blaze / bleak / blear / blind / blood / blots / blue / blunt / blurs / blurt / bones / books / bore / both / brains / breath / brews / brief / bright / buds / bulbs / burn / busts / buzz / by / carved / chairs

MINIMAL MAXIMALISM

Are these the words that Montfort selected as most evocative of "The Raven"? Given the compressed time scale of *Ream*'s composition, should we not puzzle too much over this? After trying to derive messages from these 500 pages (for twelve minutes), the reader might be tempted to shout "nevermore," and abandon any attempt at sense-making—which might not be an invalid way to read the work. There is something undoubtedly troll-like about a poem written so quickly that withholds syntax and normative meaning. An accumulation of monosyllabic words in English may inevitably devolve into lewd innuendo, as Montfort suggests in describing the second half of *Ream* (or, more precisely, "shortly after page 230") as "the sexy part." "Ream" in English has referred to a 500-page bundle of paper since at least the sixteenth century. As a verb, "ream" can also suggest to bore a hole, or, according to the *OED*, in North American slang, "ream" can mean to "criticize or rebuke someone" or to "have anal intercourse with." Whether these senses of "ream" pertain, I leave to the reader/viewer. Montfort's own performance of *Digital Ream* in a video online gives little indication as to how the poem is to be interpreted. The author reads the poem at a desk without an audience; he reads each page quickly and without expression; his rapid turning of the pages makes a shuffling sound as he reads. There would seem to be little "sense" to be derived from the individual words or their specific sequence.

**11.3**
*Digital Ream/Rame*, trans. Anick Bergeron, 2008.

Like many of Montfort's projects, *Digital Ream* has generated offshoots and collaborations. Anick Bergeron's French version of the poem, *Rame*, describes itself as an "adaptation" rather than a "translation."[19] Rather than translate the "sens" of *Ream*, Bergeron attempts to adapt the constraints into a new work. To do this, she in fact created two versions: a human-translated version called *Rame* in which she chooses words that correspond (loosely) to Monfort's constraints, and a *Rame Numérique* that proceeds by a fixed mathematical formula. Although alphabetical ordering is retained in both, Bergeron's versions differ considerably from Montfort's. In the Flash interface, both Bergeron's and Montfort's versions can be compared word for word (figure 11.3). At about halfway through the text, where Montfort's version reads "light," Bergeron's reads "nous"—perhaps an allusion to the Greek *nous*, evoking Neoplatonic notions of light associated with the noumenon, or what exists beyond the senses. The display of the text is eminently minimal, in black and white, and the effect of these juxtapositions may suggest that translation becomes nearly impossible in the absence of syntax or specific meaning. Though created in collaboration with Montfort, the translations answer few questions. The recapitulation of "The Raven," for instance, is, according to Bergeron, redistributed throughout the entire text as opposed to constituting the poem's first fifty-one words. *Ream/Rame* could thus be said not only to parody procedural or machinic composition, but also to parody procedural or machinic translation.

A more recent book by Montfort, *Sliders*, encapsulates many of the media-theoretical considerations of this book. Availing itself of POD technology, it "is the smallest square book, in trim size and number of pages, that can be printed on an Espresso Book Machine." The book's final poem—

```
cube
upon
bold
ends
```

—is a word square which is isomorphic with the book's square pages, and may allude to Robert Grenier's drawing poems (which often take the form of four lines consisting of four letters), as well as to the famous Sator Square in Latin. The title *Sliders* is itself suggestively polyvalent. According to the Wikipedia disambiguation page, a slider (or plural "sliders") can refer to a baseball pitch; an adjustable electronic control; a graphical widget in a GUI, in which a user may set a value by moving an indicator; a removable bowl component of a bong; an interdimensional being who slides through multiple universes; a 1972 album by T. Rex; a 1995–2000 science fiction television show; a part of a parachute; or a small hamburger. The last of these is possibly alluded to by the book's cover, which seems to show the parapets of a slider-serving White Castle Restaurant. Any and all of these meanings might pertain; for me, furniture sliders also came to mind. *Sliders* seems to announce itself as occasional literature in both its

material form and its title's evocation of the diminutive. The book is dedicated to "the terse & those who strive to be terse." The second half of the dedication suggests that it is possible to aspire to be terse, whereas in American English to be "terse" connotes a sense of being rude or brusque, neither of which one would typically aspire to be. The *OED*, insofar as it implies value judgments for the word "terse," does not include this pejorative sense, but rather defines being "terse" in favorable terms, defining the most common current usage as "Freed from verbal redundancy; neatly concise; compact and pithy in style or language."

A good example of a terse poem from *Sliders* is an entire page devoted to the word "wind." Two possibilities immediately emerge as to how one might read this poem out loud, and perhaps that is the point. We are returned to Aram Saroyan's youthful question: "What are words?"—a question which can be answered only in the context of a sender and a receiver. Consider, as an extreme example of a serial one-word poem, Allison Parrish's @everyword, a bot that from 2007 to 2014 tweeted every word of the English language in alphabetical order once per half hour, and was subsequently published as an e-book. It is, of course, impossible to create a complete dictionary of the English language, and no English speaker could possibly "know" the 109,000 words that were tweeted by the @everyword bot. According to Parrish, perhaps the most surprising aspect of the project was which words were favorited or retweeted most often by the bot's followers, who numbered over 100,000 at the project's completion. In effect, users could choose which words had significance for them within the context of Twitter. Popular words often were either sexual ("titty") or signified transgression ("weed") or frustration ("ugh").

During the bot's run, its creator transitioned from a man to a woman, and her experience reinforced for her the socially constructed nature of language, and how dictionaries define what is and is not a word. Returning to the question "What are words?," Parrish offers a striking conclusion:

> words are imaginary and do not exist. This is a strong claim to make, I know. But it turns out that there really are no firm, empirical rules for breaking the continuous flow of language into discrete units. To take the easy example, think of the English compound nouns "inkblot" and "basketball net." There's no reason, aside from historical accident and convention, that "inkblot" is one word (not two), but "basketball net" is two words (not three, or one).[20]

Parrish's concern with the unit of the word within the (impossible) scope of the entire language could hardly be more minimal or maximal. Had the project tweeted out every word at the fastest possible speed, it would have been much more difficult to engage its readers. The half-hour pause between each tweet almost functions like the prolonged turning of a page—offering a pause that reinforces the unit of the word at the same time that the inherent stability of the word in the context of a complete sentence or utterance is undermined. Although minimalism, conceptualism, and procedural literature are often derided as identity-denying, Parrish takes the opposite tack:

"I write with procedures not because I'm trying to silence myself, but because, as a trans woman, conventional language wasn't made with my voice in mind. I had to come up with something different."[21]

It's worth stepping back from Parrish's project to think about Twitter as a platform for art and literature. For Kenneth Goldsmith, "Every time we tweet, using a 140-character constraint, we could be said to be composing an Oulipian poem."[22] Whether or not this is the case, it is difficult to deny Twitter's exceptional influence on writing and politics. As Parrish writes, "The story of @*everyword* is, for me, the story of how Twitter magnifies and distorts not just words, but also writing and identity."[23] Twitter makes possible what José van Dijck refers to as "platformed sociality."[24] Parrish's @everyword parodies the self-promotion and self-identification strategies of Twitter's human users.[25] The @everyword feed became a collective mirror of the word preferences of those who followed the account, rather than a reflection of anything specific having to do with Parrish's (shifting) identity. The Twitter account itself effectively became an algorithmic microcelebrity while its creator remained comparatively anonymous. (Microcelebrity, according to Marwick, is "a state of being famous to a niche group of people, but it is also a behavior: the presentation of oneself as a celebrity regardless of who is paying attention.... Becoming a micro-celebrity requires creating a persona, producing content, and strategically appealing to online fans by being 'authentic.' Authenticity in this context is a quality that takes many forms, from direct interaction with admirers to the public discussion of deeply personal information.")[26] Parrish, in contrast to a conventional microcelebrity, revealed very little about herself and created no persona or sense of authenticity until the project had been completed. Her ambitions are hardly those of a conventional author: "It may turn out that my legacy as a poet and artist is facilitating 2000 retweets of the word 'titties,' with no further context or explanation. I am okay with this."[27] The purportedly taboo language of @everyword in fact turns out to be rather harmless, although perhaps indicative of persistent gender assumptions.

As a platform, Twitter is premised on the minimalism of its character limit, but embedded links, as well as the sheer volume of tweets in the aggregate, result in Twitter being anything but minimal in practice. Describing how Twitter came to be named, one of its cofounders, Jack Dorsey, remarks:

> We wanted to capture that feeling: the physical sensation that you're buzzing your friend's pocket. It's like buzzing all over the world.... So we looked in the dictionary for words around it, and we came across the word "twitter," and it was just perfect. The definition was "a short burst of inconsequential information," and "chirps from birds." And that's exactly what the product was.
>
> The whole bird thing: bird chirps sound meaningless to us, but meaning is applied by other birds. The same is true of Twitter: a lot of messages can be seen as completely useless and meaningless, but it's entirely dependent on the recipient. So we just fell in love with the word. It was like, "Oh, this is it." We can use it as a verb, as a noun, it fits with so many other words. If you get too many messages you're "twitterpated"—the name was just perfect.[28]

It's hard to imagine a shorter or more inconsequential burst of information than a single word tweeted out by a bot. And yet, if we extend the metaphor of bird song that Dorsey suggests, not all messages are meaningful to all species of birds. One's identity is defined not only by what one tweets, but by what tweets one favorites and retweets. Parrish's project ingeniously parodies the share and like economy not only of Twitter, but of social media more generally. The parody extends beyond Twitter as well. The @everyword website tracks exactly how many people have bought the e-book for ten dollars (I was customer number 21), and it offers a progressive scale of parodic remediation: at 25 copies sold, a USB of the work will be created and circulated; at 50 sold, a poster will be offered; at 400 sold, "a giant 'desk reference' edition of @everyword, handsomely bound 'Family Bible-style'" will be offered; and finally, and perhaps most tellingly, at 3,000 sold, there will be "@everyword: the motion picture à la Christian Marclay's *The Clock*." Parrish's list mocks crowdfunding platforms such as GoFundMe and Kickstarter at the same time that it semi-earnestly engages its readership/viewership to participate in perpetuating thought experiments about the project's potential continuation beyond the format of the book. Marclay's *The Clock* (2010)—a twenty-four-hour looped film composed of movie clips with images of clocks—brings the media experimentation full circle. @everyword becomes potentially filmic; it also becomes an experiment that could be infinitely repeated. But this process cannot take place without audience support. @everyword is exemplary of what Lori Emerson has referred to as "readingwriting," which she defines as "the practice of writing through the network, which as it tracks, indexes, and algorithmizes every click and every bit of text we enter into the network is itself constantly reading our writing and writing our reading. This strange blurring of and even feedback loop between reading and writing signals a definitive shift in the nature and definition of literature."[29]

Parrish's project differs considerably from other constraint-based alphabetical or chronological conceptual projects such as Marclay's *The Clock* in that it depends on the feedback provided by its audience, who in effect become minimal co-creators of meaning. @everyword only takes on its full significance in the context of the "readingwriting" nature of the responses it elicits. Perhaps the most elaborate response to @everyword is @nondenotative or "every non-word," a bot created by Daniel Temkin in 2015 to create combinations of English syllables that do not appear in the dictionary. Temkin describes his project in relation to @everyword: "While Allison Parrish's bot had a limited run by design, @nondenotative's corpus, while not endless, will still likely be growing when Twitter finally shuts down. If the bot were to actually exhaust all possibilities, it will not crash, but will enter an endless loop of crafting random words and rejecting them as being English or previously tweeted."[30] As of my writing, @nondenotative has tweeted 53,600 nonwords—most of which sound plausibly like English, but for which no precise meaning can be assigned. According to Temkin, the most retweeted nonwords have been "wetmood," "automoon, and "endhetero"—

all plausible English compounds. As a photonegative version of @everyword, the site places further in question the immutability of the unit of the word.

Bots like @nondenotative and @everyword demonstrate how the nature of authorship has been transformed since the introduction of networked computing and social media. For Kenneth Goldsmith, "The reconception of art as networked power, not content, is the true death of the author."[31] For Matthew Kirschenbaum, who also alludes to Barthes in his "What Is an @uthor?," "Today you cannot write seriously about contemporary literature without taking into account myriad channels and venues for online exchange.... Authorship, in short, has become a kind of media, algorithmically tractable and traceable and disseminated and distributed across the same networks and infrastructure carrying other kinds of previously differentiated cultural production."[32] As a platform, Twitter may offer the ultimate in undifferentiated cultural production, particularly given that so many of its users are nonhuman. Twitter has already proven a rich resource for all manner of literary expression—from procedural work such as Parrish's to meticulously crafted tweets by more traditional authors. Whatever Twitter's ultimate fate, its success in channeling text and image is too pervasive to be overlooked by literary and art historians.[33]

Friedrich Kittler famously claimed that "Under the conditions of high technology, literature has nothing more to say. It ends in cryptograms that defy interpretation and only permit interception."[34] Perhaps Kittler's paranoia is not misplaced, given how networked computing has made communications of all varieties more traceable than ever—and yet his claim is deterministic with regard to digital media. As Kathy Acker reminds us, "All aspects of language—denotation, sound, style, syntax, grammar, etc.—are politically, economically, and morally coded."[35] Whether or not one can decode a text will depend on many variables. And if one cannot decode a text, does that mean that text is without value? Literature, it seems to me, only has nothing to say if we refuse to make it engage with present conditions, or if we refuse to acknowledge that a text's degree of encoding or difficulty is variable, depending on how willing and how well equipped a reader is to do the work of decoding. Kittler's claim assumes that digital media have brought about the end of history, which in turn makes literature into something akin to the elite annals of analog society. His claim also disregards significant developments in postwar experimental literature. The Oulipo, for instance, attempted to make literature out of the very cryptograms that Kittler posits are anathema to literature. One final question raised by Kittler's claim: What would be the difference between "interception" and interpretation? Most literary texts are by definition public by virtue of their publication and circulation. They are designed to be intercepted—and interpreted. Too many authors and readers continue to essentialize literary genre and to maintain a strict divide between literature and visual art or literature and technology or literature and science or mass culture and high art. Literary texts are inherently steganographic and inherently visual. Minimal writing emerges from, and intervenes in, multifarious

conditions of technological reproduction. Translation is our condition and, more than ever, machine translation is our condition. Until we develop telepathy, all communications will involve mediation, and scholars of literature, art history, and new media will have a significant role to play in documenting and interpreting even the most minute elements of textual representation and display.

# Coda     @no_ideas_but_in_???

If there is one concern in my work, it is to reduce the form to the minimum necessary in order to visualize a thought or idea.[1]
—Cia Rinne

"No ideas but in memes," read a recent post in my Twitter feed.[2] This led me to reflect, "No ideas but in words," a phrase so pithy that I immediately assumed someone had said it before, although I could find no record of it with a Google search (perhaps due to the generic nature of the terms). Mallarmé famously said to Degas, "You do not write poetry with ideas, but with words."[3] And Smithson claimed, "My sense of language is that it is matter not ideas," which echoes the implicit materialism of Williams's original "no ideas but in things."[4] One might further complicate these various strong claims about language, ideation, materiality, and visuality with statements such as "No ideas but in images"—or "No words but in images." Pierre Garnier wrote in 1962, "Every word is an abstract picture"—a statement that could be taken as almost axiomatic for concrete poetry, but comes across as an overstatement in the context of minimalism.[5]

12.1 Screenshot from @no_ish, Instagram

The preceding claims about word, thought, and image are highly pertinent to the circulation of text and art in the social media era. When art historians of the future come to study the past few years, Instagram will be inescapable as the dominant content aggregator for emerging trends in visual culture. Consider these three Instagram accounts devoted primarily to art, poetry, and minimal writing: Sophia Le Fraga's @no__ish, Hans Ulrich Obrist's @hansulrichobrist, and Aram Saroyan's @saroyanesque. Only Le Fraga's account is explicitly framed as a literary periodical, but Obrist's and Saroyan's accounts also function, to an extent, as periodical publications.

Le Fraga's @no__ish "No Issue" feed wittily gestures to the ease of instantaneous global publication, and bills itself as the "mixed media zine made for right here" (figure 12.1). This may be an invocation of the indexical present—Piper's term for the engagement of artists and viewers in the here and now—but if so, the "hereness" is quickly undone by a map location indicator emoji positioned next to an open book. The pink bow and scissors emojis likely allude to the strong tradition of queer female zines in the 1990s. As of my writing, @no__ish has 505 followers, and has published thirty visual poems, a few of them conventionally left-justified on a white background, but most featuring imagery and/or some kind of unconventional presentation of the text. Comically, the first post (which appears last, given the reverse chronological order of the feed) is a filmic image of the word "FIN."

By contrast, Hans Ulrich Obrist's account, which is devoted almost entirely to handwritten text art, has 343,000 followers and nearly 3,500 posts since 2012. Obrist's account features many of the canonical artists of our time, and he frames the undertaking in terms of literary constraint. Obrist refers to his account as "The Art of Handwriting," and says, "It's got a lot to do with Oulipo, the way I approached it—the French movement or group, Oulipo or Oulipans [sic].... [I]t's about constraints, rules of the game."[6] A majority of Obrist's feed is composed of Post-it notes or other scraps of paper. Instagram provides Obrist with an enormous instantaneous audience, but the success of the account seems in large part due to nostalgia for the gestural and casual dimensions of handwriting. Included in Obrist's feed are Saroyan and Grenier, as well as some of the most famous writers, artists, and musicians in the world: William Gibson, Jonas Mekas, Yoko Ono, Cindy Sherman, and Kanye West, to name a few.

Obrist credits Etel Adnan for inspiring his interest in the constraint of handwriting. The first handwritten post on Obrist's account, written by Adnan in 2012, read:

Light encounters
the ocean's horns
Light on light[7]

This is recognizably a lyric poem—or a snippet of one—and yet it seems unlikely that these lines will appear in one of Adnan's books. Part of the point of Obrist's account is its spontaneity, which might return us to some of the issues raised by Dickinson's

scraps and envelope poems. A Post-it note is the most ephemeral of documents, and as such is difficult to assign a status as a literary object or artwork. And yet the Post-it note is only one of multiple layers of media when posted on Instagram. The document (or post) itself is a digital image of a Post-it note circulated on a global social-media platform. Given that this poem has likely been viewed hundreds of thousands of times, it seems that quantity is not the issue with according the work significance—but rather the seemingly casual, improvisatory nature of the feed and its materials.

How should a literary or art historian approach such seemingly fragmentary and occasional works? Take, for instance, Philippe Parreno's oneworder posted by Obrist, which reads

PTYX!
PTYX!
PTYX!
PTYX![8]

This Post-it note meets all the criteria of a oneworder set out in my concluding bibliography, and I have included it as such—and yet I was initially disinclined to do so, considering that it hadn't been published or displayed in a more conventional location. Clearly this is a text, but is it a work (in Roland Barthes's terms)? Parreno's oneworder ingeniously borrows Mallarmé's famously undefinable made-up word "ptyx"—a word that is, in the terms of the previous chapter, "nondenotative."[9] As such, it seems indisputably literary, and perhaps could even be construed as a work of microcriticism.

Obrist's account does much to upset conventional artistic roles. All of the following statements—each relevant to this book in some way—appeared as handwritten notes on Obrist's account:

Monumentality is most poetic when small.[10]
Annabelle Selldorf

Poetry is a moving space.[11]
Eileen Myles

Poetry has nothing to do with words but it needs them [12]
Etel Adnan

How beautiful, the word on the page.[13]
Simone Forti

I HAVE MEME FATIGUE.[14]
Douglas Coupland

**12.2**
Aram Saroyan, "Thoughts?" from "American Typewriter," *Poetry* (November 2018).

**12.3**
@twitter screenshot, November 21, 2018.

These statements are aphorisms rather than poems, although three of them directly reference poetry or poetics. One quick takeaway is that Obrist's account is remarkably interdisciplinary and international in scope, and could make for an excellent case study in comparative literature. Selldorf is best known as an architect, Myles as a poet, Adnan as a painter, Forti as a dancer, Coupland as a novelist. Embedded in these quotes are various notions of the circulation of text-as-poetry or text-as-meme. Each Post-it on Obrist's feed may seem tiny and occasional in and of itself, but in the aggregate his feed constitutes an enormous community for the production and reception of ideas about textuality. How do we render thoughts in script or image? Or, to adapt Rinne's terms, how can thoughts be visualized in the most minimal form possible?

To attempt a reply, I turn again to Saroyan and some of his most recent work. Perhaps the greatest American practitioner of minimal poetry in the 1960s, as we have seen, Saroyan spent much of the 1970s, 80s, and 90s trying to live down his reputation for extreme concision. @saroyanesque marks something of a return to minimalism for Saroyan. One recent informal poem-sculpture, constructed out of wooden blocks and published on @saroyanesque, reads "ACTUAL SIZE"—a conceptual joke of sorts.[15] A recent series, *American Typewriter*, published in *Poetry Magazine*, as well as on Instagram, features typewritten poems Photoshopped onto billboards around Los Angeles. One poem reads "Thoughts?" (figure 12.2) —much like the subject heading of an email, and not unlike the title of John Ashbery's book *Quick Question*.[16] The square billboard above a generic suburban home concealed by a wall evokes the square photo aesthetic of Instagram. Not long after this poem was published, @twitter, a meta-account that is the sixteenth most popular feed in the world with nearly 56 million followers, posted exactly the same text (figure 12.3).[17] Uncannily, in the following week, @twitter would post a blank tweet (bringing to mind *@1968*) and a tweet that read in its entirety "Mmhmmmm" (bringing to mind the four-shouldered *m*).[18] The @twitter feed seems to be collectively edited, and I can find no direct evidence @twitter was influenced by Saroyan. Nevertheless, these overlaps are suggestive of larger patterns in the circulation of minimal texts.

Saroyan's Instagram account features several other "thoughts"-related works. One, installed on a gallery wall, reads—"Big thoughts."—in a typewriter font.[19] Another, which reads "THOUGH," is aligned to the right so that a viewer might expect it is a partial word.[20] And still another reads "THOUGHT" (figure 12.4)—but the final T has been tipped on its side. The combination of conjunction ("though") and abstract noun ("thought") could signify an interrupted thought—or perhaps a breakdown of rationality. How might this three-dimensional representation of text relate to a two-dimensional poem like "Big thoughts"? How does one represent a thought according to its size? "Thoughts?" in the plural with a question mark is at once supremely ambiguous and supremely succinct. These one- or two-word poems again invite exophora- and contemplation.

CODA

**12.4**
Aram Saroyan, "THOUGHT," on Instagram.

Perhaps we are returned to a circularity of meaning: no ideas but in thoughts? As snippets of the ambient, these poems can be experienced as profound or profane. They pop up in feeds only to be scrolled past. Text, it seems, is becoming ever more prevalent in visual art; meanwhile poems are getting shorter. In conclusion,

**12.5**
@twitter screenshot, March 7, 2018.

# Acknowledgments

**This book is for F.H.S. and W.A.S.**

Thanks are due to Matthew Abbate, Michael Aird, Andrea Andersson, Bruce Andrews, Erica Baum, Derek Beaulieu, Charles Bernstein, Jen Bervin, Christian Bök, Sebastian Campos, Seamus Cowan, Natalie Czech, Diane Daughtry, James Davey, Andrew Durbin, Craig Dworkin, Brent Hayes Edwards, Margarita Encomienda, Andrew Epstein, Ben Fama, Robert Fitterman, Susan Friedland, Albert Gelpi, Annette Gilbert, Judith Goldman, Michael Golston, Robert Grenier, Forsyth Harmon, Ursula Heise, Victoria Hindley, James Hoff, Geof Huth, Michael Ives, W. Bliem Kern, Shiv Kotecha, Charley Lanning, Sophia Le Fraga, Glenn Ligon, Tan Lin, Jessica Janet Lipton, Ann Harmon Mayes, Richard Mayes, Jim Maynard, Steve McCaffery, Holly Melgard, Nick Montfort, Julie Montgomery, Simon Morris, Stephen Motika, Karla Nielsen, Nathaniel Otting, Allison Parrish, Michalis Pichler, Maika Pollack, Stephen Ratcliffe, Cia Rinne, Judah Rubin, Aram Saroyan, Andrew Shurtz, Sarah Stephens, Martine Syms, Dennis Tenen, Nick Thurston, Jennifer Tobias, Ben Tripp, Michael Waltuch, Patrick Wildman, Tim Wood, Paula Woolley, Divya Victor, Joey Yearous-Algozin, and Steven Zultanski.

An early version of chapter 6 appeared in *ASAP/Journal* 4.1 (January 2019): 189–210; a version of chapter 7 was published in *Jacket2*; chapter 8 was published in *American Literary History* (Summer 2018): 278–303; a portion of chapter 9 is forthcoming in *Natalie Czech: To Icon* (Berlin: Spector Books, 2020).

Archival materials were consulted at Special Collections, Stanford University; Poetry Collection, SUNY Buffalo; Fales Collection, New York University; Rare Book and Manuscript Library, Columbia University; Department of Special Collections, UCLA; MoMA Library; Department of Special Collections, New York Public Library; Department of Special Collections, University of Delaware.

This book was made possible, in part, by a Book Grant from Creative Capital/The Andy Warhol Foundation. That funding was originally allocated toward a separate book on Robert Grenier—that book remains a long-term work in progress.

# Appendix

## A Selected Bibliography of Oneworders (Categorized by Primary Word)

An exhaustive bibliography of one-word artworks and one-word poems could easily run into thousands of examples. Some practitioners of the form produced hundreds of examples. The present bibliography restricts itself to a single artwork or poem per artist or author. Generally in each case I have chosen a favorite work. Pursuant to the argument of this book, these works will best be viewed in their original media format (many of these works were realized in multiple formats). Images of nearly all of these works can be found online.

The list is organized by the primary word that constitutes the poem or artwork, which is then followed in square brackets, in some cases, by the title of the oneworder or, in some cases, by a translation of the primary word. My definition of a oneworder (as described in chapter 6) derives from Ian Hamilton Finlay: a single word must constitute the body (or central image) of the work, but a oneworder may have a title that differs from its primary word. A single word repeated (for example, Saroyan's "crickets / crickets / crickets …") constitutes a serial one-word poem. Phil Chernofsky's serial oneworder, *And Every Single One Was Someone* (2013), which repeats the word "jew" six million times over 1,250 pages, might be the longest oneworder. In some cases, as with ambigrams (for example, Dom Sylvester Houédard's "ache/mind" where the letterforms can be interpreted in multiple ways), more than one primary word is listed. I have tried to preserve original uppercase and lowercase lettering as much as possible. The dates of composition, publication, or display of these works can sometimes be difficult to ascertain; the dates recorded here are typically the date of publication (or display) of the work in the form in which I encountered it. Oneworders quoted from *&2: an/thology of pwoermds*, for instance, are dated as 2004, although some were composed or published earlier.[1]

Generally excluded from this list are logos and found oneworders (by which I mean images of single words that have no identifiable creator or artistic aim). As the anthology *In a Word: A Dictionary of Words That Don't Exist but Ought To*, ed. Jack Hitt (New York: Dell, 1992), is entirely devoted to one-word neologisms, I have not listed these individually. I have also generally excluded artworks with one-word titles where no word is visible (e.g., Barnett Newman's *Onement*).

AABEHLPT [*Retour à l'ordre*] (2007). Étienne Pressager (1959–).
ABRACADABRA [*Typings*] (1979). Christopher Knowles (1959–).
ache/mind [*Begin Again: A Book of Reflections & Reversals*] (1975). Dom Sylvester Houédard (1924–1992).
achtung [*un sorriso*] (1943). Carlo Belloli (1922–2003).
AGITATE (2010). Shannon Ebner (1971–).
AHA (2013). Alicia Eggert (1981–).
AIDS [*Imagevirus*] (1989). General Idea (founded 1967).
ajar (1967). Ian Hamilton Finlay (1925–2006).
albers (1966). Jiří Kolár (1914–2002).
aldri [trans. "never"] (2007). Ottar Ormstad (1944–).
Amarrotado (1987). Abílio-José Santos (1926–1992).
*America* (2016). Maurizio Cattelan (1960–).
AMERICA [*Untitled*] (2006). Glenn Ligon (1960–).
amor (2003). Amir Brito Cadôr (1976–).
amore (1923). Nelson Morpurgo (1899–1978).
Amour (1939). Michel Leiris (1901–1990).
AND (1997). John Baldessari (1930–).
And (2013). Peter Downsbrough (1940–).
Anteantepenultimate (1976). Raymond Queneau (1903–1976).
Apfel (1965). Reinhard Döhl (1934–2004).
apocatastasis [*Matchbook*] (1973). Allen Ginsberg (1926–1997).
Apollo [*Apollo and the Artist*] (1975). Cy Twombly (1928–2011).
Après (2010). Christian Boltanski (1944–).
Äquator (1985). Lothar Baumgarten (1944–).
ARGENTINA (1974). Edgar Antonio Vigo (1928–1997).
ariadneariadne (2013). Tim Johnson (1978–).
aromaroma (1960). José Lino Grünewald (1931–2000).
arrow (1980). bpNichol (1944–1988).
ART (1962). Roy Lichtenstein (1923–1997).
ARTE [*Biscoito Arte*] (1976). Regina Silveira (1939–).
Artefacto (1970). Julio Plaza (1938–2003).
assembly [*Institutions of Wales #1*] (2012). Peter Finch (1947–).
AUMMM [*AUMMM Gatha*] (1961). Jackson Mac Low (1922–2004).
babababadalgharaghtakamminarronnkonnbronntonnerronntuonnthunntrovarrhounawnskawntoohoohoordenenthurnuk (1939). James Joyce (1882–1941).
BAUHAUS [*Bauhaus No. 2*] (2013). Liu Ye (1964–).
beeswar(m) (2004). Leroy Gorman (1949–).
Bild (2004). Markus Hofer (1977–).
Billy [*Class 31. Billy Apple® Cultivar (Red)*] (2007). Billy Apple (1935–).

blabla [*The Golden Rule*] (2008). Delphine Boël (1968–).
BLAH [*Blah, Blah, Blah*] (2015). Mel Bochner (1940–).
Blue (2012). Nico Vassilakis (1963–).
BOING [*Acumulación*] (1966). Luis Pazos (1940–).
Bomb (n.d.). Alec Finlay (1966–).
BOOM BOOM (1979). Bruce Andrews (1949–) and John M. Bennett (1942–).
Bored. [*Untitled (Bored)*] (1988–1989). Ian Breakwell (1943–2005).
Boring [*I Will Not Make Any More Boring Art*] (2005). Yann Sérandour (1974–).
Brasa (1980). Paolo Leminski (1944–1989).
BREXSHIT (2018). Michael Landy (1963–).
bye [*Yakkity Yak!*] (2010). Nicci Albenda (1966–).
Campari (1965). Bruno Munari (1907–1998).
Carl [*Charles Kynard*] (2014). Carl Ostendarp (1961–).
CENSORED [*Censored in Paris*] (1975). Betty Tompkins (1945–).
Champion [*Little Giant Still Life*] (1950). Stuart Davis (1892–1964).
Chance (2011–2012). Annette Messager (1943–).
CHARNEL (1994). Max Wigram (1966–).
CIGAR. [*A Short Story Translated by My Mother & Milk*] (2008). Jonathan Monk (1969–).
Coca [*Il cuore della consumatrice ubbidiente*] (1975). Mirella Bentivoglio (1922–2017).
cock [*Sonnets*] (1963). Carl Andre (1935–).
CODE [*DEC ODE*] (2018). Nasser Hussain (1972–).
Código (1973). Augusto de Campos (1931–).
Colombia (2010). Antonio Caro (1950–).
Connectivity (2017). Brigitte Kowanz (1957–).
"'conservative'" [*The Ideology of David Cameron's Conservative Party*] (2009). Nick Thurston (1982–).
CREDO (1974). Antonio Miranda (1940–).
Dada [*Dada-bild*] (1919–1920). Georg Grosz (1893–1959).
DADADA (2015). Allen Grubesic (1974–).
DAMAGED [*Workers Loading Neon "Damaged" Sign into Truck, West Eleventh Street, New York City*] (1928–1930). Walker Evans (1903–1975).
DEATH [*Death Wall*] (1965). Walter de Maria (1935–2013).
Deborah [*Poem for Deborah*] (1966). Cavan McCarthy (1943–).
DECAY (1980). John Fekner (1950–).
delongas (1972). Alexandre O'Neill (1924–1986).
DEPROFESSIONALIZE (2013). David Horvitz (1982–).
DIE (2009). Ivan Navarro (1972–).
DISAPPPOINTED (2014?). Luc Fuller (1989–).
DISTRACTIONS (2018). David Shrigley (1968–).
Donald [*Stella*] (2019). Abraham Adams (1985–).

DON'T (ca. 1980). Saul Steinberg (1914–1999).
dripple (2004). Lee Gurga (1949–).
Dude [*Untitled*] (2010). Sarah Morris (1967–).
DUST (2012). Nayland Blake (1960–).
earth (1980). Ronald Johnson (1935–1998).
EAT (1967). Tomi Ungerer (1931–).
ECO [*ode/eco*] (1967). Alvaro de Sá (1935–2001).
ECONOMY [*Main Street Meltdown*] (2008). Melted Away (founded 2006).
Eeroo-tic (1971). Paul de Vree (1909–1982).
EGO [*Big Ego*] (1990). Nancy Dwyer (1954–).
Ego (2015). Gavin Turk (1967–).
Ego (2014). André Vallias (1963–).
Egoiste (1997). Sylvie Fleury (1961–).
egreturnswampwateripple (2004). Emily Romano (1924–).
Endless (from *One-Word Poems*) (2016). Adam Westman (1988–).
Energija (1978). Mangelos (1921–1987).
ENTENDRE [*Double Entendre*] (2013). John Langdon (1946–).
Equilibrio (1976?). Paulo Bruscky (1949–).
Eros [*Libation to Eros*] (2014). Michael Petry (1960–).
etc … (2011). Peter Liversidge (1973–).
eva (1968?). Ladislav Novák (1931–2011).
evening (1973). W. Bliem Kern (1943–).
EVOLUTION (n.d.). Crag Hill (1957–).
EVOLUTION [*Revolution without an R*] (2008). Lars Worm (1977–).
EXIL [*Exit*] (1996). Adel Abdessemed (1971–).
EXILIO (2017). José Vincench (1973–).
EXIST (2009). Kelly Mark (1967–).
exposed [*Exposed*] (2011). Bobbi Woods (1973–).
eye (1968). Jiří Valoch (1946–).
Fame (1998). Jack Pierson (1960–).
Farvaluate (1972). Bern Porter (1911–2004).
FEAR [*FEAR/YOW*] (2009–2010). Jenny Holzer (1950–).
FEARS (1992). Louise Bourgeois (1911–2010).
felt [*Untitled 5 (Felt)*] (2003). Terence Koh (1977–).
fennel [fenouil] (1957). François Le Lionnais (1901–1984).
feuille [*L'Image Concrete feuille L'Objet Abstrait*] (1976). Theresa Hak Kyung Cha (1951–1982).
FICTION (2003). Nicholas Delprat (1972–).
FIGMENT (1994). Itai Doron (1967–).
finite (2009). Cia Rinne (1973–).

fishes (n.d.). Amelia Etlinger (1933–1987).
fleece (1967). Stephen Bann (1942–).
FOOL [*Museum Camouflage: Christopher Wool*] (2001). Harvey Opgenorth (1977–).
fossilence (2004). Nicholas A. Virgilio (1928–1989).
*Fountain* (1917). Marcel Duchamp (1887–1968).
Forever (1996). Tim Noble (1966–) and Sue Webster (1967–).
FREE (2016). Doug Aitken (1968–).
FREE [*Free Stamp*] (1991). Claes Oldenburg (1929–).
frou frou (1996). Alighiero Boetti (1940–1994).
FUCK [*Love, AIDS, Riot (Study 2)*] (1990). Marlene McCarty (1957–).
GENELYP3E. John Robert Colombo (1936–).
ghjost. Jim Kacian (1953–).
ghohshthshs (1983). Geof Huth (1960–).
(G)HOST [*Word(s)*] (2006). Melik Ohanian (1969–).
GIRRRL GIRLLL GIIIRL GIRRRL (2017). Martine Syms (1988–).
GLORY (n.d.). Jonathan Williams (1929–2008).
gnowing (2004). Ezra Mark (dates unknown).
*God* (1917). Baroness Elsa von Freytag-Loringhoven (1874–1927).
GOETHE (1972). Klaus Peter Denker (1941–).
GONG! [*Visual Soundpoem*] (1965?). Edwin Morgan (1920–2010).
GRASS (1962). Robert Indiana (1928–).
Great! [*Sans titre, Great*] (2010). Bruno Peinado (1970–).
gr∞w (2004). Paloin Biloid (1965–).
HAHAHA (2014). Claudia Comte (1983–).
Hame [*Hame #3*] (2004). Kate Murdoch (1973–).
HELP (2002). Olivier Mosset (1944–).
help [*HELP*] (2007). Laurent Pernot (1980–).
Hey Hey (2013). James Hoff (1975–).
HOGO (2003). Eduard Ovčáček (1933–).
Homage à Shannon (1975). Ruth Wolf-Rehfeldt (1932–)
hope [*Trial for Beyond (hope)*] (2013). Linda Hutchins (1957–).
Horizons (1976?). Shant Basmajian (1950–1990).
Horny? (2015). Michael Shaowanasai (1964–).
humor [*Amor*] (1927). Oswald de Andrade (1890–1954).
I [*I-Box*] (1963). Robert Morris (1931–2018).
I [*Matchbook*] (1973). James Schuyler (1923–1991).
ich (1966). Vladmir Burda (1934–1970).
Igevär [trans. "presentarms"] (1963). Åke Hodell (1919–2000).
ilovveyou (2016). Robert Fitterman (1959–).
imigração (1986). Armando Macatrão (1957–).

l'imitation [*LIMITATION*] (2008). Pavel Büchler (1952–).

In (1964). Corita Kent (1918–1986).

Independance (2018). Adam Pendleton (1984–).

infinity [*Infinity Circle*] (1981). Scott Kim (1955–).

INNIT (2016). Jeremy Deller (1966–).

inverse (2013). Anatol Knotek (1977–).

invisible (1967?). Ilse Garnier (1927–).

isn't [*Bonsai No. 3*] (2007). Márton Koppány (1953–).

jew [*And Every Single One Was Someone*] (2013). Phil Chernofsky (dates unknown).

JOUR [*Verre, bouteille et journal*] (1912). Georges Braque (1882–1963).

Klares (1965). Claus Bremer (1924–1996).

leafrog (2004). George Swede (1940–).

Leben [trans. "Life"] (1974). Jochen Gerz (1940–).

leib (1955). Gerhard Rühm (1930–).

Leonor [*Variação XXIX*] (1970). Ana Hatherly (1929–2015).

Liar (1977). Jamie Reid (1947–).

licht (1962). Heinz Mayr (1925–2010).

lighf (2004). Bob Grumman (1941–2015).

lighght (1965). Aram Saroyan (1943–).

light (1994). Maurizio Nannucci (1939–).

lightime (2004). Karl Young (1947–2017).

LIKE (n.d.). Richard Prince (1949–).

Lilac (1963). Mary Ellen Solt (1920–2007).

líneas / lines [*Looking for Poetry / tras la poesía*] (1973). Ulises Carrión (1941–1989).

Liquors [*Palace Liquorsoul*] (2010). Nari Ward (1963–).

LISTEN [*Silent (Music Box)*] (2005). Christian Marclay (1955–).

love [*A Love Poem*] (1967). Bob Cobbing (1920–2002).

LOVE [*Love, Love, Love (Homage to Gertrude Stein)*] (1928). Charles Demuth (1883–1935).

LOVE [*poem by ewa*] (1972). Ewa Partum (1945–).

LOVE [*Untitled*] (2008). Heimo Zobernig (1958–).

Loving (2013). Tracey Emin (1963–).

lustig (1964). Ernst Jandl (1925–2000).

luv [*waves of luv*] (1967). Hans Clavin (1946–2015).

luv (1968?). David Uu (1948–1994).

maman (n.d.). Jean-François Bory (1939–).

MARTINI (1968). Raymond Hains (1926–2005).

MATER (1976). Tomaso Binga (1931–).

mauve [*purple; study 3: for mark rothko*] (ca. 1970?). Philip Jenkins (1949–).

ME [*Caged*] (2018). Olivia Steele (1985–).

meant [See] (2016). Craig Dworkin (1969–).
menfogp (2004). Greg Evason (1961–).
micro (2012). Andrew Russ (Endwar) (1962–).
Miedzy [trans. "Between"] (1977). Stanislaw Dróżdż (1939–2009).
might (2015). Jill Magi (1968–).
MIND/WIND [MIND WIND] (2008). Arnaldo Antunes (1960–).
mitlove (2019). @nondenotative / Daniel Temkin (1973–)
MOI [Inner Telescope] (2017). Eduardo Kac (1966–).
monochrome [Keyword] (2006). Reynald Drouhin (1969–).
Monostique [trans. "monostich"] (ca. 1970). Bernar Venet (1941–).
monoton e (1970). Alex Selentisch (1946 ).
montagne [Le paysage fantôme] (1928). René Magritte (1898–1967).
moon [Words Are Shadows] (1967). Eugen Gomringer (1925–).
Moratorium [Flag (Moratorium)] (1969). Jasper Johns (1930–).
Mothers [Work No. 1092] (2011). Martin Creed (1968–).
Narcissus (1972). Betty Radin (dates unknown).
neither (2005). Leo Zogmayer (1949–).
NEON (1965). Joseph Kosuth (1945–).
NEU [Untitled] (1999). Daniel Pflumm (1968–).
(N)E(U)ROTIC (2016). Darren Bader (1978–).
ney / mo / money [A Poem By Repetition by Aram Saroyan] (2013). Natalie Czech (1976–).
nichego (ca. 1975). Vsevolod Nekrasov (1934–2009).
nightrain (2004). Michael Dylan Welch (1962–).
NO [You Keep Out of This] (2014). Stefan Brügemann (1975–).
NO [No, No, No] (2011). Matt Keegan (1976–).
no (1985). Barbara Kruger (1945–).
NO (2009). Santiago Sierra (1966–).
NO NO NO NO (2016). Jeff Whetstone (1968–).
(noite) (1974). Clarival Valladares (1918–1983).
NoNo (1983). Bruce Nauman (1941–).
NO/ON (n.d.). A. Doyle Moore (1931–2013).
nothing (n.d.). Ray Johnson (1927–1995).
nothing (1971). Endre Tot (1937–).
NOW (1968). Mary Beach (1919–2006).
now (2006). Christopher Leitch (1960–).
now [Predelle Now] (2014). Agnès Thurnauer (1962–).
Nowhere (2014). Corith Wyn Evans (1958–).
NUMSHIN [For Grandpa, Many Magpies] (2014). Hock E Aye Vi Edgar Heap of Birds (1954–).

Obliterate (2017). Samuel Jablon (1986–).
OBSESS [*Open Up and Bleed*] (2013?). Maria Damon (1955–).
odéon / ocean (1982). Simon Cutts (1944–).
oil (1965). Hansjörg Mayer (1943–).
on((((i))))on (2004). Karl Kempton (1943–).
oolongphaeic (2004). Michael Helsem (1958–).
oro (1965). Mathias Goeritz (1915–1990).
Otoño (1968). Ana Maria Uribe (1951–2004).
OVID/VOID [*Circle(s) in the Round: OVID/VOID*] (2010). Newell Harry (1972–).
OY / YO (2015). Deborah Kass (1952–).
ozon (1964). Herman Damen (1945–).
pajaro (1970). Elena Asins (1940–2015).
Palabrarma (1974). Cecilia Vicuña (1948–).
Péndulo (1968). E. M. Melo de Castro (1932–).
PERFECT (1970). Allen Ruppersberg (1944–).
permutation (1970). Davi Det Hompson (1939–1996).
pichler pichler (*the beginning of the system of lies*) (2007). Michalis Pichler (1980–).
pirate (2004). Simon Moretti (1974–).
POET [*Lego Poem*] (2015). S. J. Fowler (1983–).
Poetry (1969). Ed Ruscha (1937–).
POTATO . . . [*64*] (2004). Robert Grenier (1941–).
ppineaple (2017). Nick Montfort (1972–).
PTYX! (2015). Philippe Parreno (1964–).
PUTA (2008). Aldo Chapparo (1965–).
Radicality (1974). Dennis Oppenheim (1938–2011).
Rain (1966). Seiichi Niikuni (1925–1977).
reading (1985). Ben Vautier (1935–).
Reason [*Untitled (Reason)*] (1997). Erica Baum (1961–).
repetition (ca. 1975). bill bissett (1939–).
REVELATiON (2017). Steffani Jemison (1981–).
Rêvez (2008). Claude Lévêque (1953–).
Revolução (1977). António Barros (1953–).
revolver [*Revolver 2*] (ca. 1970). Alan Riddell (1927–).
Rien [*Rien bleu*] (2011). Jean-Michel Alberola (1953–).
Rio [*Tallose Berge*] (1965). Max Bense (1910–1990).
RIOT (1990). Christopher Wool (1955–).
river (1962). Robert Lax (1915–2000).
rose (1966). Timm Ulrichs (1940–).
rotor (1963). Franz Mon (1926–).
RUN (2012). Monica Bonvincini (1955–).

RUN [*Untitled (RUNNRUNN*] (2015). Karl Holmqvist (1964–).

RUPTURED (1972). Lawrence Weiner (1942–).

RWANDA (1994). Alfredo Jaar (1956–).

SAD [*THE DAY IAN HAMILTON FINLAY DIED*] (2006). Antonio Claudio Carvalho (1949–).

SAME / SANE (2000). Jackie Chang (1963–).

Schoenberg (1963). John Sharkey (1936–2014).

s e c o n d s (2004). Strawberry Saroyan (1970–).

SEPARATE [*Poem Field* #2] (1966). Ken Knowlton (1931–) and Stan VanDerBeek (1927–1984).

sex (1970). Thomas Ockerse (1940–).

Sick [*Sic [Sic] Sick*] (1989). Kay Rosen (1944–).

Sisyphus (ca. 1966?). Václav Havel (1936–2011).

Slaughter (2003). Kendell Geers (1968–).

snowflake [*Snowflakes*] (2003). Christian Bök (1966–).

sn wfl k s (2004). Marlene Mountain (1939 ).

SOL [*Sol—Tridemensional*] (2010). Osmar Dillon (1930–).

SOLD (2011?). Pieter Engels (1938–).

soleil [*Grains de Pollen*] (1962). Pierre Garnier (1928–).

Solidao (1954?). Clemente Padín (1939–).

Sorry (2013). Alan Magee (1947–).

SPAM (1980). Andy Warhol (1928–1987).

Spazio (1966). Arrigo Lora-Totino (1928–2016).

Speechless (2012). W. Mark Sutherland (1955–).

SPLITTING [*Subtraction (Splitting)*] (2007). Tauba Auerbach (1981–).

square (2018). derek beaulieu (1973–).

STAY (2017). Sam Durant (1961–).

STOPP (1955). Vagn Steen (1928–2016).

stress (2004). Christian Robert-Tissot (1960–).

STRIKE [*(K. font V.II)*] (2005–2007). Claire Fontaine (collective, 2004–).

strip-tease (1974). Erthos Albino de Souza (1932–2000).

sun [*Sunset*] (1968). Luis Camnitzer (1937–).

sun [*solar eclipse*] (1998). Darren Wershler (1967–).

Suncycle (1968). Kenelm Cox (1927–1968).

Surréalisme (1931-32). Joseph Cornell (1903–1972).

sweethearts (1967). Emmett Williams (1925–2007).

TASTE. [*Zorns Lemma*] (1970). Hollis Frampton (1936–1984).

taube (1957-58). Friedrich Achleitner (1930–).

terra (1956). Décio Pignatari (1927–2012).

TERROR (2006). Clemente Padín (1939–).

THINK [*Think Flag*] (1964). William Copley (1919–1996).

This (1998). William Anastasi (1933–).
This [*So Is This*] (1982). Michael Snow (1929–).
Thoughts [*THOUGHTS, THOUGHTS, THOUGHTS, THOUGHTS*] (2016). Eve Fowler (1964–).
TIERRA (1971). Carlos Ginzburg (1946–).
TIGER [*Thicket No. 2*] (1990). Roni Horn (1955–).
TIME (2014). Mungo Thomson (1969–).
TOUCH [*Untitled*] (1969). Terry Fugate-Wilcox (1944–).
TRASH [*Trash Mirror Boxes*] (2016). Stefan Brüggemann (1975–).
tree [*proverb (tree poem 4)*] (n.d.). Michael Gibbs (1949–2009).
TRIÂNGULO (2005?). Zenilton Gayoso (1975–).
TRUMP (2015). Ji Lee (1971–).
TRUTH (ca. 1975?). Richard Kostelanetz (1940–).
tundra (n.d.). Cor Van den Heuvel (1931–).
tunnel (1962). Ivan Chermayeff (1932–).
TUNNEL (1969). Steve McCaffery (1947–).
twenty (ca. 1970). Rosemary Mayer (1943–2014).
typewriter [*Meta Typewriter Piece*] (2008). Petra Schulze-Wollgast (dates unknown)
UH-OH (2015). Frances Stark (1967–).
Ulcérations (1974). Georges Perec (1936–1982).
Unfinished [*Art and War*] (2007). Robert Barry (1936–).
unique (1971). Michael Harvey (1944–).
ut tu (1965). Dieter Rot (1930–1998).
variation (1973). Adriano Spatola (1941–1988).
Velocidade (1957). Ronaldo Azevedo (1937–2006).
Venus (1982). Jean-Michel Basquiat (1960–1988).
vocábulo (1966). Edgard Braga (1897–1985).
The Voice (2010). Simon Evans (1972–).
voice(s) (n.d.). Peggy Willis Lyles (1939–).WALK / TALK (1969). Ferdinand Kriwet (1942–).
WARNING (2015). Julia Beliaeva (1988–).
water (1975). Brian Eno (1949–) and Peter Schmidt (1931–1980).
water (1975?). Carole Itter (1939–).
waves (1995?). Miekal And (1957–).
weed [from @everyword] (2014). Allison Parrish (1982–).
Week (2012). J. M. Calleja (1952–).
WELCOME (2011). Ceal Floyer (1968–).
WHISKEY (1964?). Thomas Merton (1915–1968).
WHY (ca. 1970). Henri Chopin (1922–2008).
WHY? (1970). Yoko Ono (1933–).
Will [Sonnet 135 from *Nets*] (2014). Jen Bervin (1972–).

work (2007). Natascha Sadr Haghighian (1967–).

WOUND (2007). Anita Dube (1958–).

yarim (1965). Yüksel Pazarkaya (1940–).

Yoo [*Death to Art*, translated by Volodymyr Bilyk] (1913). Vasilisk Gnedov (1890–1978).

you (2010). Jung Lee (1972–).

Zaire (1977). David Hammons (1943–).

Zapomanie [trans. "forgetting"] (1967). Stanisław Dróżdż (1939–2009).

ZEIT [*Untitled*] (1964). Mira Schendel (1919–1988).

ZEN (1966). Pedro Xisto (1901–1987).

Zipper (1961). Jim Dine (1935–).

@ / om (1970). Norman Pritchard (1000–1990).

# Notes

### Introduction

1. Robert Smithson, "The Spiral Jetty," in *The Collected Writings*, ed. Jack Flam (Berkeley: University of California Press, 1996), 147. Similarly, Carl Andre writes in 1970: "the only single thing that art has is scale, something that has nothing to do with size." See Carl Andre, *Cuts: Texts 1959–2004*, ed. James Meyer (Cambridge, MA: MIT Press, 2005), 231.

2. See Craig Dworkin, "Klatsch," *Convolution* 4 (2016): 8–17; Robert Grenier, letter to Burroughs Mitchell, October 19, 1976, Robert Grenier Papers, M1082, TS, Box 4, Department of Special Collections, Stanford Libraries, CA (this letter is quoted in chapter 8).

3. For Antin's account, see David Antin, "Fine Furs," *Critical Inquiry* 19, no. 1 (Autumn 1992): 151–163. For more on the sky poems, which were reproduced in 2018 at the Los Angeles County Museum of Art and the Museum of Contemporary Art, San Diego, see "Q&A with Julien Bismuth: David Antin's Sky Poems," *LACMA Unframed*, September 25, 2018, https://unframed.lacma.org/2018/09/25/qa-julien-bismuth-david-antin's-sky-poems. In 1969, Bruce Nauman proposed a similar skywriting project, which was to read "LEAVE THE LAND ALONE." His *Untitled 1969/2009* was realized in Pasadena in 2009.

4. Jen Bervin, "Artist's Note to *Silk Poems*," accessed June 4, 2019, http://jenbervin.com/projects/silk-poems#2.

5. A recent version of the cliché appeared in *Artforum*: "Whoever said less is more never had more. And they've certainly never stayed at the Trump® International Hotel & Tower Panama." Ian Volnor, "Fool's Gold: The Architecture of Trump," *Artforum* (November 2016), https://www.artforum.com/print/201609/fool-s-gold-the-architecture-of-trump-64212.

6. See, for instance, Ad Reinhardt, who in 1957 writes: "The first rule and absolute standard of fine art, and painting, which is the highest and freest art, is the purity of it. The more uses, relations, and 'additions' a painting has, the less pure it is. The more stuff in it, the busier the work of art, the worse it is. 'More is less.'" Ad Reinhardt, *Art as Art: The Selected Writings of Ad Reinhardt*, ed. Barbara Rose (Berkeley: University of California Press, 1975), 204. The cliché also surfaces in a key critical context for conceptual art, the introduction to Lucy Lippard's *Six Years: The Dematerialization of the Art Object [ … ]* (Berkeley: University of California Press, 1973): "If Minimalism formally expressed 'less is more,' Conceptual art was about saying more with less" (13).

7. Robert Venturi, *Complexity and Contradiction in Architecture* (New York: Museum of Modern Art, 1966), 17.

8. John Ashbery, "The New Spirit," in *Three Poems* (New York: Viking, 1972), 3.

9. Liz Kotz, *Words to Be Looked At: Language in 1960s Art* (Cambridge, MA: MIT Press, 2007), 7.

10. Beatrice Wood, "The Richard Mutt Case," *The Blind Man* 2 (May 1917): 5. Wood's authorship is not specified in the original text but she claims it in *I Shock Myself: The Autobiography of Beatrice Wood* (San Francisco: Chronicle Books, 2006), 165.

11  Marcel Duchamp, *The Complete Works of Marcel Duchamp*, ed. Arturo Schwarz (New York: Harry N. Abrams, 1969), 79. For more on the history of titles in art, see John Welchman, *Invisible Colors: A Visual History of Titles* (New Haven: Yale University Press, 1997). Welchman goes so far as to suggest that "The signifying range of Duchamp's titles and the variousness of their orders of interaction with the images, objects, and exhibitions around which they circulate represent probably the fullest and most diverse repertoire of titular activities in the history of visual representation" (220). See also Ruth Bernard Yeazell, *Picture Titles: How and Why Western Paintings Acquired Their Names* (Princeton: Princeton University Press, 2015).

12  For example, Duchamp's *Fountain* was chosen in a poll of 500 British art experts as the most influential artwork of the twentieth century. "Duchamp's Urinal Tops Survey," BBC News, December 1, 2004, http://news.bbc.co.uk/2/hi/entertainment/4059997.stm.

13  Marcel Duchamp, *The Writings of Marcel Duchamp*, ed. Michel Sanouillet and Elmer Peterson (New York: Da Capo, 1973), 74.

14  Ibid., 125

15  Ibid.

16  Ibid., 124.

17  "Je n'ai créé mon Oeuvre que par *élimination*, et toute vérité acquise ne naissait que de le perte d'une impression …" Stéphane Mallarmé to Eugène Lefébure, May 27, 1867, in *Oeuvres complètes*, ed. Bertrand Marchal (Paris: Gallimard, 1998), 717.

18  For more on erasure art and erasure practices in general, see Heather and Raphael Rubinstein, *Under Erasure* (New York: Nonprofessional Experiments, 2018), the exhibition catalog for a wide-ranging show of erasure works at Pierogi Gallery. See also Kaja Marczewska, "Erasure," in *This Is Not a Copy: Writing at the Iterative Turn* (London: Bloomsbury, 2018), 69–122.

19  Xu Bing's *Book from the Earth* (Cambridge, MA: MIT Press, 2014), for instance, is composed entirely of symbols and icons.

20  In an extended discussion of Lessing's book-length essay *Laocoön*, W. J. T. Mitchell argues forcefully that "there is no *essential* difference between poetry and painting, no difference that is, that is given for all time by the inherent natures of the media, the objects they represent, or the laws of the human mind" (49; emphasis his)—a position that I also take in this book. Mitchell goes on to note:

   Since the end of the eighteenth century Western culture has witnessed a steady stream of innovations in the arts, media, and communication that make it hard to see exactly where the line [between poetry and painting or text and image] ought to be drawn. In a culture that has seen everything from the eidophusikon to the laser light-show, and which is surrounded by photography, film, television, and computers equipped for graphics, games, word-processing, information storage, computation, and general design ("programming"), it is no wonder that the polarity of "painting versus poetry" seems obsolete, and that we prefer more neutral terms like "text versus image."

   W. J. T. Mitchell, *Iconology: Image, Text, Ideology* (Chicago: University of Chicago Press, 1982), 49–50.

21  Duchamp, quoted in Craig Dworkin, *No Medium* (Cambridge, MA: MIT Press, 2013), 18.

22  Marjorie Perloff, *21st Century Modernism: The "New" Poetics* (Oxford: Blackwell, 2002), 117 (emphasis in original).

23  Aram Saroyan, quoted in *Concrete Poetry: A World View*, ed. Mary Ellen Solt (Bloomington: Indiana University Press, 1968), 57–58.

24  Ibid., 58.

25  Aram Saroyan, *The Street* (Lenox, MA: The Bookstore Press, 1974), 63.

26  Ibid., 82

27  Velimir Khlebnikov, "On Poetry," in *Collected Works*, volume 1, *Letters and Theoretical Writings*, ed. Charlotte Douglas (Cambridge, MA: Harvard University Press, 1987), 371 (emphasis in original).

28  Solt, *Concrete Poetry*, 158.

29  Ian Hamilton Finlay, *Selections*, ed. Alec Finlay (Berkeley: University of California Press, 2012), 204.

30  In Bernar Venet, *Poetic? Poétique?: Anthologie 1967–2017* (Paris: Jean Boîte Editions, 2017), 94.

31  For an entertaining and informative inventory of artists who write, as well as of writers who make art, see Stefan Ripplinger, "Going Astray: Artists Who Write," *how to write* 1 (Berlin: Wiens Verlag, 2013), 31–55.

32  Marcel Broodthaers, "to be *bien pensant* … or not to be. to be blind," in *Conceptual Art: A Critical Anthology*, ed. Alexander Alberro and Blake Stimson (Cambridge, MA: MIT Press, 1999), 358.

33  Ibid.

34  "Interview with Seth Siegelaub, April 11, 2013," in Michalis Pichler, ed., *Books and Ideas after Seth Siegelaub* (Berlin: Sternberg Press, 2016), 126, 127.

35  Lawrence Weiner, *Statements* (New York: The Louis Kellner Foundation and Seth Siegelaub, 1968), n.p.

36  "Interview with Seth Siegelaub," 127.

37  Aram Saroyan, email to author, September 9, 2016.

38  "Media" here might more accurately be described in terms of mediality. This book explores old and new media on a historical continuum, but it does not offer a comprehensive theory of media or mediation. For a concise history of the terms "media" and "medium," see Ben Kafka, "Media/Medium," *Dictionary of Untranslatables: A Philosophical Lexicon*, ed. Barbara Cassin (Princeton: Princeton University Press, 2014), 626–629.

39  In line with the view that the body is a medium—or for more general discussions of technology and embodiment—see Bernadette Wegenstein, "The Body," *Critical Terms for Media Studies*, ed. W. J. T Mitchell and Mark B. N. Hansen (Chicago: University of Chicago Press, 2010), 19–34, and N. Katherine Hayles, *How We Became Posthuman* (Chicago: University of Chicago Press, 1999). Embodied perception is a central concern of phenomenology, as evidenced by Maurice Merleau-Ponty's claim: "The body is our general medium for having a world." Maurice Merleau-Ponty, *Phenomenology of Perception*, trans. Colin Smith (London: Routledge, 2002), 169.

40. Jerome McGann in fact makes the case that poetry is the genre most aware of its own mediation. According to McGann, "Poets understand texts better than most information technologists. Poetics texts make a virtue of the necessity of textual noise by exploiting textual redundancy. The object of the poetical text is to thicken the medium as much as possible—literally, to put the resources of the medium on full display, to exhibit the processes of self-reflection and self-generation which texts set in motion, which they *are*." Jerome McGann, *The Textual Condition* (Princeton: Princeton University Press, 1991), 14.

41. For more on the history of the poetry reading, see Peter Middleton, "Poetry Reading," *The Princeton Encyclopedia of Poetry and Poetics*, 4th ed., ed. Roland Greene et al. (Princeton: Princeton University Press, 2012), 1068–1070.

42. Minimal and conceptual art and writing can be understood as especially engaged with processes of mediation and remediation. Mel Bochner writes, for instance: "For me, the medium was never transparent, never something to be seen through, never a neutral delivery system. No matter how reduced the means, they always remained something material, something to be taken apart and put back together, something to be confronted. Any genuine critique can arise only out of the process of using the medium against itself.... [T]his is how I see my job as an artist: to grapple with the means of expression until an idea finds its own form." Mel Bochner, "The Medium and the Tedium," *Triple Canopy* 9 (2010), https://www.canopycanopycanopy.com/contents/the_medium_and_the_tedium.

43. Among the many postwar figures whose work could merit consideration under the rubric of minimal writing, here are some names whose work is not included here (or is discussed only in passing): Vito Acconci, Doug Aitken, Carl Andre, David Antin, Shusaku Arakawa and Madeline Gins, Tauba Auerbach, John Baldessari, Fiona Banner, Robert Barry, Erica Baum, Samuel Beckett, bill bissett, Xu Bing, Mel Bochner, Alighiero Boetti, Monica Bonvicini, Mark Booth, Pavel Büchler, Victor Burgin, John Cage, Theresa Hak Kyung Cha, Julia Chang, Nathan Coley, Martin Creed, Robert Creeley, Simon Cutts, Cynthia Daignault, Hanne Darboven, Shannon Ebner, Shepard Fairey, Alec Finlay, Ian Hamilton Finlay, Robert Fitterman, Claire Fontaine, Eve Fowler, Liam Gillick, John Giorno, Felix Gonzalez-Torres, Douglas Gordon, Hans Haacke, Karl Holmqvist, Roni Horn, Dom Sylvester Houédard, Mustafa Hulusi, Nasser Hussain, Geof Huth, Robert Indiana, Robert Irwin, Donald Judd, Eduardo Kac, Deborah Kass, On Kawara, Mary Kelly, Richard Kostelanetz, Joseph Kosuth, Aleksei Kruchenykh, Robert Lax, Ji Lee, Michael Leong, Mark Lombardi, Jackson Mac Low, Agnes Martin, Steve McCaffery, Robert Morris, Matt Mullican, Maurizio Nannucci, Bruce Nauman, Vsevolod Nekrasov, Shirin Neshat, bpNichol, Yoko Ono, Simon Patterson, Raymond Pettibon, Tom Phillips, Jack Pierson, Adrian Piper, Francis Ponge, Robert Rauschenberg, Tom Raworth, Ad Reinhardt, Kay Rosen, Martha Rosler, Allen Ruppersberg, Sparrow, Betty Tompkins, Cy Twombly, Ben Vautier, Hock E Aye Vi Edgar Heap of Birds, Hannah Weiner, Jeff Whetstone, Ruth Wolf-Rehfeldt, Christopher Wool, Carey Young, Young-Hae Chang Heavy Industries. Many more names could be compiled: this list should not be considered definitive. I became aware of James Davies's excellent and highly pertinent doctoral thesis, "stack: Minimalist Poetics" (University of Roehampton, 2018), as this book was going to press.

44. Dan Tynan, "Online Behind Bars: If Internet Is a Universal Human Right, Should Prisoners Have It?," *The Guardian*, October 3, 2016, https://www.theguardian.com/us-news/2016/oct/03/prison-internet-access-tablets-edovo-jpay.

45. Independently of this instance of "ojojo," Nick Montfort has published an "ojojo" poem in his *Sliders* (Boston and New York: Bad Quarto, 2017), n.p.

46  The poem was published more or less simultaneously in three places: Neil Barrett's *Drainage*, early in 1967 (the first issue doesn't have a month specified, but the second issue came out in May 1967); the Winter 1967 issue of *Patterns* (where it appeared in green); and in the Emmett Williams *Anthology of Concrete Poetry* (New York: Something Else Press, 1967). For more on the poem's composition, see Aram Saroyan, "Virginia Admiral and TOP," *Convolution* 3 (Fall 2014): 15.

47  Wikipedia explains the collaboration by these two well-known chocolatiers by citing the deprivations of World War II: "Due to wartime rationing, the two ostensible competitors, Mars and Hershey, combined forces to produce a knock-off of the British candy Smarties, first produced in 1937." "M&M's," Wikipedia, accessed October 21, 2017, https://en.wikipedia.org/wiki/M%26M%27s.

48  James Joyce, *Ulysses*, ed. Hans Walter Gabler (New York: Vintage, 1986), 46.

49  For an exhaustive account of the word "yes" and its role in *Ulysses*, see Jacques Derrida, "Ulysses Gramophone: Hear Say Yes in Joyce," *Acts of Literature*, ed. Derek Attridge (London: Routledge 1992), 253–309.

50  Roman Jakobson, "What Is Poetry?," *Language in Literature*, ed. Krystyna Pomorska and Stephen Rudy (Cambridge, MA: Harvard University Press), 369–370.

51  Gregg Bordowitz, *General Idea: Imagevirus* (London: Afterall Books, 2010), 14.

52  Ibid., 111.

53  Quoted in Tom McDonough, ed., "All the King's Men," in *Guy Debord and the Situationist International* (Cambridge, MA: MIT Press, 2002), 156.

54  Kayla Guthrie, "Words Are People: Q + A with Karl Holmqvist," *Art in America*, June 7, 2012, https://www.artinamericamagazine.com/news-features/interviews/karl-holmqvist-alex-zachary-peter-currie-moma/.

55  Audre Lorde, "Age, Race, Class, and Sex," in *Sister Outsider: Essays and Speeches* (Trumansburg, NY: Crossing Press, 1984), 116.

56  Dick Higgins, "Some Poetry Intermedia," in *Intermedia, Fluxus and the Something Else Press*, ed. Ken Friedman and Steve Clay (Catskill, NY: Siglio, 2018), 241.

57  Dick Higgins, "Intermedia," *Something Else Press Newsletter* (February 1966), n.p.

58  Claudia Rankine, *Citizen: An American Lyric* (Minneapolis, MN: Graywolf Press, 2014); for more on Cameron Rowland, see Alex Kitnick, "Openings: Cameron Rowland," *Artforum* (March 2016): 260–267.

59  Henry Jenkins, *Convergence Culture: Where Old and New Media Collide* (New York: New York University Press, 2006), 2.

60  My thinking regarding adverse convergence is influenced by Jerzy Grotowski's notion of a "poor theatre," as well as Hito Steyerl's "In Defense of the Poor Image," in *The Wretched of the Screen* (Berlin: Sternberg Press, 2012), 31–45. Grotowski claimed that "No matter how much theatre expands and exploits its mechanical resources, it will remain technologically inferior to film and television." Jerzy Grotowski, *Towards a Poor Theatre*, ed. Eugenio Barba (London: Routledge, 2003), 19. Much the same might be said of text art and visual poetry, although cross-media comparisons of this sort tend to elide important distinctions and exceptions. For Grotowski, "An act of creation has nothing to do with either external comfort or conventional human civility; that is to say, working conditions in which

everybody is happy. It demands a maximum of silence and minimum of words" (258). For a parallel account of phenomena related to "adverse convergence" in relation to conceptual art, see Garrett Stewart, *Transmedium: Conceptualism 2.0 and the New Object Art* (Chicago: University of Chicago Press, 2018).

61  For an account of the "discrepant rates of production and consumption" within the economy of contemporary poetry publication, see Craig Dworkin, "Seja Marginal," in *The Consequence of Innovation: 21st Century Poetics*, ed. Craig Dworkin (New York: Roof Books, 2008), 7–24.

62  Merleau-Ponty, *Phenomenology of Perception*, xxiii.

63  The *OED* cites the earliest usage of "tl;dr" in 2002, and defines it as "too long; didn't read … used as a dismissive response to an account, narrative, etc., considered excessively or unnecessarily long, or to introduce a summary of a longer piece of text."

## Chapter 1

1  This definition is meant to be expansive, rather than exclusive. For a discussion of various linguistic definitions of a single sentence, see chapter 8. I take a work such as Magritte's *La Trahison des images* [Ceci n'est pas une pipe], for instance, to qualify as a work of minimal writing.

2  Ulises Carrión, "The New Art of Making Books," *Kontexts* 6–7 (1975), n.p.

3  Writing of technologies of compression, Jonathan Sterne argues:

> The history of MP3 belongs to a general history of compression. As people and institutions have developed new media and new forms of representation, they have also sought out ways to build additional efficiencies into channels and to economize communication in the service of facilitating greater mobility. These practices often begin close to economic or technical considerations, but over time they take on a cultural life separate from their original, intended use. As with the quest for verisimilitude, compression practices have created new kinds of aesthetic experiences that come to be pleasurable in themselves for some audiences—from the distortion that is a side effect of electrical amplification in radio, phonography, and instrument amplification, to the imagined intimacy of the phone conversation, to the mashups that aestheticize the MP3 form and the distribution channels it travels. Histories of contemporary immersive technologies point to a multiplicity of antecedents, going back centuries, even millennia.

> Jonathan Sterne, *MP3: The Meaning of a Format* (Durham: Duke University Press, 2012), 5–6.

4  Alexander Akin, "Protest Signs: Barometers of Social Change," *The New Antiquarian*, blog of the Antiquarian Booksellers Association of America, April 17, 2017, https://www.abaa.org/blog/post/protest-signs-barometers-of-social-change. For historical accounts of protest signage, see also Bonnie Siegler, *Signs of Resistance: A Visual History of Protest in America* (New York: Artisan Books, 2018), and Milton Glaser and Mirko Ilić, *The Design of Dissent, Expanded Edition: Greed, Nationalism, Alternative Facts, and the Resistance* (New York: Quarto Books, 2017).

5  It is interesting to speculate on how human perceptual limitations influence how we read and apprehend text, although a full exploration of this topic goes well beyond my area of expertise (and might venture into the territory of "neuromania," discussed in chapter 10). According to the cognitive neuroscientist Stanislaus Dehaene, when humans read,

our perceptual abilities depend exclusively on the number of letters in words, not on the space these words occupy on our retina. Indeed, our saccades when we read vary in absolute size, but are constant when measured in numbers of letters. When the brain prepares to move our eyes, it adapts the distance to be covered to the size of the characters, in order to ensure that our gaze always advances by about seven to nine letters. This value, which is amazingly small, thus corresponds approximately to the information that we can process in the course of a single eye fixation.

Stanislaus Dehaene, *Reading in the Brain: The New Science of How We Read* (New York: Penguin, 2009), 14–15.

6   For the last of these, the pixel, see Dennis Tenen, "Literature Down to the Pixel," *Plain Text: The Poetics of Computation* (Stanford: Stanford University Press, 2017), 165–196.

7   Stephanie Strickland offers an account of the spatiotemporal experience of digital versus print reading that bears quoting at length:

Scale is elided on the Web, as it is in the stenographer's practice, where events in the conference room, in her brain, in her hand, and on her code-filled writing machine are nearly simultaneous. Many different scales can be present to the same screen, as if they belonged together, as if they cohered there as "naturally" as they do in the stenographer's body. But a change in scale is a change of context: the view/read cusp will shift differently for zoomed text than it will for text that is panned. In fact, this kind of zoom or scale-changing cusp may be a particularly important one in a world where we are asked to process simultaneously scales from the nano to the cosmic.

Stephanie Strickland, "Quantum Poetics: Six Thoughts," in *Media Poetry: An International Anthology*, ed. Eduardo Kac (Bristol: Intellect Books, 2007), 31. Her account of the scale of online media, in particular, may help to explain why minimal textual practices have such widespread appeal in the digital era.

8   Some other notable one-letter poems include jwcurry's translation of Vladimir Burda's "ich," Timm Ulrichs's "e," Jiří Valoch's "Homage to Ladislav Novák," and Steve McCaffery's "William Tell: A Novel"; the last is closely read by Christian Bök in his essay "Two Dots over a Vowel," *boundary 2* 36, no. 3 (2009): 11–24. See also *Alphabet Anthology: One-Letter Poetry*, ed. Joyce Holland (Iowa City: X Press, 1973).

9   For an informative discussion of technological miniaturization in relation to poetic form, see Craig Saper's introduction to Bob Brown, *Words*, ed. Craig Saper (Baltimore: Roving Eye Press, 2014). Saper points to how Brown was influenced by "the miniaturizing of secret messages by spies" (xi), and notes that Brown's reading machine "highlighted the emerging peculiar ways of reading abbreviated language in stock market tickertape, shorthand, technical manuals, recipes, and specialized actuarial and accounting codes that came into widespread use in the first quarter of the twentieth century" (xii).

10  Though there is no direct connection, it is interesting to note that in 1965, the same year that Saroyan's *m* was created, Moore's Law was formulated, ushering in an era of extraordinary advances in information technology. (Moore, a cofounder of Intel, proposed that the number of transistors per square inch on integrated circuits would double roughly every two years.)

11  Recent surveys of visual poetry, concrete poetry, text art, typewriter art, etc., point to some of these difficulties of classification. For more, see Michael Petry, *The Word Is Art* (London: Thames and Hudson, 2018); Dieter Burchardt, ed., *Words without Thoughts Never to Heaven Go* (New York: Almine Rech Gallery, 2017); *The New Concrete: Visual Poetry in the 21st Century*, ed. Victoria Bean and Chris McCabe (London: Hayward Publishing,

2015); *It Is Almost That: A Collection of Image+Text Work by Women Artists and Writers*, ed. Lisa Pearson (Los Angeles: Siglio, 2011); *Art and Text*, ed. Aimee Selby (London: Black Dog Publishing, 2009); Marvin and Ruth Sackner, *The Art of Typewriting* (London: Thames and Hudson, 2015); *Typewriter Art: A Modern Anthology*, ed. Barrie Tullett (London: Laurence King, 2014); *Writing on the Wall: Word and Image in Modern Art*, ed. Simon Morley (Berkeley: University of California Press, 2003); *The Last Vispo Anthology: Visual Poetry 1998–2008*, ed. Crag Hill and Nico Vasillakis (Seattle: Fantagraphics Books, 2012); "Ecstatic Alphabets / Heaps of Language," *Bulletins of the Serving Library* 3 (2012) [Museum of Modern Art exhibition catalog]; "Visual Poetry Today," ed. Geof Huth, *Poetry Magazine* (November 2008): 125–140.

12  Solt, *Concrete Poetry*, 7 (emphasis in original).

13  The 1971 anthology *This Book Is a Movie: An Exhibition* (which included a sequence by Saroyan—and the title of which mixes media metaphors of book and film as well as gallery exhibition) reveals some of the perennial difficulties in categorizing language-based art. Its editors write:

The premise behind this activity is simple: words have a dimension (and, hence, an artmaking potential) as form that goes beyond their historical function as media for conveying information and meaning.
   This trend—which is interdisciplinary, crossing the boundaries of poetry, painting, sculpture and photography—is so widespread and the forms it takes are so diverse, that it still lacks a proper name. Structured language is presented under many labels, none of them completely satisfactory. Consider those areas called concrete, conceptual, visual, found; all refer to specialized areas of language-structure experimentation. But none of them describe the movement as a whole. A better label might be simply "language art," a term that seems broad enough to cover all activities now underway.

Jerry G. Bowles and Tony Russell, eds., *This Book Is a Movie: An Exhibition of Language Art and Visual Poetry* (New York: Dell, 1971), n.p.
   This assessment rings true even after nearly fifty years, and the term "language art"—which seems as suitable as any other—is not widely used. See also Dick Higgins, "Intermedia," *Something Else Press Newsletter* (February 1966), n.p.

14  Marjorie Perloff, "Minimalism," *The Princeton Encyclopedia of Poetry and Poetics*, 4th ed., ed. Roland Greene et al. (Princeton: Princeton University Press, 2012), 886–887. For another useful overview, see Bob Grumman, "MNMLST Poetry: Unacclaimed but Flourishing," https://www.thing.net/~grist/l&d/grumman/egrumn.htm.

15  This piece was exhibited as an artwork and published in book form on the back cover of Cia Rinne, *notes for soloists* (Stockholm: OEI Editörm, 2009).

16  Jamie Hilder, *Designed Words for a Designed World: The International Concrete Poetry Movement 1955–1971* (Montreal and Kingston: McGill-Queen's University Press, 2016), 4.

17  Many of the poems and artworks under discussion in this book—particularly those that seem to incorporate children's speech or ungrammatical language—might alternatively be described as what Maria Damon has called "micropoetry." For Damon, "micropoetry refers positively to the rawness of fragmentary, ephemeral, nonliterary, unintentional, or otherwise 'unviable' poetry." "Micropoetries," *Princeton Encyclopedia of Poetry and Poetics*, 883. Among the primary examples she offers are the "strange and charming utterances of children" (883). Micropoetry, it should be noted, is not synonymous with minimalism, and it also tends to refer to poetry produced by amateurs; thus the term should be applied with caution.

18  Hilder, *Designed Words*, 85.

19  Richard Wollheim, "Minimal Art," in *Minimal Art: A Critical Anthology*, ed. Gregory Battcock (New York: Dutton, 1968), 395.

20  For more on "deskilling," see John Roberts, *The Intangibilities of Form: Skill and Deskilling in Art after the Readymade* (London: Verso, 2007).

21  Daniel Albright, *Quantum Poetics: Yeats, Pound, Eliot, and the Science of Modernism* (Cambridge, UK: Cambridge University Press, 1997), 1.

22  Ibid.

23  For more on the influence of quantum physics and relativity theory on twentieth-century experimental poetry, see Daniel Tiffany, *Toy Medium: Materialism and Modern Lyric* (Berkeley: University of California Press, 2000) and Peter Middleton, *Physics Envy: American Poetry and Science in the Cold War and After* (Chicago: University of Chicago Press, 2015).

24  Albright, *Quantum Poetics*, 1.

25  Ibid, 1–2.

26  Quoted in Kay Rosen, "A Constructed Conversation Between Kay Rosen and Virginia Woolf," *Social Medium: Artists Writing, 2000–2015*, ed. Jennifer Liese (New York: Paper Monument, 2016), 36.

27  Ibid.

28  Larry Eigner, "Be minimal then … ," in *Areas/Lights/Heights: Writings 1954–1989*, ed. Benjamin Friedlander (New York: Roof Books, 1989), 8.

29  Hart Crane, "The Tunnel," in *Complete Poems and Selected Letters*, ed. Langdon Hammer (New York: Library of America, 2006), 67.

30  Eigner, "Be minimal then … ," 7.

31  Ibid.

32  A history of literary compression (or of impulses and imperatives toward concision, etc.) could someday be written, but it might be too long for anyone to read. "Brevity is the soul of wit," noted the longwinded Polonius, only to have Gertrude ask him for "More matter with less art." William Shakespeare, *Hamlet*, The Riverside Shakespeare (Boston: Houghton Mifflin, 1974), II.2, lines 90, 95. Since antiquity, the plain or Attic style has been contrasted with the grand or Asiatic style. Horace's *Ars Poetica* begins with an injunction against "purple prose." In his *Dictionary of Received Ideas*, Flaubert defines "concision" as "A language no one speaks any more," and defines "Book" as "No matter which one, always too long." Gustave Flaubert, *Bouvard and Pécuchet and Dictionary of Received Ideas*, trans. Mark Polizzotti (Normal, IL: Dalkey Archive, 2005), 288, 292. In her 1923 poem, "The Snail," Marianne Moore alludes to the long history of rhetorical injunctions to compression by quoting the Attic orator Demetrius in the poem's first line: "If 'compression is the first grace of style,' / you have it." In Marianne Moore, *The Complete Poems* (London: Faber and Faber, 1968), 85. Born two years earlier, Ezra Pound alluded to the plain style of the Attic orators in his *Hugh Selwyn Mauberley*. What "the age demanded" was "Not, at any rate, an Attic grace," but rather "a prose kinema." Ezra Pound, *Hugh Selwyn Mauberley* (London: Ovid Press, 1910), 10. Pound seemed hardly able to pronounce "cinema" with a soft c in the English or French manner—rather, his reversion to Greek marks a dismissal of mass culture. Postwar minimal writing and text art, by contrast, absorbs and reframes almost every variety of contemporary textuality.

For an entertaining account of the perennial contest between minimalism and maximalism with special reference to fiction, see John Barth, "A Few Words on Minimalism." Barth writes:

> The medieval Roman Catholic Church recognized two opposite roads to grace: the *via negativa* of the monk's cell and the hermit's cave, and the *via affirmativa* of immersion in human affairs, of being in the world whether or not one is of it. Critics have aptly borrowed those terms to characterize the difference between Mr. Beckett, for example, and his erstwhile master James Joyce, himself a maximalist except in his early works.

John Barth, "A Few Words about Minimalism," *New York Times*, December 28, 1986. For other accounts of minimalist fiction, see Warren Motte, *Small Worlds: Minimalism in Contemporary French Literature* (Lincoln: University of Nebraska Press, 1999) and Robert C. Clark, *American Literary Minimalism* (Tuscaloosa: University of Alabama Press, 2015).

33  Marc Botha, *A Theory of Minimalism* (London: Bloomsbury, 2017), xiii.

34  James Meyer, *Minimalism: Art and Polemic in the Sixties* (New Haven: Yale University Press, 2004), 6.

35  Quoted in ibid.

36  Gwen Allen, *Artists' Magazines: An Alternative Space for Art* (Cambridge, MA: MIT Press, 2011), 54.

37  Emmett Williams, "instructions for use," *sweethearts* (New York: Something Else Press, 1967), n.p.

38  Emmett Williams, *sweethearts* [online version], http://www.sweetheartsweetheart.com.

39  Susan Sontag, "The Aesthetics of Silence," *Aspen* 5+6 (1967), n.p.

40  As Merleau-Ponty writes, "An isolated datum of perception is inconceivable." Maurice Merleau-Ponty, *Phenomenology of Perception*, trans. Colin Smith (London: Routledge, 2002), 4.

41  For more, see Sarah Lehrer-Graiwer, *Lee Lozano: Dropout Piece* (London: Afterall, 2014). See also Martin Herbert, *Tell Them I Said No* (Berlin: Sternberg Press, 2017).

42  Michael Fried, "Art and Objecthood," *Artforum* 5 (June 1967): 12–23.

43  Roland Barthes, *Image-Music-Text*, trans. Stephen Heath (New York: Hill and Wang, 1978), 145–146.

44  Ed Ruscha, *They Called Her Styrene* (New York: Phaidon, 2000), n.p.

45  Jeff Yang discusses the racial implications of such fonts, sometimes referred to as "chop suey fonts" or "wonton fonts"—which mimic the brush strokes of Chinese characters, in "Is Your Font Racist?," *Wall Street Journal*, June 20, 2012, https://blogs.wsj.com/speakeasy/2012/06/20/is-your-business-font-racist/.

46  For more, see the entry on "Pure Poetry" in *The Princeton Encyclopedia of Poetry and Poetics*, 1134–1135.

47  Robert Smithson, "Language to Be Looked At and/or Things to Be Read," in *The Collected Writings*, ed. Jack Flam (Berkeley: University of California Press, 1996), 61.

48  Ed Ruscha, *Leave Any Information at the Signal: Writings, Interviews and Images*, ed. Alexandra Schwartz (Cambridge, MA: MIT Press, 2002), 57.

49  Clement Greenberg, "Avant-Garde and Kitsch," in *Art and Culture: Critical Essays* (Boston: Beacon Press, 1961), 5.

50  Clement Greenberg, "Towards a Newer Laocoön," *Partisan Review* (July-August 1940): 307.

51  Gertrude Stein, *Three Lives* (New York: Vintage, 1909), 86.

52  Scott Rothkopf, *Glenn Ligon: AMERICA* (New York: Whitney Museum of Art, 2011), 45.

53  Glenn Ligon, *Some Changes* (Toronto: The Power Plant, 2009), 185.

54  Rachel Churner, "Erica Baum," *Artforum* (April 2019): 193. The line is from Gertrude Stein, *Tender Buttons: The Corrected Centennial Edition*, ed. Seth Perlow (San Francisco: City Lights, 2014), 13.

55  Carrión, "The New Art of Making Books," n.p.

56  Mónica de la Torre, "Ulises Carrión's The Poet's Tongue," *BOMB Magazine*, January 1, 2013, http://bombmagazine.org/article/6931/ulises-carri-n-s-the-poet-s-tongue.

57  Carrión, "The New Art," n.p. For more on conceptual art's and text art's use of event scores, see Liz Kotz, *Words to Be Looked At: Language in 1960s Art* (Cambridge, MA: MIT Press, 2007).

58  Carrión, "The New Art," n.p.

59  With specific reference to Mallarmé, Christophe Wall-Romana applies the word "cinepoetry" to "a writing practice whose basic process is homological: it consists of envisioning a specific component or aspect of poetry as if it were a specific component of cinema, or vice versa, but always in writing. The screen becomes the page, a close-up turns into a metaphor, or conversely, the irregular spacing of words on the page is meant to evoke the movement of the screen." Christophe Wall-Romana, *Cinepoetry: Imaginary Cinemas in French Poetry* (New York: Fordham University Press, 2013), 3. Films such as Hollis Frampton's *Zorns Lemma* (1970) might be described as inverting the analogy wherein poetry incorporates cinematic effects.

60  For more on textual films from the 1960s and for a reading of Snow's *So Is This*, see Justin Remes, "Boundless Ontologies: Michael Snow, Wittgenstein, and the Textual Film," *Motion(less) Pictures: The Cinema of Stasis* (New York: Columbia University Press, 2015), 85–110.

61  Kenneth Goldsmith, "Hollis Frampton's *Zorns Lemma* (1970)," April 2, 2007, https://www.poetryfoundation.org/harriet/2007/04/hollis-frampton-zorns-lemma-1970.

62  For more on Andre and minimal seriality, see Marjorie Perloff, "The Palpable Word: The *one hundred sonnets*," in *Carl Andre: Sculpture as Place, 1958–2010* (New Haven: Yale University Press, 2014), 289–296.

63  Alison Knowles, "[Note on The House of Dust]," *Artforum* (September 2012), 116.

64  Jeff Kelley, *Childsplay: The Art of Allan Kaprow* (Berkeley: University of California Press, 2004), 71.

65  For more, see Alison Knowles, *The Big Book* (Berlin: Passenger Books, 2013).

66  N. Katherine Hayles, *Writing Machines* (Cambridge, MA: MIT Press, 2002), 25–26.

67  Martine Syms, "Black Vernacular: Reading New Media," in *Mass Effect: Art and the Internet in the Twenty-First Century*, ed. Lauren Cornell and Ed Halter (Cambridge, MA: MIT Press, 2015), 369.

68  Martine Syms, "The Mundane Afrofuturist Manifesto," *Rhizome*, December 17, 2013, http://rhizome.org/editorial/2013/dec/17/mundane-afrofuturist-manifesto/.

69  Zora Neale Hurston, "How It Feels to Be Colored Me," *Folklore, Memoirs, and Other Writings*, ed. Cheryl A. Wall (New York: Library of America, 1995), 828.

70  Syms, "Black Vernacular," 369.

71  Ibid., 373.

72  It is instructive in this context to revisit Anna C. Chave's perceptive, though dated, critique, "Minimalism and the Rhetoric of Power," in which she claims "the blank face of Minimalism may come into focus as the face of capital, the face of authority, the face of the father." *Arts Magazine* (January 1990): 51. Chave may well be correct when speaking of artists such as Frank Stella, Richard Serra, and Carl Andre, but she omits from her discussion female minimalists, as well as minimal artists of color. See also Botha, *A Theory of Minimalism*, chapters 1 and 2, for an account of global and postcolonial minimalist art that complicates Chave's position.

73  For a useful overview of contemporary African American visual artists whose work is strongly text-based, see Evan Moffitt, "What Can't Be Read," *Frieze* 192 (January-February 2018), https://frieze.com/article/what-cant-be-read.

74  Minimal art, conceptual art, and performance art can also forcefully critique normative white masculinity. Jacolby Satterwhite writes, for example, that "[Bruce] Nauman's work can be understood as an interrogation of the banality of his white male body; its scale, identity, and relationship to his environs." Jacolby Satterwhite, review of Bruce Nauman's *Disappearing Acts*, *Artforum* (October 2018), 180. Satterwhite is thinking in particular of Nauman's *Self-Portrait as a Fountain* (1966), which he reads in response to Duchamp's *Fountain*. See also Ralph Lemon, "Positions," and Glenn Ligon, "Neon Sign, None Sing," in *Bruce Nauman: Disappearing Acts*, ed. David Frankel (New York: MoMA, 2018), 116–123, 162–167. Two of Ligon's neon works explicitly draw upon prior Nauman works: *One Live and One Die* (2006), referring to Nauman's *100 Live and Die* (1984); and *Impediment* (2006), referring to Nauman's *My Name as Though It Were Written on the Surface of the Moon* (1968).

75  For a useful overview of the installation and film, see Doreen St. Félix, "How to Be a Successful Black Woman," *The New Yorker*, July 8, 2017, http://www.newyorker.com/culture/persons-of-interest/how-to-be-a-successful-black-woman.

76  Jocelyn Miller, "Project 106: Martine Syms" [brochure], Museum of Modern Art, New York, 2017.

77  Quoted in Richard Prince, "Vito Acconci," *BOMB* 36 (July 1, 1991), http://bombmagazine.org/article/1443/vito-acconci.

78  Ibid.

**Chapter 2**

1  Raphael Rubinstein, "Missing: erasure | Must include: erasure," in *Under Erasure* (New York: Nonprofessional Experiments, 2018), 11.

2   Joseph Kosuth, "Art after Philosophy," *Art after Philosophy and After*, ed. Gabriele Guercio (Cambridge, MA: MIT Press, 1991), 18.

3   The term "demediate" is taken from Garrett Stewart, who defines it as

*the undoing of a given form of transmission, now blocked or altered, in the medium of its secondary presentation*. Where in Marshall McLuhan's well-known sense of the form/content dyad, the content of a new medium is always the lingering form of the old, in the art of demediation the *absence* of the old medial form becomes the content of the new work. The actual book objects to come (sculptures, appropriations, composites) often appear, like these first virtual or fictive ones, as abstract volumetric forms—demediated in just this sense, no longer broadcast from within as explicit textual signification or legible message. So that their point, too, is one we must in the best of cases half *make up* for ourselves; or, as we say, make up our minds about.

Garrett Stewart, *Bookwork: Medium to Object to Concept to Art* (Chicago: University of Chicago Press, 2011), 1–2 (emphases in original).

4   Nick Thurston, "Readography," *Reading as Art*, ed. Simon Morris (York: Information as Material, 2016), 91–92.

5   Ibid., 92.

6   Ibid., 48–49 (emphasis in original).

7   Eric Kandel, *Reductionism in Art and Brain Science* (New York: Columbia University Press, 2016), 5.

8   Quoted in Walter Benjamin, "Karl Kraus," in *Selected Writings*, vol. 2, *1927–1934*, ed. Michael W. Jennings et al. (Cambridge, MA: Belknap Press, 1999), 453.

9   Robert Smithson, "A Museum of Language in the Vicinity of Art," in *The Collected Writings*, ed. Jack Flam (Berkeley: University of California Press, 1996), 87 (emphasis in original).

10  Christopher Wool, *Untitled (The Harder You Look the Harder You Look)* (2000), enamel on aluminum, 108" × 72".

11  For an aptly titled recent defense of philology, see Werner Hamacher, *Minima Philologica*, trans. Catharine Diehl and Jason Groves (New York: Fordham University Press, 2015).

12  For more, see Jerome McGann, *A New Republic of Letters: Memory and Scholarship in the Age of Digital Reproduction* (Cambridge, MA: Harvard University Press, 2014), 32–48.

13  Susan Howe, *The Spontaneous Particulars: The Telepathy of Archives* (New York: New Directions, 2014), 21.

14  McGann, *A New Republic of Letters*, 19.

15  Friedrich Nietzsche, *Daybreak*, ed. Maudemarie Clark and Brian Leiter (Cambridge, UK: Cambridge University Press, 1997), 5.

16  Stephen Best and Sharon Marcus, "Surface Reading: An Introduction," *Representations* 108, no. 1 (Fall 2009): 1–21, 9, 10. Derek Attridge and Henry Staten have offered a similar term, "minimal reading," which they differentiate from "close reading": "The term 'close reading' is too ideologically radioactive, and means too many different things, to serve as a name for the kind of reading we do here. We have considered various names for it, which turn up in our discussions: 'weak reading,' 'minimal reading,' 'literal reading,' and 'reading for the essentials.' In the end, we have settled on 'minimal reading' or 'minimal interpretation.'"

Derek Attridge and Henry Staten, *The Craft of Poetry: Dialogues on Minimal Interpretation* (New York: Routledge, 2015), 2.

17  Building on the work of Moretti, Best, and Marcus, Dennis Tenen has recently called for a "computational poetics," which he defines as "a strategy of interpretation capable of reaching past surface content to reveal platforms and infrastructures that stage the construction of meaning. Where 'distant reading' and cultural analytics perceive patterns across large-scale corpora, computational poetics breaks textuality down into its minute constituent components. It is a strategy of microanalysis rather than macroanalysis." Dennis Tenen, *Plain Text: The Poetics of Computation* (Stanford: Stanford University Press, 2017), 6.

18  Charles Bernstein, introduction to *Close Listening: Poetry and the Performed Word*, ed. Charles Bernstein (Oxford: Oxford University Press, 1998), 5.

19  Fred Moten, *In the Break: The Aesthetics of the Black Radical Tradition* (Minneapolis: University of Minnesota Press, 2003), 90.

20  Warren Motte, "Abecedaries," *Verbivoracious Festrschrift*, vol. 6, *The Oulipo*, ed. G. N. Forester (Singapore: Verbivoracious Press, 2017), 34.

21  Christian Bök, "Statement: A Zoom Lens for the Future of the Text," presented at "Text/Sound/Performance: Making in Canadian Space," University College Dublin, April 25–27, 2019, https://textsoundperformance.wordpress.com/plenary-speakers/.

22  For more on lettrism, see Jean-Paul Curtay, *La Poesie Lettriste* (Paris: Seghers, 1974).

23  Susan Howe, *The Birth-Mark: Unsettling the Wilderness in American Literary History* (Middletown, CT: Wesleyan University Press, 1993), 141.

24  Jen Bervin, introduction to Emily Dickinson, *The Gorgeous Nothings: Emily Dickinson's Envelope Poems*, ed. Jen Bervin and Marta Werner (New York: New Directions, 2013), 9.

25  Ibid., 8 (emphasis in original).

26  Ibid.

27  Sharon Cameron, *Choosing Not Choosing: Dickinson's Fascicles* (Chicago: University of Chicago Press, 1993), 6.

28  Emily Dickinson, *The Single Hound* (Boston: Little, Brown, 1914), 132.

29  Emily Dickinson, *The Poems of Emily Dickinson*, ed. Thomas Johnson (Cambridge, MA: Belknap Press, 1955), 214–215.

30  Emily Dickinson, *Emily Dickinson's Poems: As She Preserved Them*, ed. Cristanne Miller (Cambridge, MA: Harvard University Press, 2016), 182.

**Chapter 3**

1  Moretti observes that "Half-sign, half-ad, the title is where the novel as language meets the novel as commodity." Franco Moretti, *Distant Reading* (London: Verso, 2013), 181. To which I might add (somewhat speculatively): minimal poems and works of text art are often eponymously titled or untitled—thus avoiding a title/content split, and making the work all-sign and all-ad (if commercial) or no-ad (if noncommercial). Lawrence Weiner, for instance, claims "Titles are my art." Quoted in *Writing on the Wall: Word and Image in Modern Art*, ed. Simon Morley (Berkeley: University of California Press, 2003), 147.

2   In Bernar Venet, *Poetic? Poétique?: Anthologie 1967–2017* (Paris: Jean Boîte Editions, 2017), 98–99.

3   Kyle Chayka, "The Oppressive Gospel of 'Minimalism,'" *New York Times*, July 26, 2016, http://www.nytimes.com/2016/07/31/magazine/the-oppressive-gospel-of-minimalism.html?_r=0.

4   Devin Leonard, "Deep Thoughts with the Homeless Billionaire," *Bloomberg*, September 28, 2012, https://www.bloomberg.com/news/articles/2012-09-27deep-thoughts-with-the-homeless-billionaire.

5   Katie Hope, "Eight Billionaires 'as Rich as World's Poorest Half,'" *BBC News*, January 16, 2017, http://www.bbc.com/news/business-38613488.

6   Berggruen, who also funds a think tank, takes pride in his commitment to social justice. According to *Bloomberg*, the think tank exists to further his view that "developed countries are in crisis because their leaders are too focused on getting reelected. The result is political gridlock in such places as Washington, D.C., and California. Berggruen believes at least part of the solution to Western political paralysis is the Asian equivalent of the smoke-filled room." Leonard, "Deep Thoughts."

7   Arielle Bernstein, "Marie Kondo and the Privilege of Clutter," *The Atlantic*, March 25, 2016, http://www.theatlantic.com/entertainment/archive/2016/03/marie-kondo-and-the-privilege-of-clutter/475266/. See also Marie Kondo, *The Life-Changing Magic of Tidying Up: The Japanese Art of Decluttering and Organizing* (New York: Ten Speed Press, 2014).

8   Rob Horning, "Everything in Its Place," *The New Inquiry*, June 28, 2017, https://thenewinquiry.com/blog/everything-in-its-place/.

9   It is difficult to generalize about the individual lifestyle practices of writers and artists, but it should be noted that a number of prominent minimal and concrete poets practiced extreme forms of asceticism and/or were members of monastic orders: Robert Lax, Corita Kent, Dom Sylvester Houédard, and Thomas Merton could be cited as examples.

10  Margot Adler, "Behind the Ever-Expanding American Dream House," *All Things Considered*, NPR, July 4, 2006, http://www.npr.org/templates/story/story.php?storyId=5525283.

11  Liam Gillick, "A Building on Fifth Avenue," *e-flux* 78 (December 2016), http://www.e-flux.com/journal/78/83040/a-building-on-fifth-avenue/.

12  Danny Heitman, "Thoreau, the First Declutterer," *New York Times*, July 3, 2016, https://www.nytimes.com/2015/07/04/opinion/thoreau-the-first-declutterer.html.

13  Walter Isaacson, "How Steve Jobs' Love of Simplicity Fueled a Design Revolution," *Smithsonian Magazine* (September 2012), https://www.smithsonianmag.com/arts-culture/how-steve-jobs-love-of-simplicity-fueled-a-design-revolution-23008877/.

14  Henry David Thoreau, *A Week, Walden, The Maine Woods, Cape Cod*, ed. Robert F. Sayre (New York: Library of America, 1985), 395.

15  Ross Posnock describes the contradiction between overconsumption and renunciation in these terms:

> in a culture and economy whose byword is "more," one imprinted upon not only our economic but also psychic and cultural life, renunciation seems bewilderingly perverse.... Under capitalism, Minimalism has a hard time remaining minimal. Recall the concept's postwar career: it began in the early sixties as minimal art, and after a post-Minimalism reaction, migrated over several decades from an aesthetic into a taste, marketed as a lifestyle and design option including an expensive diet regimen.

Ross Posnock, *Renunciation: Acts of Abandonment by Writers, Philosophers, and Artists* (Cambridge, MA: Harvard University Press, 2016), 16. For a pop culture embodiment of this contradiction, see the site Becoming Minimalist, http://www.becomingminimalist.com/, and its attendant lifestyle improvement offshoots.

16  Lawrence Weiner, *Statements* (New York: Louis Kellner Foundation, 1968), n.p.

17  Theodor Adorno, *Minima Moralia: Reflections on a Damaged Life*, trans. E. F. N. Jephcott (London: Verso, 1978), 18.

18  Ibid., 15.

**Chapter 4**

1  Adrian Piper, "On Conceptual Art," in *Out of Order, Out of Sight*, vol. 1, *Selected Writings in Meta-Art, 1968–1992* (Cambridge, MA: MIT Press, 1996), 242.

2  See, for instance, Cathy Park Hong's critique of conceptual writing, "Delusions of Whiteness in the Avant-Garde," *Lana Turner* 7 (2014), http://www.lanaturnerjournal.com/print-issue-7-contents/delusions. For a range of responses to that essay, see Stefania Heim, "Race and the Poetic Avant-Garde," *Boston Review*, March 10, 2015, http://bostonreview.net/blog/boston-review-race-and-poetic-avant-garde.

3  Mónica de la Torre, "Response to Race and the Poetic Avant-Garde," *Boston Review*, March 10, 2015, http://bostonreview.net/poetry/monica-de-la-torre-forum-response-race-avant-garde.

4  David Kaplan, "Demonstratives: An Essay on the Semantics, Logic, Metaphysics, and Epistemology of Demonstratives and Other Indexicals," in *Themes from Kaplan*, ed. J. Almog et al. (Oxford: Oxford University Press, 1989), 490.

5  Benjamin H. D. Buchloh, "Conceptual Art, 1962–1969: From the Aesthetic of Administration to the Critique of Institutions," in *Conceptual Art: A Critical Anthology*, ed. Alexander Alberro and Blake Stimson (Cambridge, MA: MIT Press, 1999), 514–537.

6  Nizan Shaked, *The Synthetic Proposition: Conceptualism and the Political Referent in Contemporary Art* (Manchester: Manchester University Press, 2017), 17.

7  Piper, "On Conceptual Art," 257.

8  For more on *Untitled (I Am a Man)*, see Gregg Bordowitz, *Glenn Ligon: Untitled (I Am a Man)* (London: Afterall Books, 2018).

9  The 1968 sign (and Ligon by extension) have inspired other artistic adaptations as well, such as Sharon Hayes's *In the Near Future* (2005) and Hank Willis Thomas's *I Am a Man* (2009).

10  National Gallery of Art, https://www.nga.gov/Collection/art-object-page.159784.html.

11  Shaked, *The Synthetic Proposition*, 2.

12  North Carolina's "bathroom bill" (or Public Facilities Privacy and Security Act) of 2016 preempted local antidiscrimination ordinances, and required people to use single-gender restrooms based on the gender assigned by their birth certificate.

13  "Lets [sic] just call them WALLS from now on and stop playing political games! A WALL is a WALL!" Donald J. Trump, Twitter post, January 31, 2019, 7:16 a.m., https://twitter.com/realdonaldtrump.

14  W. J. T. Mitchell reads the gender of the statue as indeterminate, a move that adds even more indexical indeterminacy. Irrespective of how the statue's gender is construed, Mitchell is astute to note that "The words 'belong' alternately to the statue, the photograph, and to the artist, whose labor of cutting and pasting is so conspicuously foregrounded." W. J. T. Mitchell, *What Do Pictures Want? The Lives and Loves of Images* (Chicago: University of Chicago Press, 2005), 45.

## Chapter 5

1  F. T. Marinetti, "Technical Manifesto of Futurist Literature," in *Critical Writings*, ed. Günter Berghaus and trans. Doug Thompson (New York: Farrar, Straus and Giroux), 108.

2  Mina Loy, *The Lost Lunar Baedeker*, ed. Roger Conover (New York: Farrar, Straus and Giroux, 1996), 94.

3  F. S. Flint, "Imagisme," *Poetry* (March 1913), 199.

4  Marinetti, "Destruction of Syntax—Untrammeled Imagination—Words-in-Freedom," in *Critical Writings*, 126.

5  Ibid., 131 (emphasis in original).

6  Ibid., 128.

7  Gertrude Stein, "Sacred Emily," *Geography and Plays* (Boston: Four Seas, 1922), 187.

8  For more, see *Russian Futurism through its Manifestoes, 1912–1928*, ed. Anna Lawton and Herbert Eagle (Ithaca, NY: Cornell University Press, 1988), 63–64, 67–68.

9  For more on Gnedov, see Vasilisk Gnedov, *Alphabet for the Entrants*, trans. Emilia Loseva and Danny Winkler (Brooklyn: Ugly Duckling Presse, 2018). See also Volodymyr Bilyk's two translations of *Death to Art* (2016), https://medium.com/@volodymyrbilyk/vasilisk-gnedov-death-to-art-282e3d59cea.

10  Flint, "Imagisme," 199.

11  Ezra Pound, *ABC of Reading* (New York: New Directions, 1934), 36.

12  Very little of the work considered in Johanna Drucker's definitive survey *The Visible Word: Experimental Typography and Modern Art, 1909–1923* (Chicago: University of Chicago Press, 1995), for instance, is recognizably minimal in the postwar sense.

13  *The Princeton Encyclopedia of Poetry and Poetics*, ed. Roland Greene et al., 4th ed. (Princeton: Princeton University Press, 2012), 293.

14  Ezra Pound, *Gaudier-Brzeska: A Memoir* (New York: New Directions, 1970), 89.

15  Ben Lerner, *The Hatred of Poetry* (New York: Farrar, Straus and Giroux, 2016).

16  Marianne Moore, "Poetry" [1925 version], *Observations*, ed. Linda Leavell (New York: Farrar, Straus and Giroux, 2016), 28.

17  Moore's *New Collected Poems*, ed. Heather Cass White (New York: Farrar, Straus and Giroux, 2017) reverses Moore's final wishes for her *Collected Poems*, and places the shortened version in the notes section.

18  Hugh Kenner, "Artemis and Harlequin," *National Review* 19 (December 26, 1967): 1432.

19  Anthony Hecht, "Writers' Rights and Readers' Rights," *Hudson Review* 21 (Spring 1968): 209.

20  For an exhaustive account, see Eric McLuhan, *The Role of Thunder in* Finnegans Wake (Toronto: University of Toronto Press, 1997).

21  William Carlos Williams, *Autobiography* (New York: New Directions, 1967), 311.

22  William Carlos Williams, *An Early Martyr* (New York: Alcestis Press, 1935).

23  Madison Malone Kircher, "This Is Just to Say I Have Written a Blog Post Explaining the Icebox-Plum Meme," *New York Magazine*, November 30, 2017.

24  Annie Lowrey, "A Poem Becomes Meme. Forgive Me." http://nymag.com/daily/intelligencer/2015/07/poem-becomes-meme-forgive-me.html.

25  Just To Say bot, Twitter, November 22, 2016, https://twitter.com/JustToSayBot.

26  Louis Zukofsky, *Prepositions +: The Collected Critical Essays*, ed. Mark Scroggins (Middletown, CT: Wesleyan University Press), 22 (emphasis in original).

27  Ibid.

28  Ibid., 22.

29  Ibid., 25.

30  Ibid., 17.

31  Gertrude Stein, "A Transatlantic Interview," *A Primer for the Gradual Understanding of Gertrude Stein*, ed. Robert Haas (Los Angeles: Black Sparrow, 1971), 31.

32  Zukofsky, *Prepositions +*, 17.

33  Quoted in Sandra Kumamoto Stanley, *Louis Zukofsky and the Transformation of a Modern American Poetics* (Berkeley: University of California Press, 1994), 15.

34  Lorine Niedecker, "Poet's Work," in *Collected Poems*, ed. Jenny Penberthy (Berkeley: University of California Press, 2002), 194.

35  Niedecker, "In the great snowfall before the bomb," in *Collected Poems*, 143.

36  Charles Olson, "Projective Verse," in *Collected Prose*, ed. Donald Allen and Benjamin Friedlander (Berkeley: University of California Press, 1997), 241.

37  Ibid., 245.

38  Ibid.

39  Charles Olson, *The Principle of Measure in Composition by Field: Projective Verse II*, ed. Joshua Hoeynck (Tucson, AZ: Chax Press, 2010), 31.

40  Eugen Gomringer, *The Book of Hours and Constellations*, trans. Jerome Rothenberg (New York: Something Else Press, 1968), n.p.

41  Ibid.

42  For more, cf. Jamie Hilder, *Designed Words for a Designed World: The International Concrete Poetry Movement 1955–1971* (Montreal and Kingston: McGill-Queen's University Press, 2016); Marjorie Perloff, "From Avant-Garde to Digital: The Legacy of Brazilian Concrete Poetry," in *Unoriginal Genius: Poetry by Other Means in the New Century* (Chicago:

University of Chicago Press, 2010), 50–75; and Marvin and Ruth Sackner, *The Art of Typewriting* (London: Thames and Hudson, 2015).

43   Haroldo de Campos, *Novas: Selected Writings*, ed. Antonio Sergio Bessa and Odile Cisneros (Evanston, IL: Northwestern University Press), 226 (emphasis in original).

44   Ibid., 224.

45   Hilder, *Designed Words for a Designed World*, 39.

46   Eugen Gomringer, "Concrete Poetry as a Means of Communication within a New Universal Community: A Retrospective View of Its Origins in the Early 1950s," in *Poetry—Concrete: On Concrete Poetry's Worldwide Distribution and Diversification*, ed. Anne Thurmann-Jajes (Bremen: Salon Verlag, 2012), 210.

47   For a reading of "silencio" as a sonnet, see Nick Montfort, "Gomringer's Untitled Poem ['silencio'], an Unlikely Sonnet," nickm.com/post, July 2, 2019.

48   For a reading of the poem's German version, see Steve McCaffery, *The Darkness of the Present: Poetics, Anachronism, and the Anomaly* (Tuscaloosa: University of Alabama Press), 203–205.

49   Willard Bohn, *Modern Visual Poetry* (Newark: University of Delaware Press, 2000), 246.

50   Malcolm McCullough, *Ambient Commons: Attention in the Age of Embodied Information* (Cambridge, MA: MIT Press, 2013), 139. Similarly, Willard Bohn notes the impact of developments in mass culture on early visual poetry:

> As newspapers and magazines began to proliferate ... they became increasingly oriented toward the visual. For one thing, there was a sharp increase in the number of photographic illustrations in periodicals around 1910. For another, advertisements in the same publications began to incorporate more and more photographs. This development paralleled the rise of modern commercial advertising, which introduced an additional visual stimulus to everyday life. It is no accident, for example, that posters and billboards figure prominently in much of the early visual poetry.

Willard Bohn, *The Aesthetics of Visual Poetry 1914–1928* (Cambridge, UK: Cambridge University Press, 1986), 2–3.

51   David Antin, "Fine Furs," *Critical Inquiry* 19, no. 1 (Autumn 1992): 155.

## Chapter 6

1   *Oulipo Compendium*, ed. Alistair Brotchie and Harry Matthews (London: Atlas Press, 1998), 178.

2   Ian Hamilton Finlay to Aram Saroyan, July 27, 1967, box 2, Aram Saroyan Papers, UCLA Special Collections, Los Angeles, California.

3   The column version of "crickets" was first recorded January 14, 1967, and released on *Mother 9*, ed. Lewis MacAdams and Duncan McNaughton, Mother Publishing, 1968, 33⅓ rpm. Another recording (looped) of the poem was released in the wind-off grooves of *10+2: 12 American Text Sound Pieces*, ed. Charles Amirkhanian, Arch Records, 1975, 33⅓ rpm. "not a cricket" was recorded by John Giorno in 1969, and released on *The Dial-a-Poem Poets*, Giorno Poetry Systems, 1972, 33⅓ rpm.

4   Liner notes, *10+2: 12 American Text Sound Pieces*.

5   "Field Cricket," Insect Identification website, last modified June 6, 2019, http://www.insectidentification.org/insect-description.asp?identification=Field-Cricket.

6   Louis Zukofsky, *All: The Collected Short Poems* (New York: Norton, 1965), 55. Saroyan's crickets poems may also allude indirectly to Keats's "hedge-crickets sing"—three words from "To Autumn" quoted in isolation by Zukofsky in *A Test of Poetry* (New York: The Objectivist Press, 1948), 41.

7   Aram Saroyan, email to author, October 27, 2016.

8   Aram Saroyan, "not a cricket," in *Pages* (New York: Random House, 1969), n.p.

9   Aram Saroyan, *Sled Hill Voices* (London: Cape Goliard, 1967). The sequence was also reprinted in *Pages*.

10  The poem has been translated into French and is included in Aram Saroyan, *Poèmes Électriques*, trans. Martin Richet (Genève: Éditions Héros-Limite, 2015), 84–85.

11  Aram Saroyan to Vito Acconci, September 11, 1967, folder 9, *0 To 9* papers, NYU Fales Collection.

12  Frank Kermode, *The Sense of an Ending: Studies in the Theory of Fiction* (New York: Oxford University Press, 1967), 45.

13  Ibid.

14  Aram Saroyan, *Bibliography* (Los Angeles: Air Books, 2010), 7.

15  Aram Saroyan, *The Rest* (New York: Telegraph Books, 1971); "oxygen" ... "oxygen" are on pages 84–85; "oxygen" ... "gum" on pages 48–49.

16  Clark Coolidge to Aram Saroyan, November 15, 1967, box 19, Aram Saroyan Papers.

17  Clark Coolidge, "Arrangement," in *Talking Poetics at the Naropa Institute*, vol. 1, ed. Anne Waldman and Marilyn Webb (Berkeley: Shambhala, 1978), 161.

18  The poem is included in Vito Acconci, *Language to Cover a Page: The Early Writings of Vito Acconci*, ed. Craig Dworkin (Cambridge, MA: MIT Press, 2006), 210–224.

19  Vito Acconci, promotional blurb for Aram Saroyan, *coffee coffee* (repr., New York: Primary Information, 2007).

20  For Saroyan's own account of the controversy, see "The Most Expensive Word in History," *Mother Jones* (August 1981): 36–38, in which Saroyan objects (perhaps semiseriously) to the *Washington Post*'s ignoring the poem's copyright. Under U.S. law, a single word (even if it is "original") is not copyrightable unless it is trademarked.

21  Ibid., 38.

22  Aram Saroyan, quoted in *Concrete Poetry: A World View*, ed. Mary Ellen Solt (Bloomington: Indiana University Press, 1968), 57–58.

23  Marshall McLuhan, *Understanding Media: The Extensions of Man* (New York: McGraw-Hill, 1964), 8.

24  Saroyan specifically notes that "lighght" was not the result of a typo in a 2014 interview with Michael C. Ford included in Aram Saroyan, *Between Today* (Rotterdam: Sea Urchin Editions, 2016), audio cassette.

25  Aram Saroyan, *The Door to the River: Essays and Reviews from the 1960s into the Digital Age* (Boston: Black Sparrow Press, 2010), 177.

26  Aram Saroyan, *Words & Photographs* (Chicago: Big Table, 1970).

27  For more, see Aram Saroyan, *My Own Avedon: A Memoir with Photographs* (Los Angeles: Air Books, 2010).

28  For Morice's own account, see Dave Morice, "The Joyce Holland Hoax," *Word Ways* (August 1, 2012), https://www.thefreelibrary.com/The+Joyce+Holland+Hoax.-a0302117148.

29  Richard Kostelanetz, *Dictionary of the Avant-Gardes* (New York: Routledge, 2001), 427.

30  See, for instance, *this* 3 (Fall 1972), edited by Robert Grenier and Barrett Watten, which includes minimal poems by both Dave Morice and Joyce Holland.

31  *Matchbook* L (1974?).

32  *Matchbook* E/H (double issue) (1973?).

33  It is interesting to note that much of the early 1970s work by writers who would later become associated with Language writing tended to be minimal. See, for instance, the early issues of *this*, ed. Robert Grenier and Barrett Watten, or *Toothpick, Lisbon, and the Orcas Islands*, ed. Bruce Andrews, or early books by Andrews such as *Corona*.

34  See Craig Dworkin, *No Medium* (Cambridge, MA: MIT Press, 2013), 13–17.

35  Roger Gastman, *Wall Writers: Graffiti in Its Innocence* (Berkeley: Gingko Press, 2016), 18.

36  For more on Saroyan's early life and his relation to his father, see Aram Saroyan, *Trio: Portrait of an Intimate Friendship* (New York: Simon and Schuster, 1985) and *Last Rites: The Death of William Saroyan* (New York: William Morrow, 1982).

37  Jack Kerouac, "The Art of Fiction" [Interview with Ted Berrigan, Duncan McNaughton, and Aram Saroyan], *Paris Review* 43 (Summer 1968): 60–105.

38  Dworkin, *No Medium*, 14.

39  Ibid.

40  Aram Saroyan, "activity," *Gum* 6 (1971), 17.

41  There is no explicit connection to "Eight Days a Week," but it may be worth noting that Saroyan published two Beatles-based minimal books at nearly the same time, *MY MUMMY'S DEAD* (1971) and *The Beatles* (1970).

**Chapter 7**

1  Pritchard was perhaps closer to those in the intermedia/film scene than he was to those in the poetry scene in the late 1960s. He was close friends with the filmmaker Aldo Tambellini, and participated with Ishmael Reed in multimedia performances (in March and June of 1965) of two of Tambellini's films. Pritchard is also featured prominently in Al Carmines's 1968 film *Another Pilgrim*, in which he reads from *Mundus*. He also was close friends with Judith Malina and Julian Beck of the Living Theater, and collaborated briefly with James Tenney. For a general overview of the Lower East Side art scene in the early 60s, see *Inventing Downtown: Artist-Run Galleries in New York City, 1952–1965*, ed. Melissa Rachleff (New York: Prestel, 2017). For more on the Umbra group, see Aldon Nielson, *Black Chant: Languages of African-American Postmodernism* (Cambridge: Cambridge University Press, 1997), 78–170, and David Grundy, *A Black Arts Poetry Machine: Amiri Baraka and the Umbra Poets* (London: Bloomsbury, 2019).

2   Lillian-Yvonne Bertram, "'a lance to pierce the possible': Reading N. H. Pritchard," *Harriet Blog* (May 26, 2015), https://www.poetryfoundation.org/harriet/2015/05/a-lance-to-pierce-the-possible-reading-n-h-pritchard/.

3   Norman Pritchard, "HOOM, a short story," in *19 Necromancers from Now: An Anthology of Original American Writing for the 1970s*, ed. Ishmael Reed (New York: Anchor, 1970), 258–259.

4   Compare, for instance, "Metagnomy," in *The New Black Poetry*, ed. Clarence Major (New York: International Publishers, 1969), 100–102, and the version printed in N. H. Pritchard, *The Matrix: Poems 1960–1970* (Garden City, NY: Doubleday, 1970), 40–42; or compare the multiple versions of "ASWELAY" in *Dices or Black Bones: Black Voices of the Seventies*, ed. Adam David Miller (New York: Houghton Mifflin, 1970), 64, and in *The Matrix*, 14–17.

5   The precise dating of the poems is difficult to establish, in part because "Hoom" and *The Matrix* were both published in the same year by the same publisher, Doubleday, and thus the two books may have overlapped in production.

6   The poem appeared in substantially different form in the same year as "Alcoved Agonies," in *Dices or Black Bones*, 66.

7   Kevin Young, "Signs of Repression: N. H. Pritchard's *The Matrix*," *Harvard Library Bulletin* 3, no. 2 (1992): 41–42.

8   Norman Pritchard to Ishmael Reed, July 8, 1969, box 49, folder 131, Ishmael Reed Papers, University of Delaware Special Collections. The first sentence of this definition is quoted verbatim in *Yardbird Reader*, vol. 1, ed. Ishmael Reed (Berkeley, CA: Yardbird Publishing, 1972), 183.

9   The circle was an important enough motif to Pritchard to be repeated ten times in *The Matrix*. In the form of the lumagram, or a slide exposed to direct sunlight that captures the shape of the sun, the circle was also key to the early Black films of Aldo Tambellini (who later married Pritchard's ex-wife Sarah Dickenson). Tambellini ran The Gate theater, one of the first avant-garde theaters in New York City, and later founded the Black Gate. Tambellini made experimental films without using a camera. In common with his friends, filmmaker Otto Piene and painter Ben Morea, Tambellini was obsessed with solar and circular imagery. For more on Tambellini's work and his use of the lumagram, see Tambellini's website, accessed February 20, 2019, http://www.aldotambellini.com/rebel.html.

10  Advertisement on Friday, March 17, 1972 (newspaper unknown), box 48, folder 132, Ishmael Reed Papers. Held at Bliem Kern's loft space Supernova, the "transreal awakening" was like a Happening, where writers and artists would spontaneously interact and perform.

11  Lorenzo Thomas, *Extraordinary Measures: Afrocentric Modernism and Twentieth-Century American Poetry* (Tuscaloosa: University of Alabama Press, 2000), 120.

12  Jack Kerouac, *Big Sur* (New York: McGraw-Hill, 1962), 225.

13  Anthony Reed, *Freedom Time: The Poetics and Politics of Black Experimental Writing* (Baltimore: Johns Hopkins University Press, 2014), 43.

14  Norman Pritchard to Ishmael Reed, July 21, 1970, box 48, folder 132, Ishmael Reed Papers.

15  A brief selection from *Mundus* was printed as "The Vein" in *The East Village Other* 3, no. 7 (January 19–25, 1968): 10–13.

16  Norman Pritchard to Ishmael Reed, May 6, 1968, box 48, folder 130, Ishmael Reed Papers.

17  Ibid.

18  Reed, *19 Necromancers from Now*, 277.

19  Reed, *Freedom Time*, 39–40.

20  Pritchard spoke at the New Arts Program, Kutztown Arts Center in 1981. This video remains unreleased.

21  Reed, *Freedom Time*, 39.

22  Norman Pritchard to Ishmael Reed, August 18, 1971, box 48, folder 132, Ishmael Reed Papers.

23  The poem was not published in book form, and can only be found in the anthology *Dices or Black Bones*, 67.

## Chapter 8

1  Grenier uses nonstandard punctuation in his prose; quotations from letters and published prose have been transcribed as he wrote them.

2  Bob Perelman, *The Marginalization of Poetry: Language Writing and Literary History* (Princeton: Princeton University Press, 1996), 46.

3  Although the term "interactive" is more typically applied to works produced in the digital era, it seems the best term in this context, and it is helpful to note the term's media theoretical implications. According to Peter Merchant and Jan Van Looy's entry in *The Johns Hopkins Guide to Digital Media*, ed. Marie-Laure Ryan et al. (Baltimore: Johns Hopkins University Press, 2014):

> The academic literature distinguishes between three perspectives on interactivity: (1) as a formal property, (2) as a type of communication, and (3) as a cognitive process. The first perspective positions interactivity as a formal property of a media technology, as "a measure of a media's potential ability to let the user exert an influence on the content and/or form of the mediated communication." The second perspective describes interactivity as a communication process. The focus here is not on the analysis of technological characteristics, but on the study of interactivity as a form of information exchange between different actors. These actors can be (groups of) people, but exchanges can also take place between humans and machines. From this perspective interactivity is a "cyclical process in which two actors alternately listen, think and speak." The third perspective describes interactivity as "an information-based process that takes place within the individual." This viewpoint studies the effects of interactive communication channels and emphasizes the perspective of the user. (303)

All three of these perspectives apply to *Sentences*, which in my view can be aptly described as a work of interactive poetry (in either its analog or digital format).

4  Roland Barthes, *S/Z: An Essay*, trans. Richard Miller (New York: Hill and Wang, 1975), 4.

5  Grenier, letter to Burroughs Mitchell.

6  J. L. Austin, *How to Do Things with Words* (Oxford: Oxford University Press, 1962), 6.

7  Barthes, *S/Z*, 4. In this vein, Ron Silliman has argued (in a polemic partially aimed at Bob Perelman's reading of *Sentences*) that academic literary critics are incapable of acknowledging the "meaninglessness" of works such as *Sentences*. See Silliman, "The Marginalization of Poetry by Bob Perelman," *Jacket 2* (1997), http://jacketmagazine.com/02/silliman02.html.

8    Henry Ansgar Kelly, *Chaucerian Tragedy* (Cambridge, UK: D. S. Brewer, 1997), 4.

9    Stephanie Burt, *The Poem Is You: 60 Contemporary American Poets and How to Read Them* (Cambridge, MA: Belknap Press, 2016), 69.

10   Craig Dworkin, "Klatsch," *Convolution* 4 (2016): 8.

11   Copies were advertised as costing $10 for individuals and $20 for institutions in L=A=N=G=U=A=G=E 5 (October 1978), n.p. For more, see "Interview and Discussion on 1960s–1970s with Robert Grenier, Charles Bernstein, Al Filreis, and Michael Waltuch," PennSound, March 19, 2010, https://media.sas.upenn.edu/pennsound/authors/Grenier/Grenier-Interview-2_3-19-10_NYC.mp3.

12   Guide to the Robert Grenier Papers, p. 80, M1082, Stanford University Libraries, Department of Special Collections.

13   For more on Andrews's and Hejinian's composition techniques, see chapter 5 of my book *The Poetics of Information Overload: From Gertrude Stein to Conceptual Writing* (Minneapolis: University of Minnesota Press, 2015). See also Craig Dworkin, "Penelope Reworking the Twill: Patchwork, Writing, and Lyn Hejinian's *My Life*," *Contemporary Literature* 36, no. 1 (Spring 1995): 63–81. For a more general overview of postwar quotational practices, see Patrick Greaney, *Quotational Practices: Repeating the Future in Contemporary Art* (Minneapolis: University of Minnesota Press, 2014).

14   All of Grenier's post-*Sentences* poems (other than his drawing poems) have been printed in a monospaced font. Of his insistence on a monospaced font, Grenier remarks in an interview: "It [the Courier font] gives you a sense of the words as being equal to speech, or hand printing, so you don't look at a page as secondary or even a third remove from reality. There's an insistence on units. Each one is one." Robert Grenier, "Typewriter v. Typeface: An Interview with Robert Grenier," *The Ampersand* 6, no. 2 (April 1986): 7.

15   See Silliman, *The New Sentence* (New York: Roof Books, 1987), 169.

16   Grenier's most famous slogan, "I HATE SPEECH," has often been taken as a flippant gesture of rebellion aimed at Robert Creeley and Charles Olson, for whom Grenier nonetheless felt a deep affinity. But it should also be understood as an intervention in the medial system of the New American Poetry, which had emphasized the individual voice over the visual experience of silently reading a poem on a page. By removing the poems from a codex book, Grenier doubly draws attention to their existence as visual, as well as aural, artifacts. His 1971 "On Speech"—one of the most influential essays of the Language writing movement—makes clear the poet's obsession with the mediation of poetry both visually and sonically. The essay's second paragraph, in its entirety, reads: "In the process of writing what does not occur in the head is a distraction." Robert Grenier, "On Speech," *This* 1 (Winter 1971), n.p. The essay is, of course, tongue-in-cheek, and Grenier recognizes that poems must take some kind of written or aural form.

17   Guide to the Robert Grenier Papers, 81.

18   Markus Krajewski, *Paper Machines: About Cards and Catalogs, 1548–1929*, trans. Peter Krapp (Cambridge, MA: MIT Press, 2011), 64.

19   Ibid.

20   For example, according to Husárová and Montfort,

> The 150 pages of *Composition No. 1* [by Marc Saporta] have 150! (150 factorial) possible arrangements or permutations. 150! = 150 × 149 × 148 × … × 3 × 2 × 1, which is a number with 263 digits.

This calculation is the appropriate one in this case because in choosing a first page, a reader has 150 choices, there are then 149 choice [sic] for the next page, then 148 for the next, and so on. The same principle, of course, applies to all of the five main shuffle texts discussed here and any shuffle text meant to be read exhaustively. In "Heart Suit" there are 12 cards to be shuffled, thus 12! = 479,001,600 possible arrangements. This is far fewer, but about half a billion possible arrangements is still quite a large number.

Husárová and Montfort discuss *Sentences* at length, but do not provide a similarly specific calculation for it. Zuzana Husárová and Nick Montfort, "Shuffle Literature and the Hand of Fate," *Electronic Book Review*, August 5, 2012, https://electronicbookreview.com/essay/shuffle-literature-and-the-hand-of-fate/.

21  Marcel Duchamp too resisted applying a sequential ordering to the seventy-nine handwritten notes he reproduced in his 1966 *White Box*. For more, see Duchamp, *à l'infinitif*, trans. Ecke Bonk et al. (Berlin: The Typosophic Society/Walther König, 1999).

22  Eve Meltzer, *Systems We Have Loved: Conceptual Art, Affect, and the Antihumanist Turn* (Chicago: University of Chicago Press, 2013). For more on the late 1960s "aesthetic of information," see also Liz Kotz, *Words to Be Looked At: Language in 1960s Art* (Cambridge, MA: MIT Press, 2007).

23  For more on the web version of *Sentences*, see Alan Golding, "Language Writing, Digital Poetics, and Transitional Materialities," *New Media Poetics: Contexts, Technotexts, and Theories*, ed. Adalaide Morris and Thomas Swiss (Cambridge, MA: MIT Press, 2006), 249–283, and Michael Waltuch, "Letter to Jessica Lowenthal," *Silliman's Blog*, March 9, 2003, http://ronsilliman.blogspot.com/2003_03_09_archive.html.

24  Robert Grenier, "Language/Site/World," *Writing/Talks*, ed. Bob Perelman (Carbondale: Southern Illinois University Press, 1985), 230.

25  Marshall McLuhan, *Understanding Media: The Extensions of Man* (New York: McGraw-Hill, 1964), 260.

26  Charles Bernstein and Robert Grenier, "Linebreak Radio Program," October 20, 2006, https://media.sas.upenn.edu/pennsound/authors/Grenier/Grenier-Robert_Close-Listening_02_Ch-Bernstein_WPS1-NY_10-20-06.mp3.

27  Ibid.

28  For an introductory overview of Grenier's color drawing poems, see Paul Stephens, "At the Limits of Comprehension," *Art in America* (April 2016): 86–91. See also Ondrea Ackerman, "Wandering Lines: Robert Grenier's Drawing Poems," *Journal of Modern Literature* 36, no. 4 (Summer 2013): 133–153.

29  This notion of the pairing of poems is somewhat difficult to account for, as there is little textual evidence of the pairings. Rather the author, and those familiar with the sequence (like Bernstein, who has known Grenier since the 1970s), seem over time to have "paired" some of the poems in conversation and in readings. The "pairing" of the cards can also simply describe cards that share similar themes, even if there is no directly stated relation.

30  There is a Washington Avenue in Grenier's native Minneapolis; in January 1972, John Berryman committed suicide by jumping from the Washington Avenue Bridge. Grenier would have been well aware of Berryman's work, but I am unable to establish a direct connection to the poem (which may have been composed earlier). Through an odd twist of fate, after writing this poem, Grenier lived at 21A Washington Avenue in Cambridge, Massachusetts.

31  For a consideration of the sentence as a literary unit, see Jan Mieszkowski, *Crises of the Sentence* (Chicago: University of Chicago Press, 2019).

32  Gertrude Stein, *How to Write* (New York: Dover, 1975), 13, 155.

33  Ibid., 35.

34  Robert Grenier Papers, box 2.

35  Astrid Lorange, *How Reading Is Written: A Brief Index to Gertrude Stein* (Middletown, CT: Wesleyan University Press, 2015), 95.

36  This quotation can be found on Al Filreis's website for English 88 at the University of Pennsylvania, and seems to be a personal anecdote—I am unable to locate a more specific date or context.

37  Personal interview, August 9, 2015.

38  Stein, *How to Write*, 39.

39  Curtis Faville has argued that *Sentences* invokes a kind of paranoia about this difficulty of sense-making, but I think the opposite reading—that *Sentences* revels in a relief from sense-making—can be equally valid. According to Faville, "Grenier arrives, with *Sentences*, at a juncture of development in which there are no longer 'poems' as such, but a coded short-hand for the cognitive verbal processes underneath the layers of habitual practice and daily presumption. Perhaps even a regression to a level of preoccupation with primitive apprehension: A rejection of systematic rationality common to certain kinds of depression or paranoia, implying a suspicion with, and a rejection of all formal syntactic or quotidian practice."

Faville's reading is in line with how Language writers generally described their rejection of what Barrett Watten refers to as "total syntax" or what Ron Silliman terms "the referential fetish"—i.e., a "systematic rationality" under capitalism that makes all communication ideological and suspect. But one might also suggest that Grenier's reticence in *Sentences* to construct an overarching theme or argument is *too skeptical*, on its own terms, to claim for itself "a rejection of systematic rationality." Curtis Faville, "Stone Cutting All the Way," *Jacket 2* 34 (2007), http://jacketmagazine.com/34/faville-saroyan-grenier.shtml. See also Silliman, "Disappearance of the Word, Appearance of the World," *L=A=N=G=U=A=G=E*, supplement no. 3 (October 1981), and Barrett Watten, *Total Syntax* (Carbondale: Southern Illinois University Press, 1984).

40  Robert Grenier Papers, boxes 1, 2, and 20.

41  Poems from *Sentences* appeared in *Alcheringa*, *Big Deal*, *boundary 2*, *Franconia Review*, *Gum*, *Hills*, *L Magazine*, *Roof*, *This*, and *Tottel's*. Particularly notable is the selection of thirty cards included with *This* 5 (Winter 1974), referred to as "30 from Sentences" and printed on sixteen 4.5" × 6.5" cards. For more on the periodical versions of poems from *Sentences*, see Daniel Scott Snelson, "Alcheringa, 'The Dwelling Place' and Structuralist Tendencies," *Mimeo Mimeo* 3 (2009): 18–32.

42  Gertrude Stein, *Writings 1903–1932*, ed. Harriet Chessman and Catherine Stimpson (New York: Library of America, 1995), 749.

43  The Stanford archive has ten photos of the exhibition. It is difficult to determine the number of cards in the show, but a rough count suggests approximately 300 poems were included.

44  For more on CAMBRIDGE M'ASS and its relation to *Sentences*, see "Robert Grenier and Paul Stephens in Conversation," *BOMB* 132 (Summer 2015): 94–107, https://bombmagazine.org/articles/robert-grenier-and-paul-stephens/.

45  CAMBRIDGE M'ASS included poems from the 1978 Sentences box, poems culled from Sentences "reject" cards, as well as poems not included in Sentences.

46  Grenier discusses the visual congestion of the CAMBRIDGE M'ASS layout both in a February 8, 1979, letter to Robert Creeley and in "Robert Grenier and Paul Stephens in Conversation."

47  For an account of Saroyan's influence on Grenier, see Dworkin, "Klatsch."

48  Robert Grenier Papers, letter to Clark Coolidge, July 11, 1972, TS, box 4, M1082.

49  Guide to the Robert Grenier Papers, 81. The Stanford Finding Aid makes it clear that the meticulous spacing and centering of the poems on each index card would have been difficult, if not impossible, without the Selectric. Matthew Kirschenbaum incidentally cites the 1964 Selectric MT/ST as the first commercially available word processor in his *Track Changes: A Literary History of Word Processing* (Cambridge, MA: Belknap Press, 2016). For more on the literary history of the Selectric, see Darren Wershler-Henry, *The Iron Whim: A Fragmented History of Typewriting* (Ithaca, NY: Cornell University Press, 2005), 253–256.

50  Robert Grenier, introduction to *The Collected Poems of Larry Eigner*, vol. 1 (4 vols.), ed. Curtis Faville and Robert Grenier (Stanford: Stanford University Press, 2010), xiii.

51  Michael Davidson, *Concerto for the Left Hand: Disability and the Defamiliar Body* (Ann Arbor: University of Michigan Press, 2008), 124.

52  Pursuant to the logic of my argument about the importance of the media specificity of these poems, I recommend listening to this recording on the PennSound website at exactly 25:00: https://media.sas.upenn.edu/pennsound/authors/Grenier/Grenier-Robert_St-Marks_NY_4-8-81.mp3.

53  In the Stanford Finding Aid, Grenier describes the Sentences slides as "'works in themselves'/alternate material embodiments of SENTENCES text which were shown by Bob Perelman in San Francisco on July 14, 1977 to interested persons at the beginning of the Language Writing scene in SF & again shown & interpreted by RG during RG talk series 'Language/Site/ World' in SF in Fall 1982" (80). Grenier is here making an important claim for the effects of medium and context on the work's reception. It should be noted that in the slides the white area of the cards is grey and the words are white (or transparent). The poems would have looked significantly different as slides than as cards; the card `brightened equipment bulb` likely refers to the experience of projecting the poems.

54  Samuel Beckett, *Molloy, Malone Dies, The Unnamable* (New York: Grove Press, 1965), 176.

55  "`if rain it's raining`" might allude more broadly to philosophical discussions in which the present-tense construction of "it rains" (or rain more generally) is used as an example. Roman Jakobson, for instance, claims that: "The sentence 'it rains' cannot be produced unless the utterer sees that it is actually raining." From Jakobson, "Two Aspects of Language and Two Types of Aphasic Disturbances," in *Language in Literature* (Cambridge: Belknap Press, 1987), 101. Similarly, Ludwig Wittgenstein argues in *Philosophical Investigations*, trans. G. E. M. Anscombe (Oxford: Blackwell, 1953) that the sentence "I believe it's going to rain" (190e) is meaningless. There are literary parallels as well; there are rain poems in many traditions going back to ancient times, and there is Stein's "Water Raining" of *Tender Buttons*, which reads: "Water astonishing and difficult altogether makes a meadow and a stroke" (24). One has to triple-check quotations like this when retyping them. "Altogether" interrupts the flow of the sentence, almost as if it is a noun that "makes a meadow and a stroke." The water (or rain) could cause the meadow to come into being, but it could also cause a surrounding forest to come into being. And what kind of "stroke"

is being described? Is it a human stroke caused by astonishment? Or perhaps a lightning strike (in an awkward made-up past tense)? Or a paddle "stroke" that invokes the fluidity of rain? And given that "Water Raining" is taken from the "Objects" section of *Tender Buttons*, are we meant to think of rain as an object or objects? Grenier would have been well aware of "Water Raining," although it is unlikely that he was specifically aware of the Jakobson and Wittgenstein passages. Grenier has cited Heidegger, whom he first read as an undergraduate in the early 1960s, as a strong influence, and in particular *What Is Called Thinking?*, trans. J. Glenn Gray (New York: Harper, 1954), which contains the following passage: "What else can we say and think of being, except that it is? The statement is not only self-evident—it remains totally vacuous. It actually tells us nothing: and what it does tell, we knew before. 'Being is' sounds like rain rains. Of course rain rains. What else could it do?" (172). It may be in part this sense of ontological vacuity that Grenier is attempting to represent in "`if rain it's raining,`" although it should be noted that Heidegger is here speaking in the voice of a straw man who believes that the nature of existence (or essence) is self-evident. Does the poem in fact tell us anything in terms of useful information? Probably not, but it does mark a kind of temporal threshold.

56  Gertrude Stein, *Writings 1932–1946*, ed. Harriet Chessman and Catherine Stimpson (New York: Library of America, 1998), 288.

57  In Grenier, "Language/Site/World," 241–242. Hejinian, a close friend of Grenier's, may have been influenced by these paired rain poems. The first poem in *The Cell* contains the line "It rains with rain supplied" (Los Angeles: Sun and Moon, 1992), 7, which might also allude to the *Sentences* card "`the snow with snow.`"

58  In Grenier, "Language/Site/World," 242.

59  Golding, "Language Writing," 263.

60  Albert Gelpi offers an Emersonian reading of Grenier's poetry in *American Poetry after Modernism: The Power of the Word* (Cambridge, UK: Cambridge University Press, 2015), 236–246.

61  Koral Ward offers the following description of Heidegger's concept of the *Augenblick*:

Augenblick translates into English as the "blink" or "twinkling of an eye" … or simply "moment" in everyday use. "In the blink of an eye" carries the dimension of an experience of temporality as fleeting and momentary, with the inference of something momentous occurring. More than an experience of a sudden event, the moment holds a change more far reaching than the next "now" moment of time, rather a radical turnabout from one "world" or view to another becomes possible. It implies a temporal passing away or transcendence of time. For Heidegger, the futural impetus of our Being, which compels us through life and onto ever new projects, arises in moments, and there are some rare moments of a special intensity which we may seize hold of and exploit. There is also an intimation that only a few people can have access to what this Augenblick holds.

While one lives, a moment is just another instant in the flow of time. It is necessary to feel arrested in the moment, to be astonished by the very fact of something's existence, by existence itself.

Koral Ward, *Augenblick: The Concept of the Decisive Moment in 19th and 20th Century Western Philosophy* (Hampshire, UK: Ashgate, 2008), 103.

62  Letter from Robert Grenier to Robert Creeley, May 10, 1977, TS, box 67, M0662, The Robert Creeley Papers, Stanford University Libraries.

63  Ibid.

## Chapter 9

1. Natalie Czech, *A Poem by Repetition by Aram Saroyan #3*, 2015, three prints, 112.2 × 62.5 cm (total), Heidelberger Kunstverein, Heidelberg.
2. K. Silem Mohammad, "Sought Poems" (2005), accessed July 26, 2015, http://home.earthlink.net/~ululate/data/11-11-05.pdf.
3. Aram Saroyan, "Poem," *Lines* 6 (November 1965), 2. The title "Poem" was dropped from the version in Saroyan's 2007 *Complete Minimal Poems* (Brooklyn: Ugly Duckling Presse, 2007), 108.
4. Jens Asthoff, review, "Natalie Czech" [Centre Rhénan d'Art Contemporain Alsace exhibition], *Artforum* (October 2016): 283.
5. Natalie Czech, *A Poem by Repetition by Aram Saroyan*, 2013, three prints, 65 × 65 cm, 65 × 15.7 cm, 65 × 18.5 cm, Museum of Modern Art, New York.
6. Craig Dworkin, "The Stutter of Form," in *The Sound of Poetry / The Poetry of Sound*, ed. Craig Dworkin and Marjorie Perloff (Chicago: University of Chicago Press, 2009), 166–167.
7. Ibid., 167–168.
8. Aram Saroyan, *Works: 24 Poems* (New York: Lines Press, 1966), n.p.
9. Natalie Czech, *A Poem by Repetition by Aram Saroyan (CD)*, 2016, three prints, 101 × 65 cm (total), Capitain Petzel Gallery, Berlin.
10. Pink Floyd, *The Wall*, film, Metro-Goldwyn-Mayer, 1982 (transcription by author).
11. Natalie Czech, *A Poem by Repetition by Aram Saroyan #2*, 2014, four prints, 136 × 81.4 cm (total), Heidelberger Kunstverein, Heidelberg.
12. Natalie Czech, *A Poem by Repetition by Gertrude Stein*, 2013, two prints, 101.8 × 49.1 cm (total), Capitain Petzel Gallery, Berlin.
13. Gertrude Stein, *Everybody's Autobiography* (New York: Random House, 1937), 92.
14. Andrew Bowie, *Aesthetics and Subjectivity: From Kant to Nietzsche* (Manchester, UK: Manchester University Press, 1990).
15. Gertrude Stein, "The World Is Round," in *Writings 1932–1946*, ed. Harriet Chessman and Catherine Stimpson (New York: Library of America, 1998), 572.
16. Aram Saroyan, *I Am Rose* (Pacific Palisades, CA: Mini-Books, 1971).
17. Natalie Czech, *I Can Not Repeat What I Hear* (Berlin: Spector Books, 2014), 55, quoting a sentence from Hegel's *Aesthetics*, vol. 2, which is also quoted by Bowie in *Aesthetics and Subjectivity*, 228.
18. Czech, *A Poem by Repetition by Gertrude Stein*.
19. Natalie Czech, *A Poem by Repetition by Bruce Andrews*, 2013, three prints, 58 × 68.1 cm (each), Capitain Petzel Gallery, Berlin.
20. See Paul Stephens, *Poetics of Information Overload: From Gertrude Stein to Conceptual Writing* (Minneapolis: University of Minnesota Press, 2015), 144–151.
21. Bruce Andrews, *Corona* (Providence, RI: Burning Deck, 1973), 17.

22  These prints, at 58 cm x 68 cm each, are difficult to reproduce legibly in book form.

23  Natalie Czech, *A Poem by Repetition by Robert Grenier #2*, 2017, two prints, 28.4" × 21.7" × 1.6", Heidelberger Kunstverein, Heidelberg.

24  Robert Grenier, *A Day at the Beach* (New York: Roof Books, 1984), n.p.

25  Sharon Cameron, *Choosing Not Choosing: Dickinson's Fascicles* (Chicago: University of Chicago Press, 1993).

26  Lori Emerson, *Reading Writing Interfaces: From the Digital to the Bookbound* (Minneapolis: University of Minnesota Press, 2014).

27  For an account of the development of icons for waiting (hourglass, beach ball, watch, clock), and in particular Susan Kare's role in their creation and dissemination, see Jason Farman, "Spinning in Place," in *Delayed Response: The Art of Waiting from the Ancient World to the Instant World* (New Haven: Yale University Press, 2019), 65–82.

28  Natalie Czech, *Paperdraft*, 2015, print, 46.7" × 32.6" × 1.6", Company Gallery, NYC.

29  Natalie Czech, *Avatar / Me*, 2016, print, 34.3" × 50" × 1.6", Capitain Petzel Gallery, Berlin.

30  Natalie Czech, *One Can't Have It Both Ways and Both Ways Is the Only Way I Want It* (CRAC Alsace—Centre rhénan d'art contemporain, 2016), 14–15.

31  Natalie Czech, *Avatar / We*, 2016, print, 120 x 81.8 cm, Capitain Petzel Gallery, Berlin.

32  This anecdote is recounted in Dan Piepinbring, "George Plimpton on Muhammad Ali, The Poet," *Paris Review*, June 6, 2016, https://www.theparisreview.org/blog/2016/06/06/george-plimpton-on-muhammad-ali-the-poet/. Ali's poem provided the source material for Glenn Ligon's *Give Us a Poem (Palindrome #2)* (2007), the text of which is merely "ME/WE."

33  Wendy Chun, *Updating to Remain the Same: Habitual New Media* (Cambridge, MA: MIT Press, 2016).

34  Natalie Czech, *to icon: poems* (Berlin: Capitain Petzel, 2017).

35  Ibid.

36  Natalie Czech, *Speech Bubble / Richard Hell*, 2017, print, 34.7" x 25" x 1.6", Heidelberger Kunstverein, Heidelberg.

37  McLaren discusses Hell's influence on the Sex Pistols in *Please Kill Me: The Uncensored Oral History of Punk*, ed. Legs McNeil and Gillian McCain (New York: Grove Press, 1996), 198–199.

38  Lydia Lunch, introduction to *Ripped: T-Shirts from the Underground*, ed. Cesar Padilla (New York: Universe Publishing, 2010), 7.

39  Richard Hell and the Voidoids, "Blank Generation," on *Blank Generation* (Sire Records, 1977), 33⅓ rpm.

40  For a more general media history of blank spaces in office culture and in literature, see Lisa Gitelman, "A Short History of _____," in *Paper Knowledge: Toward a Media History of Documents* (Durham: Duke University Press, 2014), 1–52.

41  Richard Hell quoted in Clinton Heylin, *From the Velvets to the Voidoids: The Birth of American Punk* (Chicago: Chicago Review Press, 2005), 123.

42  Richard Hell, *I Dreamed I Was a Very Clean Tramp: An Autobiography* (New York: HarperCollins, 2013), 207.

43  Emerson, *Reading Writing Interfaces*, 133.

44  In a similar vein, Dennis Tenen argues:

> A truly materialist poetics would analyze embedded representation in the context of the surrounding medium. More than superficial embellishment, skeuomorphic metaphors enacted at the digital surface affect all higher-order meaning carrying units, from individual letters to words, paragraphs, chapters, pages, and books.
>
> Why do readers tolerate misleading media metaphors then? Why not simply make use of novel interfaces afforded by new technology? The literature on human-computer interaction suggests a formalist answer: habituation. The initial effort it takes to inhabit a new cognitive environment discourages curiosity. Smart designers therefore rely on acculturated practice, the turning of pages in our case, to minimize adaptive friction.

Dennis Tenen, *Plain Text: The Poetics of Computation* (Stanford: Stanford University Press, 2017), 39.

45  Tom Wolfe, "The 'Me' Decade and the Third Great Awakening," *New York Magazine*, August 23, 1976, http://nymag.com/news/features/45938/.

46  Ibid.

47  Richard Hell, "'Punk' Couture: Insides Out," in *Punk: Chaos to Couture*, ed. Andrew Bolton (New York: Metropolitan Museum of Art, 2013), 19.

48  Ibid.

49  Ibid.

50  Christopher Wool, *Untitled (Riot)*, in Sotheby's auction catalog, May 12, 2015, http://www.sothebys.com/en/auctions/ecatalogue/2015/contemporary-evening-n09345/lot.7.html.

51  Christopher Wool, *Untitled (Fool)*, in Sotheby's auction catalog, May 16, 2019, https://www.sothebys.com/en/auctions/ecatalogue/2019/contemporary-art-evening-auction-n10069/lot.21.html.

52  Wool quoted in ibid.

53  Richard Hell and Christopher Wool, *Psychopts* (New York: JMC & GHB Editions, 2008).

54  Glenn O'Brien quoted in *Christopher Wool*, ed. Katherine Brinson (New York: Guggenheim Museum Publications, 2013), 235.

**Chapter 10**

1  Jen Bervin, *Silk Poems* (New York: Nightboat Books, 2017), 142.

2  Cecilia Vicuña quoted in *Silk Poems*, 162.

3  Bervin, *Silk Poems*, 156.

4  I am thinking here of the wholesale appropriation techniques advocated by Kenneth Goldsmith and others. For more, see Goldsmith's introduction to the special "Flarf and Conceptual Writing" section of *Poetry* (July/August 2009), 315–316.

5   These figures are taken from the website of the Human Genome Project, accessed November 15, 2011, http://www.ornl.gov/sci/techresources/Human_Genome/project/info.shtml.

6   Quoted in Stephen Wilson, *Information Arts: Intersections of Art, Science and Technology* (Cambridge, MA: MIT Press, 2002), 57.

7   Bervin, *Silk Poems*, 172.

8   Ibid.

9   For more, see Paul Saenger, *Space Between Words: The Origins of Silent Reading* (Stanford: Stanford University Press, 1997).

10  Bervin, *Silk Poems*, 145.

11  Ibid., 149.

12  Ibid., 148.

13  Ibid., 102.

14  Ibid., 2.

15  "Silk Poems with Jen Bervin, Cristina Gitti and Lydia Matthews," Matta Soho, NYC, November 16, 2017.

16  Mary Ruefle, back jacket blurb, *Silk Poems*.

17  Ronald Johnson, *ARK* (Chicago: Flood Editions, 2013), 34.

18  Craig Dworkin, *Fact*, 24" × 36" poster (New York/York, UK: Printed Matter/Information as Material, 2016). For a lecture discussion on the "Fact" project by the author himself, see Craig Dworkin, "And Nothing But," http://www.leedsbeckett.ac.uk/larc/lectures/craig-dworkin/.

19  Craig Dworkin, *Twelve Erroneous Displacements and a Fact* (York, UK: Information as Material, 2016).

20  "Substrate" is an important media-theoretical term for Dworkin. For more, see Craig Dworkin, "The Logic of Substrate," in *No Medium* (Cambridge, MA: MIT Press, 2013), 1–34.

21  Craig Dworkin and Kenneth Goldsmith, eds., *Against Expression: An Anthology of Conceptual Writing* (Evanston, IL: Northwestern University Press, 2011), 289.

22  For a more general consideration of facticity in poetry, see Peter Quartermain, "Poetic Fact," in *Stubborn Poetries: Poetic Facticity and the Avant-Garde* (Tuscaloosa: University of Alabama Press, 2013), 269–287.

23  Dan Graham quoted in Dworkin and Goldsmith, *Against Expression*, 290.

24  Ibid.

25  Craig Dworkin, Other Room Reading, December 2009, YouTube video, posted November 17, 2013, https://www.youtube.com/watch?v=tVlQuMG5CiE.

26  "Beta-Endorphin: MeSH Descriptor Data 2019," National Institutes of Health, accessed August 8, 2019, https://meshb.nlm.nih.gov/record/ui?ui=D001615.

27  Steven Shapin, "Chateau Neuro," review of Gordon Shepherd's *Neuroenology*, *Los Angeles Review of Books*, December 30, 2016, https://lareviewofbooks.org/article/chateau-neuro/#! (emphases in original).

28  Christian Bök, *'Pataphysics: The Poetics of an Imaginary Science* (Evanston, IL: Northwestern University Press, 2002), 13.

29  Daniel Robinson, "Still Looking: Science and Philosophy in Pursuit of Prince Reason," in *Neuroscience and Philosophy: Brain, Mind, Language*, ed. Maxwell Bennett et al. (New York: Columbia University Press, 2003), 193.

30  Michael Lynch, *The Internet of Us: Knowing More and Understanding Less in the Age of Big Data* (New York: Liveright, 2017), 3.

31  Ibid., 5.

32  Joshua Shannon, *The Recording Machine: Art and Fact during the Cold War* (New Haven: Yale University Press, 2018), 5.

33  Ibid., 5–6.

34  Ibid., 6.

35  In Lewis Campbell, *The Life of James Clerk Maxwell* (London: McMillan and Co., 1882), 637.

36  Ulises Carrión, *Dear Reader, Don't Read*, ed. Guy Schraenen (Madrid: Museo Nacional Centro de Arte Reina Sofía, 2016), 95.

37  Michael Leong, "Poetry for the Apocalypse," review of Christian Bök's *The Xenotext: Book 1*, *American Scientist* (2016), https://www.americanscientist.org/article/poetry-for-the-apocalypse.

38  Darren Wershler, *The Xenotext So Far* (Calgary: Chromium Dioxide Press, 2015), 26.

39  Christian Bök, Purple Blurb Reading, MIT, YouTube video, December 2, 2015, https://www.youtube.com/watch?v=gesrlLxA1O4.

40  Christian Bök, *The Xenotext: Book One* (Toronto: Coach House Press, 2015), 17.

41  Jack Halberstam, *The Queer Art of Failure* (Durham: Duke University Press, 2011), 2.

42  Christian Bök, "The Xenotext," *Island* 151 (2017): 120–121.

43  Ibid.

44  Nikki Skillman, *Lyric in the Age of the Brain* (Cambridge, MA: Harvard University Press, 2016), 265.

45  Bök, *Xenotext*, 153.

46  Ibid., 8.

47  Nathan Brown, *The Limits of Fabrication: Materials Science, Materialist Poetics* (New York: Fordham University Press, 2016), 184.

48  For more, see Bern Porter, *I've Left: A Manifesto and a Testament of Science and Art* (New York: Something Else Press, 1971), 43–47.

## Chapter 11

1. Joey Yearous-Algozin, "Keep Your Friends Close//We Upload Trash," *Convolution* 4 (2016): 78.

2. Gertrude Stein, *The Making of Americans* (Normal, IL: Dalkey Archive, 1995), 289.

3. Holly Melgard, *The Making of the Americans* (New York: Troll Thread, 2012), 17.

4. For a theoretical account of online trolling, see Whitney Phillips, *This Is Why We Can't Have Nice Things: Mapping the Relationship between Online Trolling and Mainstream Culture* (Cambridge, MA: MIT Press, 2015).

5. Lynne Murphy, "Linguistics Explains Why Donald Trump Sounds Racist When He Says 'The' African Americans," *Quartz* (October 11, 2016), http://qz.com/806174/second-presidential-debate-linguistics-explains-why-donald-trump-sounds-racist-when-he-says-the-african-americans/.

6. For a reading of *The Making of Americans* as a narrative of assimilation, see Priscilla Wald, "A 'Losing-Self Sense': *The Making of Americans* and the Anxiety of Identity," in *Constituting Americans: Cultural Anxiety and Narrative Form* (Durham: Duke University Press, 1995), 237–298.

7. *Black Friday* blurb, http://www.lulu.com/shop/holly-melgard/black-friday/hardcover/product-20531151.html.

8. *RGB Color Atlas* can currently be viewed on the Museum of Modern Art website, https://www.moma.org/explore/multimedia/videos/214/1097, as well as on the artist's site: http://taubaauerbach.com/view.php?id=286.

9. Jean Keller, author's blurb for *Black Book*, accessed July 4, 2019, http://www.lulu.com/us/en/shop/jean-keller/the-black-book/paperback/product-21008894.html. The POD edition of Keller's *Black Book* (2010) preceded Melgard's *Black Friday* (2012), but Bernar Venet also published a *Livre Noir* of completely black pages—first as a one-of-a-kind book in 1963, and in 2011 as a limited edition; see Bernar Venet, *Livre Noir* (Paris: Le Néant editeurs, 2011).

10. Hannes Bajohr discusses *Black Book* in "Experimental Writing in Its Moment of Digital Technization: Post-Digital Literature and Print-on-Demand Publishing," in *Publishing as Artistic Practice*, ed. Annette Gilbert (Berlin: Sternberg Press, 2016), 100–115.

11. Nick Montfort, *Autopia* (New York: Troll Thread, 2016), n.p.

12. Nick Montfort, "A Note on the Two," in Nick Montfort, Serge Bouchardon, Andrew Campana, Natalia Fedorova, Carlos León, Aleksandra Małecka, and Piotr Marecki, *2x6* (Los Angeles: Les Figues Press, 2016), 244.

13. According to Cayley,

    In Montfort's work—especially when presented in this format, as book—the code is a (constitutive) facet of the poem. It is (also) the text. There is no question but that in work such as this, the code must be appreciated, in an extended practice of human reading, even as its execution is, simultaneously, delegated to a computational machine and even where the machine's generative "reading" produces further opportunities for human reader- and thinkership.

    John Cayley, "Poetry and Stuff: A Review of #!," *Electronic Book Review*, January 31, 2015, http://www.electronicbookreview.com/thread/electropoetics/shebang. His article "The Code Is Not the Text (Unless It Is the Text)," is at *Electronic Book Review*, September 10, 2002, https://electronicbookreview.com/essay/the-code-is-not-the-text-unless-it-is-the-text/.

14  Louis Aragon, "Suicide," *Cannibale* 1 (April 1920): 4. For visual poems that employ the entire alphabet, see also Marvin and Ruth Sackner, *The Art of Typewriting* (London: Thames and Hudson, 2015), 43–48.

15  For a comprehensive account of *©1968*, see Craig Dworkin, *No Medium* (Cambridge, MA: MIT Press, 2013), 13–17.

16  Nick Montfort, *Digital Ream*, http://nickm.com/poems/ream/.

17  Aram Saroyan, *Cloth: An Electric Novel* [electronic edition], http://www.ubu.com/historical/saroyan/cloth/title.html.

18  Montfort, "About," *Digital Ream*, http://nickm.com/poems/ream/about.html.

19  Nick Montfort, *Rame*, trans. Anick Bergeron, in *bleuOrange: Revue de Littérature Hypermédiatique*, http://revuebleuorange.org/bleuorange/01/montfort/rame.php.

20  Allison Parrish, *@everyword* (New York: Instar Books, 2015), xiv.

21  Ibid., xix.

22  Kenneth Goldsmith, *Wasting Time on the Internet* (New York: Harper Perennial, 2016), 20.

23  Parrish, *@everyword*, xv.

24  See José van Dijck, *The Culture of Connectivity: A Critical History of Social Media* (New York: Oxford University Press, 2013).

25  For more on platformed sociality, see Alice Marwick, *Status Update: Celebrity, Publicity, and Branding in the Social Media Age* (New Haven: Yale University Press, 2013). For an interpretation of a specific literary work based on appropriated tweets, see my article "Reading Robert Fitterman's *Now We Are Friends* through the Lens of Ten Media-Theoretical Terms," *Post45*, January 21, 2015, http://post45.research.yale.edu/2015/01/reading-robert-fittermans-now-we-are-friends-through-the-lens-of-ten-media-theoretical-terms/.

26  Marwick, *Status Update*, 114.

27  Parrish, *@everyword*, vii.

28  Quoted in David Sarno, "Twitter Creator Jack Dorsey Illuminates the Site's Founding Document, Part I," February 18, 2009, http://latimesblogs.latimes.com/technology/2009/02/twitter-creator.html.

29  Lori Emerson, *Reading Writing Interfaces: From the Digital to the Bookbound* (Minneapolis: University of Minnesota Press, 2014), xiv.

30  Daniel Temkin, "every non-word," accessed July 5, 2019, http://danieltemkin.com/everynonword/.

31  Kenneth Goldsmith, *Theory* (Paris: Jean Boîte Éditions, 2015), n.p.

32  Matthew Kirschenbaum, "What is an @uthor?," *LA Review of Books*, February 6, 2015, http://lareviewofbooks.org/essay/uthor.

33  For a critical account of the entirety of a Twitter feed as both art and literature, see Andrew Durbin, *Spiyt th'Words: Hereading Pettibon's Twitter* (New York: David Zwirner Books, 2019).

34  Friedrich Kittler, *Gramophone, Film, Typewriter*, trans. Geoffrey Winthrop-Young and Michael Wutz (Stanford: Stanford University Press, 1999), 263.

35  Kathy Acker, "Symposium: Postmodern?," in "Postmodern?," ed. Barrett Watten and Lyn Hejinian, special issue, *Poetics Journal* 7 (1987), 117.

**Coda**

1   Cia Rinne, [Poet's Statement], *Jacket 2* (February 15, 2016), https://jacket2.org/poems/cia-rinne.

2   Kamran Javadizadeh, Twitter post, 7:05 am, February 4, 2019, https://twitter.com/kjavadizadeh.

3   Quoted in Roy McMullen, *Degas: His Life, Times, and Work* (New York: Houghton Mifflin, 1984), 405.

4   Robert Smithson, "Language to Be Looked At and/or Things to Be Read," in *The Collected Writings*, ed. Jack Flam (Berkeley: University of California Press, 1996), 61; William Carlos Williams, *Paterson*, ed. Christopher MacGowan (New York: New Directions, 1992), 6. The echo was hardly accidental: Williams was Smithson's pediatrician.

5   Quoted in *Concrete Poetry: A World View*, ed. Mary Ellen Solt (Bloomington: Indiana University Press, 1968), 32.

6   Leigh Silver, "Interview: Hans Ulrich Obrist Talks [about] His Instagram Project 'The Art of Handwriting,'" *Complex*, February 20, 2014, https://www.complex.com/style/2014/02/hans-ulrich-obrist-interview-instagram-art-of-handwriting.

7   Etel Adnan, Instagram post, December 26, 2012, https://www.instagram.com/hansulrichobrist/.

8   Philippe Parreno, Instagram post, July 7, 2015, https://www.instagram.com/hansulrichobrist/.

9   Stéphane Mallarmé's "Sonnet en y-x," as it has come to be called, exists in three versions. See Mallarmé, *Oeuvres Complètes*, vol. 1, ed. Bertrand Marchal (Paris: Pléiade, 1998), 37, 98, 131.

10  Annabelle Selldorf, Instagram post, July 13, 2016, https://www.instagram.com/hansulrichobrist/.

11  Eileen Myles, Instagram post, January 29, 2017, https://www.instagram.com/hansulrichobrist/.

12  Etel Adnan, Instagram post, October 17, 2014, https://www.instagram.com/hansulrichobrist/.

13  Simone Forti, Instagram post, February 5, 2014, https://www.instagram.com/hansulrichobrist/.

14  Douglas Coupland, Instagram post, August 29, 2014, https://www.instagram.com/hansulrichobrist/.

15  Aram Saroyan, "ACTUAL SIZE," Instagram post, December 22, 2018, https://www.instagram.com/saroyanesque/.

16  Aram Saroyan, "Thoughts?," in "American Typewriter," *Poetry* (September 2018): 490.

17  @twitter, "Thoughts?," Twitter post, November 21, 2018, https://twitter.com/twitter.

18  @twitter, [blank tweet], Twitter post, November 29, 2018; @twitter, "Mmhmmmm," Twitter post, November 27, 2018, https://twitter.com/twitter.

19  Aram Saroyan, "Big thoughts," typewriter text on wall, in "Becoming American" (group show), SOIL Gallery, Seattle, September 6–29, 2018.

20  Aram Saroyan, "THOUGH" [aligned to the right], Instagram post, May 25, 2018, https://www.instagram.com/saroyanesque/.

**Appendix**

1  In 1987, Geof Huth coined the term "pwoermd" to describe "a one-word poem, often a neologism, presented without a separate title." By definition, all pwoermds are oneworders, but not all oneworders are pwoermds. For more, see *&2: an/thology of pwoermds*, ed. Geof Huth (Port Charlotte, FL: Runaway Spoon Press, 2004), n.p.

# Index

"@," 122, 124
@everyword, 212–215
@hansulrichobrist, 218–221
@no_ish, 217–218
@nondenotative, 214–215
@saroyanesque, 220–222
":," 122, 124
© 1968 [Ream], 104
#!, 205–208

*0 To 9*, 1, 10, 97, 99
*2×6*, 206
*19 Necromancers from Now*, 119
*29 Songs*, 96
*100% Abstract*, 192

"absence of clutter," 57–60
*Absence of Clutter* (blog), 57
Acconci, Vito, 45, 98–101
Acker, Kathy, 215
"activity," 105–106, 109
Adnan, Etel, 218–219
Adorno, Theodor W., 67–68
advertising, 17–18, 27, 86, 91, 150–151, 168, 225
"Aesthetics of Silence," 25
"Agon," 115
Albers, Anni, 18
Albright, Daniel, 21
*All*, 94
Allen, Gwen, 24
"Alphabet Expanding," 206–208
*American Typewriter*, 220–221
Andre, Carl, 237, 247
Andrews, Bruce, 160–161
Antin, David, 2, 91, 237
Apple Computer, 65–66, 179
Aragon, Louis, 206
*Aram Saroyan*, 95, 98, 105

*Art as Idea as Idea*, 47
ascesis, 67–68
asceticism, 60–61, 66–67
ASCII Hegemony," 208
asemic writing, 18
Ashbery, John, 2
*Aspen*, 24–26
"As Regards Plain," 60, 62–63
Auerbach, Tauba, 204
Austin, J. L., 128
*Autopia*, 205

Barth, John, 245
Barthes, Roland, 26, 128
Baum, Erica, 31–33
Beatles, The, 27, 257
*Beatles, The*, 27
"beautiful tomatoes this morning of mornings," 147
"beba coca cola," 91
Beckett, Samuel, 205
"Be minimal then ...", 22
Benglis, Linda, 1
Bentivoglio, Mirella, 18
Bergeron, Anick, 211
Bernstein, Arielle, 61
Bernstein, Charles, 49–50
Bertram, Lillian-Yvonne, 111, 113
Bervin, Jen, 50–55, 185–190
Best, Stephen, 49
bioinformatics, 185, 188
"Bird, A," 143–145
*Black Book*, 205, 270
*Black Friday*, 204–205
"Black Vernacular: Reading New Media," 41
*Blank Generation*, 175–183
*Blind Man, The*, 3
Bochner, Mel, 240
Bohn, Willard, 87, 255

Bök, Christian, 50, 197, 199–202
Bordowitz, Gregg, 13–14
Botha, Marc, 23
bots, 82–83, 212–215
*Bridge, The*, 22
Broodthaers, Marcel, 7
Brown, Bob, 188
Brown, Nathan, 202
Buchloh, Benjamin H. D., 70
Burt, Stephanie, 130

Cage, John, 25
*CAMBRIDGE, M'ASS*, 141–142
Cameron, Sharon, 51–52
Carrión, Ulises, 17, 32–38, 198
Cayley, John, 206, 270
Chave, Anna C., 248
Chayka, Kyle, 61
Churner, Rachel, 32
cinepoetry, 247
*Citizen*, 15
*Cloth: An Electric Novel*, 208
"Code Is Not the Text, The," 206
code poetry, 9, 40, 205–211
*coffee coffee*, 99
*Complete Minimal Poems*, 98, 103
compression, 17, 242, 245
computational poetics, 249
concision, 79, 245
concrete poetry, 4–6, 18–19, 86–91, 254
*Concrete Poetry: A World View*, 4–6, 18–19
convergence, 15, 241
convergence, adverse, 15, 241
Coolidge, Clark, 99, 142
Crane, Hart, 22
Creeley, Robert, 85–86, 94, 130, 135, 147–148
Crosby, Harry, 195–196
Czech, Natalie, 149–183

Damon, Maria, 244
*Dark Side of the Moon*, 150
Davidson, Michael, 143
*Day at the Beach, A*, 130, 142
"Death of the Author, The," 24, 26, 215
*Death to Art*, 78
de Campos, Haroldo, 86

"Declaration of the Word as Such, The," 78
Dehaene, Stanislaus, 242
de la Torre, Mónica, 32, 69–70
demediation, 47, 248
Dermisache, Mirtha, 18
Dickinson, Emily, 50–55
*Dickinson Composites*, 52–55
*Digital Ream*, 208–211
distant reading, 12, 48–49
Dorsey, Jack, 213–214
Douglas, Aaron, 10
*Dropout Piece*, 25
Drucker, Johanna, 253
Duchamp, Marcel, 3–4, 14–15, 78, 238
Dworkin, Craig, 1, 104–105, 130, 157, 190–198

*Early Martyr*, An, 82
Eastman, Julius, 111
"eatc.," 5–6
*EECCHHOOEESS*, 113
Eigner, Larry, 22–23, 143
eisegesis, 130
*Electric Poems*, 101
Emerson, Lori, 168, 179, 214
Emerson, Ralph Waldo, 17
erasure, 4, 238
*Everybody's Autobiography*, 159–160
exophora, 1, 130
"eyeye," 4, 10, 101

*Fact*, 190–198
Farman, Jason, 266
Faville, Curtis, 262
Fenollosa, Ernest, 78
Finlay, Ian Hamilton, 2, 5–6, 93–94, 225
*Finnegans Wake*, 81
Flaubert, Gustave, 78, 245
Flint, F. S., 77–78
"FORM," 138
Foucault, Michel, 67
*Fountain*, 3, 10, 248
Fowler, Eve, 31
Frampton, Hollis, 38
Fried, Michael, 26
"FR / OG," 113
futurism, 13, 77–78

Garnier, Pierre, 217
General Idea (collective), 13–14
"Gertrude Stein," 8, 77
Gillick, Liam, 64
Gnedov, Vasilisk, 78, 253
Goldsmith, Kenneth, 213, 215
Gomringer, Eugen, 86–87, 90–91
Google, 65, 198
*Gorgeous Nothings: Emily Dickinson's Envelope Poems*, 50–53
graffiti, 105
Graham, Dan, 24, 192
graphomania, 15, 105
graphoria, 15
Greenberg, Clement, 27
Grenier, Robert, 1, 4, 7–8, 57–60, 71, 127–148, 165–167
Grotowski, Jerzy, 241
"Gyre's Galax," 111

Hamilton, Richard, 27
handwriting, 51–53, 218–219, 221
"Harkening, The," 115, 117
Harvey, Michael, 71
*Hatred of Poetry*, 81
Hayles, N. Katherine, 40
Heidegger, Martin, 263–264
Hejinian, Lyn, 146
Hell, Richard, 175–183
Higgins, Dick, 14
Hilder, Jamie, 19, 87
Holmqvist, Karl, 14
Holzer, Jenny, 71
*House of Dust, The*, 38, 40
Howe, Susan, 49, 51
*How to Write*, 135–136
Hurston, Zora Neale, 41
Husárová, Zuzana, 131, 160
Huth, Geof, 272

icons, 168–183, 266
"if rain it's raining," 145–146, 263–264
"I guess...", 59
"I love the shapes of things," 136
*Imagevirus*, 13–14
Imagism, 77–80

"I'm Ronald McDonald...", 146–147
"In a Station of the Metro," 79–80
*Incense Sweaters & Ice*, 43–45
indexical present, the, 27, 69–76
Indiana, Robert, 13–14
infrathin/inframince, 4
Instagram, 217–222
"Instant Poem," 6
Insurance, 15
interactivity, 259
intermedia, 9, 14–15, 244, 257
*I Sell the Shadow to Sustain the Substance*, 31
*I shop therefore I am*, 67
"I've been reading to this & laughing," 128

Jakobson, Roman, 13, 263
Jenkins, Henry, 15
Jobs, Steve, 57, 65
Joyce, James, 81

Kandel, Eric, 48
Kaplan, David, 69
Kaprow, Allan, 38, 40
Kare, Susan, 266
Keller, Jean, 205
"kept on going to the corner store," 133–135, 147
Kermode, Frank, 98
Khlebnikov, Velimir, 5, 78
Kirschenbaum, Matthew, 215, 263
Kittler, Friedrich, 215
Knowles, Alison, 38–40
Kondo, Marie, 61–64
Kosuth, Joseph, 47
Kotz, Liz, 3, 247
Kraus, Karl, 48
Kruchenykh, Aleksei, 78
Kruger, Barbara, 67, 74–76

Language writing (movement), 8, 104, 127, 130, 257, 260
Le Fraga, Sophia, 217, 218
Le Lionnais, François, 93
Leong, Michael, 199
Lerner, Ben, 81

Lessing, Gotthold Ephraim, 4, 238
"Letter as Such, The," 78
LeWitt, Sol, 10, 24
*lighght* / "lighght," 100–102, 142
Ligon, Glenn, 30–31, 70–71, 248
*Line Line Green Red*, 31–33
*Lines*, 94
"Locust Tree in Flower, The," 82
*looking for poetry / tras la poesía*, 33–38
Lorange, Astrid, 135
Lorde, Audre, 14
*LOVE*, 13–14
Loy, Mina, 77
Lozano, Lee, 25
"Lucy. Lucy.", 102

*m*, 11–12
*Making of Americans*, *The* (Stein), 1, 9, 204–205
*Making of the Americans, The* (Melgard), 1, 9, 204–205
Malevich, Kazimir, 78
Mallarmé, Stéphane, 4, 219, 247
Marclay, Christian, 214
Marcus, Sharon, 49
Marden, Brice, 100–101
Marinetti, F. T., 77–78
*Matchbook: Magazine of 1-Word Poetry*, 104–105, 107–108
*Matrix, The*, 115–126
*Maximus Poems*, 85–86, 90–91
Mayer, Bernadette, 1
McCaffery, Steve, 12, 255
McCullough, Malcolm, 91
McGann, Jerome, 49, 240
McLuhan, Marshall, 5, 98, 101, 131
media/new media, 5, 9, 239
*Megawatt*, 205
Melgard, Holly, 203–205
Meltzer, Eve, 131
memes, 13–14, 21, 82–83, 217, 219
Merleau-Ponty, Maurice, 16, 239
Meyer, James, 23
micropoetry, 244
Mies van der Rohe, Ludwig, 2
miniaturization, 18
*Minimalism* (Rinne), 19–20

minimal reading, 249
*Minima Moralia*, 67–68
Mitchell, W. J. T., 238, 252
Mohammad, K. Silem, 149
"Money," 157
Montfort, Nick, 205–211
Moore, Marianne, 81
Moretti, Franco, 48, 60, 250
Morice, Dave (a.k.a. Joyce Holland), 104, 107–108
Moten, Fred, 50
*Motiv: Avatar / Me*, 169–174
*Motiv: Avatar / We*, 169–174
Motte, Warren, 50
Mulvey, Laura, 76

nanosublime, 188, 201
*Nanowatt*, 205
Nauman, Bruce, 248
neuromania, 196–197
neuromedia, 198
"New Art of Making Books, The," 17, 32–33
*New Jazz Poets*, 111
*New Sentence, The*, 130
"New Spirit, The," 2
Niedecker, Lorine, 84–85
Nietzsche, Friedrich, 49
"`nobody to talk to anything about`," 135–136
"not a / cricket …", 97

Objectivism, 83–85
Obrist, Hans Ulrich, 218–221
O'Doherty, Brian, 24
Olson, Charles, 85, 88–89
oneworder (one-word poem), 12, 78, 93–110, 181, 219, 225–236, 272
"Oppressive Gospel of Minimalism, The," 60–61
"o   r …", 159
Oulipo (Ouvroir de littérature potentielle), 93, 215
"oxygen," 99

*Pages*, 154
*Paperdraft*, 168–170
Parreno, Philippe, 219

Parrish, Allison, 212–215
"PASSAGE," 116–117
Perelman, Bob, 127, 146, 263
performative (utterance), 26, 128
Perloff, Marjorie, 4, 19
"Pharmacie du Soleil," 195–196
philology, 16, 49–50, 249
"Philosophy of Composition, The" 209
Pichler, Michalis, 232
*Pieces*, 85–86, 130
Pignatari, Décio, 91
Pink Floyd, 150–151, 153, 156–157
Piper, Adrian, 69–70
Poe, Edgar Allan, 17, 209–210
*Poem by Repetition by Aram Saroyan #1*, 150–152, 154–155
*Poem by Repetition by Aram Saroyan #2*, 157–159
*Poem by Repetition by Aram Saroyan #3*, 149–150, 152
*Poem by Repetition by Aram Saroyan #3* (CD), 151, 156
*Poem by Repetition by Gertrude Stein*, 159–160, 162–163
*Poem by Repetition by Robert Grenier #2*, 165–167
poememe, 21
*Poetry*, 26–28
"Poetry," 81
"Poet's Work," 84–85
*Poor. Old. Tired. Horse.*, 93
Porter, Bern, 202
Posnock, Ross, 251
Pound, Ezra, 77–81
print-on-demand (POD), 203–205, 270
Pritchard, Norman, 111–126
"Projective Verse," 85, 131
protest art, 17–18, 242
punk, 175, 181
*Pure Poetry*, 26–29

Queneau, Raymond, 93
"question of recognition phenomena," 148

"rain drops the first of many," 146
Rame, 210–211

Rankine, Claudia, 15
"Raven, The," 209–211
*Reading Writing Interfaces*, 168, 179
readography, 47–48
readymade, 3–4, 14–15
redaction, 4, 81
reductionism, 48
"Red Wheelbarrow, The," 82–83
Reed, Anthony, 118–119
Reed, Ishmael, 115–116, 118–119, 122
Reinhardt, Ad, 237
remediation, 159, 240
renunciation, 251
"restless moving to the right," 143
Rinne, Cia, 19–20
Rosen, Kay, 21–22
Rowland, Cameron, 15
Rubenstein, Raphael, 47
Ruscha, Ed, 26–29

Saper, Craig, 243
Saroyan, Aram, 1, 4–8, 10–12, 18, 93–110, 142, 149–159, 208, 220–222
"Schema (Poem-Schema)," 24, 192
"schweigen," 87
*Sentences*, 57–69, 127–148
*Sentences toward Birds*, 143–145
*Sergeant Pepper's Lonely Hearts Club Band*, 27
Seu, Mindy, 24
Shaked, Nizan, 70–71
Shannon, Joshua, 198
Shapin, Steven, 196
shuffle literature, 131, 260
Siegelaub, Seth, 7
signage, 17–18, 91
"silencio," 87, 90
"Silhouette," 116–117
*Silk Poems*, 185–190
Singer, Brian, 67
*Sky Poems*, 2, 91
*Sliders*, 211–212
Smithson, Robert, 1, 27, 48–49
"SNOW," 142
Solt, Mary Ellen, 5–6, 18
"someoldguyswithscythes," 138
"Some Poetry Intermedia," 14

INDEX     279

Sontag, Susan, 25
*Speech Bubble / Richard Hell*, 175–183
Spicer, Jack, 93
*Spontaneous Particulars: The Telepathy of Archives*, 48
*Statements*, 65
Stein, Gertrude, 31–32, 77–78, 84, 127–128, 135–136, 138, 145–146, 159–160, 203–204
Sterne, Jonathan, 242
Stewart, Garrett, 241, 248–249
Stillman, Nikki, 201
Strickland, Stephanie, 243
structural film, 38, 247
"Suicide," 206
"Surface Reading: An Introduction," 49
Syms, Martine, 40–45

"Technical Manifesto of Futurist Literature," 77
Temkin, Daniel, 214–215
*Tender Buttons*, 32, 138, 263
Tenen, Dennis, 249, 266–267
texticles, 3
"This Is Just to Say," 82
Thomas, Lorenzo, 116
Thoreau, Henry David, 64–65
"Thoreau, the First Declutterer," 64–65
"Thoughts?", 220–221
Thurston, Nick, 47–48
"tick …", 97–98
titles (in art and literature), 238, 251
*To Icon*, 9, 168–171, 174, 175, 183
*to icon: poems*, 174
*TOP*, 103, 106
transreal, 111–126
*Twelve Erroneous Displacements and a Fact*, 192–194
Twitter, 82–83, 212–215, 221–222, 271
*Twoness*, 40–41

*Ulysses*, 12
Umbra, 111, 257
*Untitled (Fool)*, 181
*Untitled (I Am a Man)*, 13, 70–73
*Untitled (I live on my shadow)*, 31
*Untitled (Riot)*, 181
*Untitled (You Make Me)*, 181–183

*Untitled (Your gaze hits the side of my face)*, 74–76

Venet, Bernar, 6, 60–63, 270
Venturi, Robert, 2
"VIA," 122, 125–126
"Visual Pleasure and Narrative Cinema," 76

"`walking down Washington Avenue`," 135, 261
*Wall, The*, 157
Wall-Romana, Christophe, 247
Ward, Koral, 264
*Warm Broad Glow*, 30–31
Weiner, Hannah, 18
Weiner, Lawrence, 27, 65, 250
Welchman, John, 238
Werner, Marta, 50
Wershler, Darren, 199
"`what a weird deserted place New Hampshire is`," 142
"What is an @uthor," 215
Williams, Emmett, 24–25, 31
Williams, William Carlos, 5, 82–83, 217
Wittgenstein, Ludwig, 263
Wolfe, Tom, 179–180
Wollheim, Richard, 19
Wool, Christopher, 49, 181–183
Woolf, Virginia, 21
*Words & Photographs*, 102–103
*Words to Be Looked At*, 3
*Works: 24 Poems*, 155

*Xenotext, The*, 198–202
Xu Bing, 238

Yearous-Algozin, Joey, 203
Young, Kevin, 115

*Zorns Lemma*, 38–39
Zukofsky, Louis, 83–84, 94, 96